Our city, state, and country are brutalized with suffering from COVID-19, racial injustice and the lingering destructive effects of hurricanes. Is it the right time to celebrate frivolity? After additional consideration, we believe it is. Because we're not simply celebrating frivolity, but because *I Wanna Do That!* shines a spotlight on the best of what people have within. It focuses on the creative impulse, the desire to build and support community, and the ability to bring joy to others. These photos depict our community in action. This book celebrates and chronicles the creative impulses that separate New Orleans from the rest of the country. This creativity uplifts our spirit and helps us to keep our sanity in dark days.

Since 1725 New Orleans has had a dominant population of people of African descent. New Orleans was home to the largest domestic slave trade in the country, in which an estimated 4.5 million people were sold into slavery. The destruction continues today as the community of African descent bears the largest negative impacts of all natural, health and economic disasters. This book is unable to right those wrongs, but we strive to acknowledge the stark reality of the history. In an effort to support the culture bearers of our community, we are allocating a portion of the sale of each book to "Feed the Second Line" which provides support and food to our important cultural community. When *I Wanna Do That!* discusses these traditions, we use the terms Black Masking Traditions and Black Masking Indians, following the manner of how the maskers speak of themselves. In reverence for their work and process of creation, we have identified these Black Maskers by name in the photo index. While we don't have names of all members of other marching krewes, we celebrate and salute you all.

I Wanna Do That! is our way of documenting a cultural movement that is important to the city and to the people within it. Our mission is to commemorate the community. This is an important story, one that needs, and deserves to be told.

As we go into our second printing, COVID 19 has necessitated the cancellation of Mardi Gras parades in 2021—the first cancellation in forty-two years. We are proud our community is practicing responsible protocols and waiting for the scourge of this virus to pass. *I Wanna Do That!* wishes everyone safe keeping and hopes that this book will remind the world of the joy to be found in the marching krewe movement. We look forward to marveling at the creative responses that arise, even in these troubled times.

–December 2020

I WANNA
DO THAT!

THE MAGIC OF
MARDI GRAS MARCHING KREWES

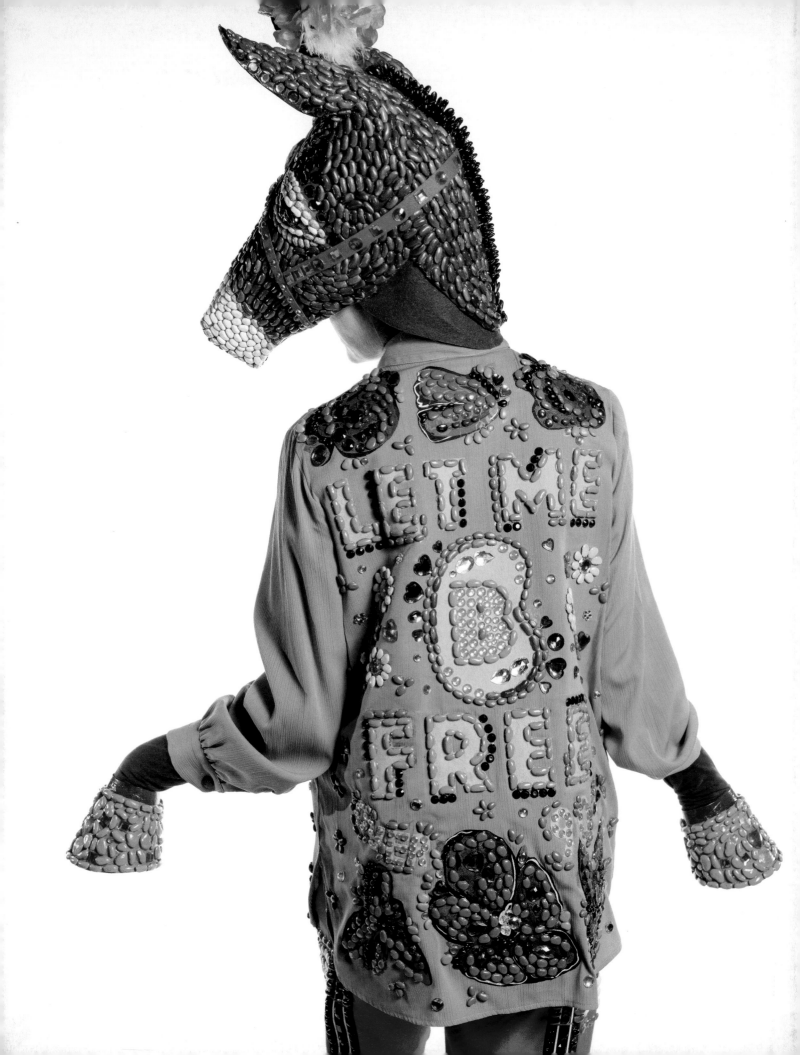

I WANNA DO THAT!

THE MAGIC OF
MARDI GRAS MARCHING KREWES

BY

ECHO OLANDER &
YONI GOLDSTEIN

PHOTOGRAPHY BY

RYAN HODGSON-RIGSBEE & PATRICK NIDDRIE

FOREWORD BY ARTHUR HARDY
EDITED BY SUSAN SCHADT

SUSAN SCHADT PRESS
New Orleans

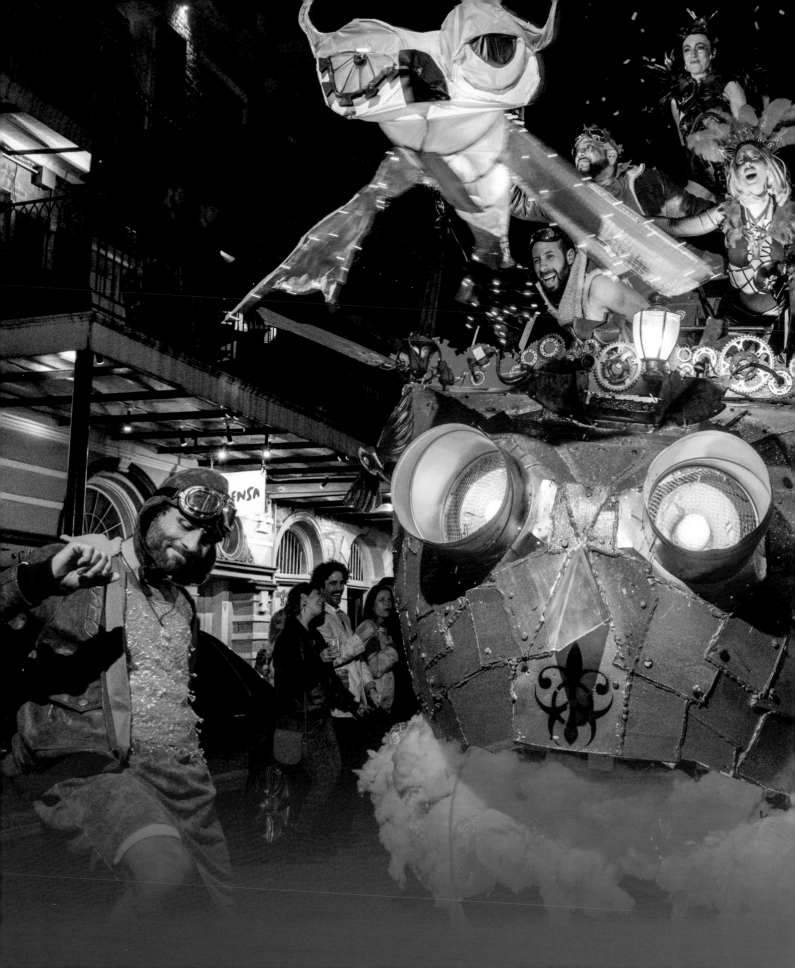

CONTENTS

FOREWORD

Arthur Hardy

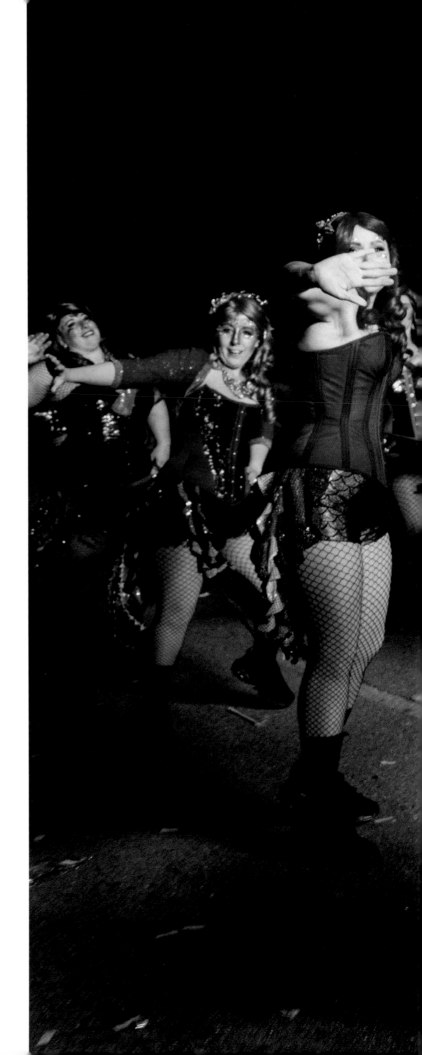

My earliest recollection of Mardi Gras is watching the 1951 Mid-City parade nine blocks from my home. My first participation in parades came as a thirteen-year-old trumpet player in the Beauregard Junior High School Marching Band. I became so fascinated by the celebration that I decided to study it. In 1977 my wife and I turned this hobby into a business when we published the first edition of our annual *Mardi Gras Guide*.

I became a fan of the "non-traditional" Krewe du Vieux years ago, although we did not give them much coverage in our magazine since, as a pre-season event, they are technically not an "official" Mardi Gras parade. They were also rather risqué.

A few years ago several other new small krewes were born although I confess I wasn't all that interested in seeing them in person. That all changed three years ago when a buddy dragged me to every alternative that rolled. And am I glad he did! My attitude was instantly and permanently changed. I was hooked. This was the new Mardi Gras. It was refreshing, and I belatedly embraced it.

So impressed was I that we started providing these krewes their own section in our magazine. And I now include additional coverage on them on the radio, on TV, in my newspaper column, and in my YouTube Vlog Mardi Gras series.

These groups complement rather than compete with the traditional parades that locals and visitors have enjoyed for more than one hundred sixty years. I can truthfully say, the recent growth in the number, quality, and popularity of "alternative" krewes is perhaps the most significant movement in Mardi Gras in decades. And the

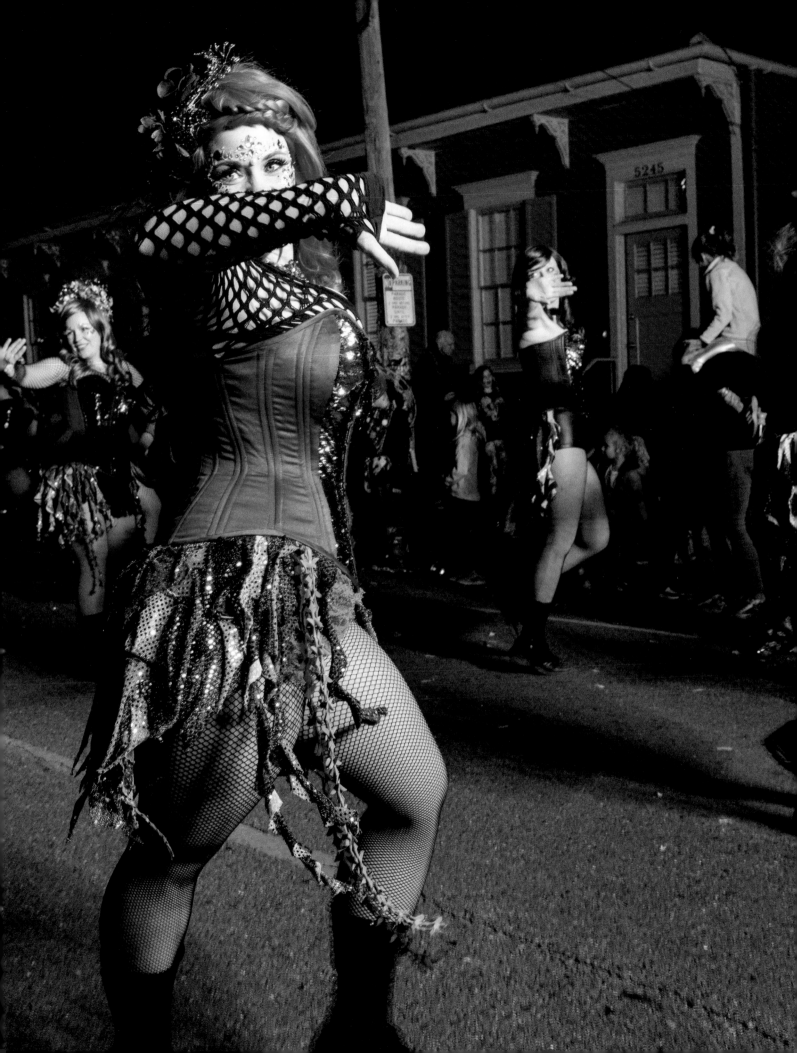

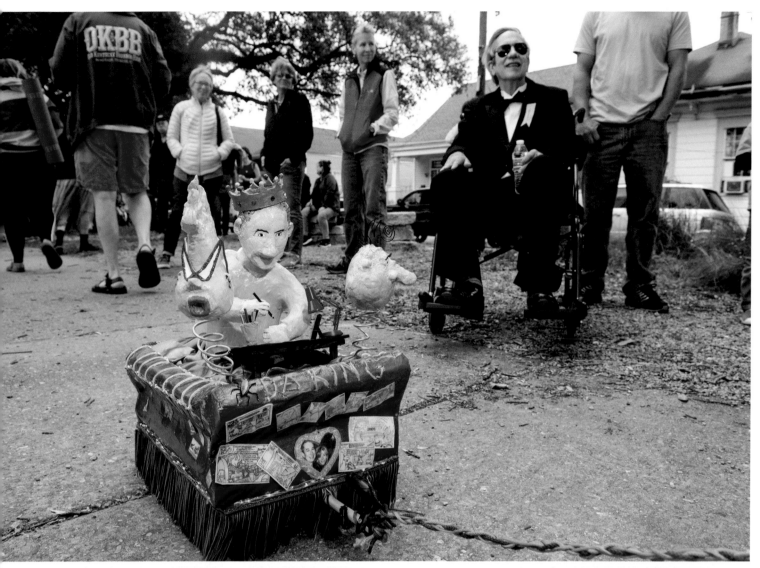

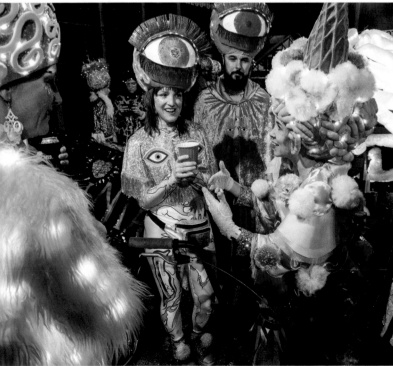

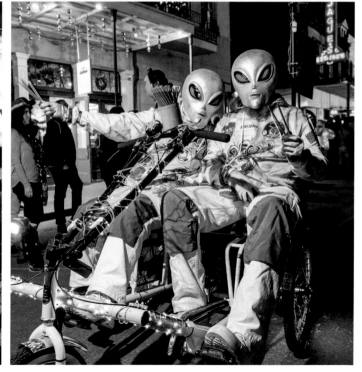

More personal and intimate in scale, these parades allow a different, direct, face-to-face interaction between revelers and spectators.

The experience of viewing a procession at eye level is quite different from seeing much grander, brightly lit, technologically advanced floats from below. More personal and intimate in scale, these parades allow a different, direct, face-to-face interaction between revelers and spectators. Unlike in traditional parades where counting bags full of plastic baubles is the measure of enjoyment; here the emphasis is clearly on admiring the visual display. Perhaps that is why the crowds appear so genial.

The growth of alternative krewes has added variety to the celebration and helped diversify Carnival while expanding the length of the parading season, as well as its geographic footprint. These groups also offer an inexpensive way to participate in Carnival in a meaningful way.

Adult marching groups are also part of the "alternative" movement. Many feature provocative names and costumes, and perform dance routines that require practice and stamina. While Mardi Gras dance groups were once the domain of "the young and the shapely," now more mature marchers also have the opportunity to strut their stuff in traditional parades.

Only time will tell how these groups evolve, but we can expect them to remain inclusive and engaged with the community at all levels. If this new movement proves anything, it is that people of various backgrounds and beliefs can be united in the celebration of Mardi Gras, where every citizen has a voice.

Taken collectively, more than three hundred groups make up the alternative krewe universe. New Orleans is richer because of them.

crowds and the media have taken note. The alternative parades such as Chewbacchus, 'tit Rex, and Krewe Bohème have become so popular (and the crowds they attract so large), that the New Orleans Police Department rescheduled their parades a week closer to Christmas when more manpower is available to properly patrol the parades in the Marigny and Bywater neighborhoods.

Alternative krewes are independent groups that are hard to place into categories. In their simplest form, these clubs are collections of individuals who share a common interest and march under an umbrella name. Members are obviously dedicated and are eager to use this new-found forum to express themselves.

It is evident that much time and thought goes into their costumes and make up. There is nothing mass-produced. It is a moving art walk. Fans, some with an almost cult-like loyalty, return year after year.

Alternative parades travel on foot. Floats are powered by humans or the occasional horse or mule. Throws are often handmade, sometimes recycled, and usually environmentally conscious. I remember receiving several lovely papier-mâché flowers, each one different, obviously the work of the walker.

PREFACE
Echo Olander, Yoni Goldstein

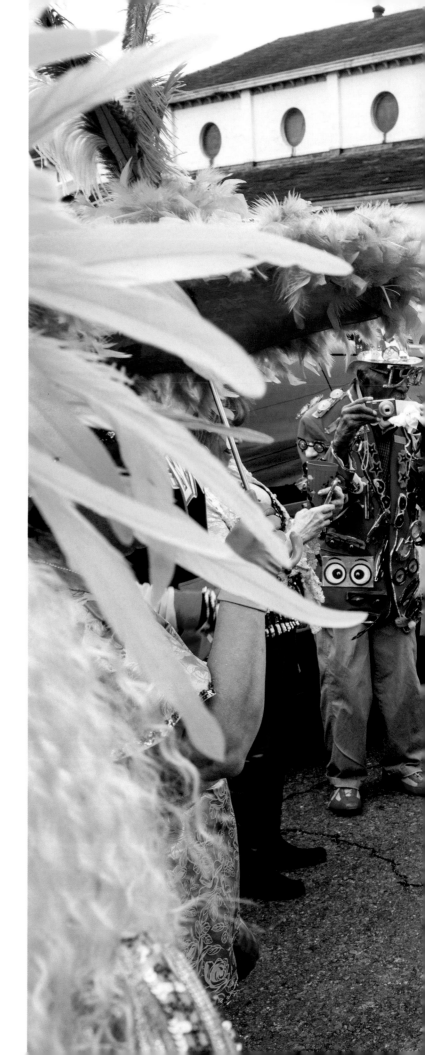

The bass drum thunders, then the snare, the syncopated rhythms underpinning a blare of trumpets. Marching bands challenge each other's prowess as majorettes prance and flag bearers swoosh their poles. Dancers review well-rehearsed moves. Excitement builds and the parade begins to roll. The title float appears, klieg lights swinging, dance teams begin to move, the police stroll and, if you're lucky, the flambeaus burn brightly. Hearts race, feet tap, and another Mardi Gras parade commences. We find ourselves bouncing in anticipation: "C'mon, let's go!"

While most of America experiences fairly static parades— sit on the curb, wave a flag, depart—New Orleans' parades are interactive, full of the creativity and joyful expression of a whole community. Here, parade goers dance and jockey to catch coveted throws from decorative floats. They sing along with bands as they play, they search in anticipation for their favorites and for their friends. The audience is, in fact, a PART of the parade.

Carnival is a universe of experiences and traditions, with parades as one aspect of that vast universe. *I Wanna Do That!: The Magic of Mardi Gras Marching Krewes* zooms in on one particularly special facet of parades: the ever-expanding creative movement of marching krewes. This compendium is documentation of an evolving culture— an art form that grows, changes and blossoms with each Carnival season. As *The Times-Picayune* arts writer Doug MacCash notes: "At this juncture, marching krewes are one of the best art stories in the city."

There is a special closeness between the people who march and their audience. In fact, that closeness often is the magic that transforms audience members into participants. In researching this book, we heard again and again, "I was watching the parade and thought to myself...**I wanna do THAT!**"

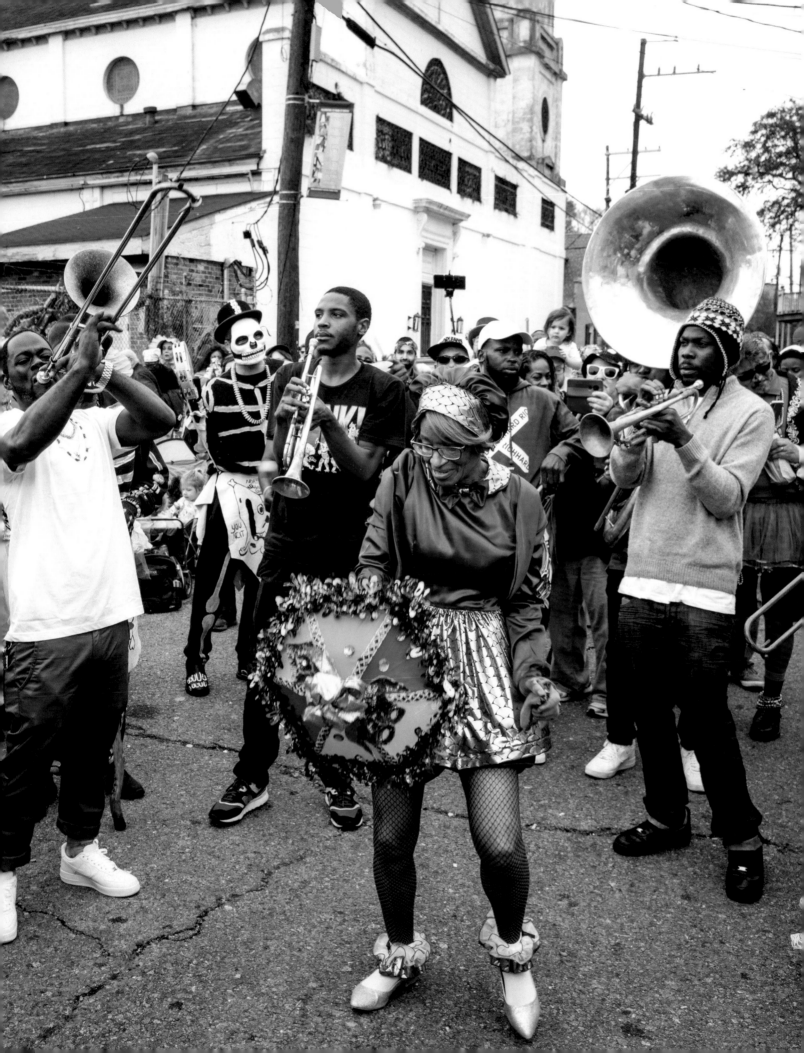

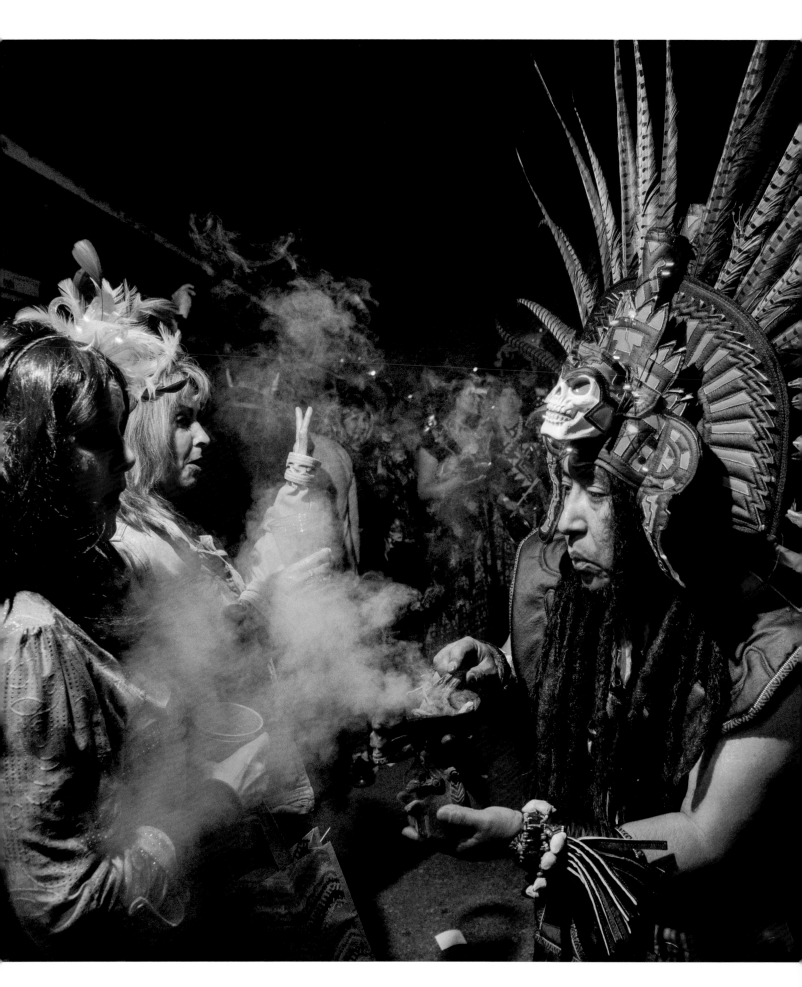

"**For me this is about the moment. The singular experience of one night when people come together to create the parade — it's never happened before, never will again. While Mardi Gras and our parade happen each year, each year it is different. We're our true selves when we're in a mask. It's magical.**"
–Brooke Ethridge, Overlord, Chewbacchus

The truth of Carnival is that it has as many versions as there are participants. New Orleans' Carnival season has layers and layers to peel, and changes its personality from one community, one parade, one neighborhood, and one part of the day to the next.

The vast majority of parades center around Mardi Gras in a Carnival season, not simply one Tuesday of the year. Beginning on Twelfth Night, January 6, the community careens and sashays throughout the season which ends with Fat Tuesday (translation from French of Mardi Gras). While the calendar relegates Carnival to one part of the year, it never really leaves the hearts of New Orleanians, who sew and bead costumes, practice their moves, and keep their creative fires burning throughout the year. Those who parade bring revelry, joy, and awe both to an adoring community—and to themselves.

And there are parades. Lots of them. Parades that range from petite to supersized, from handcrafted to professionally crafted, from mega floats to marching boots. In New Orleans, parades are organized by "krewes" or private social clubs that participate in Mardi Gras activities. *I Wanna Do That!*'s focus is on marching krewes which we define as a group of creatives who join together to participate in one or more parades centered around Mardi Gras. These marchers may walk or dance the route, ride individualized motor vehicles, or roll conveyances that are powered by people. There is a performative component that may include, but goes beyond, the performance of music. *I Wanna Do That!* focuses only on those krewes who march in New Orleans' East Bank parades and routes. With the exception of Black Masking Indians, Baby Dolls, Skeletons, and a few marching clubs that have been in existence for many years, the current iteration of marching krewes is a fairly new phenomenon. One that deserves its own focus.

The vast and fascinating world of second lines and social aid and pleasure clubs are not centered around Mardi Gras and are rich subjects on their own highlighted in many books, films, and research projects. In fact, we encourage you to dig deeper into them and all aspects of Carnival through the rich list of resources in the final section of the book.

The difference between a parade and a marching krewe begins with the parade's focus on the floats that are pulled by tractors and which carry the members, and marching krewes whose members are on foot, maintaining an emphasis on people (parade krewes are simply called parades throughout this book). If marching krewes utilize floats, they are smaller and drawn by mules, people or bicycles. Parades have multiple elements—floats, marching bands, marching krewes, and various engaging components. Marching krewes are simply themselves. Some marching krewes only participate in other parades, some are parades unto themselves, but all are people focused. Two additional characteristics differentiate parades from marching

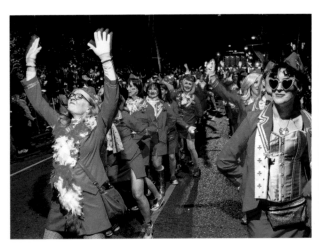

krewes: money and proximity. Membership in marching krewes is much more affordable, making participation more accessible. Generally membership is open to a broader group of people than most parades. Proximity to the audience is the other. The essential nature of marching krewes is the close contact with the audience and the magic in the personal connection as marchers inhabit the same space as their adoring audience.

The field of marching krewes is wildly varied with differences that are many and fascinating to uncover. In constructing the parameters for what should be included in this compendium, various attributes of the krewes were considered. Do they play or march to music? Do they have a single costume? Do they march in multiple parades, only one parade, or are they a parade of their own? Do they have a year-round presence? Is craftsmanship a big component of their krewe? Is there a charity component? Do they hand out throws? Are they single-sex organizations? There are common attributes, however, with the greatest being the requirements of creativity, artistry, quirkiness and humor. Inclusiveness and affordability are universal. The work is often subversive. Individuality is valued. And there is an exuberance that is impossible to miss.

Participation in marching krewes provides a badge of civic identity and bestows on its members status as a New Orleanian, contributing participants in what is arguably the country's most culturally rich city. The lines blur between our categories, and many, if not all, of the krewes could fit into several of the categories used in *I Wanna Do That!* Experiencing and participating in the krewes is done in an overlapping way as well—many marchers participate in several krewes, krewes march in several parades, and there is a continual interplay and interaction—sometimes even competition—between the krewes.

The vast majority of these vibrant photographs were taken in 2020 by intrepid photographers Ryan Hodgson-Rigsbee and Patrick Niddrie. Without their documentation skills and passion this book would not exist. To supplement, some photographs were pulled from earlier years and a few photographs were garnered from other photographers. We have tried throughout to stay true to *I Wanna Do That!* as a snapshot, 2020 vision if you will, of the current environment of marching krewes.

Rather than simply document, this book exists to celebrate the creativity and diversity of marching krewes. Come turn the page, strike up the band, put on those boots, and enjoy!

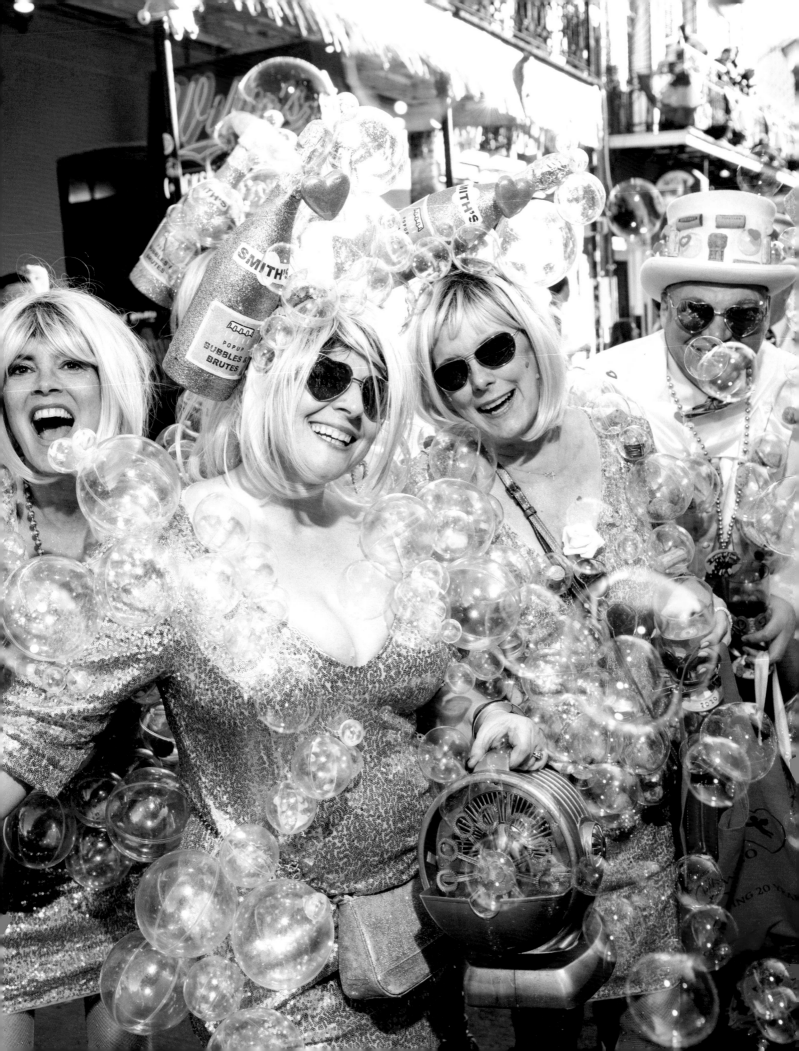

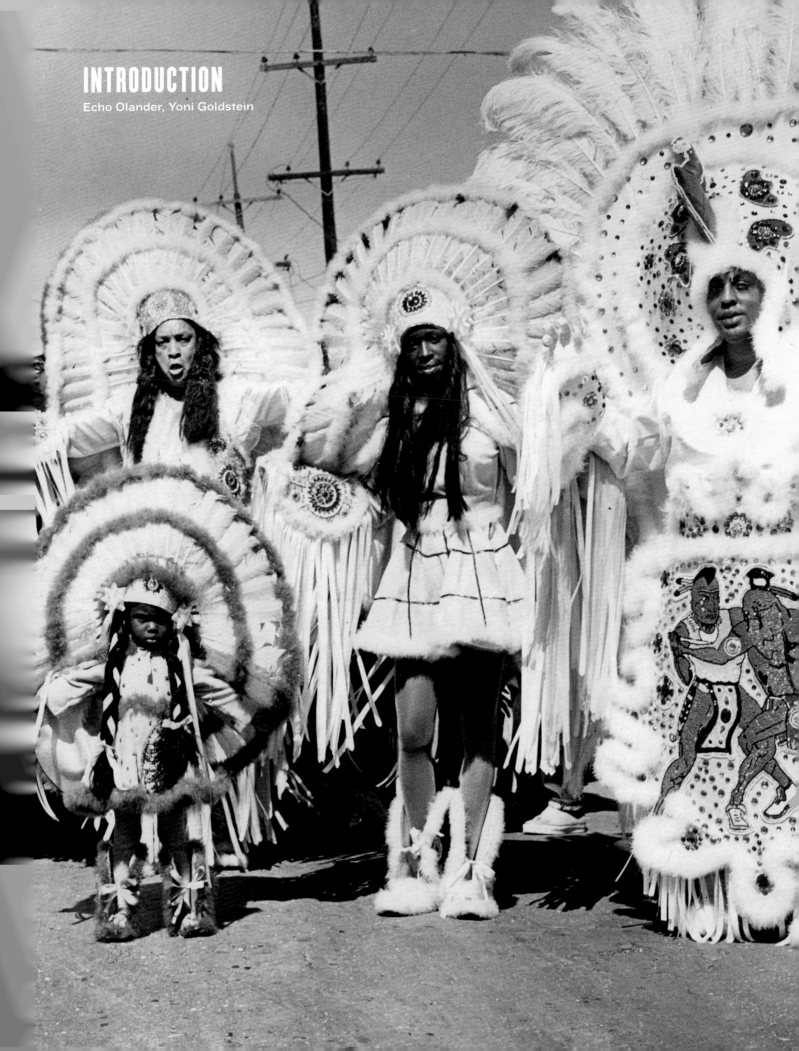

INTRODUCTION
Echo Olander, Yoni Goldstein

CARNIVAL BECOMES A PART OF NEW ORLEANS CULTURE

The coming of spring has been celebrated since the beginning of humankind. Many believe that New Orleans' current Carnival celebrations are tied to *Saturnalia*—a Roman celebration of the god of agriculture, Saturn, which was practiced in winter several centuries BCE.

What is definite is that a vast variety of communities and religions throughout time celebrated the annual transition from cold and dark to light and warm. As time evolved these spring celebrations were often called names that speak to a "farewell to flesh" as the greening of the earth allowed for diets to turn from meat to vegetable. Called *Carnelevamen* in Greece; in Italian, *Carnevale*; in French, *Carneval*, and in English, Carnival.

TIMING IS EVERYTHING

As the Christian religion became more prevalent in Europe, its leaders worked to absorb, co-opt or transform the pagan rituals they intended to replace. Pragmatically, religious leaders linked pagan cycles of nature to Christian practices. Connecting with the spring rituals of rebirth and renewal and the overcoming of the powers of darkness, the Christian Council of Nicaea in 325 CE established that Easter would be held on the first Sunday after the first full moon following the vernal equinox (the date when day and night are of even length, between March 19 and 22). Within the Christian religion, Carnival season begins with Epiphany, or Three Kings' Day (the day that marks the visitation of the three kings to the baby Jesus). Epiphany is commonly called Twelfth Night in New Orleans[1] and that date, January 6, kicks off the Carnival season with the first parades and the first date traditionalists will serve the beloved King Cake. (The multiple varieties of which could serve as the subject of another book!) A season of hijinks and excess commences. The celebration peaks on Mardi Gras Day, when dancing, parading and costuming rage, extravagances flourish, and work is suspended by the mayor of the city.

On the day that follows the overindulgence of Mardi Gras—Ash Wednesday—the Lenten period of penitence begins. During the forty days (not counting Sundays!) of Lent, many Christians commit to fasting, as well as giving up certain luxuries in order to honor the sacrifice of Jesus Christ's journey into the desert for forty days. The period between Epiphany and Lent is sometimes called Shrovetide, or more colloquially, Carnival. While the correct definition holds Carnival as the full season and Mardi Gras as only one day, locals often call the season Mardi Gras. Most commonly, the term Mardi Gras is used for the "high season" of celebration, starting when the parade schedule ramps up, two weekends before Mardi Gras Day. (Throughout *I Wanna Do That!* Carnival and Mardi Gras are used interchangeably.)

CARNIVAL IN NEW ORLEANS: CHANGE IS CONSTANT

In 1682 the Kingdom of France, with its deep Catholic roots and its Shrovetide practices, claimed the native territories inhabited by the Chitimacha, Chickasaw, Choctaw and Natchez Native Americans. While the first American Mardi Gras took place in Mobile, Alabama, in 1703, New Orleans quickly became the center of the Catholic practice.

Processional practices came from many places: Sicily, Germany, Jewish and African processional traditions were melded together as the city grew.

Founded by the French in 1718, the city of New Orleans reveled in pre-Lenten balls and fêtes. These early New Orleanians had an extreme passion for music and dancing. By 1743 when the Marquis de Vaudrieul was governor, the early European-based Carnival celebrations were centered around balls. These lavish spectacles, both public and private, were the core of Creole Carnival celebration and became the venue where the city's debutantes were presented to society.

Soon after the ceding of New Orleans to Spain in 1763, masked balls were banned by Spanish governors. In 1800 France re-acquired the city and state, which were then sold by Napoleon to the United States in 1803.

During these transitions in governance a shift happened. In the early 1800s Carnival celebrations spread from formal halls to the street, and the street-based nature of Mardi Gras began. Timothy Flint, a New Englander who observed life along the Ohio and Mississippi rivers visited New Orleans in 1823 where he witnessed a "Saturnalia" street performance in which "some hundred of negros, male and female, follow[ed] the king of the wake." This king "wore a headpiece of oblong gilt-paper boxes tapering upward like a pyramid..."[2] His followers were adorned by costumes of streamers and bells. This celebration by participants of African descent heralded a street-focused Mardi Gras. With it began the practice of highlighting social inequities, expressing bawdy truths, and poking fun at the pretensions of the powerful and the hypocritical pieties of the day—a tradition which has carried through to modern-day Mardi Gras.

In 1835 another observer documented how the parading practice had evolved. Author James R. Creecy describes New Orleans Mardi Gras as follows:

"Shrove Tuesday is a day to be remembered by strangers in New Orleans, for that is the day for fun, frolic, and comic masquerading. All of the mischief of the city is alive and wide awake in active operation. Men and boys, women and girls, bond and free, white and black, yellow and brown, exert themselves to invent and appear in grotesque, quizzical, diabolic, horrible, strange masks, and disguises. Human bodies are seen with heads of beasts and birds, beasts and birds with human heads; demi-beasts, demi-fishes, snakes' heads and bodies with arms of apes; man-bats from the moon; mermaids; satyrs, beggars, monks, and robbers parade and march on foot, on horseback, in wagons, carts, coaches, cars, &c, in rich confusion, up and down the streets, wildly shouting, singing, laughing, drumming, fiddling, fifeing, and all throwing flour broadcast as they wend their reckless way."[3]

By the 1840s and early 1850s the scarcity of maskers and the increase in scandalous and rowdy behavior of those remaining contributed to a declining reputation of the Carnival celebration. Local Creole newspaper the *New Orleans Bee* noted that, "boys throw flour and mud on each other and on spectators and painted Jezebels exhibited themselves in public carriages." The paper concluded "Better that the custom should be wholly discontinued than degenerate into a meager and idiotic display for a throng of gaping idlers."

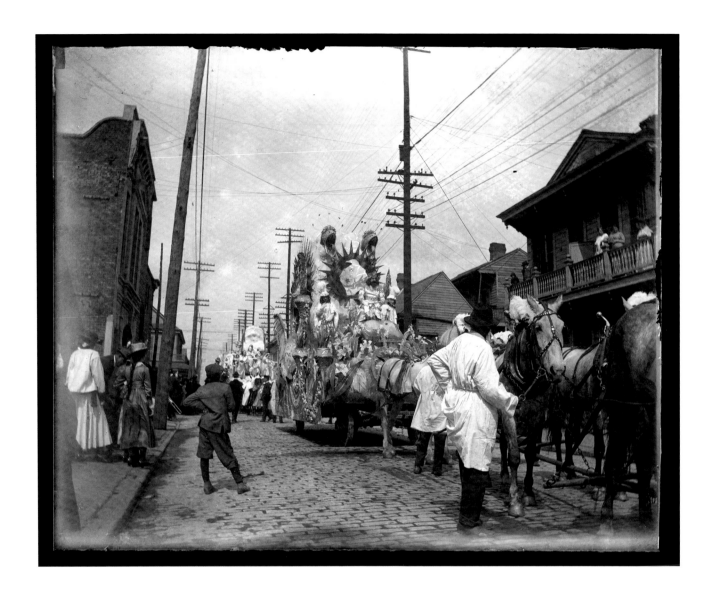

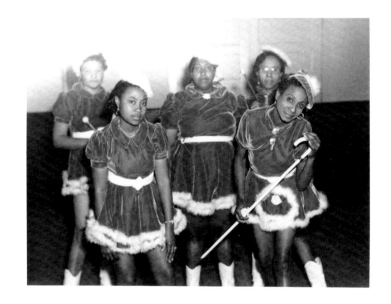

4.

13. 14. 15. 16. 17. 18.
 19.

16.
Heron
16

While some observers of these early bellicose activities wanted to abolish these traditions, others were striving to reinvent the celebration. In 1857 Carnival celebrations took a major shift when New Orleans' White elite joined together to create the first formal Mardi Gras parade: the Mistick Krewe of Comus. Comus became the first organized parade, with coordinated costumes and pageantry that culminated in a ball, bringing together many of the existing Carnival practices into one event.

Comus' practices were noted by others who said to themselves "I wanna do that," and by 1900, all-male, all-White krewes refocused Carnival celebrations from informal street masking to a set of planned and organized parades run by private organizations. While organized, these early formal parades were a riot of surrealistic creativity. As the parades became ever more elaborate spectacles, the celebration extended a one-day Mardi Gras Day celebration to an entire season of Carnival. In the process, most of the population became spectators rather than participants. And that participation became segregated, barring women, people of color, and people from other religions and socio economic groups. People of African descent practiced their own traditions, away from the French Quarter and Canal Street celebrations where they were permitted "only when on the job." By 1910 crowds called for beads and trinkets from the parade maskers and the phrase "Throw me something, Mister!" became part of the New Orleans lexicon.

HISTORY

Often called the northernmost city of the Caribbean, New Orleans is a mosaic of cultures. Its history marks a convergence and interweaving of Native American, Asian, European, American, and African influences. This history also includes the stark reality that New Orleans was the country's center of the slave trade, fostering the growth of wealth in the south for White men. Within this intolerable system the cultural influence of the enslaved Africans brought to toil in the cotton and sugar fields began to take hold. This influence included the building of most structures in the city (churches, houses, levee systems, etc.), creating a class of artisanal workers. Through the enslaved Africans and the large and stable community of free people of color, Black New Orleanians created the backbone of the city's music and cultural traditions. While restricted from participating in the formal parades of this era, influence of people of African descent is deeply embedded in, and integral to, the parading culture in the city.

The end of the nineteenth and beginning of the twentieth centuries brought the expansion of both parades and Carnival krewes which expanded to include those previously prohibited by financial, sexual or racial classification. While accounts from 1823 documented an existing Black parading culture, and the first formal documentation of the Black Masking Indians was made in the 1880s, the parading focus of the era was on White male organizations. Also during this time, however, the first White walking krewe (club) formed was the Jefferson City Buzzards (1890), the first Black krewe was the Original Illinois Club in 1894, and the first all-female krewe, Les Mysterieuses, debuted in 1896. These expansions brought the resources and creativity of non-White males, women, and the middle class to the formal parading experience, greatly increasing the range of revelers.

The celebration of Carnival has been consistent—since the founding of New Orleans Mardi Gras, celebrations have only been halted three times: for the Civil War (1862-65), World War I (1918-19) and World War II (1942-46). But change has been constant. Two especially notable events were the advent of "Super Krewes" (krewes with large ridership, membership of more than one thousand, often with a celebrity king) with the forming of Krewe of Bacchus Parade in 1969, and the legally mandated integration of krewes in 1992.

NEW ORLEANS MARDI GRAS

With special thanks to Arthur Hardy's *Mardi Gras Guide*

1823
Documentation of parading culture in the city, especially by people of African descent.

1857
Krewe of Comus forms, coining the word "krewe" and establishing the new format for Mardi Gras traditions: a secret Carnival society, a mythological namesake, a themed parade with floats and costumed maskers, and a tableau ball following the parade.

1862-65
Civil War interrupts Mardi Gras celebrations.

1866
Formal celebrations return to the city.

1870S
Political satire becomes a predominant theme in parades.

1871
Twelfth Night Revelers begin a new tradition when "selecting" the first Queen through the presentation of a golden bean hidden inside a cake, starting the King Cake tradition.

1872
Rex Parade becomes the first daytime parade and the colors of Carnival—purple, green and gold— are introduced.

1875
Archival research documents the first Mardi Gras Skeletons which some believe started in 1819.

1880S
First formal reports of Black Masking Indians are made.

1890
Jefferson City Buzzards form as the first marching club; they are still active.

1894
The Original Illinois Club debuts as the first black Mardi Gras organization.

1896
First female krewe, Les Mysterieuses, is founded.

1909
Zulu marches as a formal parade, building upon eight years of less-formal activity.

1918-1919
World War I cancels Carnival.

1941
First women's parade takes to the streets: the Krewe of Venus.

1942-46
World War II cancels four Carnivals.

1950S
Mules are replaced by tractors to draw floats through streets.

1960
Doubloons make their debut as parade throws.

PARADING TIMELINE [5] 1823/2020

1969
Krewe of Bacchus forms and breaks with tradition by having a celebrity king (Danny Kaye), creating the largest floats and replacing the traditional ball with a supper dance which includes non-krewe members.

1970S
Eighteen new krewes are formed to parade, and eighteen krewes retire from parading. A temporary cap on parades is put in effect.

1974
Ban on parading in French Quarter takes effect, with the exception of walking krewes.

1978
Krewe of Clones begins returning parading to a walking performance art format.

1979
Thirteen parades are cancelled and twelve are routed to the suburbs after police go on strike.

1980
Twenty-seven new parades are formed and nineteen parades meet their demise. Several krewes stop throwing doubloons. Krewe-emblemed throws gain popularity.

1987
"Lundi Gras" celebration is resurrected including Rex, Zulu and the City's Mayor. Only ten of the more than sixty krewes continue a "bal masque" format for the post-parade celebration.

1990S
Economic impact study states that Mardi Gras' annual economic impact nears the billion-dollar mark. Eleven new parades debut, while fifteen fold.

1991
Councilmember Dorothy Mae Taylor successfully leads an effort to pass a city ordinance requiring all parading krewes to have membership open to all races, forcing the issue of integration. Comus, Momus and Proteus protest by cancelling their parades.

2000
Economic impact of Carnival crosses the $1 billion mark.

2001
All-female krewe of Muses debuts, changing the marching krewe community forever.

2005
Hurricane Katrina hits, levees break, the city is underwater for three weeks.

2006
Rather than surrender, New Orleans holds a shortened Mardi Gras for smaller and very emotional crowds.

2010
Mardi Gras coincides with the New Orleans Saints Super Bowl victory.

2020
I Wanna Do That! documents more than three hundred marching krewes in existence.

2021
In responsible acknowledgement of the COVID-19 pandemic, parades and balls are cancelled for 2021. The community's creative response will unfold…

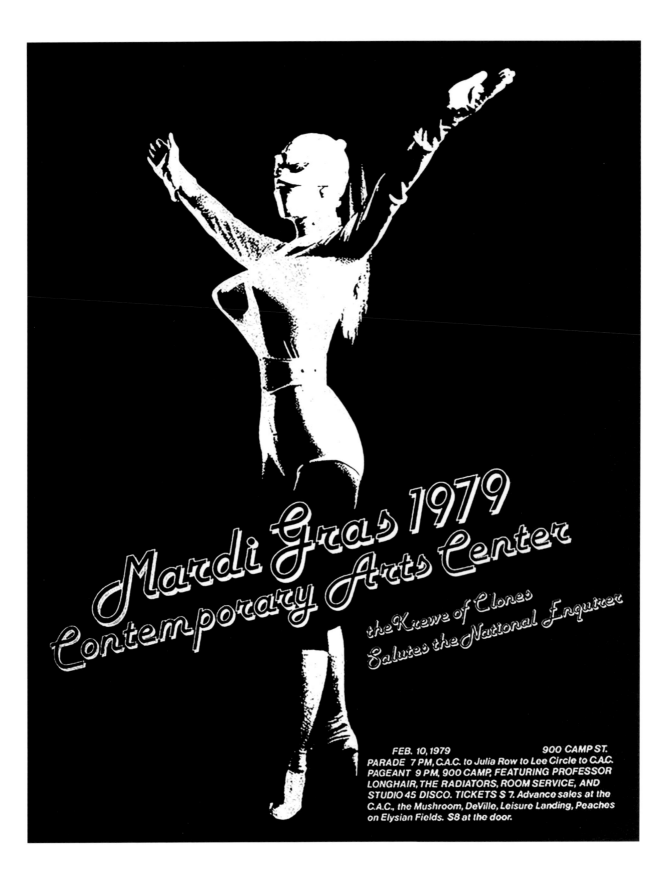

Mardi Gras 1979
Contemporary Arts Center

the Krewe of Clones
Salutes the National Enquirer

FEB. 10, 1979 900 CAMP ST.
PARADE 7 PM, C.A.C. to Julia Row to Lee Circle to C.A.C.
PAGEANT 9 PM, 900 CAMP, FEATURING PROFESSOR
LONGHAIR, THE RADIATORS, ROOM SERVICE, AND
STUDIO 45 DISCO. TICKETS S 7. Advance sales at the
C.A.C., the Mushroom, DeVille, Leisure Landing, Peaches
on Elysian Fields. S8 at the door.

Another landmark event, especially important in the evolution of marching krewes, was the formation of the all-female parade Krewe of Muses in 2001. Muses was the first to make the creativity of the marching krewes an essential component of the contemporary parade scene (although Zulu Parade and its former body the Tramps were formally doing this before the turn of the twentieth century), providing a grand stage for the marching krewes to perform upon.

By the time of the writing of this book, Mardi Gras celebrations have grown exponentially. While spending on Mardi Gras generated more than $1 billion in 2000, Arthur Hardy, the city's favorite Mardi Gras guru notes that a recent Carnival season included 53 parades (throughout the three parish area) including a total of 1,061 floats, 588 marching bands, 3,750 parade units and more than 135,000 parade participants.[4] This *I Wanna Do That!* compendium serves to document and elevate the phenomenon of marching krewes, the latest force for creativity—a new and welcomed expansion of the changing Mardi Gras landscape.

THE WELLSPRING OF THE CURRENT-DAY MARCHING KREWE

There are many events and people who paved the path for our current "alternative" style marching krewe. We submit the following as especially relevant.

THESE CLONES ARE NO IMITATION

In 1978 as a group of artists prepared for a "ball" at the Contemporary Arts Center (CAC), visual artist Denise Vallon organized a parade to get the party started. Thus began a new movement in parading: the Krewe of Clones

"The carnival procession is "*the opera of the streets*, a form of structured and driven psychogeography. It is a prime unifying display mode of creative acts in public space. Processions are to streets what exhibitions are to museums and plays to theatre, and beyond their obvious artistic content, they speak to an aesthetics of the commons."
—Claire Tancons, curator, Prospect I Biennial[6]

arrived as a performance art spectacle. The first year this walking parade marched in the Central Business District with six floats and participants dressed as cockroaches. Based out of the Contemporary Art Center, the "art parade" reveled in sauciness and political and social satire. Including concepts like "Sculpture in Motion" and the "Art Car" movement, it was initially funded by state and federal grants as arts projects. The imaginative street performance was akin to a multi-artist moving exhibition with creativity as its organizing principle. By 1985 the offbeat parade was wildly popular including thirty sub-krewes and fifteen hundred marchers, and had ushered in a new period of citizen participation in parading. After years of conflict with city hall, the impertinence of the Krewe of Clones parade led the city to cancel it in 1985 and revoke the parade permit in 1986. To accommodate the city's concerns, the nonprofit CAC board insisted that content be toned down, the route switched to uptown, and the krewe fees raised exponentially. The group splintered and disbanded.

From the ashes of the Krewe of Clones, Don Marshall and Craig "Spoons" Johnson formed the Krewe du Vieux in 1987. This alternative krewe was the first to return its route to the Vieux Carré (French Quarter) and maintains mule-drawn floats and the bawdy and provocative antics of its predecessor. It continued the efforts of artists to return Mardi Gras to its freewheeling processional roots—and walking performance art troupe with adult-themed social and political satire.

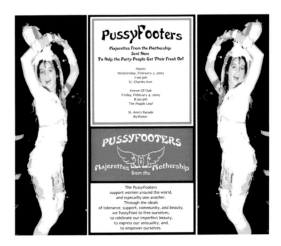

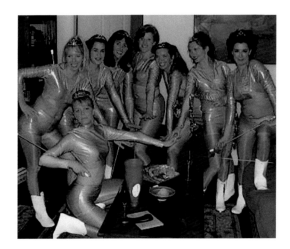

BURNING DOWN THE HOUSE – THE KREWE OF MUSES

The impact of Muses on the growth of marching krewes cannot be overstated. Before the arrival of Muses, there were high school dancing teams, one traditional adult women's dancing team, all men's old line walking krewes, Black Masking Indians, Skeletons, and Baby Dolls, and a few independent parades. Muses enveloped alternative adult marching krewes in its arms, giving a stage to prancing individuality and a feminist slant to much of the marching krewe universe.

Examples exist of women resisting gender stereotypes during Mardi Gras celebrations as far back as 1872. When the Krewe of Venus presented the first all-female parade through the streets of New Orleans in 1941, they did so before a somewhat hostile crowd. In 2001, the Krewe of Muses kicked down the gender walls in Carnival parading. One night in 2000, attorney Staci Rosenberg watched as her male friends rode in a parade down St. Charles Avenue and thought, "Why can't I do that?" echoing the theme of our book. Gathering friends, she founded Krewe of Muses, an all-female parade, which in a challenge to the domination of elite male krewes, became the first women's night parade. There was pent up demand. Calculating that three hundred fifty riders would be needed to fulfill the minimum requirements for

a parade, the captains were elated when seven hundred applications were submitted for the first year's parade, which carried the double entendre theme of "Muses First Time."

Muses resists traditional gender-based norms, "We haven't tried to replicate a man's krewe or any traditional krewe…we haven't tried to replicate what was there— we tried to do something different."[7] Counter to the exclusivity of the elite male krewes, Muses strives for wide diversity in membership through an open and public membership process. Their concept of "affectionate self-satire" pervades their work, and they are proud of the fact that Muses is clever without being cruel. They are a-MUSE-ing, they always roll on T-HERS-days, and they "throw like girls." New Orleans native and Parade Captain Dionne Randolph recognized that bands make a parade and broke through the old boy network that controlled high school marching bands by securing the coveted St. Augustine Marching 100. They were off to the races. Quirkiness and creativity are hallmarks of the parade, and when the Pussyfooters called to ask if there was a place for a group of forty-year-old majorettes, the answer was…yes! In the parade's first years it was met with criticism and befuddlement about its "weird" components. Initially seen as flaky by their male counterparts, the perception changed when the

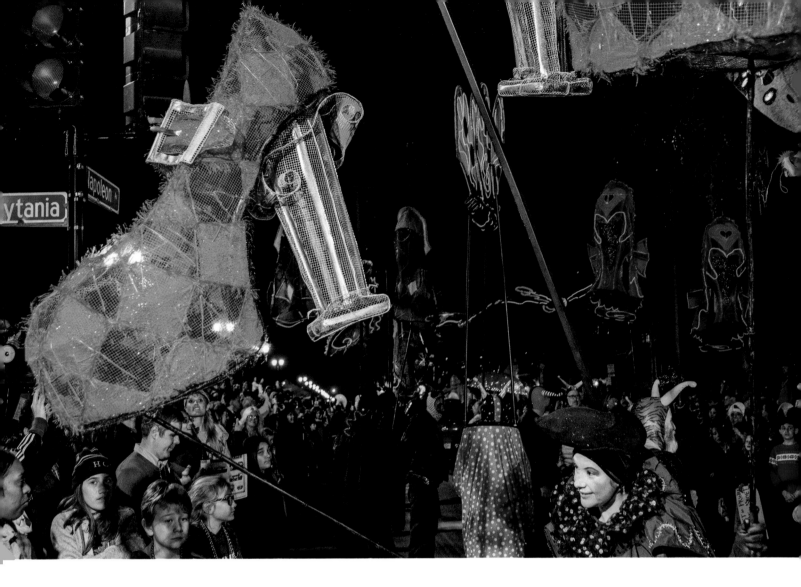

parade began an annual ritual of receiving "best parade" by critics and the general population. Marching krewes continue to be a central component of the parade, many of whom are loyal to Muses.

Muses' feminist brand is pervasive in all of their work. Throws are women and children focused and often useful in nature. The coveted signature throw is a glittered shoe (a concept borrowed from the Zulu coconuts and currently mimicked by numerous parade krewes). High school bands are placed at the beginning of the parade so that the students can get home to bed earlier ("so we can take care of the babies"). Women artists design and paint the floats. This focus on women, their priorities and their power has overtaken the New Orleans parade community: women's parades now top the krewes with the most riders.

With the exception of high school marching bands and dancing teams who have always had a full array of body sizes and types in their groups, parading women were traditionally objectified with trim and youthful body types wearing skimpy costumes, dancing or barely visible on the parade route, especially in the larger night parades. As women moved to a leadership role in parading, they were able to feel comfortable in their own skin, able to own their fun. Women became empowered, wearing costumes that feel right to them, parade on their own terms, and for their own enjoyment. Feminine empowerment is placed within their missions and mottos and their risqué names boldly claim ownership of what may have once been derogatory.

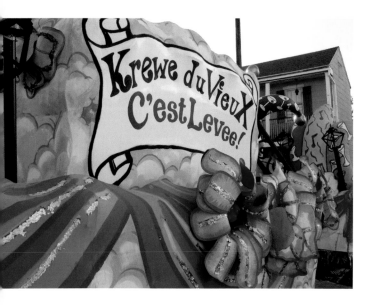

THE KATRINA INFLUENCE

Water defines the city of New Orleans which has an average elevation of one to two feet below sea level with a surround of protective levees to hold the water at bay. On August 29, 2005, Hurricane Katrina filled the Gulf of Mexico and landed her well-formed eye in Plaquemines Parish, hitting New Orleans with high winds and rain and decimating much of the Mississippi Gulf Coast. When several of New Orleans' protective levees were breached, water flooded the city in levels from one to ten feet for more than three weeks, before it was finally pumped or drained out. It was the largest residential disaster in United States history to date.

The impact of the breaches is hard to comprehend. Along with the death of more than eighteen hundred people, damage was done to seventy percent of all occupied housing units. Water flooded eighty percent of the city's footprint—an area seven times the physical size of Manhattan—leaving no power, no water, and no gas. Necessities such as trash collection, grocery stores, mail delivery and gas stations were absent. At one point more than ninety-five percent of the city's residents were evacuated. Many had never left the city, but were sent to destinations throughout the nation as the city struggled to recover. Pre-Katrina the city was sixty-seven percent African American, with a population that experienced high levels of poverty—eighty-four percent of the city's African Americans lived below the poverty line making their devastation particularly acute. It was hard to imagine how the city might come back from such deep crisis and, indeed, there were conversations throughout the country about whether New Orleans should be rebuilt.

As 2005 ended, an embattled and fatigued community was plagued by yet another question: should there be a Mardi Gras? At that point at least one-half of the population was missing or out of the city with an impoverished Black citizenry facing immense barriers to returning and rebuilding. The police force was exhausted and depleted. Full swaths of the city continued to be without basic services. Yet citizens clamored to regain control of the cultural symbols of the city. Chris Rose, author of *1 Dead in Attic* and a writer for *The Times-Picayune*, summed up the sentiment of the community, "We need to send a message that we are still New Orleans. We are the soul of America. We embody the triumph of the human spirit. Hell. We ARE Mardi Gras."[8]

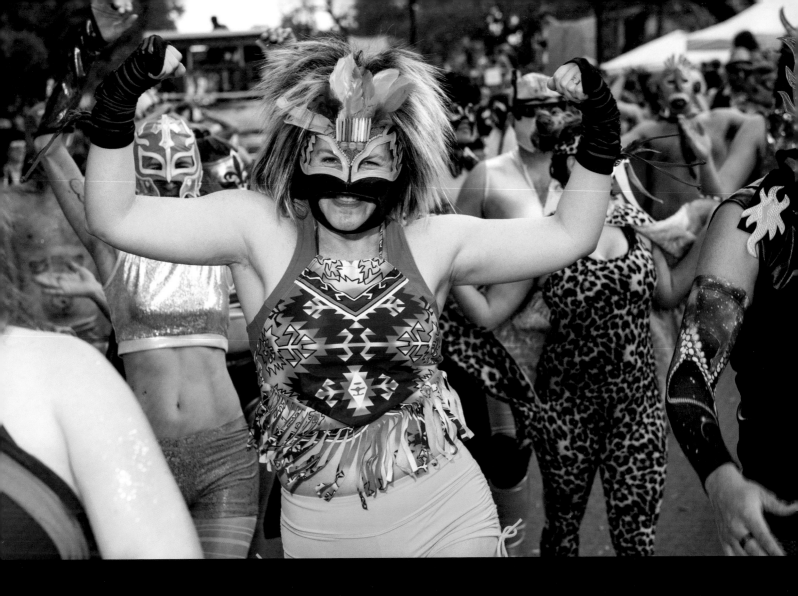

"WE ARE THE SOUL OF AMERICA.
WE EMBODY THE TRIUMPH
OF THE HUMAN SPIRIT.
HELL, WE ARE MARDI GRAS."

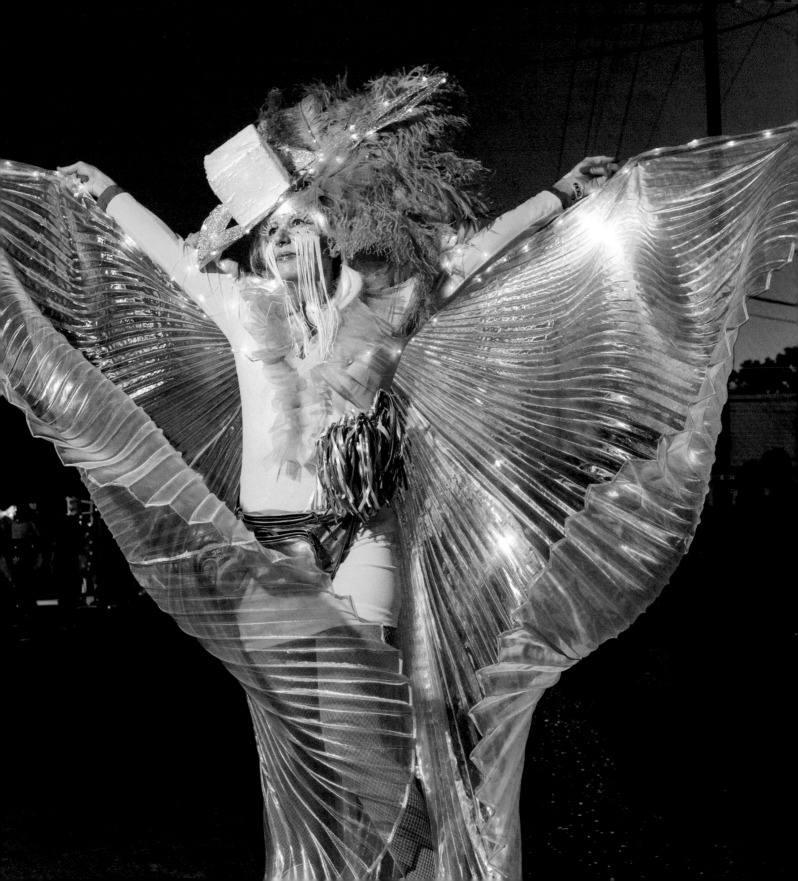

The city determined it would hold Carnival as a tribute to the life force of the city; an affirmation of resiliency. Parade goers and participants both wept as the parades rode the streets. The 2006 Mardi Gras celebration was a collective embodiment of unbroken spirit, of defiance. It showcased the conflicting emotions of the city: an exuberant commitment to its life, alongside an awareness of the great loss suffered.

While one hundred twenty-five thousand residents were able to live in the city, seven hundred thousand people were in attendance for the five-day Mardi Gras weekend from Friday—Tuesday.[9] As Geographer Richard Campanella of Tulane University noted, "Other American cities might have been hard-pressed to draw upon such a deep reservoir of cherished symbols to unify and motivate their scattered citizens. In its darkest hour, New Orleans discovered its most precious asset—itself."[10] The celebration of Mardi Gras was one of these revered symbols.

As part of the rebuild, a movement of community participation in parading grew. Prior to Katrina a handful of marching krewes existed, marching in their own parades or participating in the more formal parades around town. As the city recovered its joie de vivre and experienced a newfound passion for itself, a new phenomenon began to take hold and celebration for locals by locals reclaimed the soul of the city. New citizens also fueled the movement with a desire to be a part of the city's culture. Participation became a badge of civic pride, and it

grew, not just at parades but in parades: marching krewes flourished. With residents no longer content to watch from the sidelines, the breadth and width of participation in marching krewes increased exponentially.

LOOK AT ME!

Along with the advent of Muses and the civic joy of parading, we note another factor in the growth of marching krewes—the role of the camera phone and social media. The first social media platform launched in 1997 and emerged as a communications force in the early 2000s as Six Degrees, MySpace and finally Facebook and YouTube became a common method of sharing information, ideas, and creativity. Social media was supported in large part by the use of camera phones which came onto the market in 1999 and swiftly gained popularity. By 2003 camera phones surpassed the popularity of stand-alone cameras[11], and cameras were carried with us every day, resulting in an abundance of immediate imagery to document daily and desired life. As the camera phone and social media paths converged, an explosion of sharing happened highlighting the excitement and accessibility of participating in a marching krewe. On the parade route, in preparation and in celebration, self-taken photographs, or selfies, helped to propel the accessibility of participation into the New Orleans psyche. Social media continues to hold an important place in marching krewe culture as krewes disseminate information about their events and ideas. Many of the krewes use social media as a way of communicating within their group, and several krewes actively share design ideas for costumes, throws, floats and music.

AND HERE WE ARE

From a small group of fewer than ten marching krewes in 2006, the movement has exploded. Counting all of the sub krewes for our Supa Groups and Black Masking Indians, we identified more than three hundred marching krewes in 2020. For the purpose of examining them more closely, *I Wanna Do That!* created categories, calling out the characteristics that differentiate the krewes from one another. Each category has its own chapter. Many krewes could fit into multiple categories, so krewes are included in chapters that we feel most closely align with their core identities.

To further propel the examination and propagation of marching krewes, we have also included a few extensions. *Krewe-niverse* includes a listing, and a brief description of krewes. For those who might want to jump into the stream, our *Try This At Home* serves as an advice column, relaying words of wisdom from people who have broken ground in the marching krewe field. A *Resource List* leads to places for a deeper dive into the infinite realm of Carnival in New Orleans.

In *I Wanna Do That!*, we strive to capture the essence of New Orleans marching krewes in the year of 2020. It is a snapshot, a salute, a celebration. We hope these photographs and stories will make you want to learn more about long-standing traditions, take to the streets, attend parades, costume and revel in the joyful kaleidoscope. See if you can catch them all!

So put on your marching boots, come inside these pages and join us as we hit the streets, discovering how **"I wanna do THAT"** transformed a community.

[1] A bit of a misnomer as Twelfth Night actually refers to Epiphany Eve, the fifth of January, the twelfth day of Christmastide.

[2] Timothy Flint, Recollections of the Last Ten Years, Passed in Occasional Residences and Journeying in the Valley of the Mississippi. (New York: 1968, reprint of Boston, 1826).

[3] James R. Creecy, *Scenes in the South, and Other Miscellaneous Pieces*, (Washington: T. McGill, 1860), 43, 44.

[4] Arthur Hardy, *Mardi Gras Guide 2020*: 30 – 35.

[5] Ibid

[6] Eric Bookhardt, *New Orleans as Art Form*, http://www.insidenola.org/p/designing-pandemonium-art-history-of.html.

[7] David Winkler-Schmit, "Mardi Gras Sisterhood," *Gambit* (2007). https://www.nola.com/gambit/news/article_a4c2edd8-5aa0-5ab0-a60b-e2444544db54.html

[8] Chris Rose, *1 Dead in Attic*, (New York: Simon & Schuster, 2005), 405.

[9] "New Orleans.com.," last updated October 31, 2017, https://www.neworleans.com/articles/post/mardi-gras-2007-a-success/.

[10] Richard Campanella, *Geographies of Catastrophie*, (New Orleans: University of New Orleans Press, 2006), 21.

[11] "Business Wire," *Strategy Analytics: Camera Phones Outsell Digital Still Cameras Worldwide*, September 25, 2003. https://www.businesswire.com/news/home/20030925005309/en/Strategy-Analytics-Camera-Phones-Outsell-Digital-Cameras.

HISTORIC PHOTOS

pg 17
Unidentified Black Masking Indians, *undated*

pg 19
(top), King Rex on float on Calliope St, 1916
(bottom left) Black Masking Indian, c 1950
(bottom right) Baby Dolls, 1942

pg 20
Proteus float design, 1896 (Bonnecaze)

pg 21
Proteus rider design, 1896 (Bonnecaze)

pg 27
(left) Pussyfooter parade flyer, 2005
(right) Inaugural night of Camel Toe Lady Steppers, 2003

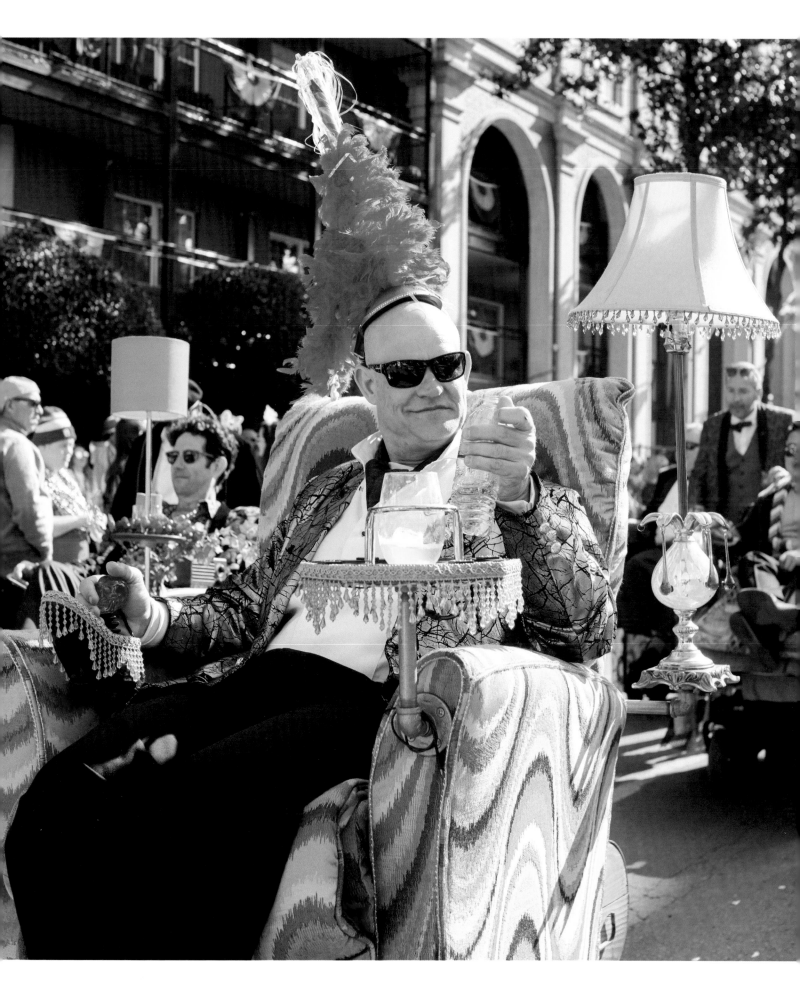

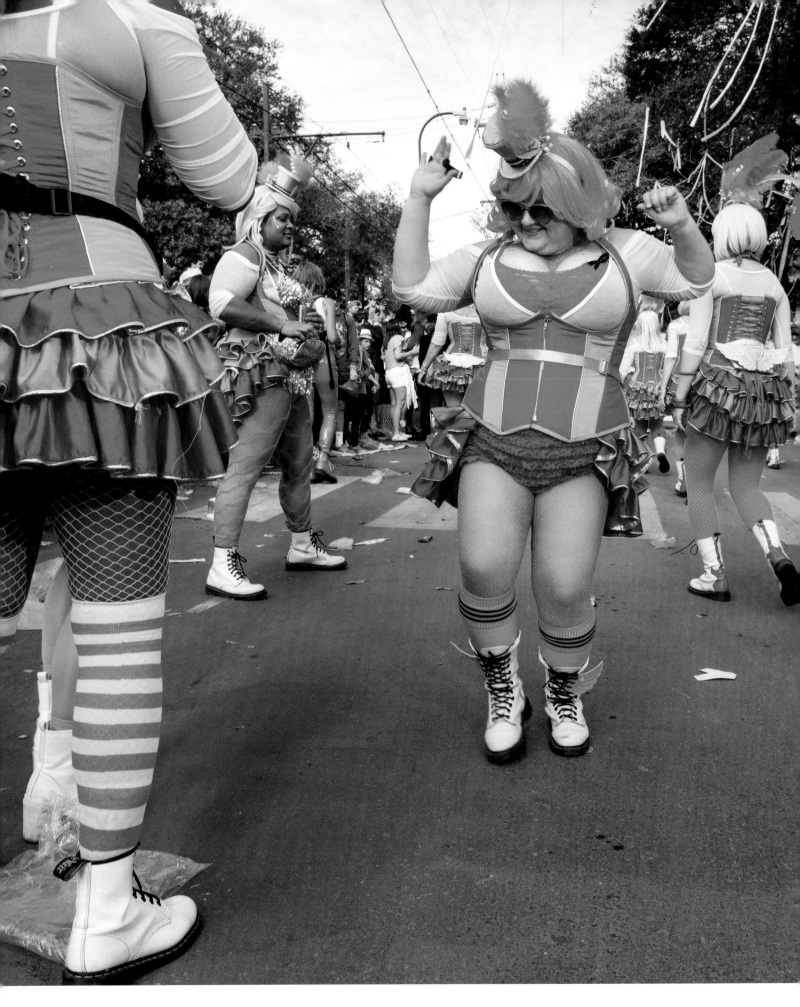

1
INNOVATORS

THEY'RE BIG, THEY'RE BOLD, AND THEIR IDEAS HAVE CHANGED THE UNIVERSE OF MARCHING KREWES. THESE KREWES HAVE BROKEN NEW GROUND, SET NEW STANDARDS, AND DANCED THEIR WAY INTO THE HEARTS OF THEIR AUDIENCES. THEIR UNIQUE NATURE ENSURES THEIR LONGEVITY.

In addition to their paradigm-shifting concepts, the Pussyfooters, New Orleans Baby Doll Ladies, Camel Toe Lady Steppers, and the 610 Stompers are celebrated exemplars of krewes that have a year-round presence, a charity component, a cohesive look, and supreme dance moves. They have added something new to the genre of marching krewes. They have class, sass and a wicked sense of humor. The female krewes also can stake claim to their sexuality with risqué names of double entendre. Often replicated, never matched, we salute these change agents.

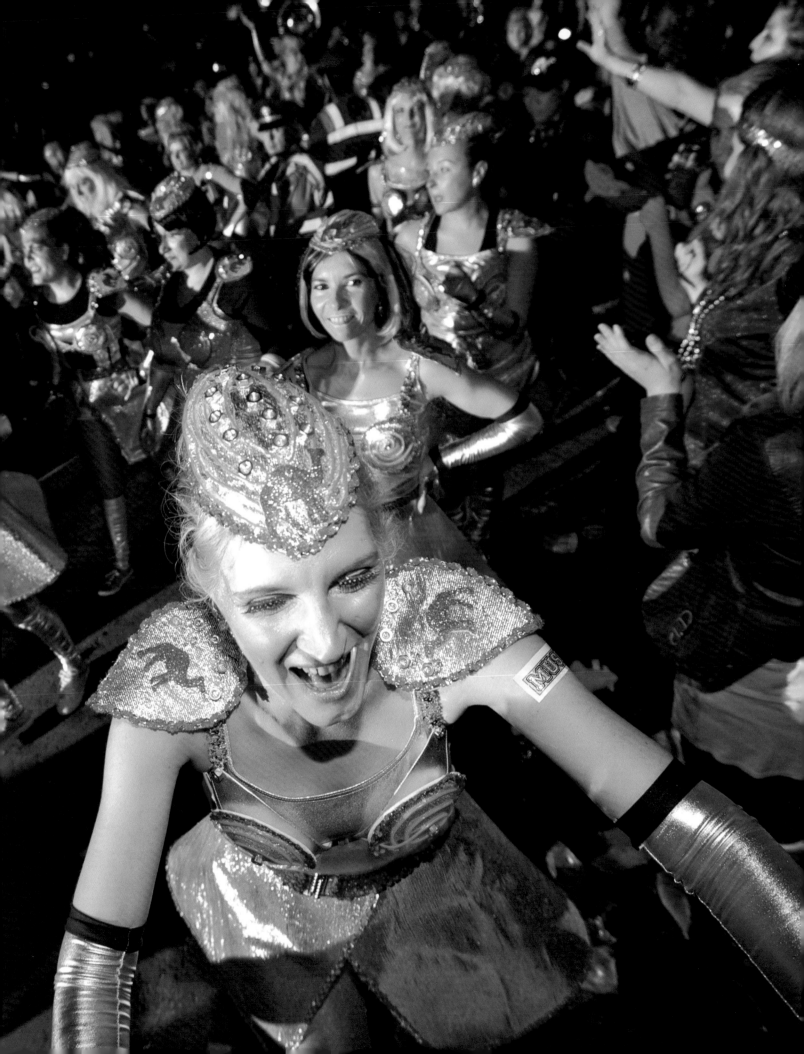

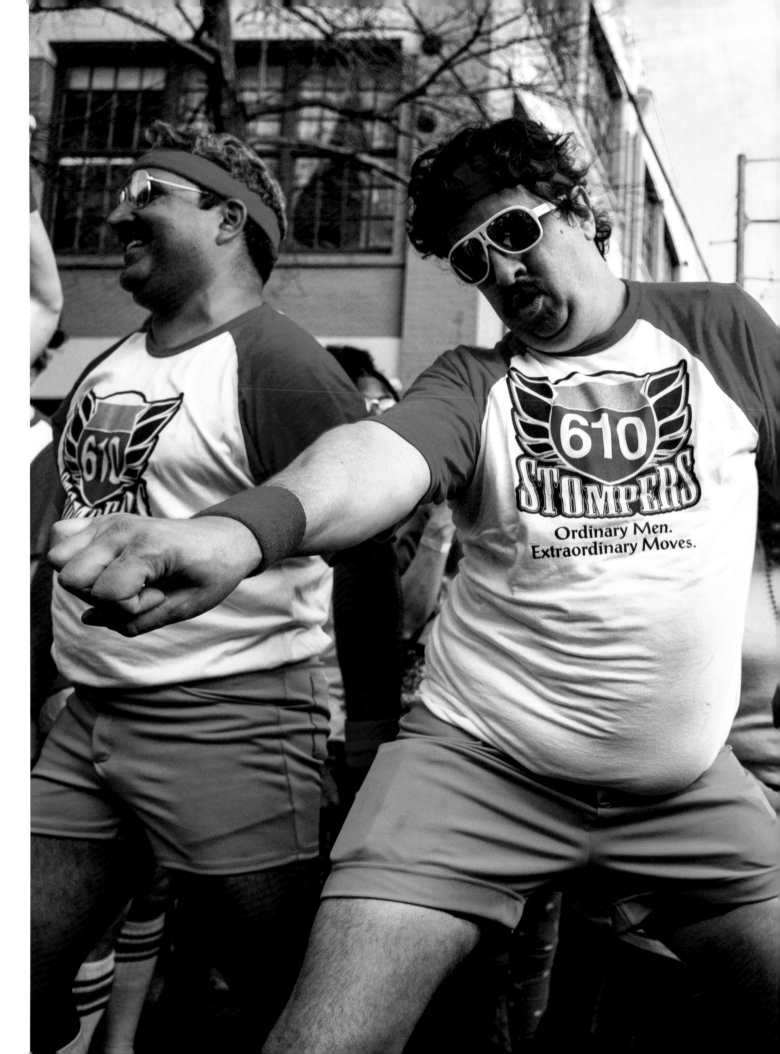

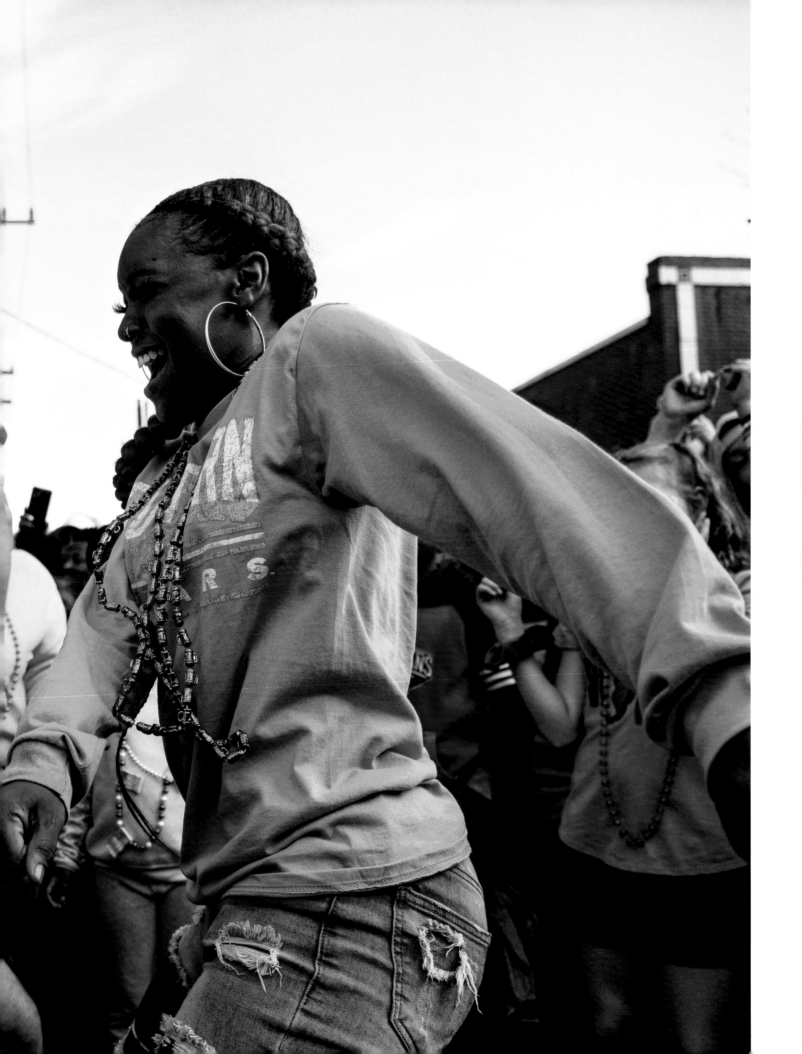

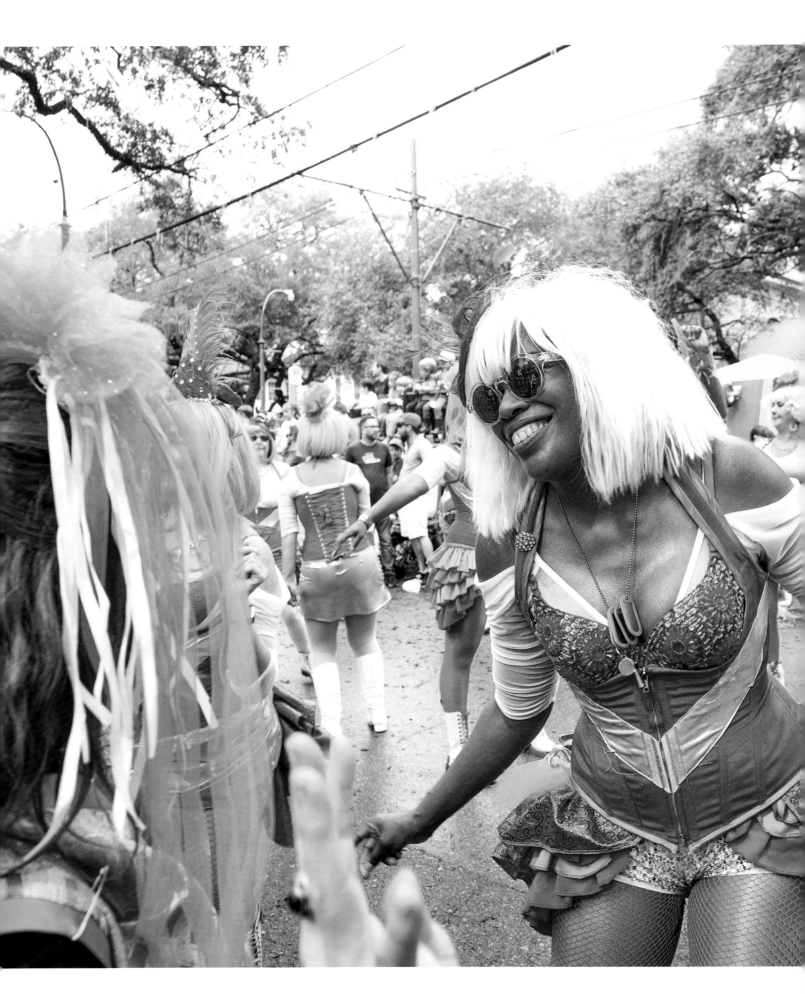

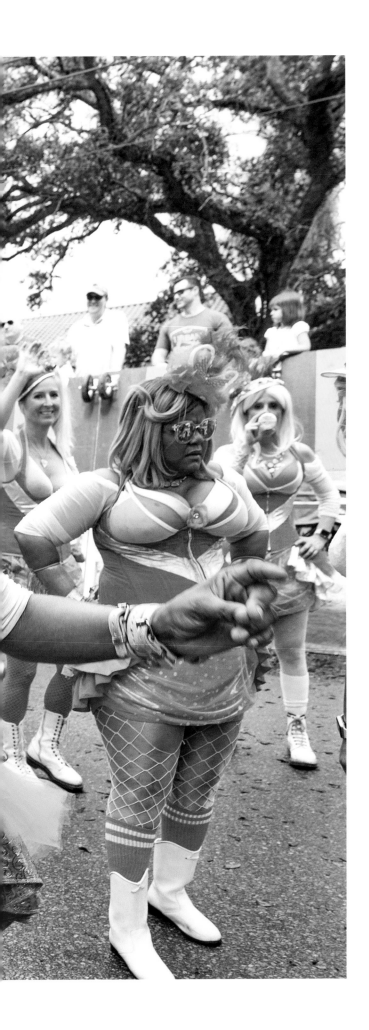

PUSSYFOOTERS

The Pussyfooters ushered in a new creative era of Mardi Gras marching krewes in 2001. A new transplant to New Orleans, Camille Baldassar initially scoffed at the idea of going to a "boring" parade. Cajoled by friends into attending, she quickly realized the vitality of New Orleans Mardi Gras parades, became enthralled and attended every parade in the 2000 season. Smitten with the marching bands and dancing squads, she experienced a sentiment common to all emerging marchers: "I want to do that!" With a group of like-minded women friends a playlist was created, choreography designed, and practice started. They reached out to the newly formed Krewe of Muses parade to ask if their group of "forty-year-old majorettes" could be included. And with that, the next wave of Mardi Gras creativity commenced.

The Pussyfooters were originally formed as a krewe of artists with the motto "We are Majorettes from the Mothership sent here to help the party people get their groove on!" With their inaugural march, a whole new world opened up: the marchers were euphoric, and so was the crowd. Initially a compact group of twenty to thirty marchers, they continued to expand and evolve. With this growth, the organization became more formal and branding more of an emphasis. Pussyfooters are now known for their signature color-scheme of bright pink and orange, their plumes, corsets, and wigs, and their instantly recognizable costumes. Their Blush Ball funds their philanthropic focus of supporting women's causes.

Eighteen years later in 2019 the Pussyfooters still can't stay still—participating in fifty parades, fundraisers and special events.

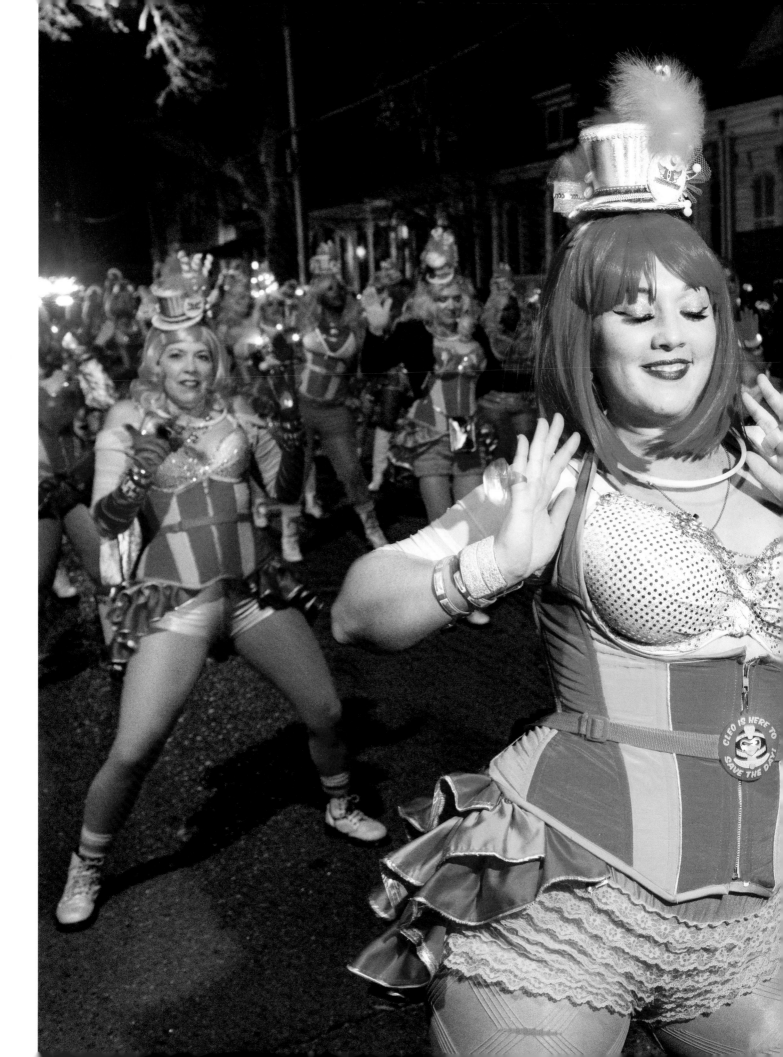

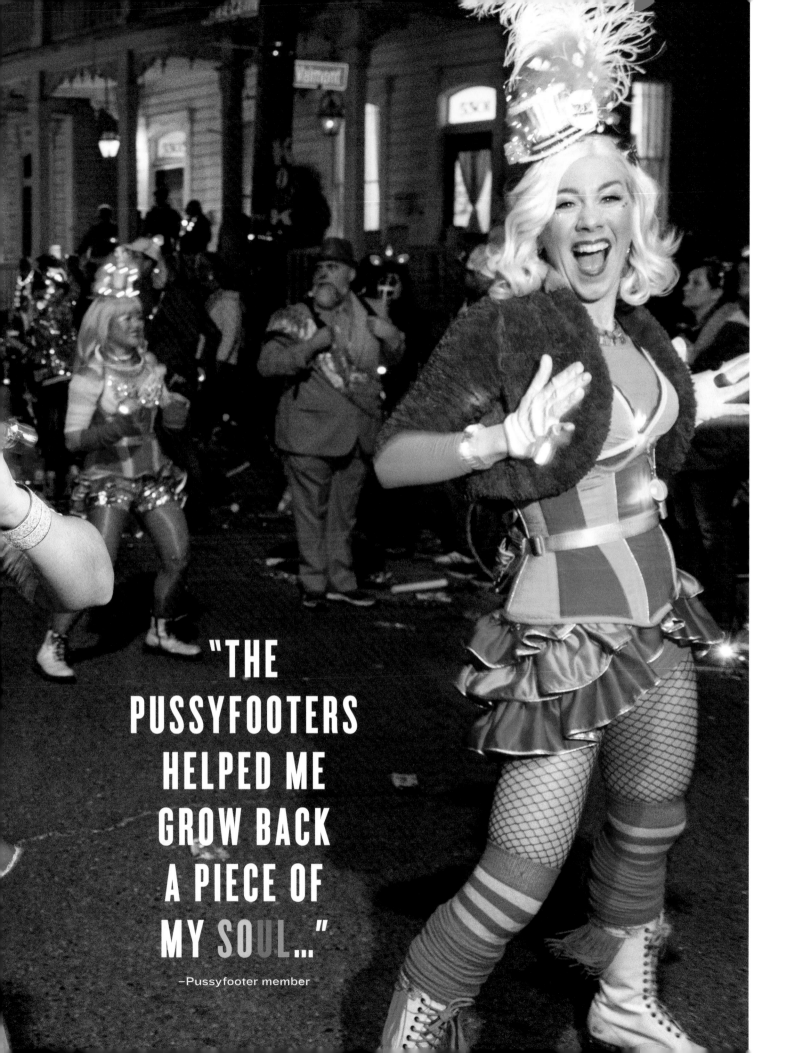

"THE PUSSYFOOTERS HELPED ME GROW BACK A PIECE OF MY SOUL..."

—Pussyfooter member

CAMEL TOE LADY STEPPERS

It started in 2003 with a group of friends, a Halloween costume, and a desire to dance. They ordered their batons, tiaras and majorette costumes online, but the teenaged sizes were just a wee bit small for the group of ten women friends in their late twenties. "Hey, ho, we got camel toe!" was the resulting battle cry.

After prancing on Halloween, the group realized it was too much fun to do just once. Too young to join the Pussyfooters, the group reorganized six weeks before Mardi Gras, built on their skills in costuming and choreography and joined the Krewe of Muses parade in 2004. It was so good, they wanted more. They formed an "all-female-identified performance collective," the Camel Toe Lady Steppers, the words "Lady Steppers" added as an homage to Black social aid and pleasure clubs.

The Camel Toe Lady Steppers began the process of designing both krewe costumes and choreography based on a theme, and they only march to the music of a live brass band. While costume colors remain the same each year—silver, pink and black—everything else changes. The krewe marches exclusively in the Muses parade, fostering a bond of loyalty and allowing members to enjoy other aspects of Carnival as spectators. Smaller teams of twenty dancers participate in community events throughout the year, and the Camel Toes hold a fundraising event each year to support local charitable causes.

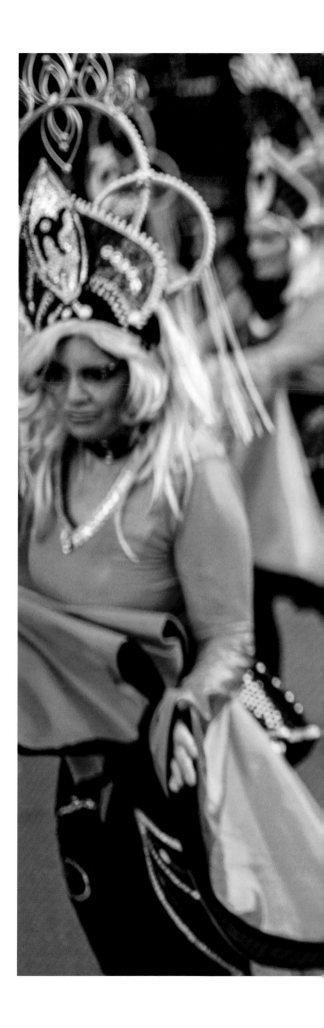

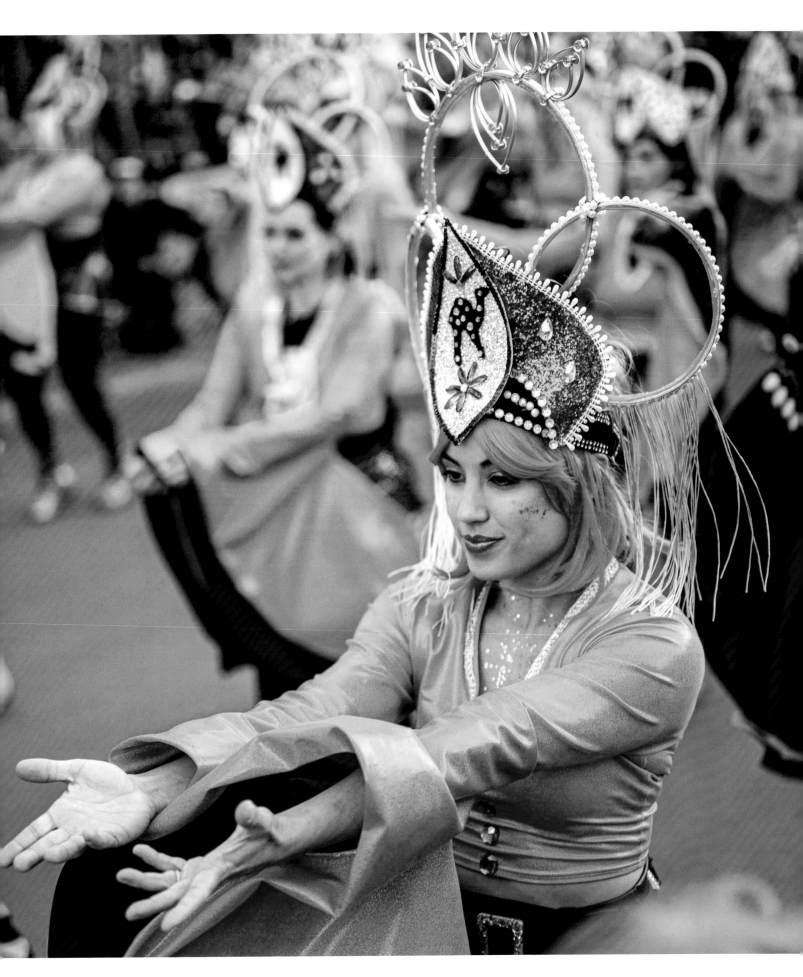

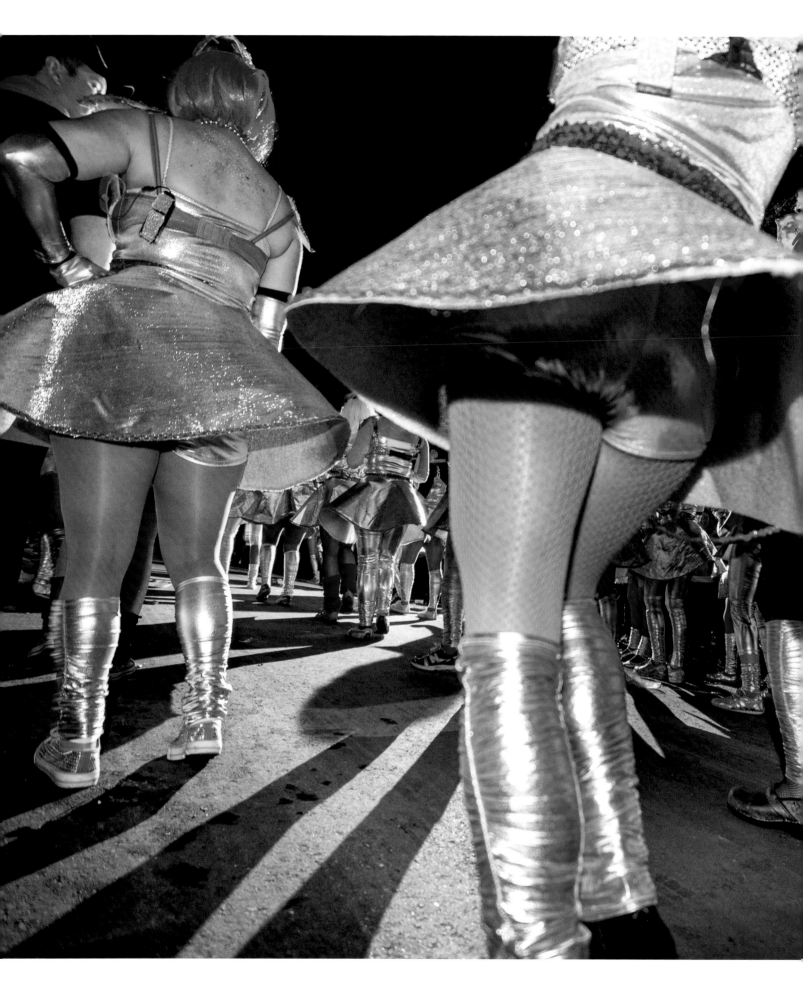

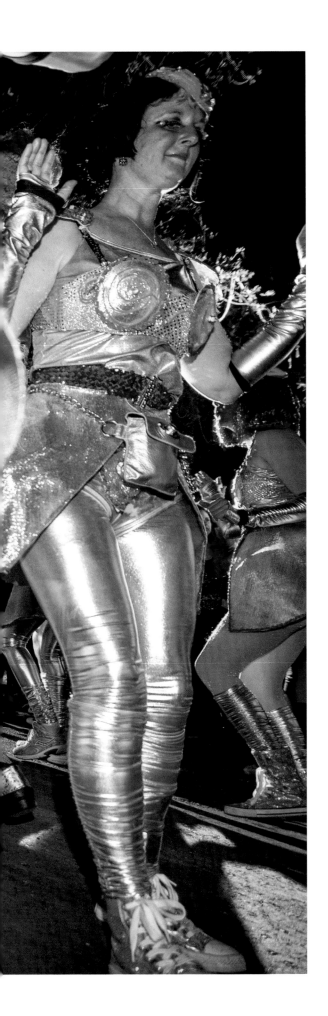

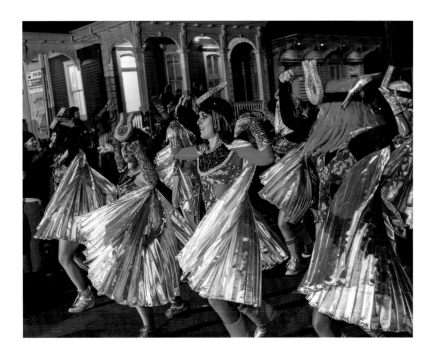

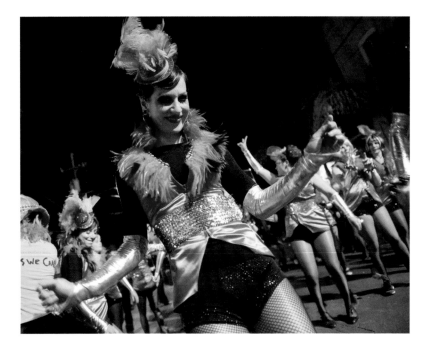

"There have been growing pains, mostly over costumes and especially over the ideal height of boots!"

–Casey Love, Camel Toe Lady Steppers

> **"What we're trying to bring forward is the essence of Creole masking, song and dance, because we have something to dance about..."**
> –Millisia White, *New Orleans Baby Doll Ladies*

NEW ORLEANS BABY DOLL LADIES

Rooted in long-standing tradition, the New Orleans Baby Doll Ladies have taken masking in a new direction in the post-Katrina city. The Baby Doll practice was fostered by the community and passed down through generations.

The krewe and their founder/artistic director Millisia White honor that practice and have made it more modern, more "now."

Dance was always central to the Baby Doll practice; in the early *Jass* days shake dancers of Storyville, referred to as Baby Dolls, used their moves to entice or hypnotize men as dancers "cut loose" on the streets. With one foot grounded in the art of dance and the other firmly in honoring the heritage, the New Orleans Baby Doll Ladies use New Orleans brass band, bounce and hip hop music (specially mixed by Brother DJ Hektik) to pop. Part dance and part cabaret, the ladies strive to give meaning, a statement, a message. They show up in surprising places: in music videos, at museum exhibitions, the New Orleans Jazz Fest and in parades including the Macy's Day Parade, Zulu, and their own Dance-Parade.

Larger than most of the Baby Doll krewes, the company also has signature painted faces to call to mind Mardi Gras masking. Since 2005 they have worked on a deeply personal mission coined "New Orleans Resurrection" to educate, promote and cultivate Baby Doll masking. This culturally centered dance company is a community of strong women who come together year round to enjoy creative fulfillment and support each other.

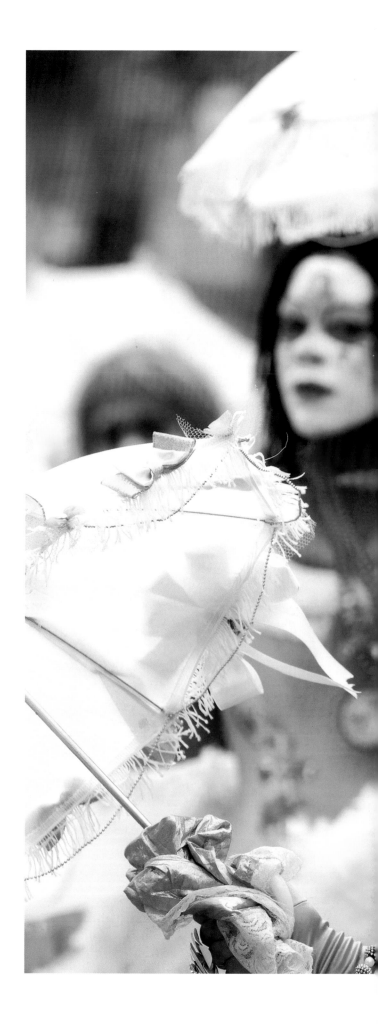

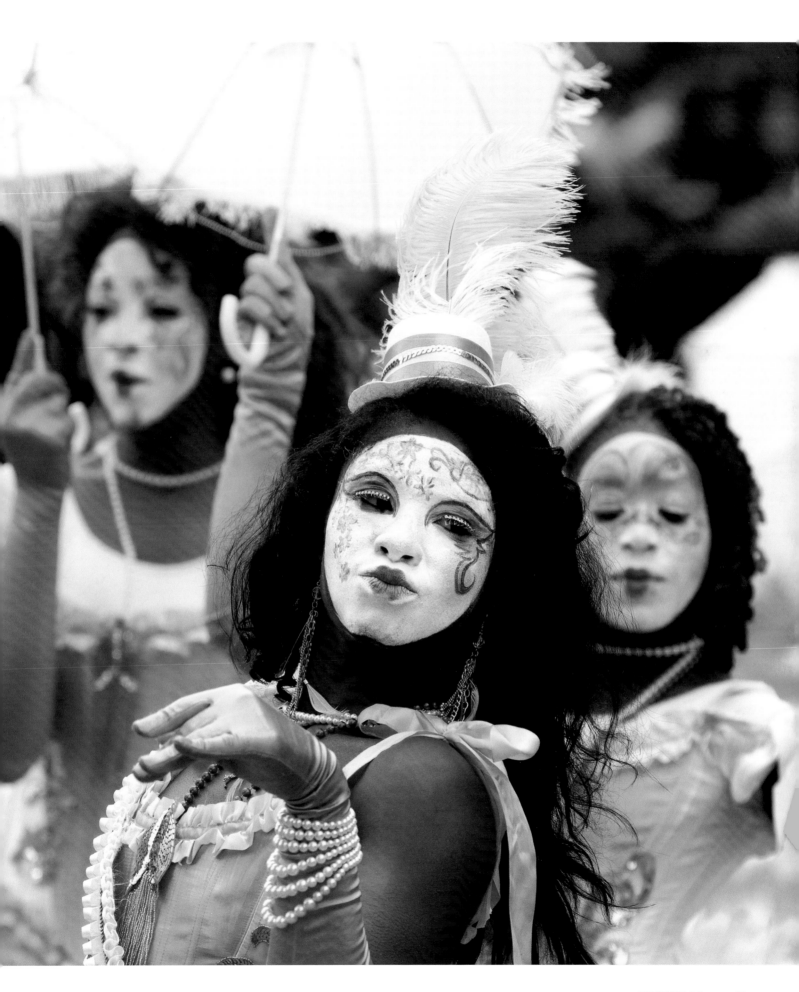

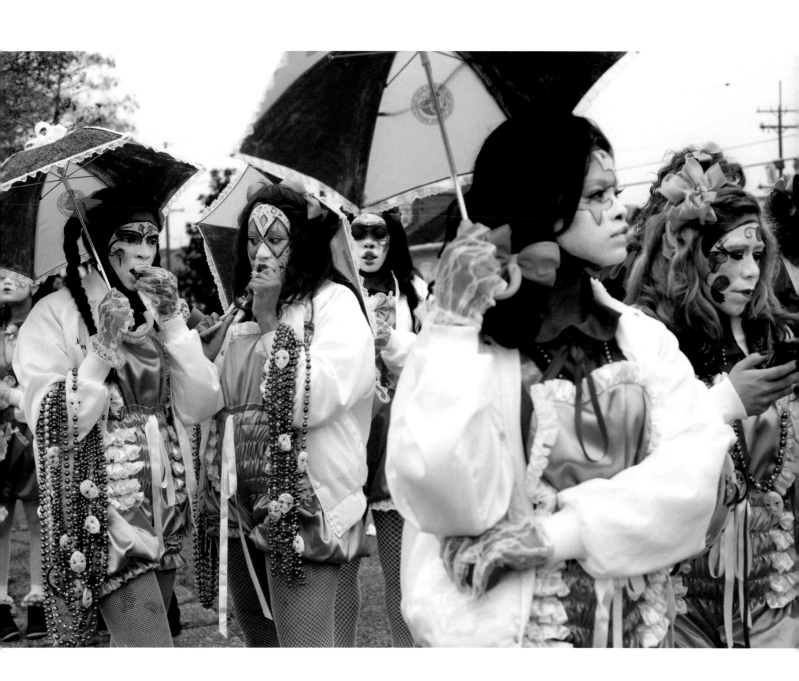

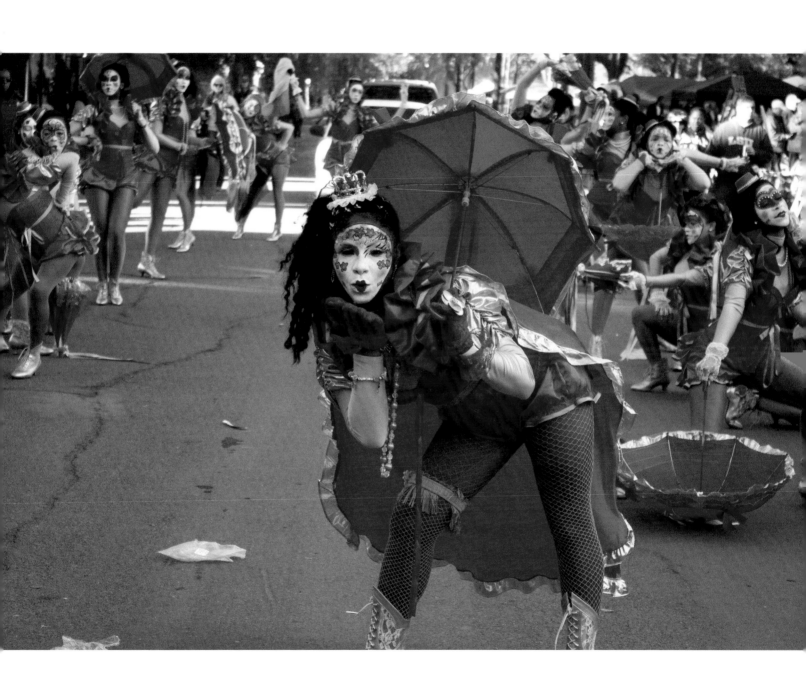

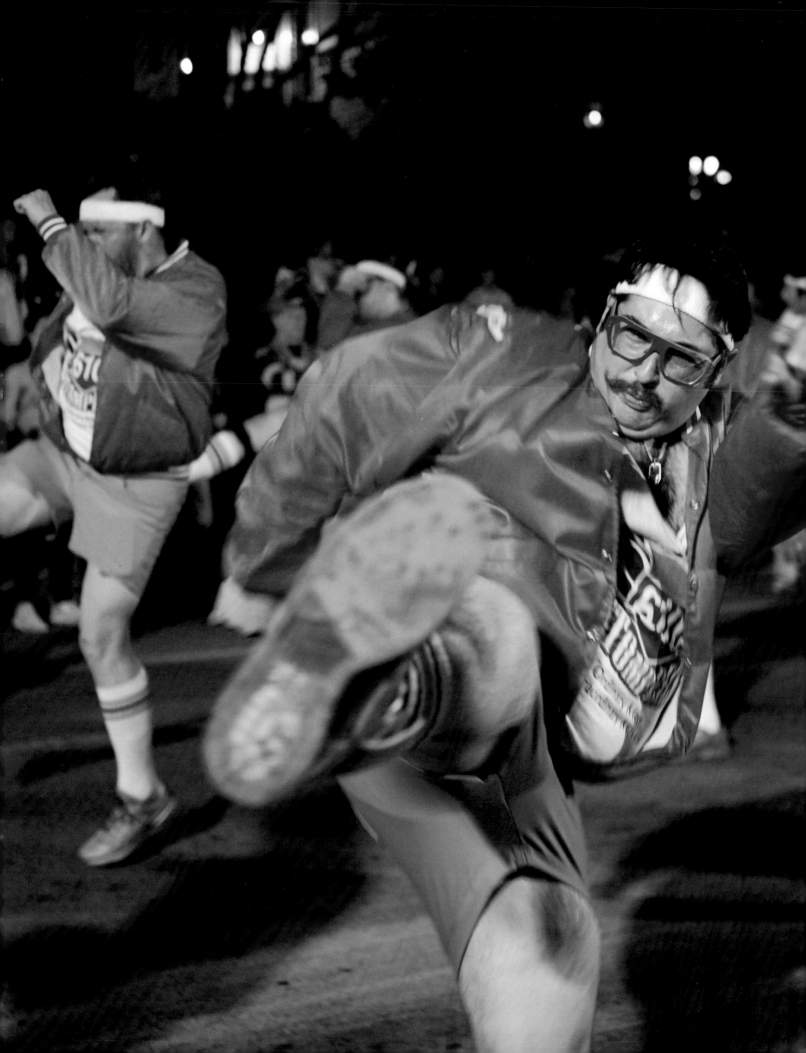

610 STOMPERS

Their motto "Ordinary Men, Extraordinary Moves" encapsulates everything about the 610 Stompers, founded in 2009. With incredible dance moves, the all-male dance group, arrayed in their signature light blue coach shorts, high white athletic socks with gold tennis shoes, red bomber jackets, and headbands, have rendered national TV announcers speechless and enthralled audiences everywhere they've performed.

The 610 Stompers stand out not just as males in a largely female field, but in their philanthropy, which is almost as robust as their dance moves. The 610 Stompers also introduced a game-changing format—the "patented 50/50" in which A and B dance teams rotate performances along the seven-mile parade routes. This switcharoo not only allows parade-goers to enjoy non-stop dancing, but gives krewe members a break in the action and a chance to enjoy the parade as walking spectators, while allowing the dancing to be the focus when performing.

The idea of the 610 Stompers was born in the back yard with a challenge to create a men's dance group to compete with female dancing krewes and children's dance teams. Gathering friends, they created open tryouts and adopted a structure that gives ordinary men a chance to have fun and dance to their hearts content.

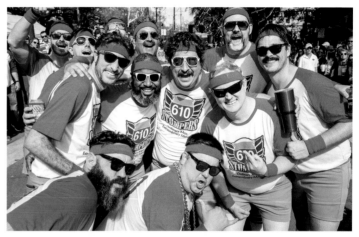

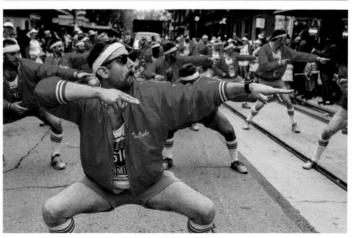

"IT'S A CREATIVE OUTLET FOR ME— I CAN DANCE THE POISON OUT OF MY BODY. IT IS A HAPPY PLACE."

–David "Tenacious D" Hoover, 610 Stomper

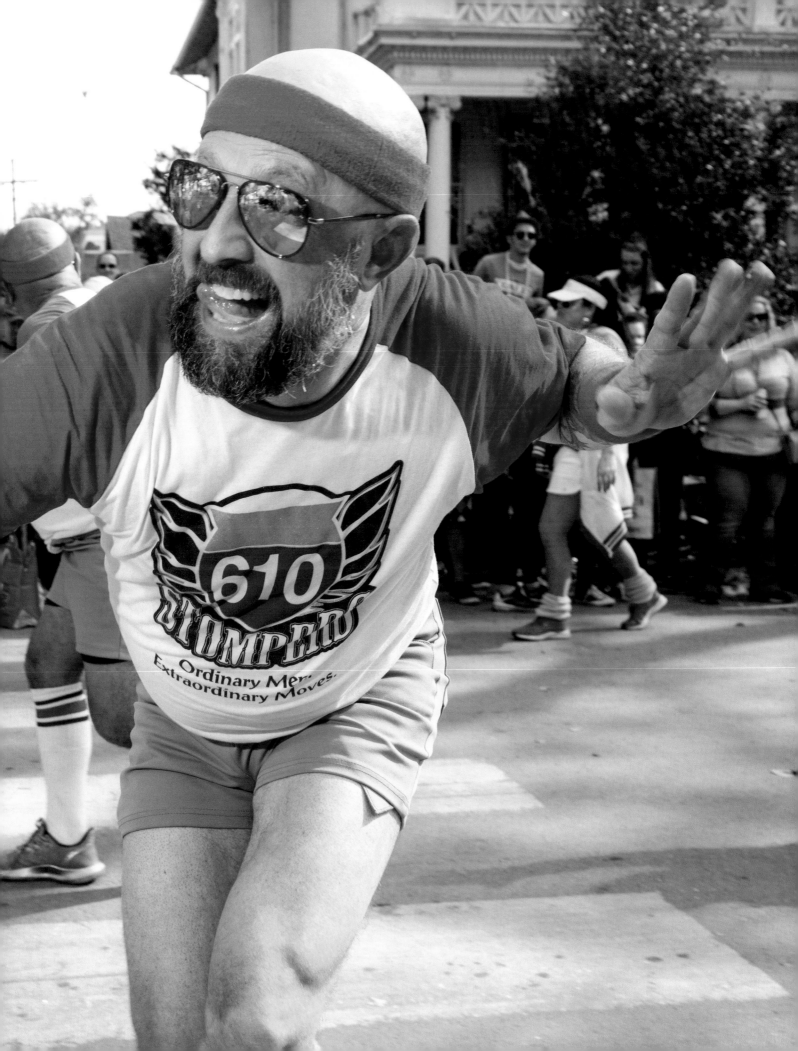

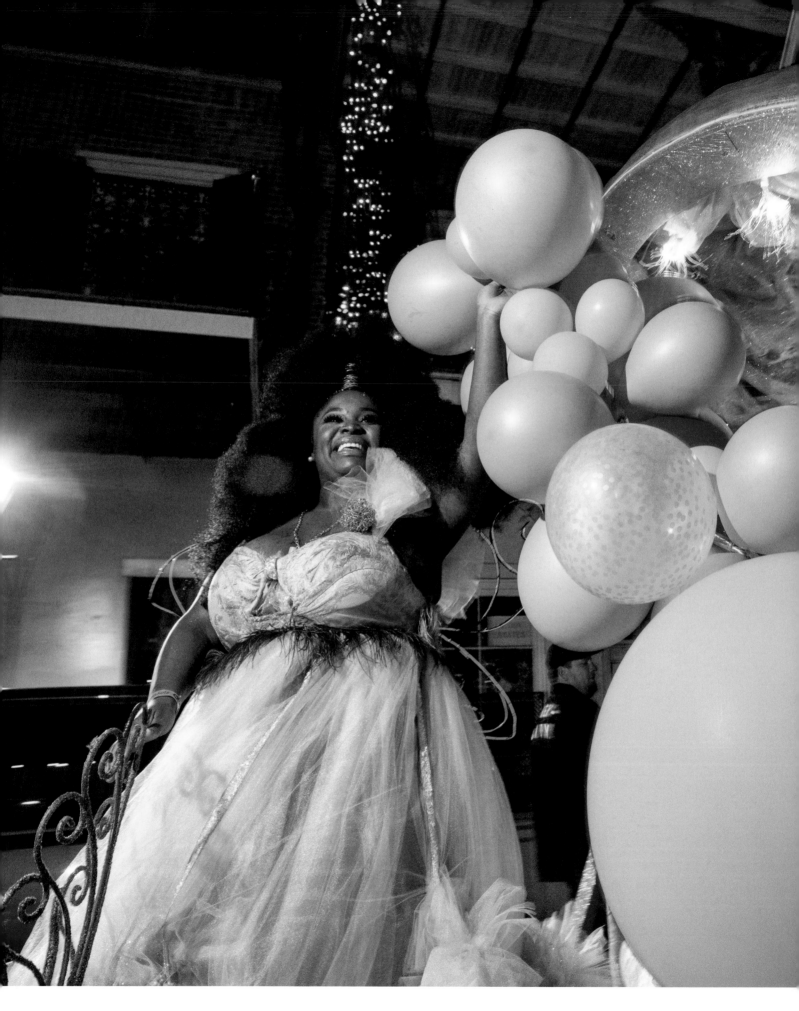

2

SUPA GROUPS

WITH ATTITUDES BOLDER THAN THEIR SIZE IS BIG, THESE GROUPS AREN'T JUST SUPER, THEY'RE SUPA. SUPA GROUPS ARE A WHOLE MADE UP OF MANY PARTS— THEIR ORGANIZATIONAL STRUCTURE SETTING THEM APART FROM OTHER FOOT PARADES. MARCHING A FEW WEEKS BEFORE THE MARDI GRAS HIGH SEASON, THESE PARADES ARE PART OF THE "ALTERNATIVE" PARADE GROUP— MORE CREATIVE EXPRESSION, MORE INDIVIDUALITY, GENERALLY QUITE SUBVERSIVE. THEY'RE ROUGHER, SCRAPPIER, CHEEKIER. THEY'RE WILD AND FREE, SOME MIGHT SAY SALACIOUS.

While many marching krewes participate in the large rolling parades held by krewes such as such as Muses, Freret, Iris and Rex, the Supa Groups have their own parades composed of many sub krewes (or inner krewes). The "Supa Group" krewe sets the theme each year and sub krewes join in with their wild and wonderful expression of that theme. These parades take pride in their hand-made throws.

KREWE DU VIEUX

The oldest of the Supa Groups is Krewe du Vieux. Arising from the foundation of the Krewe of Clones, Krewe du Vieux (the name is a nod to the location of the parade—the Vieux Carré or French Quarter), was formed in 1987. Parades in the French Quarter prohibit motorized floats, and this parade uses mules to pull floats that feature wild, bawdy, and satirical themes and are accompanied by costumed revelers who dance to live music. Themes are usually political in nature and satire is their lifeblood; the more risqué, the better! This is not a parade for the young and innocent!

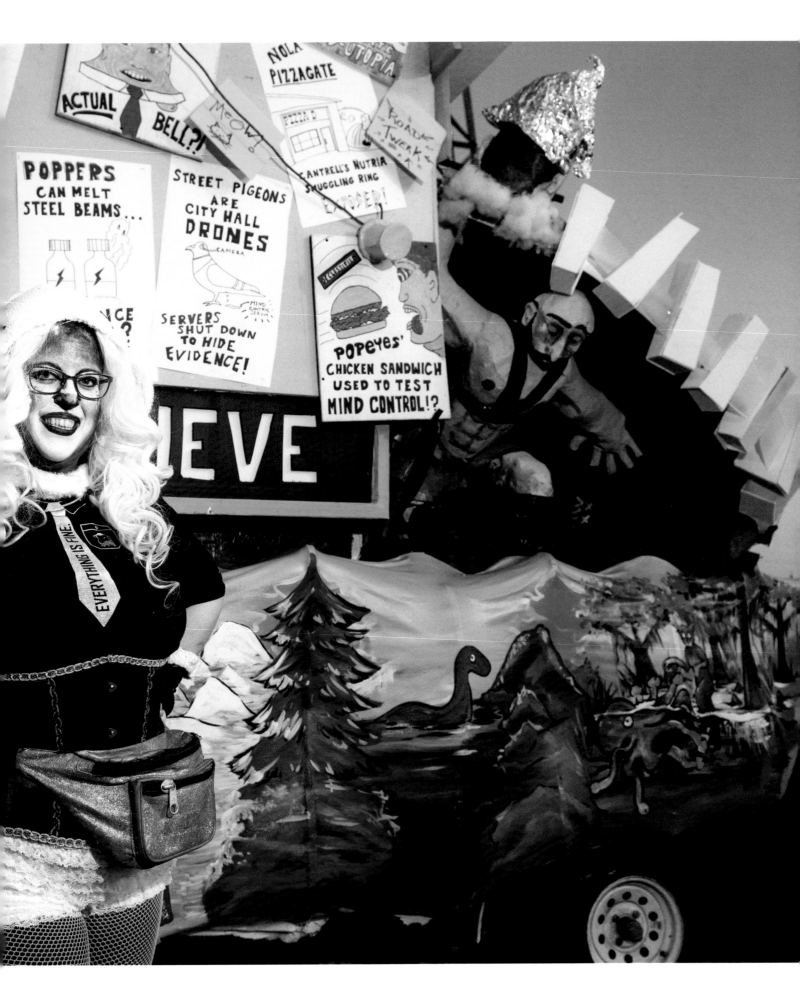

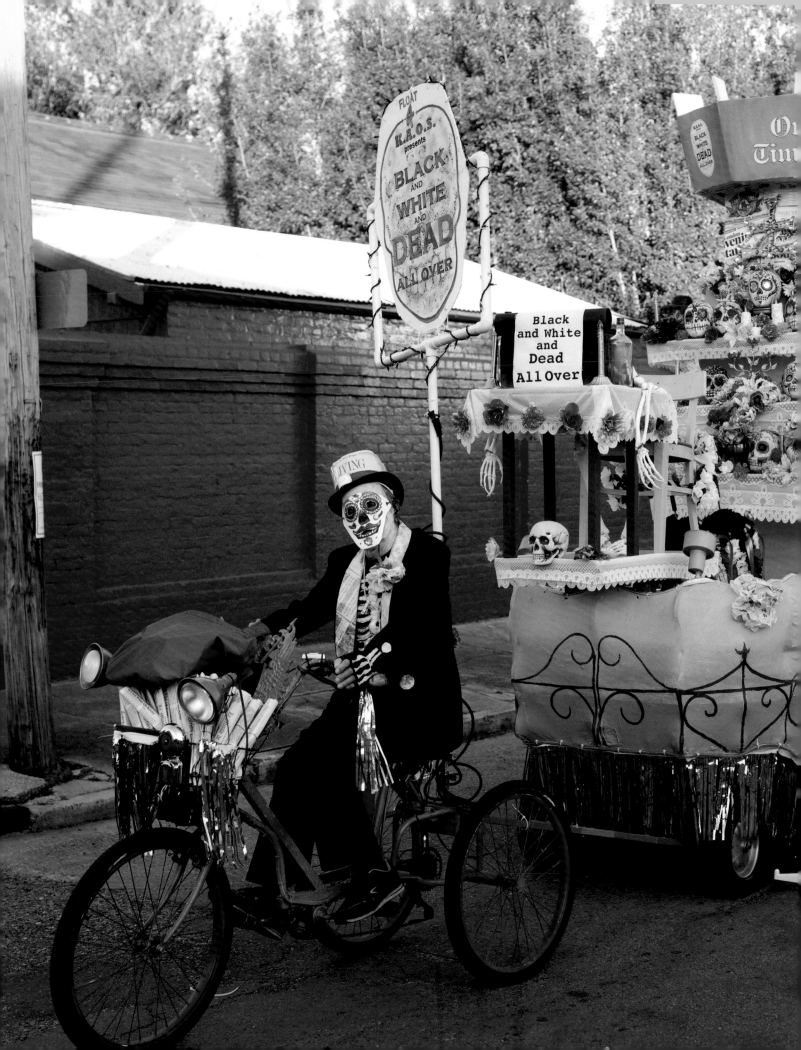

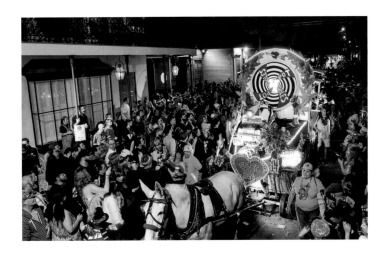

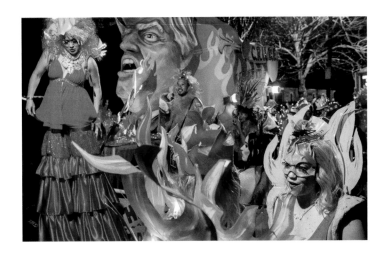

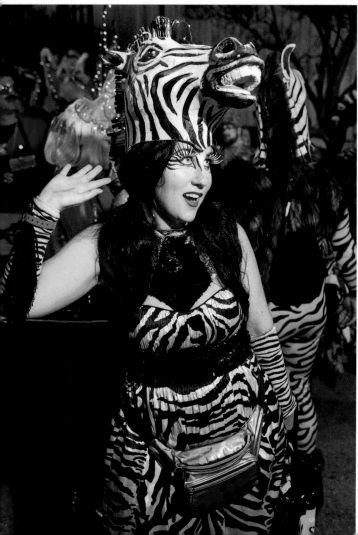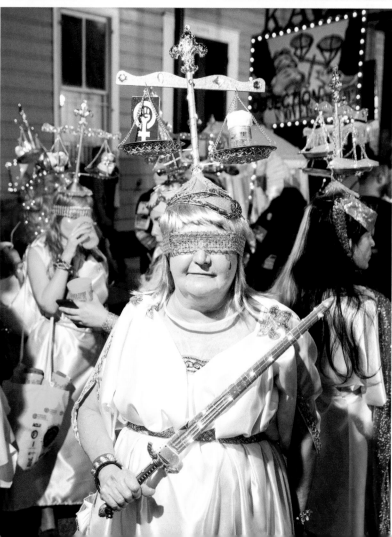

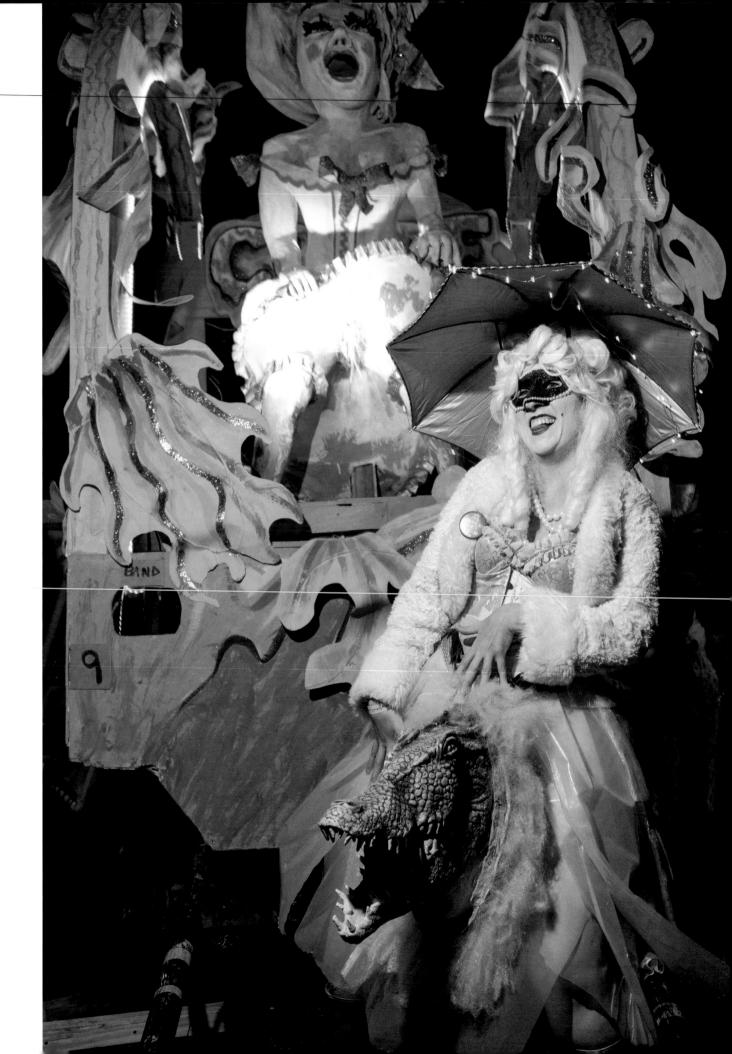

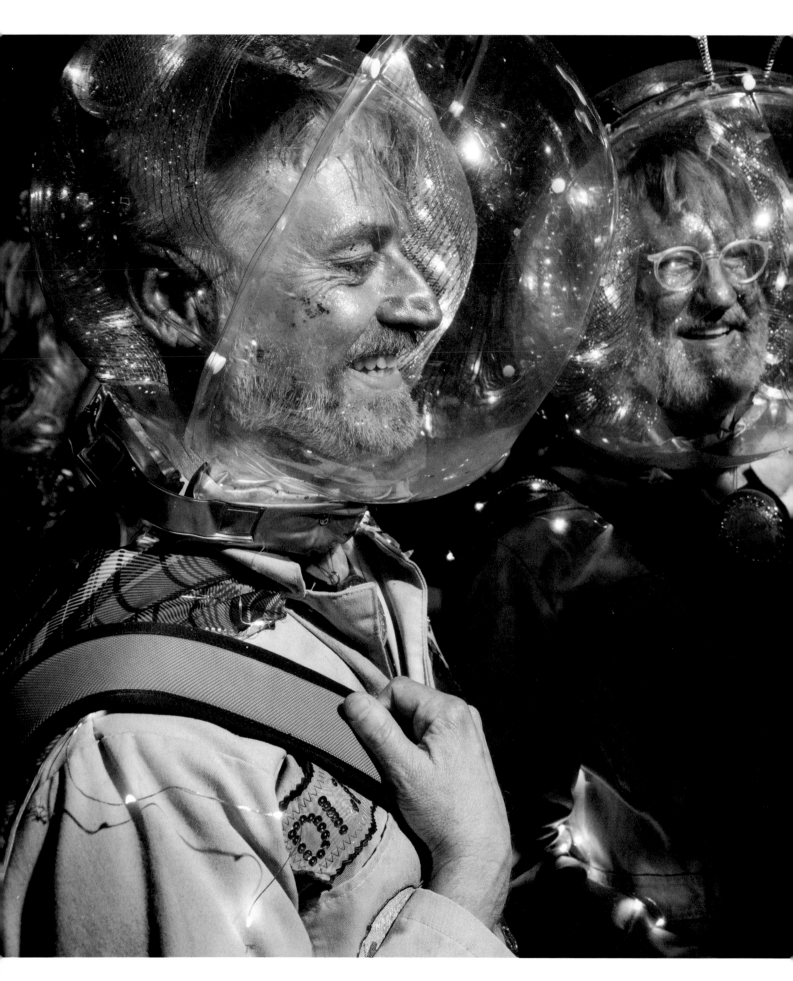

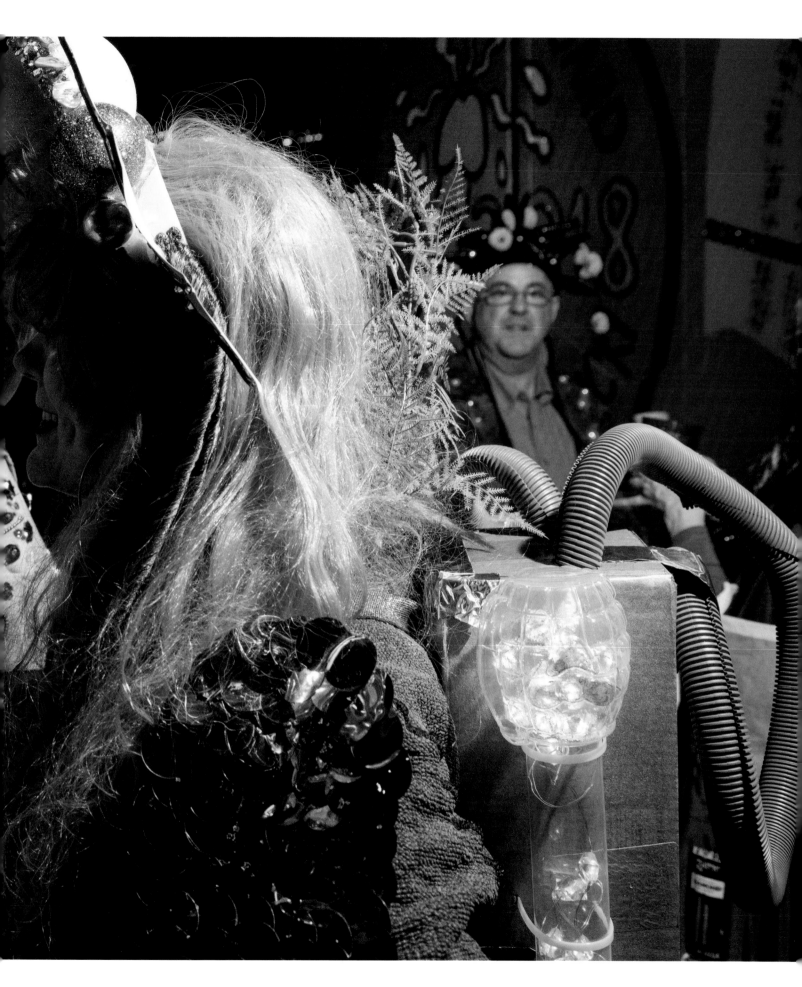

KREWE DU VIEUX
SUB KREWES

Knights of Mondu
Krewe de C.R.A.P.S.
Krewe du Mishigas
Krewe of C.R.U.D.E.
Krewe of Drips and Discharges
Krewe of K.A.O.S.
Krewe of L.E.W.D.
Krewe of Mama Roux
Krewe of Space Age Love
Krewe of SPANK
Krewe of the Mystic Inane
Krewe of Underwear
Krewe Rue Bourbon
Mystic Krewe of Spermes
Mystick Krewe of Comatose
Seeds of Decline
T.O.K.I.N.

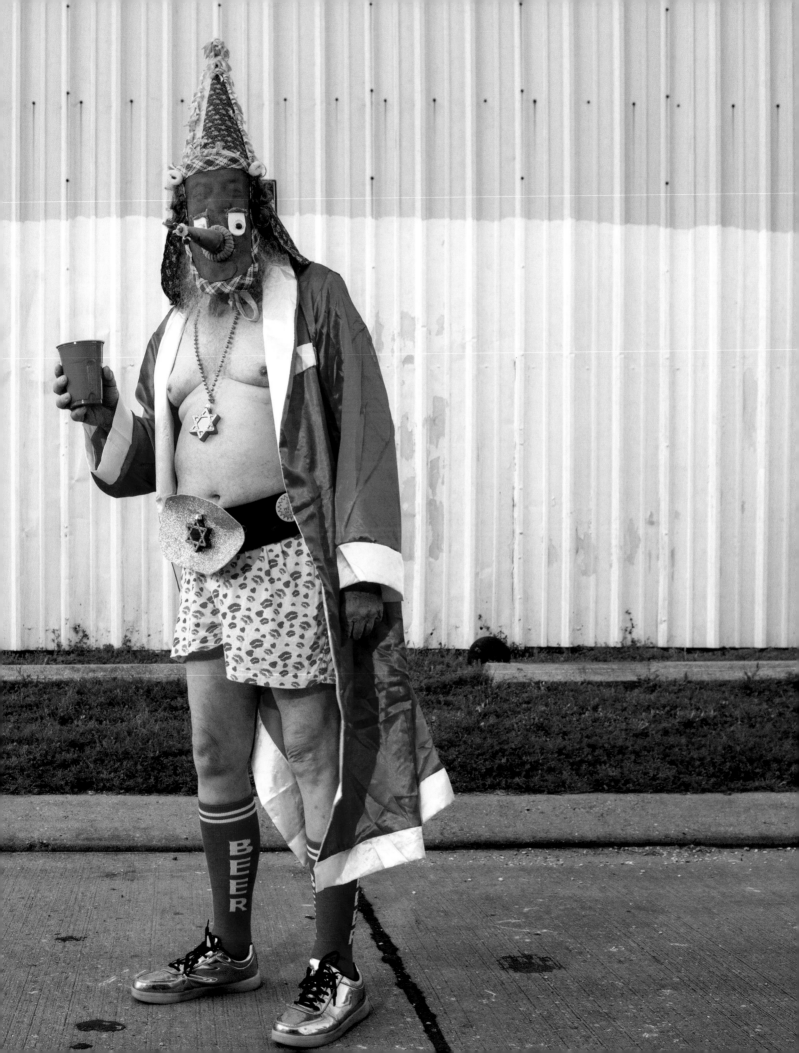

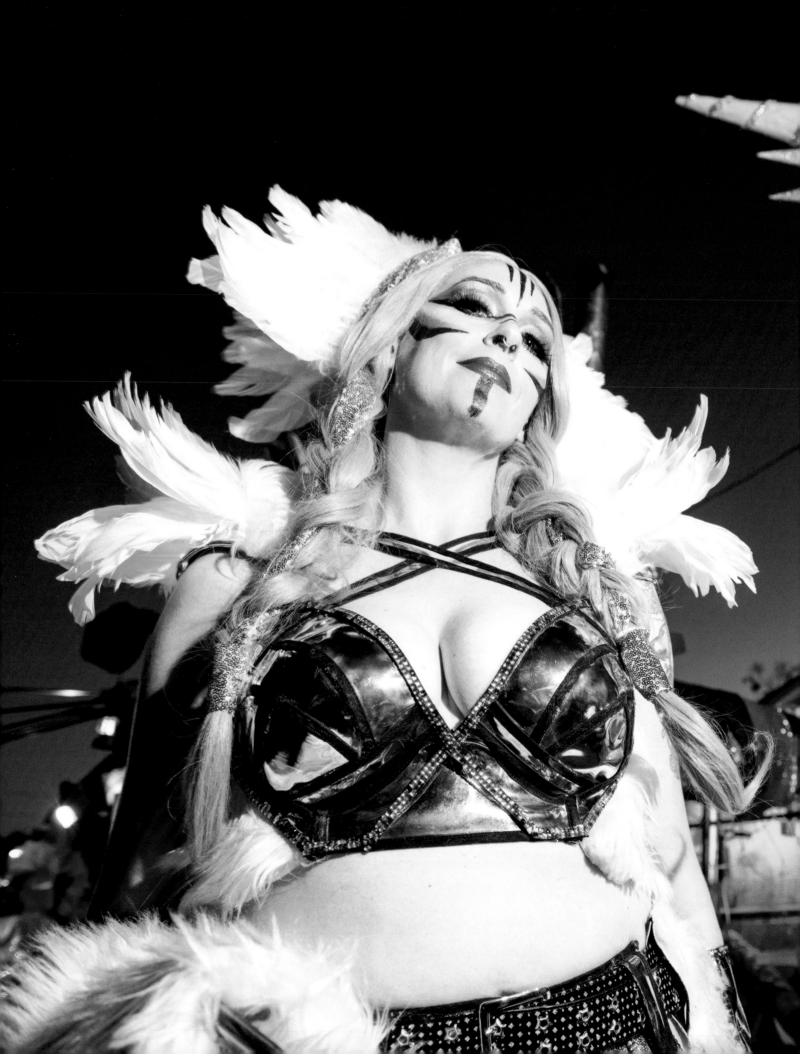

INTERGALACTIC KREWE OF CHEWBACCHUS

The Intergalactic Krewe of Chewbacchus is otherworldly. The largest of the marching parades, Chewbacchus attracts sci-fi geeks, fantasy freaks and all things nerdy and wonderful. One of the most creative parades of the whole Carnival season, Chewbacchus grew from four hundred fifty participants at its founding in 2010, to a spectacular one hundred plus sub krewes and twenty-five hundred marchers in 2020! Chewbacchus is registered as a religious cult: the Cult of the Sacred Drunken Wookie. There are no codified rituals, but Chewbacchus operates with an underpinning base of radical self-reliance. It is a tribe of many tribes with a focus on a higher mind, creativity, openness, inclusiveness, artistic expression, and the feeling of being in community. Chewbacchus is a mix of science, religion and magic. The final krewe, the Men in Black, follow each year's parade, flashing all who see them with mysterious devices and uttering the magic words, "Please disperse, there is nothing to see here. Click!"

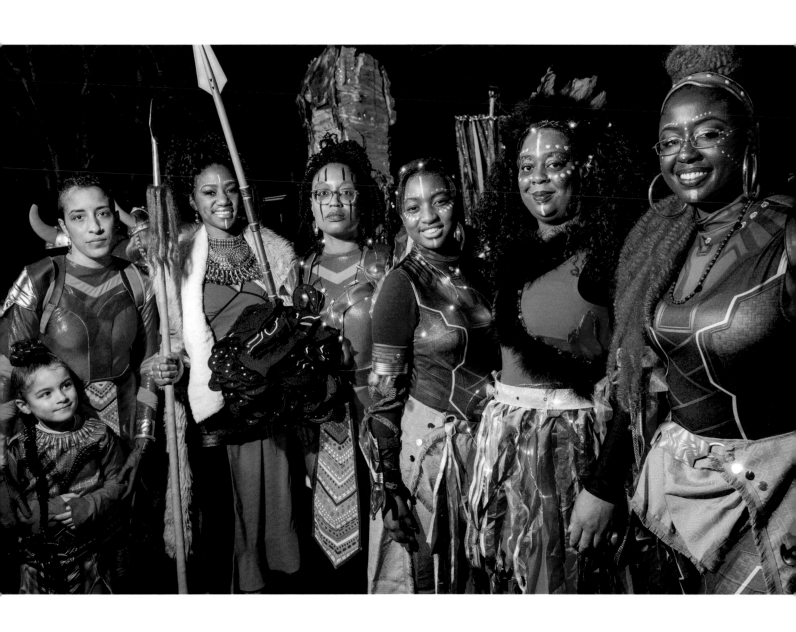

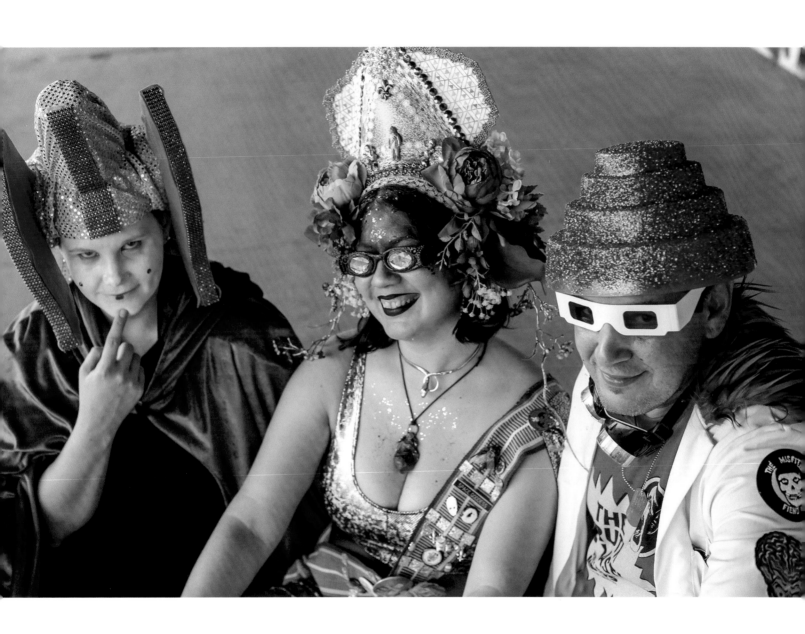

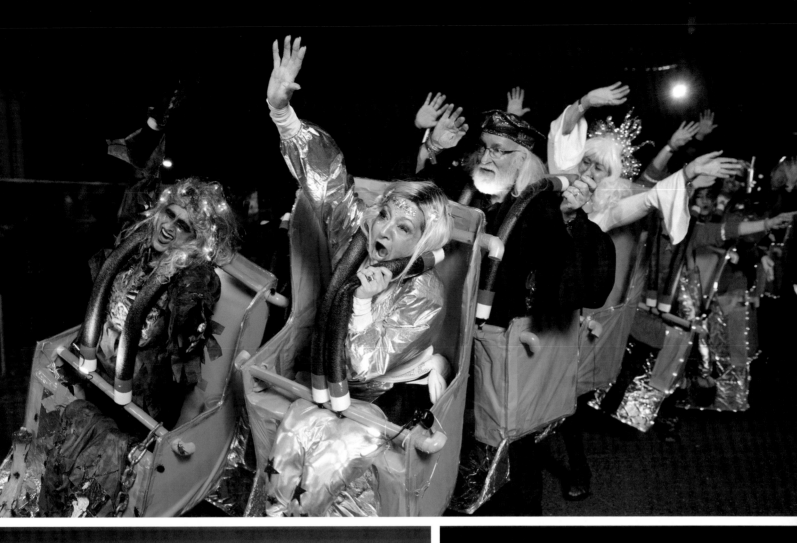
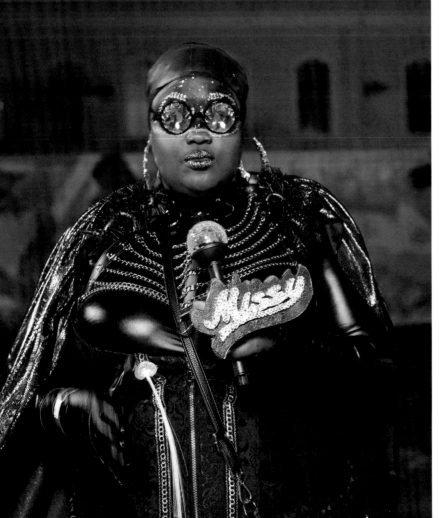
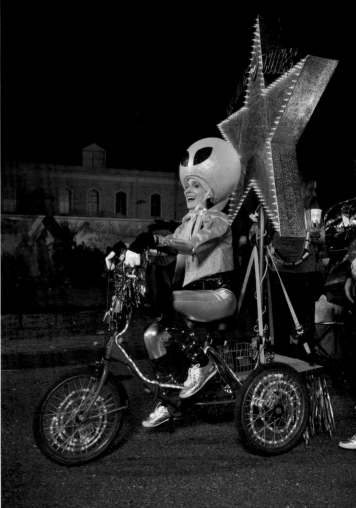

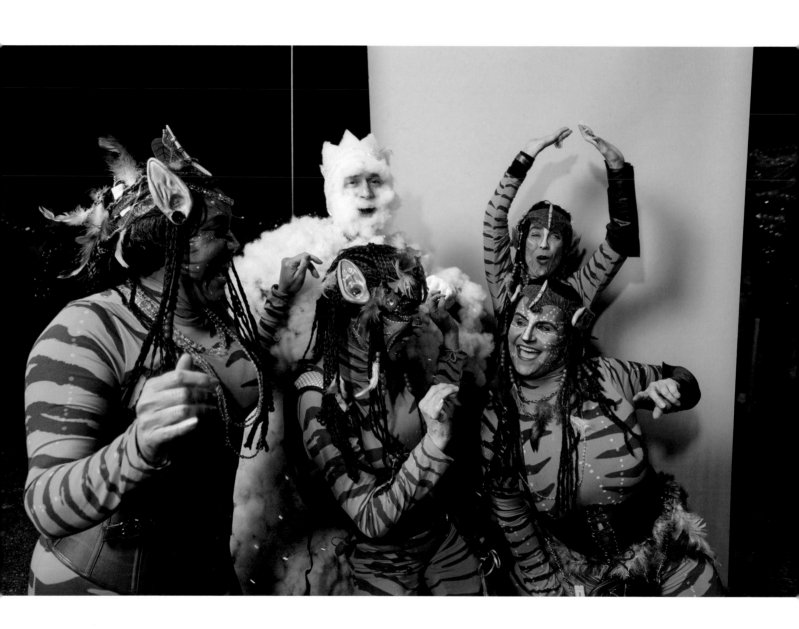

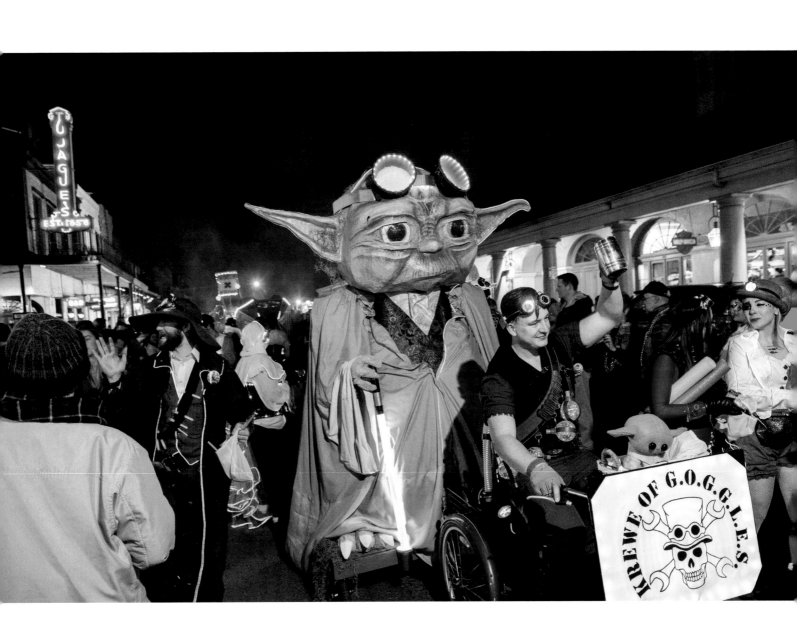

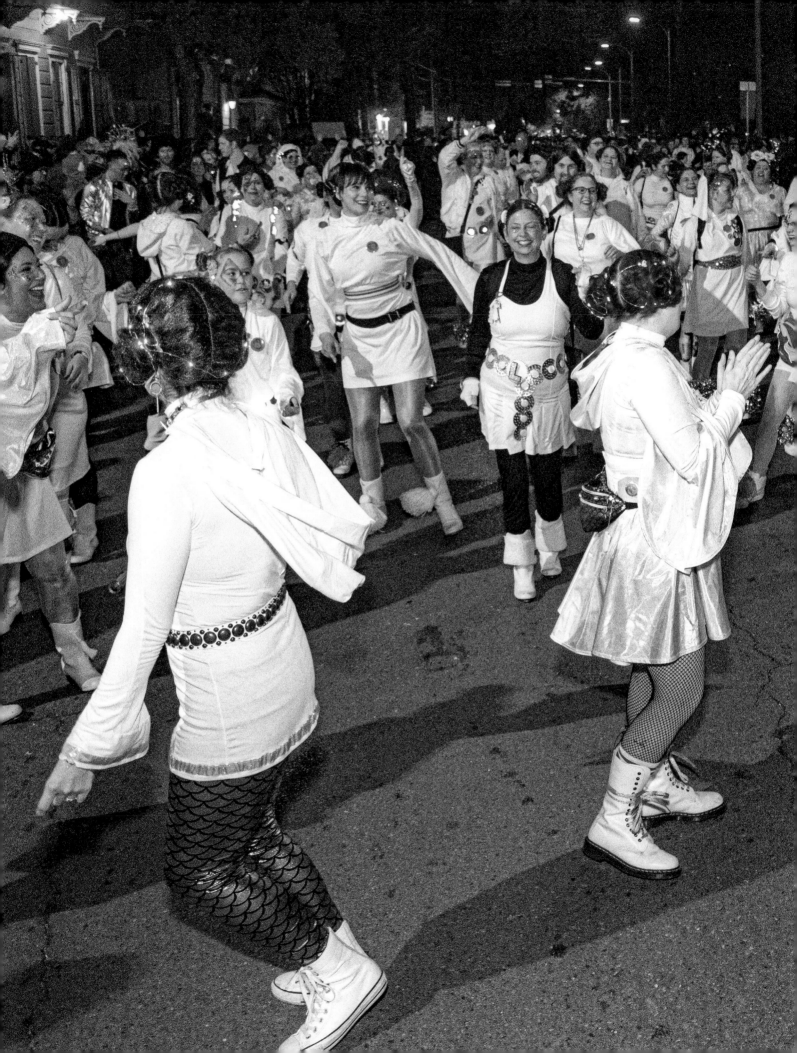

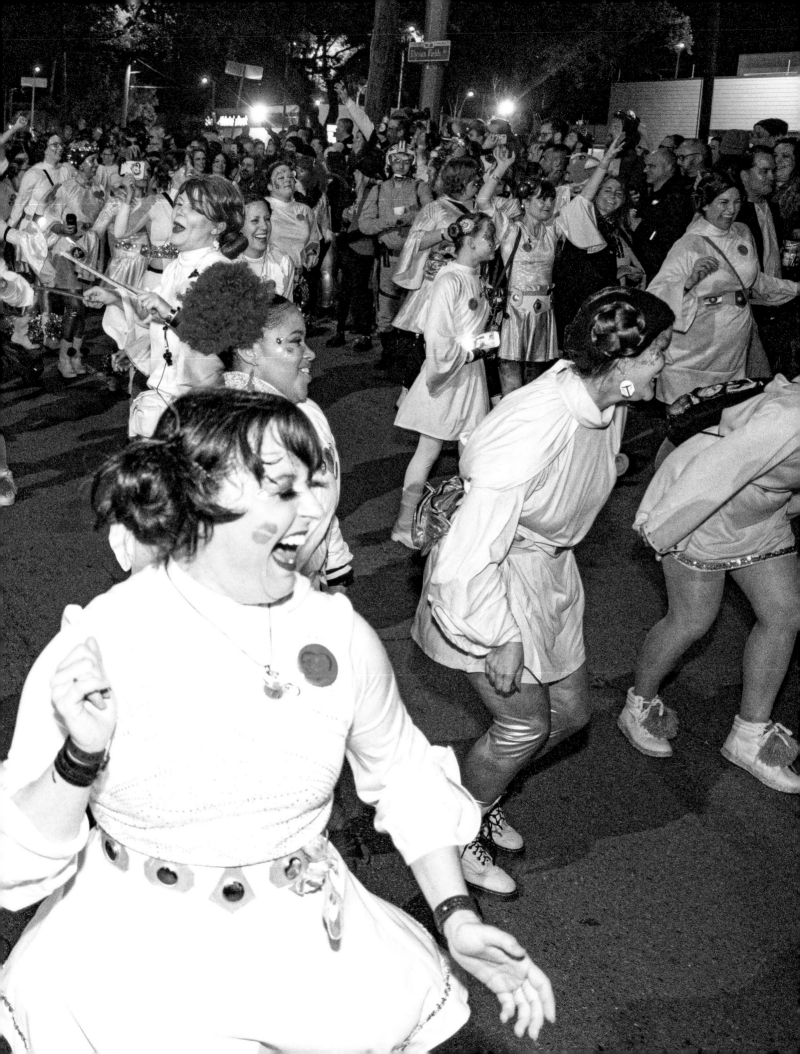

CHEWBACCHUS
SUB KREWES

610 Wampas

Acronola Space Monkeys

Aerial Space Squad

Apollo 42

At DA Beach At DA Beach

Austin Aliens

Avatarlicious

Back to the Fuschia

Batdance

Books To Kids

Brainiacs

Browncoat Brass and
The Companionettes

Chewbaccha Rockas

Chew-Bake-Us

ChewBorgUs

Cirque du Force

Cosmic Cart Coterie

Dancing in Uranus

Death Star Steppers

Dystopian Paradise

Expendable Extras

Fhloston Paradise

G.O.G.G.L.E.S.

Game Krewb

GIGERGEIST

Honey, I Blew Up the
Kingcake Babies

Illuminaughties

InVaders

Jayne Austen Book & Gun Club

Jedi Nights

KOLD

KRAP (Krewe of really
awesome parodies)

Krewe D'UndeROOs

Krewe de Fu

Krewe De Lux

Krewe du Chu

Krewe du Glitz

Krewe du Mando

Krewe du Moon

Krewe Du Resistance

KREWE DU WHO

Krewe Dza Dza

Krewe of Cosmic Cuties

Krewe of Dude

Krewe of Heavenly Bodies

Krewe of J.A.W.S.

Krewe of Kokomo

Krewe of Life

Krewe of Mardi Gore

Krewe of Remix

Krewe of Sharknadeaux

Krewe of Smegheads

Krewe of SpaceCats

Krewe of Spatacus

Krewe of Stranger Things

Krewe of Uranus

Krewe of Zissou

Krewepernatural

KREWETHULHU

Le Krewe de Chaos
Intergalactique

lee hans solo fook

Mardi Gras Dream Weavers

Mario Kart Krewe

Men in Black

Mischief Managed

Mistick Krewe of the
High Ground

Moon Marauders

Mothership NOLA

Muppets from Space

Mystic Krewe of P.U.E.W.C.

Mystic Order of Mystery Science

Nola Night Lights

Nola Ram

NOPL Children of the READ-Volution

Order of New Orleans Jedi

Papa Spat's Olives

Pink Wookie Posse

Queer Eye for the Scifi

Rogues (in other circles Irish Rogues)

Royal Order of Metatron

Saintly Squadron

Sensuous Sister of Zeltros

Sideshow of the Dammed

Silhouette Dance Company

Space Vikings

Spare Parts Express

STOMP Troopers

The AfroFuturist Krewe

The Avengers

The Call Girls

The Children of the Cone

The Droids You're Looking For

The Empowered Strike Back

The NOLA Ninjas

The Rolling Elliots

The Stank Wizards of Pomeranian

There is no Krewe only Zul
(Louisiana Ghostbusters)

Trash Monsters

We Are All Wonder Woman

We Are Three

Women of Wakanda

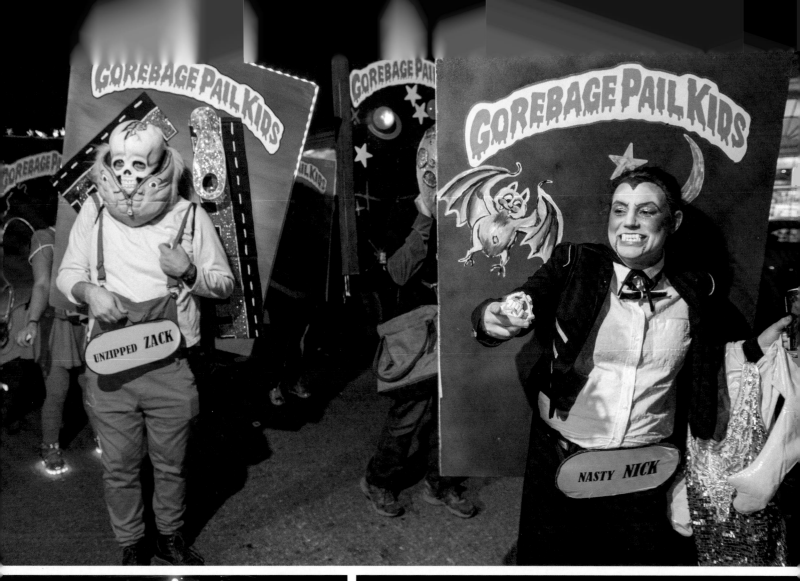

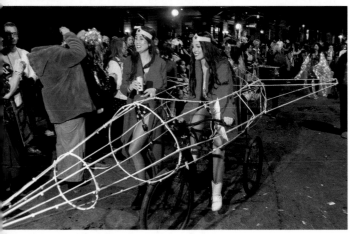

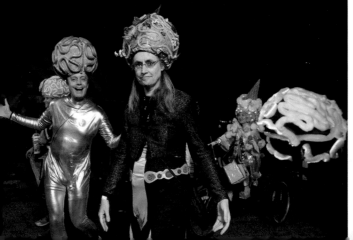

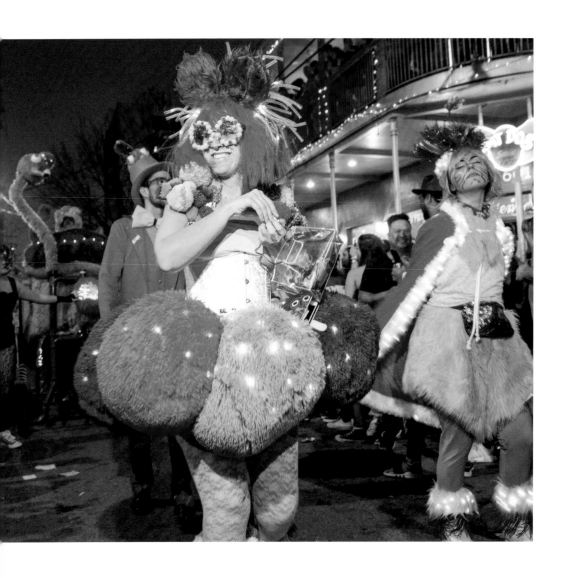

KREWEDELUSION

The mission of krewedelusion is "to save the Universe, beginning at its center—New Orleans." Founded in 2009, krewedelusion has a benevolent ruler, a king plenipotentiary, and is comprised of inner krewes (similar to a sub krewe). Keeping its theme a secret until parade day, krewedelusion is family friendly yet ever satirical and irreverent. krewedelusion notes that "The People Shall Rule—Until a Suitable Replacement Can Be Found."

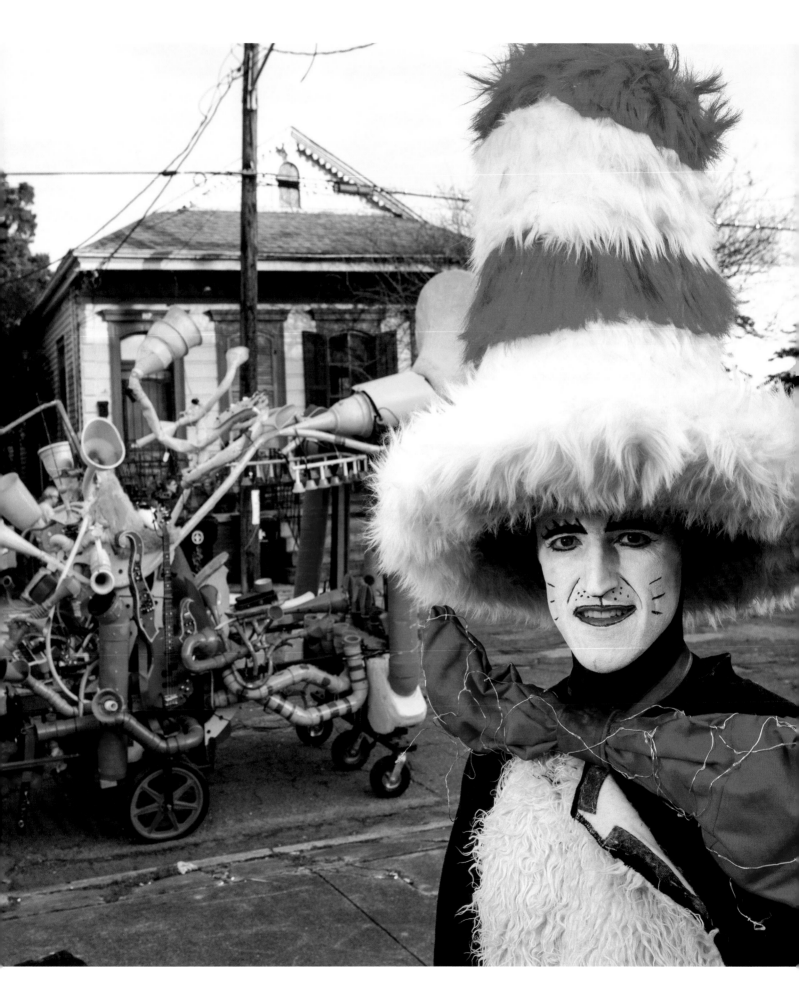

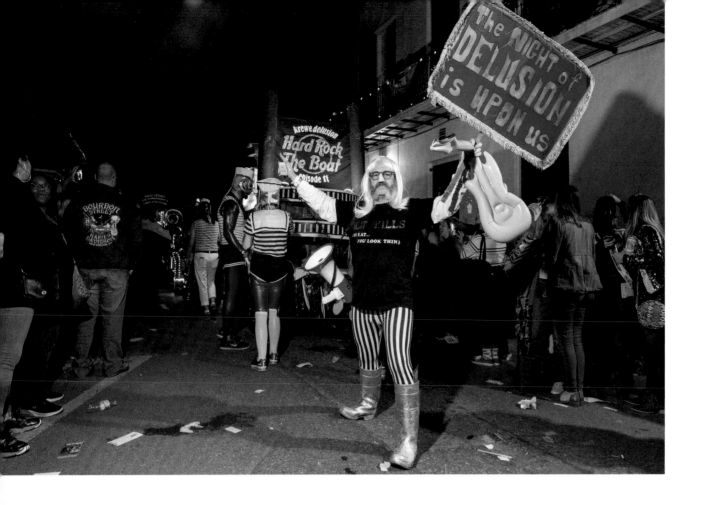

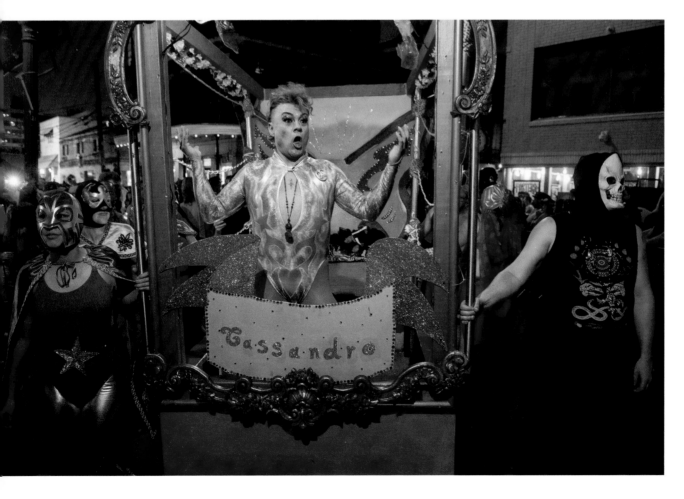

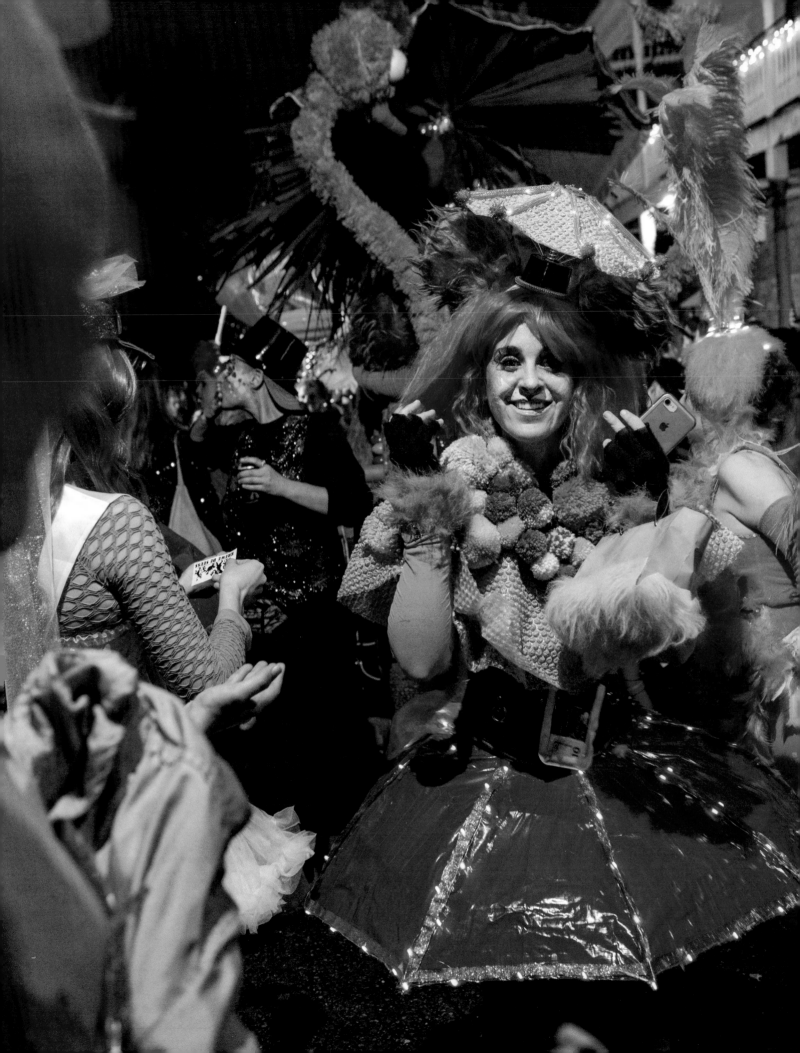

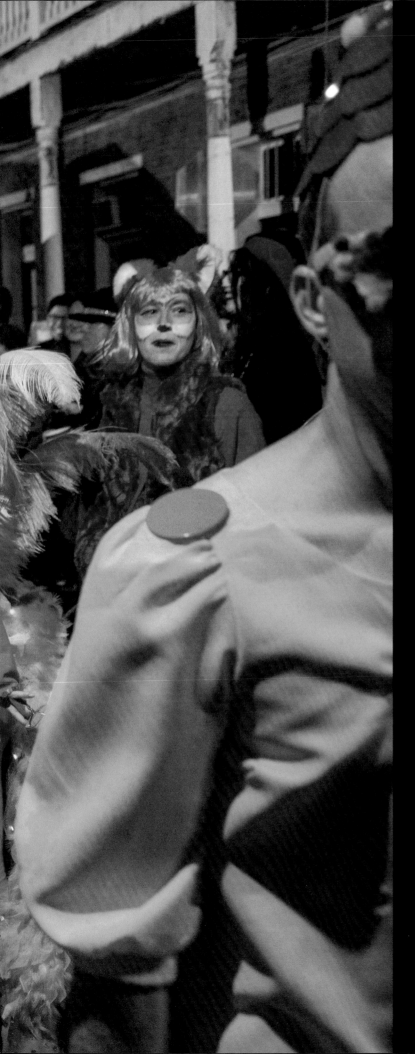

KREWEDELUSION
INNER KREWES

...and Boleyns

Amigos de los Amigos

Camel Toe Lady Steppers

Guise of Fawkes Krewe

KREWE DAT 504

Krewe de Seuss

Krewe du Jieux

Krewe du Sue

Krewe of Bananas

Krewe of Krakatoa

Krewe of Sustainable Uplift

Krewe What Thou Wilt

Mystic Krewe of London,
France & Underpants

Noisician Coalition

TAP DAT

The Alkreweists

The Krewe of Won!!!

The Pony Girls

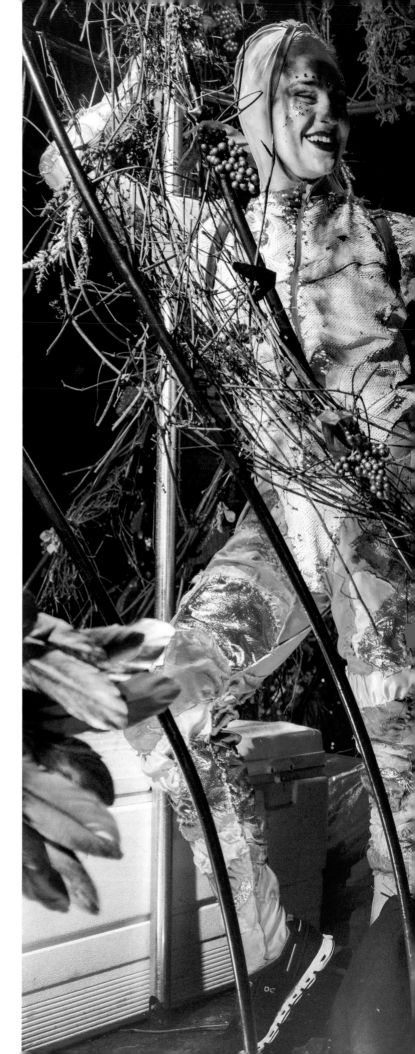

KREWE BOHÈME

A thing of grace and beauty, Krewe Bohème was formed to "present a visual and auditory feast of mystery, artistry and fun." Newcomers to the Carnival scene, the Krewe Bohème first marched in 2019, heading up the alternative parade weekend three weeks in advance of Fat Tuesday. Noting that Bohèmes are "persons with artistic or literary interests who disregard conventional standards of behavior," the parade boasts several highly creative sub krewes who dazzle everyone who sees them as they parade early in the Mardi Gras season. Concentrating on the artistic and the beautiful, Krewe Bohème created a family friendly parade that is a collection of fantastic creatures ruled by the intoxicating Queen Absinthe Fairy....a role that is filled by a different lucky sprite each year. Bohème brings you light, happiness and magic with its magnificent costumes and creative non-motorized floats.

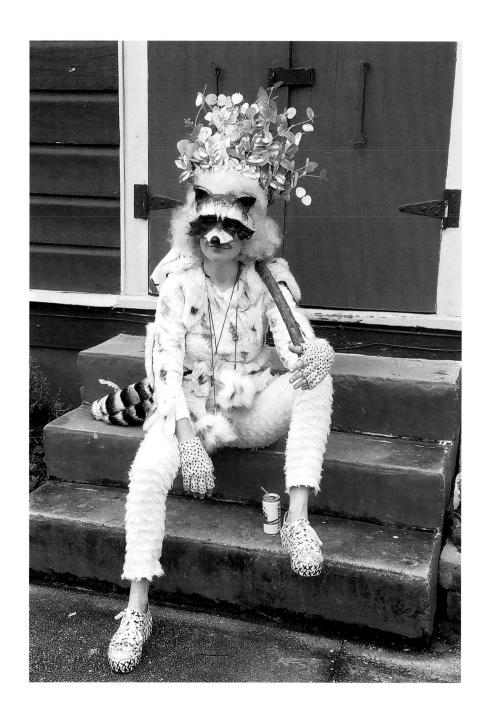

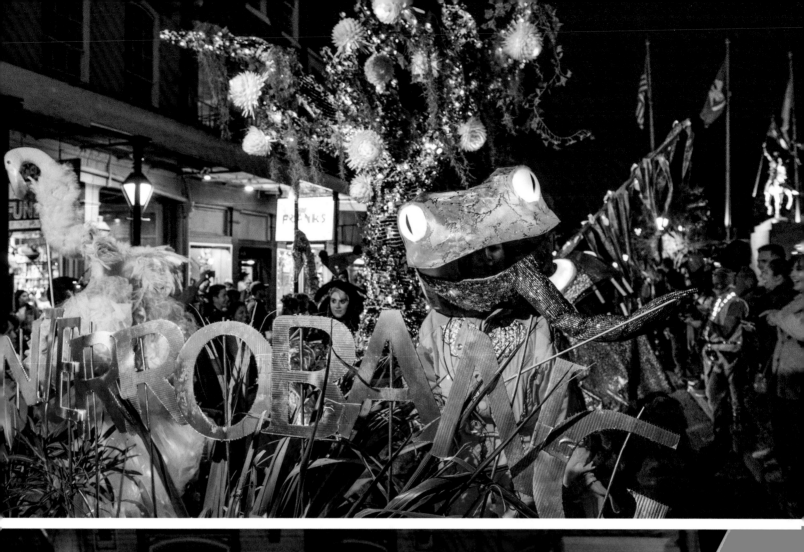

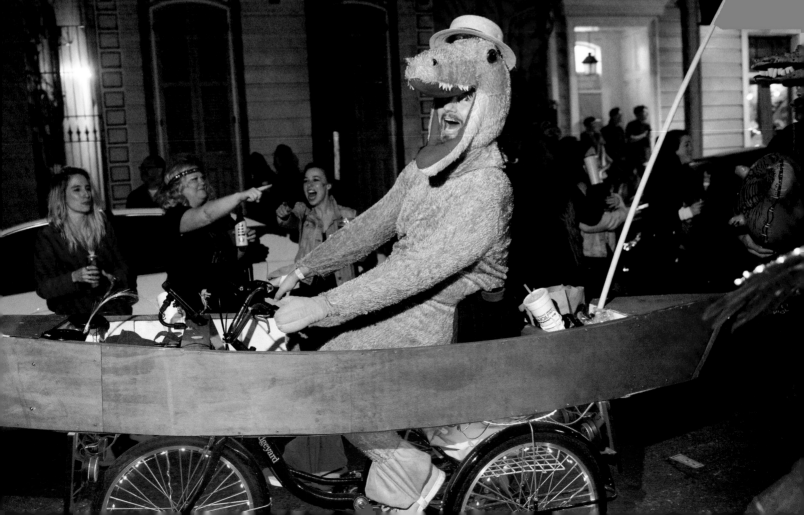

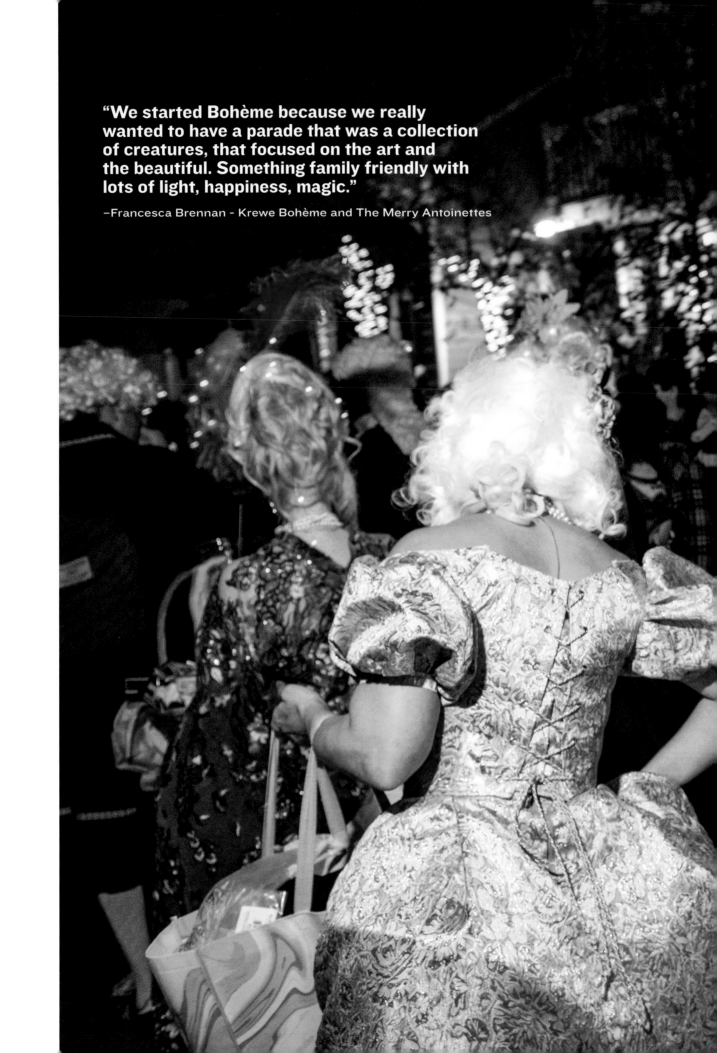

"We started Bohème because we really wanted to have a parade that was a collection of creatures, that focused on the art and the beautiful. Something family friendly with lots of light, happiness, magic."

–Francesca Brennan - Krewe Bohème and The Merry Antoinettes

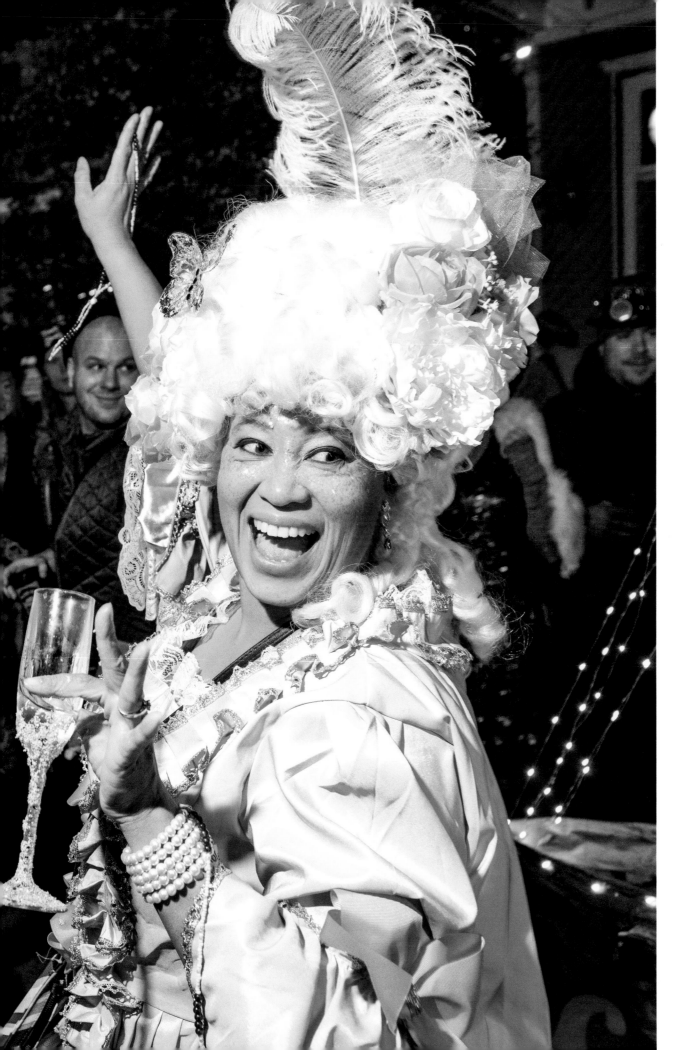

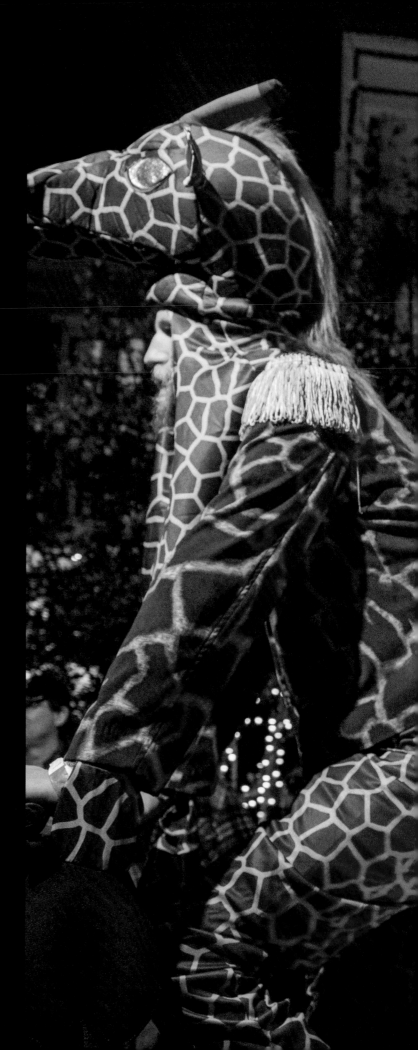

KREWE BOHÈME
INNER KREWES

Bayou Babes of New Orleans
Flora and Fauna
Interrobang‽
Krewe D'Ensite
Krewe de la Renaissance
Krewe of Dystopian Paradise
Krewe of Full Bush
Krewe of Goddesses
Krewe of Hellarious Wingnuts
Krewe of RUM
Krewe of SLUTS
Les ReBelles
Ménage a Trike
Skinz n Bonez
The Merry Antoinettes

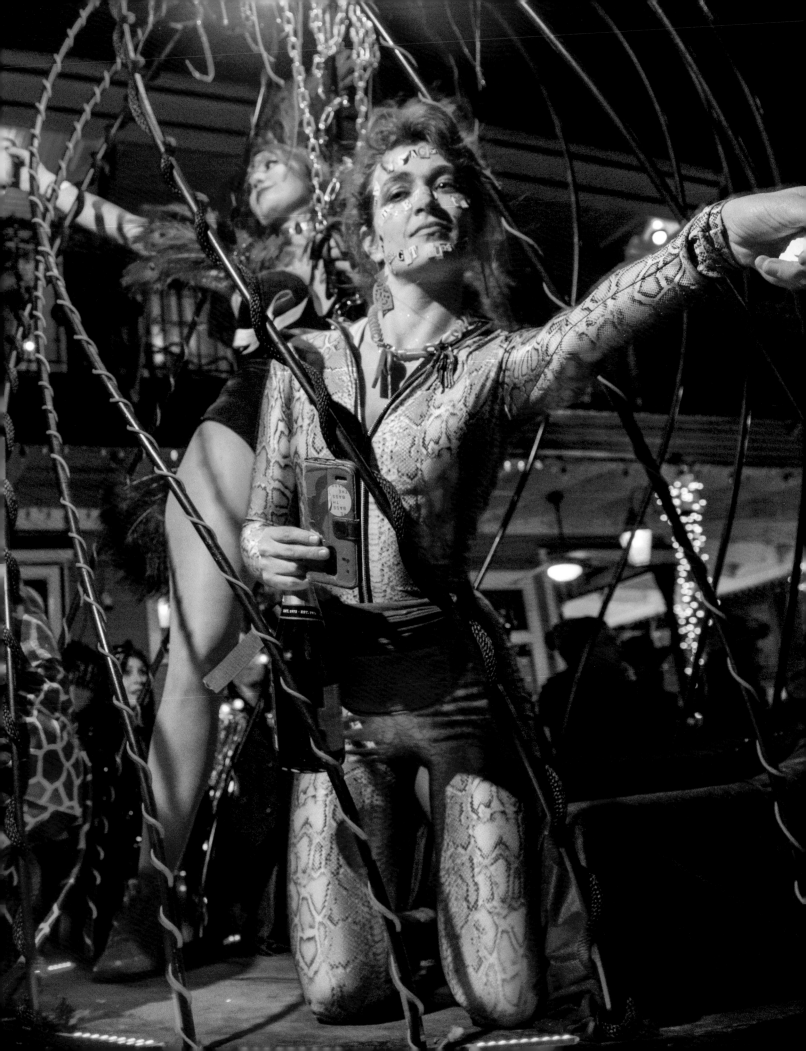

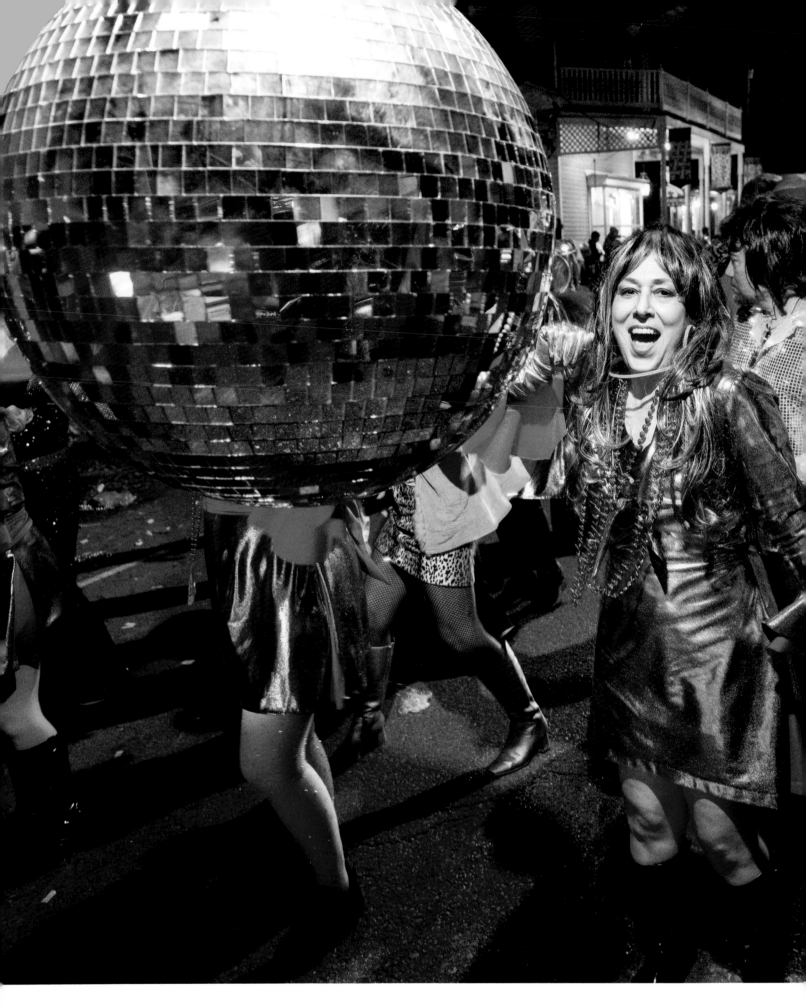

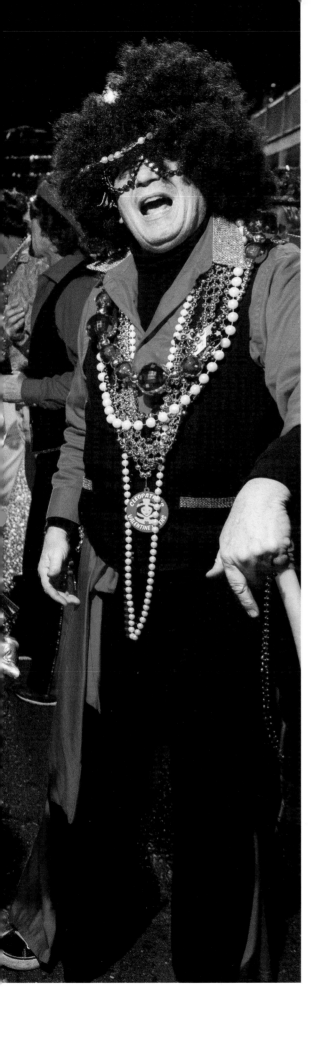

3

DANCE TO THE BOOGIE GET DOWN

MUCH OF THE MARCHING KREWE MOVEMENT OWES ITS DEPTH AND BREADTH TO THOSE KREWES WHOSE FEET MOVE TO THE BEAT, DANCING THROUGHOUT THE PARADES. WHILE THE INNOVATORS CLEARED THE DANCE FLOOR, THERE FOLLOWED A RICH AND ACTIVE GROUP OF DANCING KREWES WHO JUST CAN'T KEEP STILL. DANCE KREWES MAKE UP A LARGE PORTION OF THE MARCHING KREWE LIST, AND THEY COME IN EVERY VARIETY IMAGINABLE.

There are a myriad of themes, costumes, musical choices, and skill levels but the one trait that truly defines dancing krewes is dedication. Soon after the giddiness and glamor of Carnival season ends, these intrepid krewes are back to work holding tryouts, designing new dance routines and updating and creating costumes for the next year. All this in addition to krewe meetings, charity events and year-round parading.

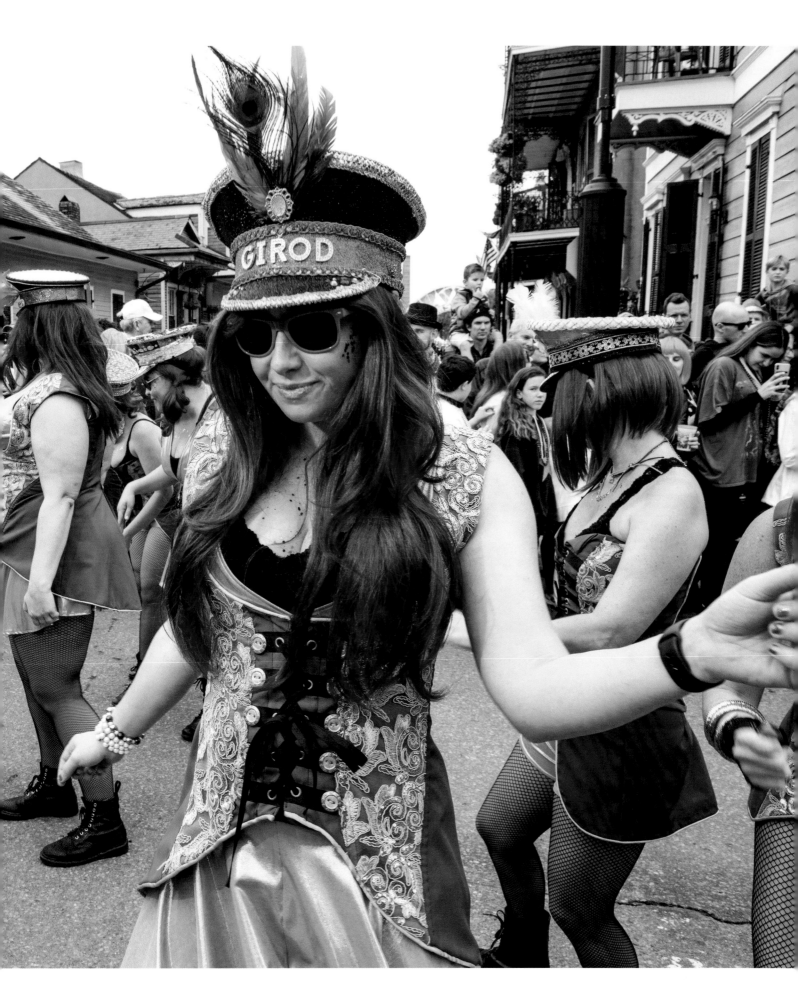

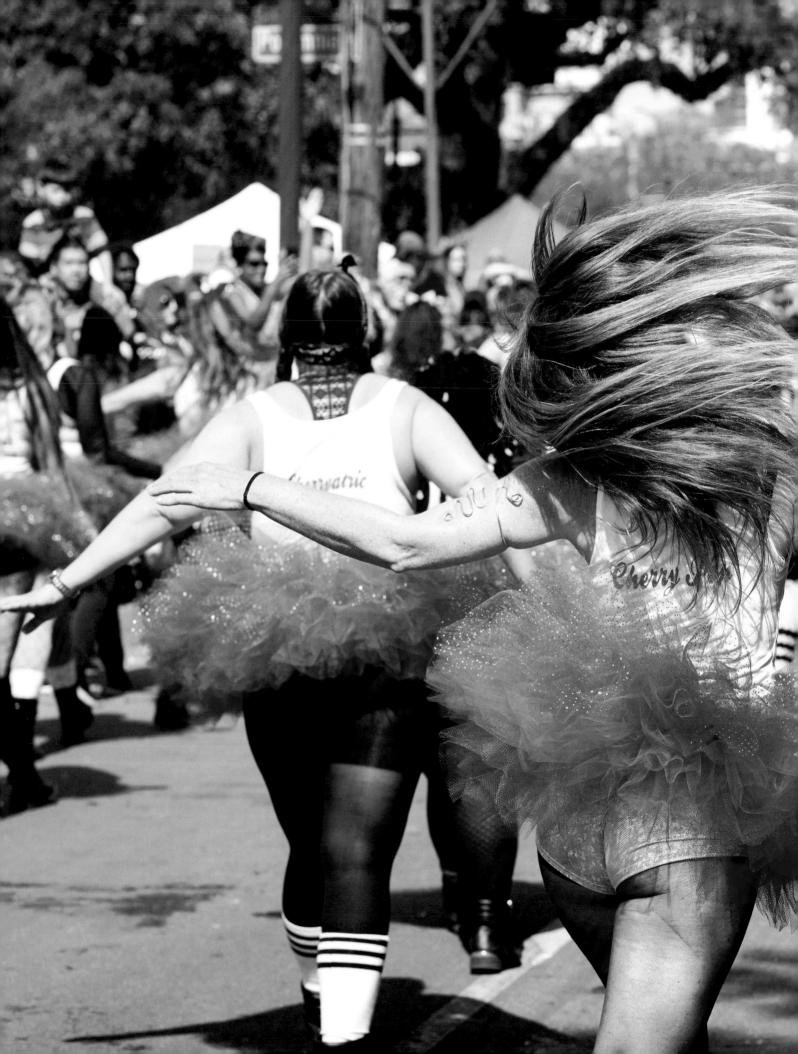

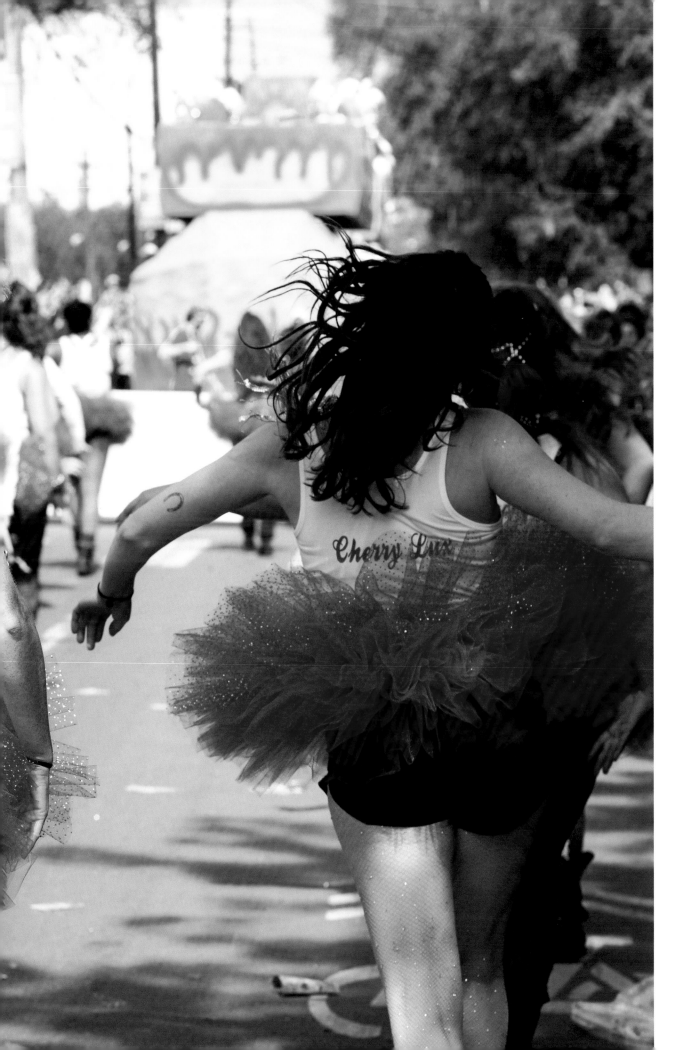

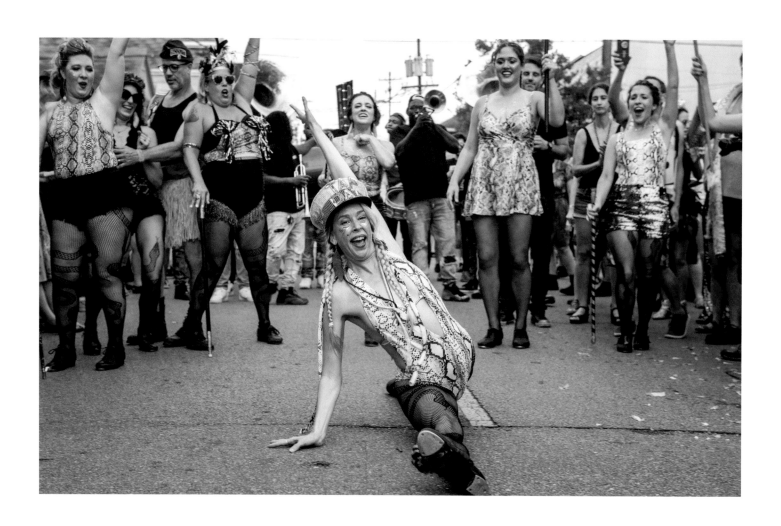

I WANNA DO THAT!

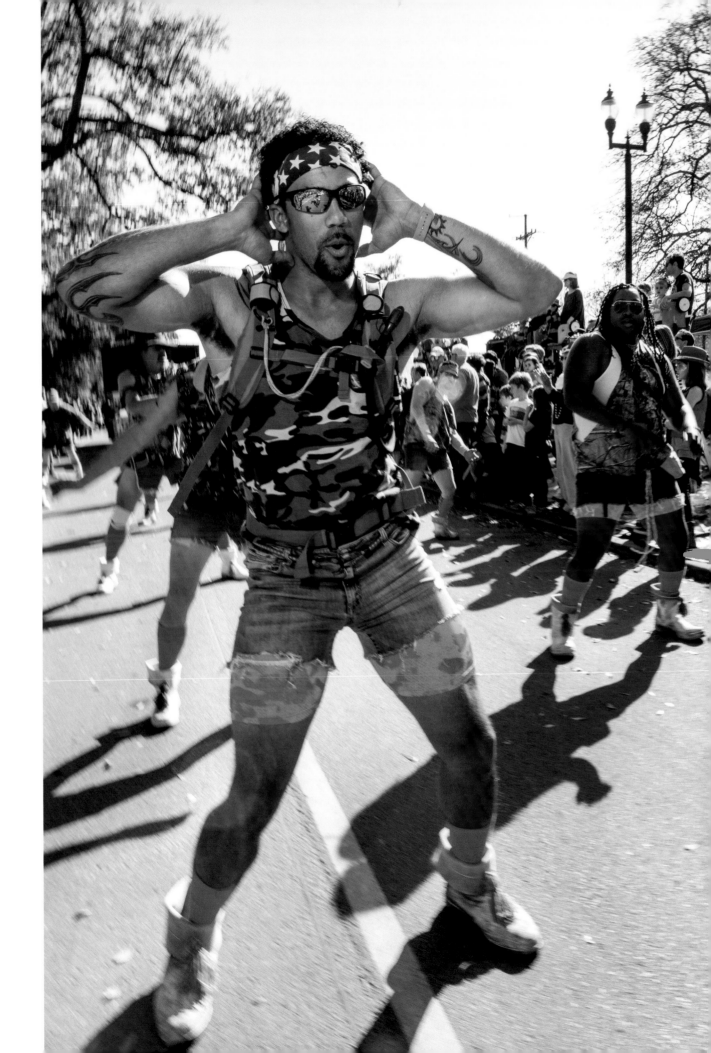

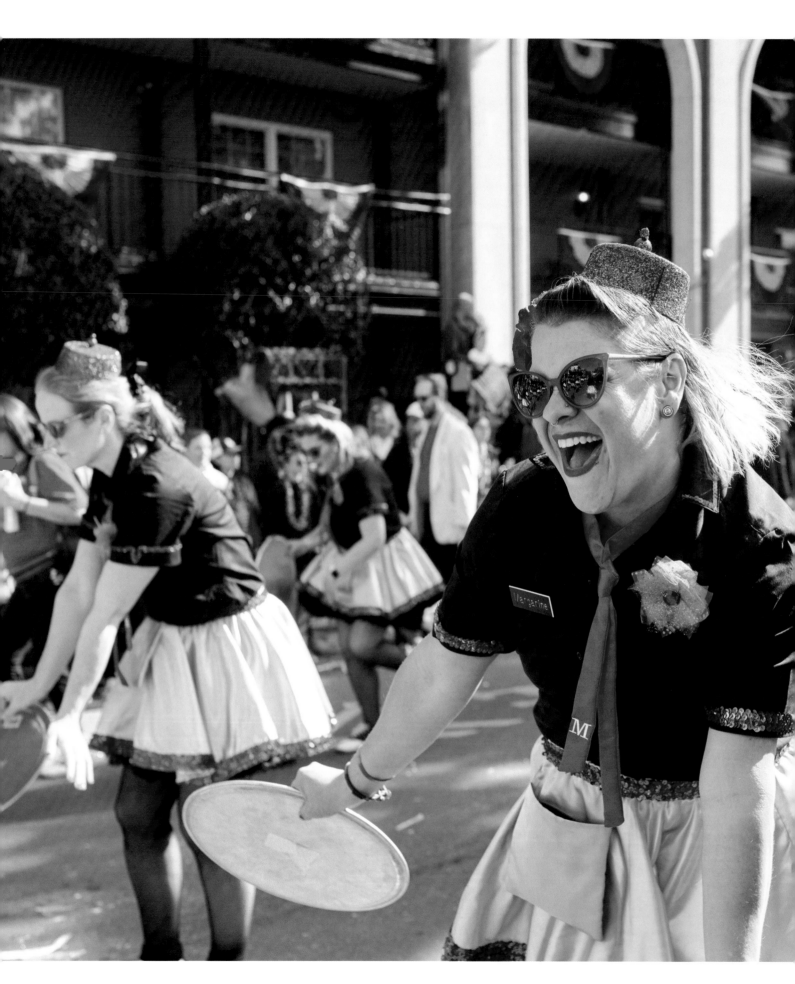

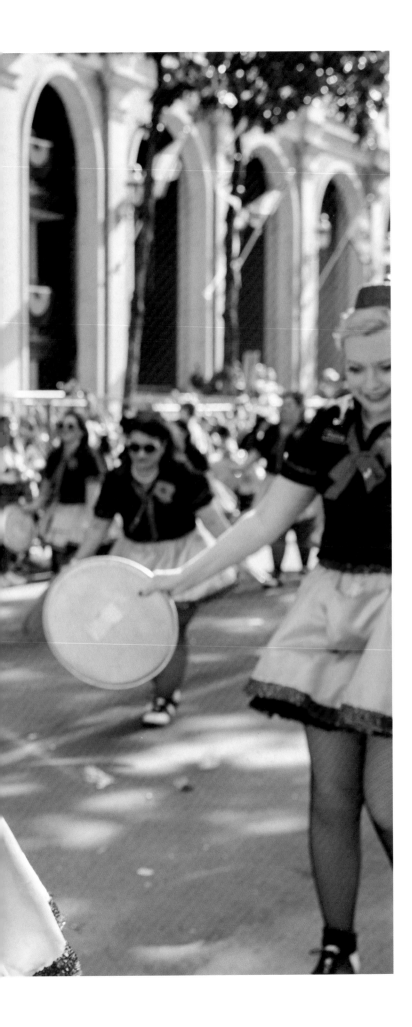

From the tray twirling antics of the Muff-A-Lottas to the syncopated steps of the Disco Amigos, these krewes take their silliness seriously! Not every krewe requires a tryout, though. Any lady of any skill level can join the Bearded Oysters and receive a blessing from the Mother Shucker herself (provided they are willing to don the signature sparkly white beard and mustache)!

With the average Mardi Gras parade lasting several miles, there is a certain amount of stamina required to strut one's stuff for the duration. No chapter on dancing krewes would be complete without mention of the support krewes that walk alongside the dancers clearing the street, carrying water and generally making the magic possible. The dolled up stewardesses of the Amelia EarHawts have their trusty Cabin Krewe, and the Organ Grinders have their Monkey Spankers to support their moves to the delight of everyone who sees them.

From the dedicated support krewes to the musicians and the dancers themselves, everyone involved in the magic of Mardi Gras dancing krewes has spent considerable time and effort for the sole purpose of spreading the joy and euphoria of Carnival to all—including themselves. Get down on it!

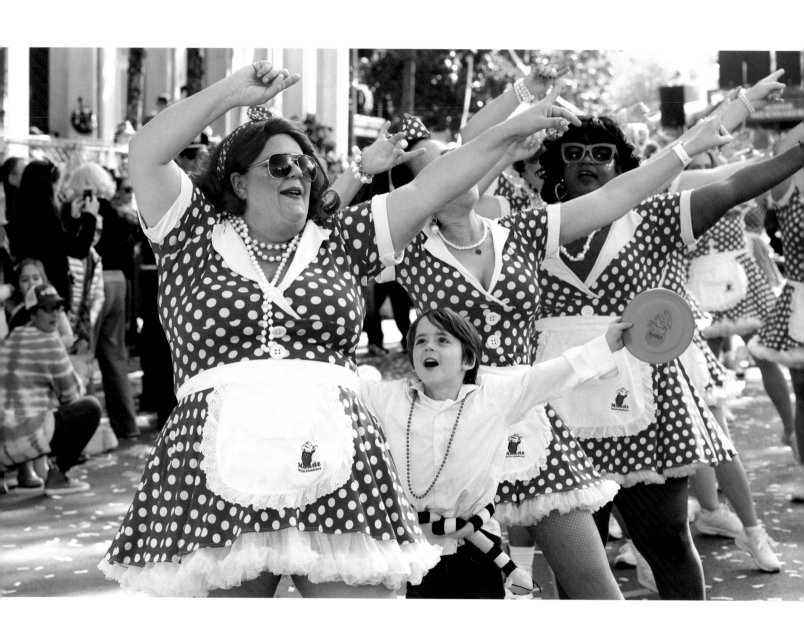

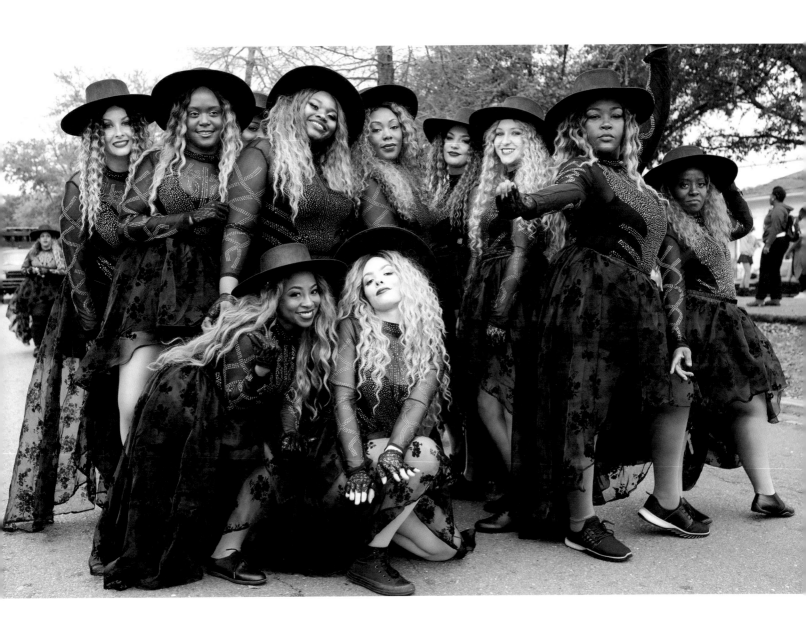

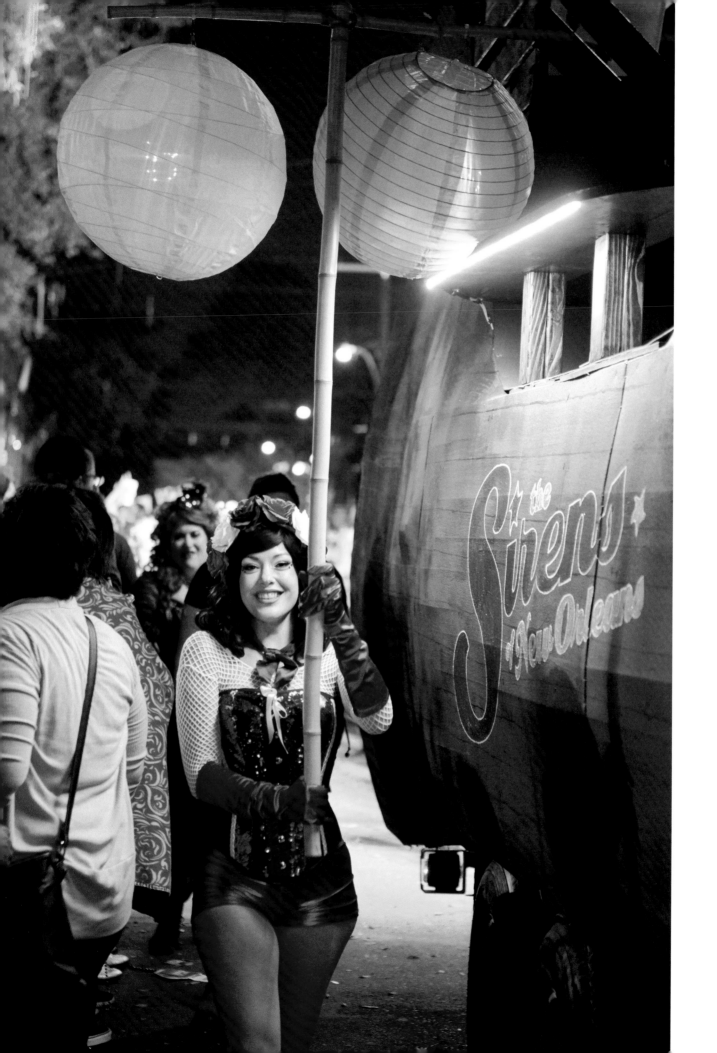

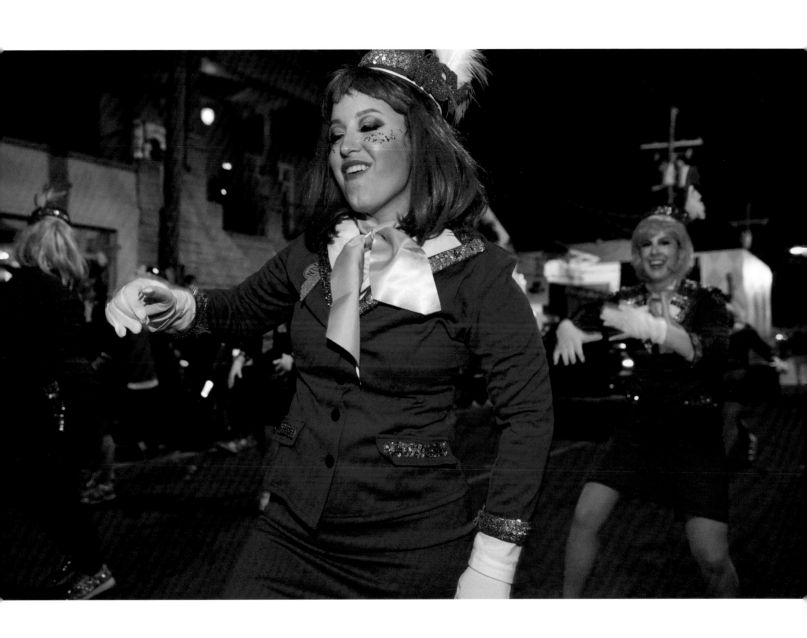

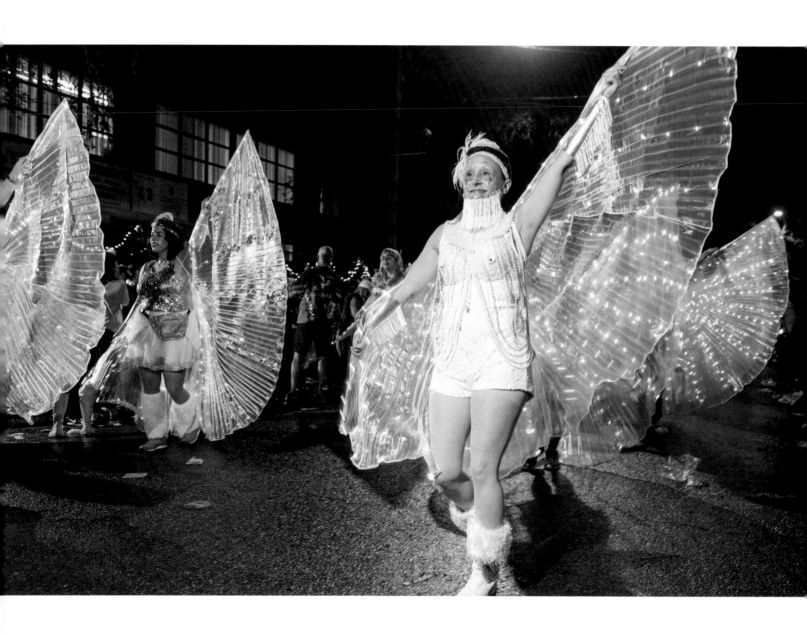

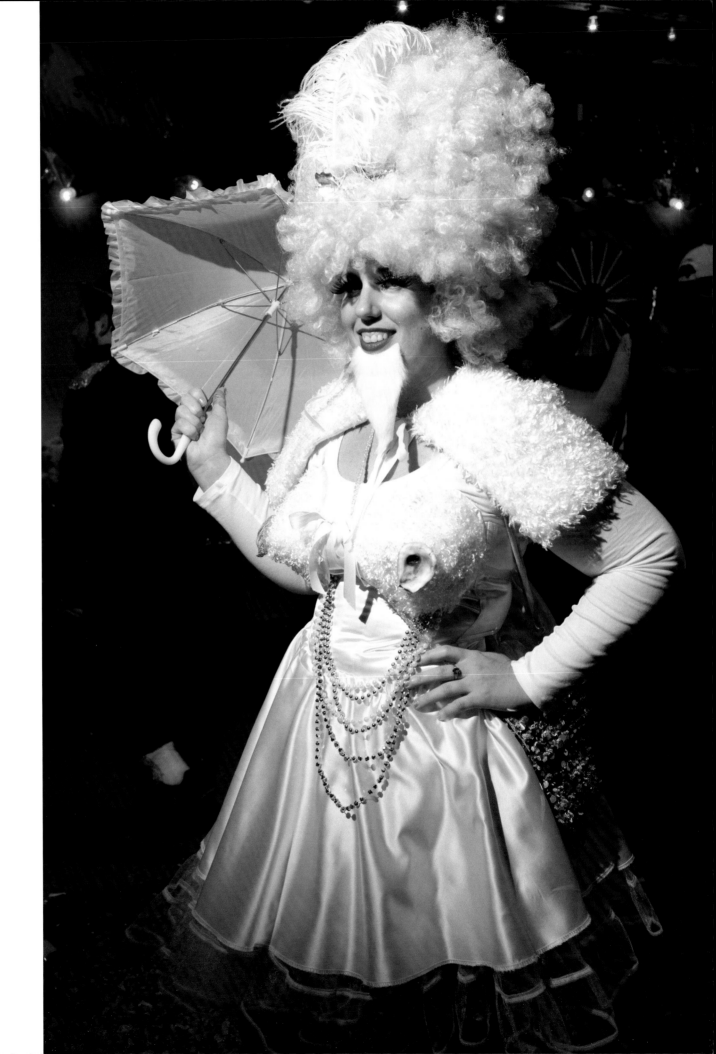

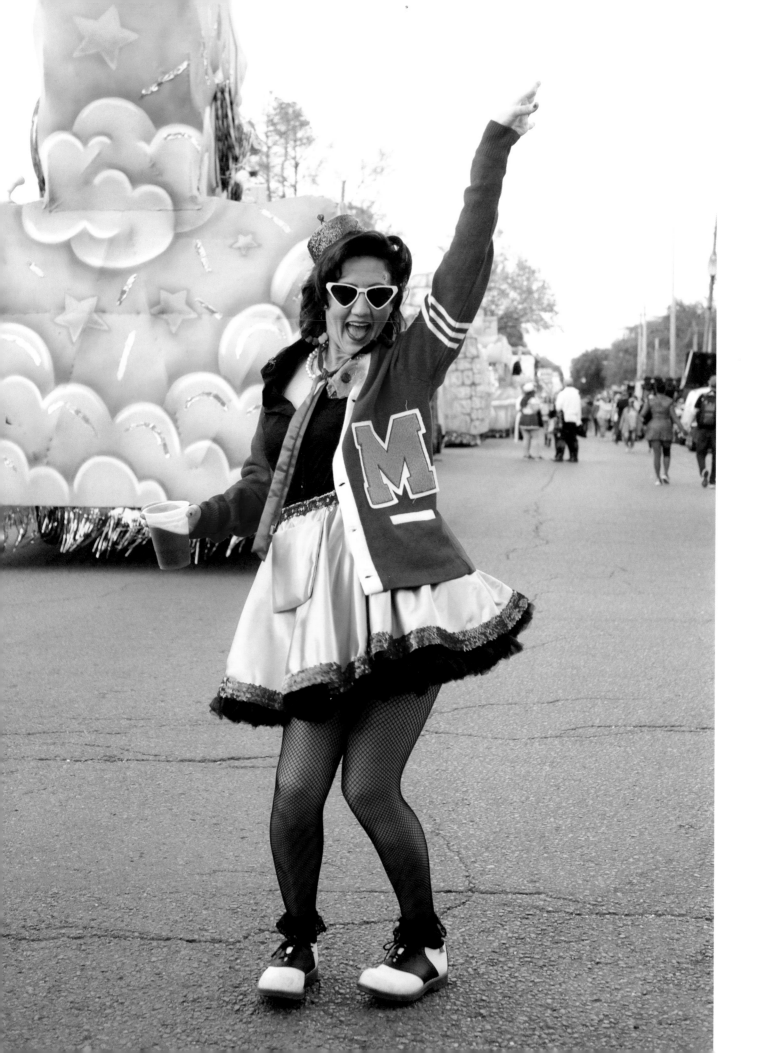

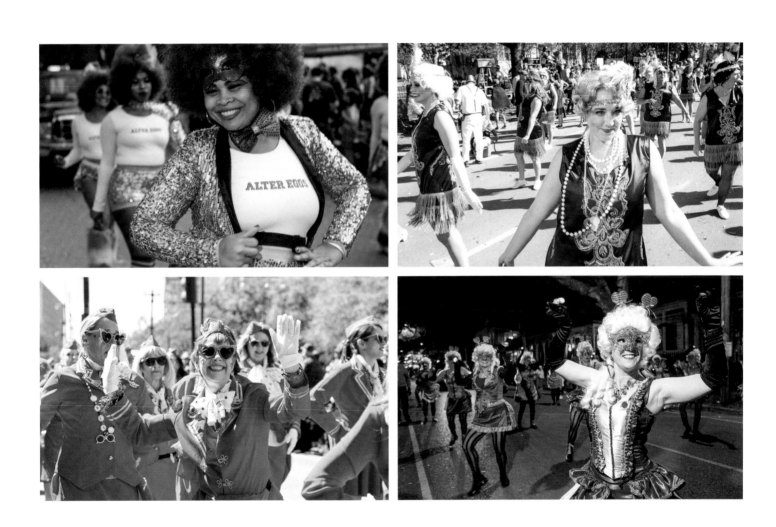

DANCE KREWES

Alter Egos Steppers
Amelia EarHawts Cabin Krewe
Bearded Oysters
Beyjorettes
Dead Rockstars
Dictator's Dancin' Darlings
Disco Amigos
Gris Gris Strut
Jailhouse Rockers
Mande Milkshakers
Muff-A-Lottas
Mystic Vixens
N'Awlins Nymphs
NOLA Bombshells
NOLA Cherry Bombs
NOLA Chorus Girls
NOLA Jewels
NOLA Nyxettes
NOLA Showgirls
Organ Grinders
Oui Dats
Ritmeaux Krewe
Roux La La
Star-Steppin' Cosmonaughties
Sirens of New Orleans
Streetcar Strutters
TAP DAT
The 689 Swampers
The Companionettes
The Dance Connection

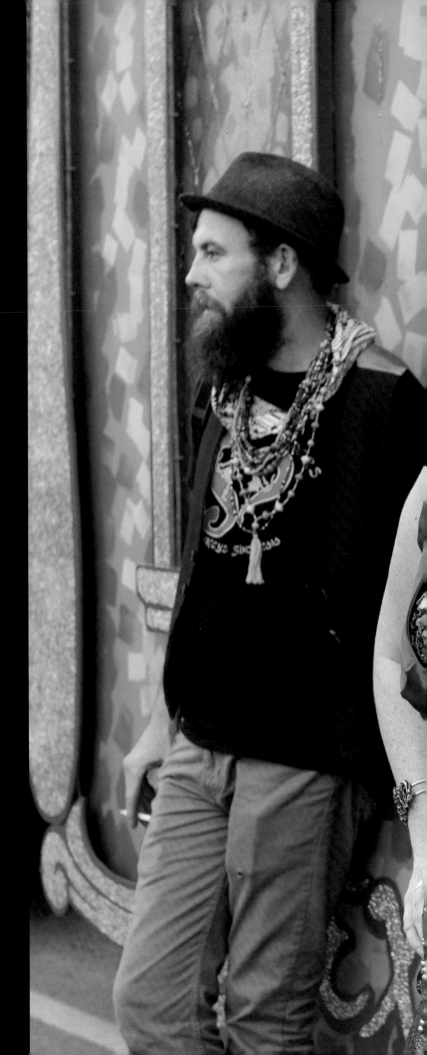

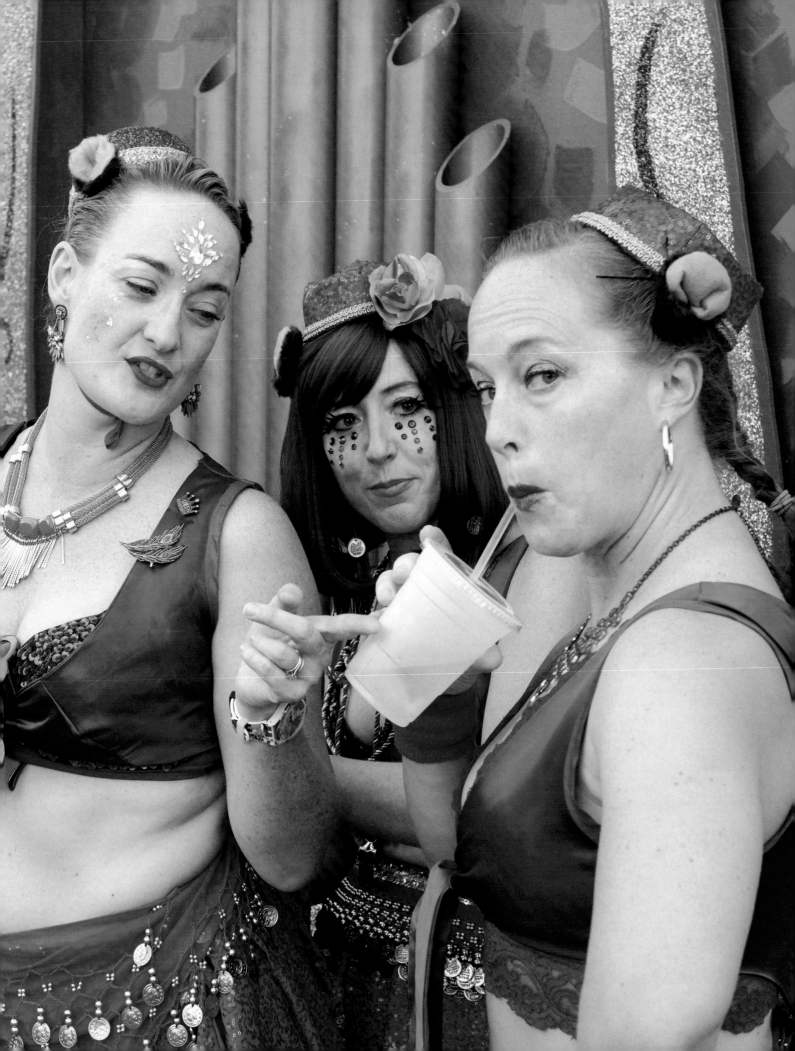

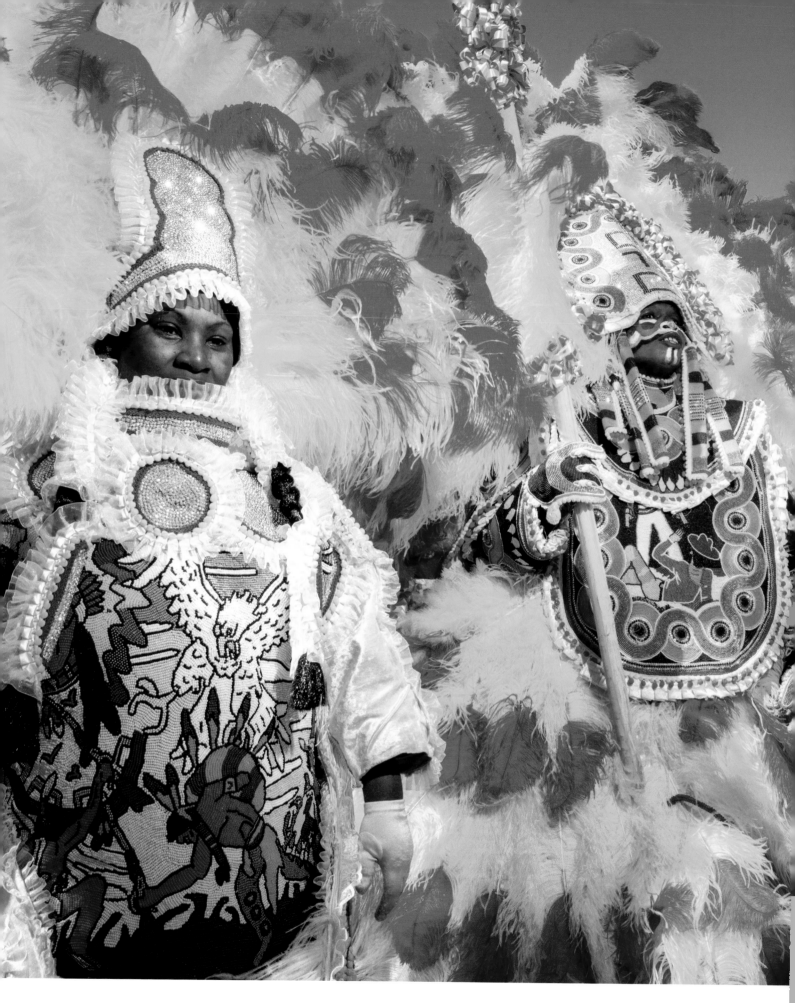

4

BLACK MASKING INDIANS

"EVERY PIECE WAS PUT ON THERE ONE AT A TIME. YOU PICK UP A SEQUIN, YOU PICK UP A BEAD; EVEN THE BEADS AROUND A STONE ARE THREADED AND YOU HOOK THEM UP ONE AT A TIME...I MAKE MY PIECES LIKE A PUZZLE."

—Big Chief Allison "Tootie" Montana, Yellow Pocahontas[1]

Jockamo fee nah nay
Jockamo fee nah nay
If you don't like what the
Big Chief say
Jockamo fee nah nay[2]

A burst of technicolor feathers announces the tribe's arrival: *"Indians, here dey come!"*[3] The Spy Boy leading the procession, scouts for rival tribes or gangs on the street, conveying directions to the Flag Boy, who waves the tribe's flag to notify the Big Chief of a rival approaching. Second Chiefs and Big Queens round out the group and feathers move in hypnotic rhythms. As tribes come together, the Wild Man's energy clears a path for the Chiefs to face off. A magical event transpires—an explosion of color, of call and response chants of song and dance. The Big Chiefs (tribe/gang leaders) shout boasts and insults, chant, and display their magnificent suits in a ceremonial battle. These energetic showdowns underlie the true goal—to be declared "the prettiest."

Excluded from participation in the White Mardi Gras celebrations, Mardi Gras Indians or Black Masking Indians evolved their own practices and in the process, became one of the best known and most beloved symbols of New Orleans: a living theater of art and culture. These private societies have no published timetables, and you won't find them on a Google map, but you are indeed fortunate to *"meet de boys on the battlefront!"*[4]

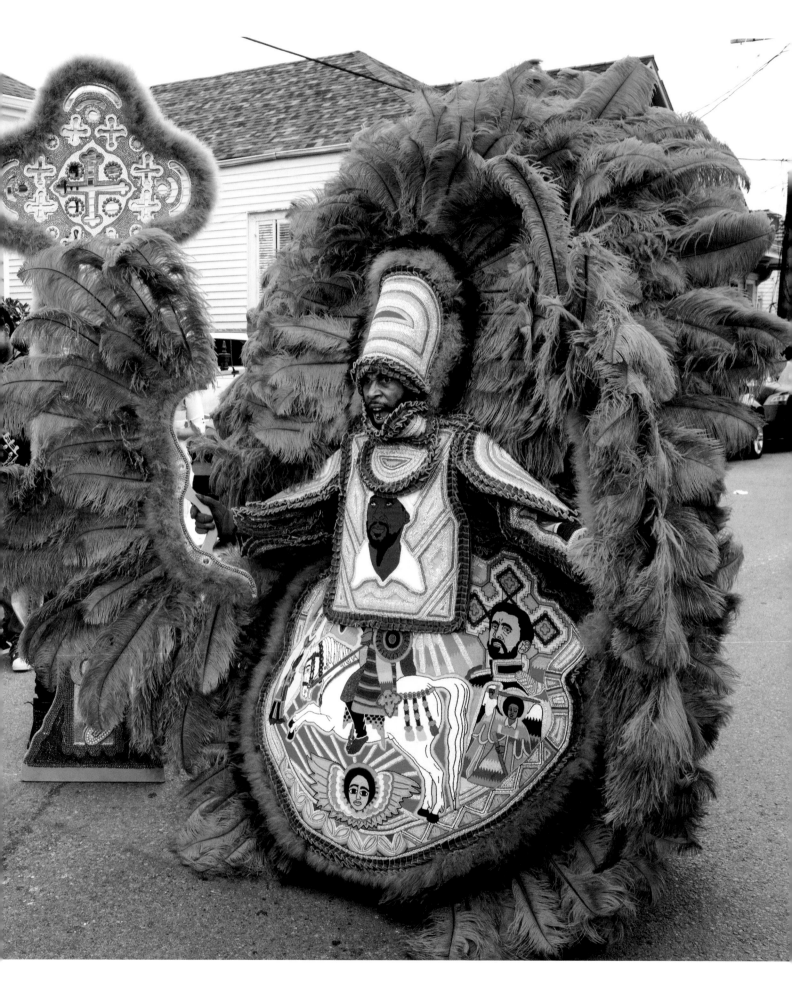

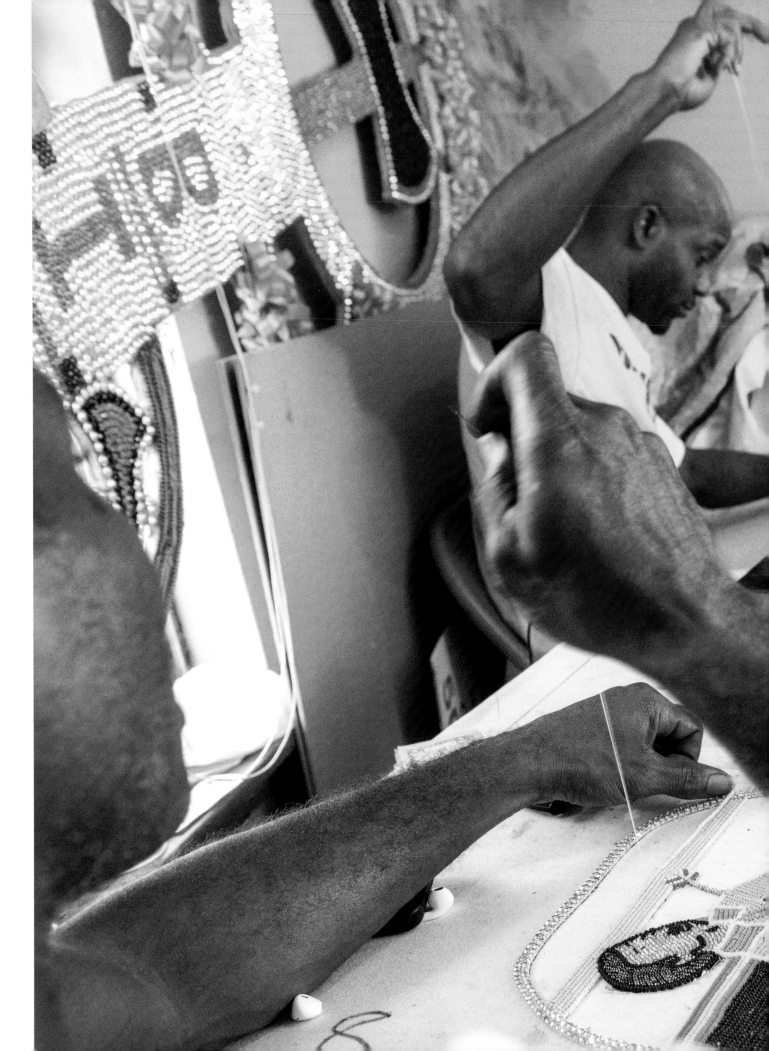

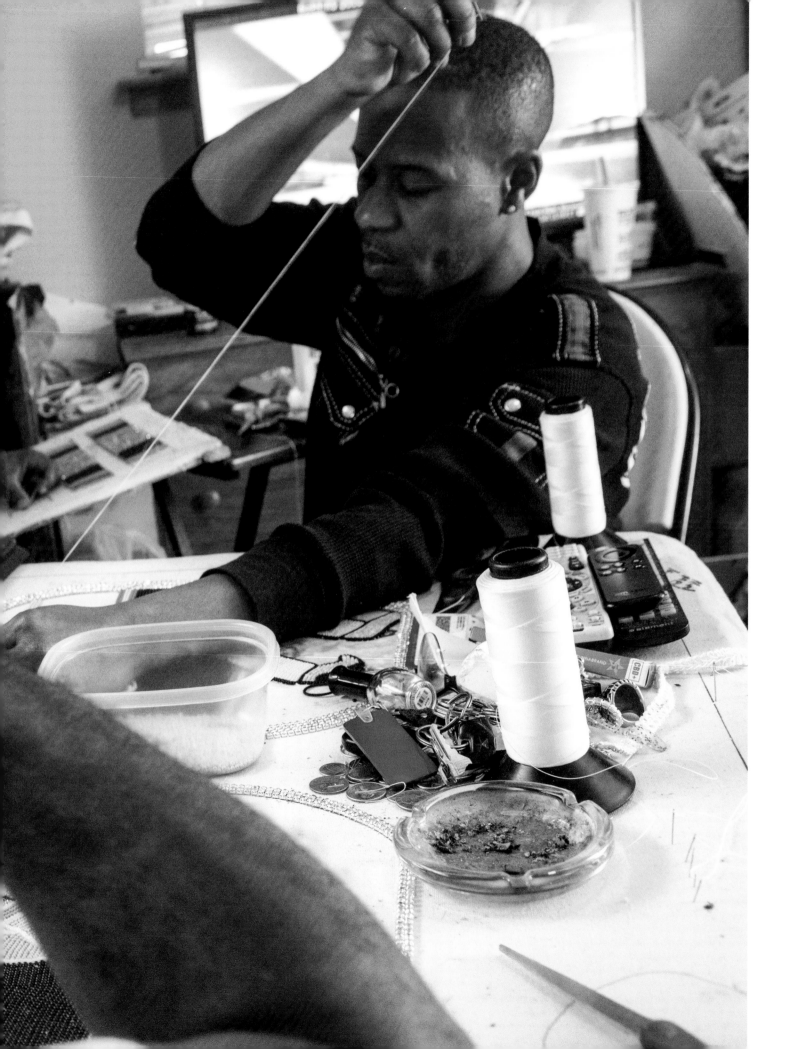

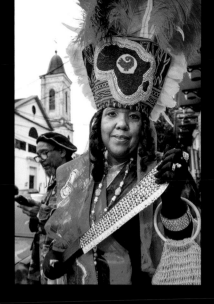

"IT IS A WAY OF BARING MY AUTHENTIC SELF. IN THE ART OF DOING THAT IT IS EXPERIENCING FREEDOM. I SHARE WITH YOU, YOU DON'T GET CONTROL OVER ME. YOU ONLY GET TO OBSERVE. I'M STITCHING MY WAY BACK TO THE HOMELAND OF AFRICA."

–Cherice Harrison-Nelson, Maroon Queen, Guardians of the Flame Maroon Society

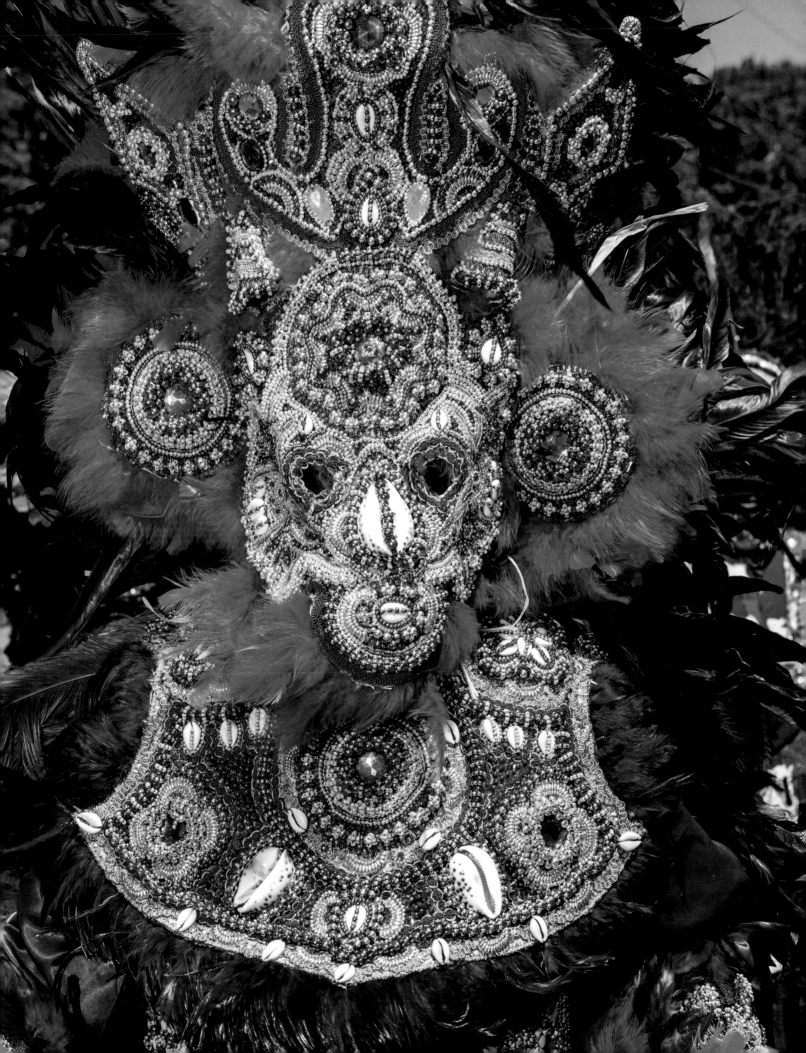

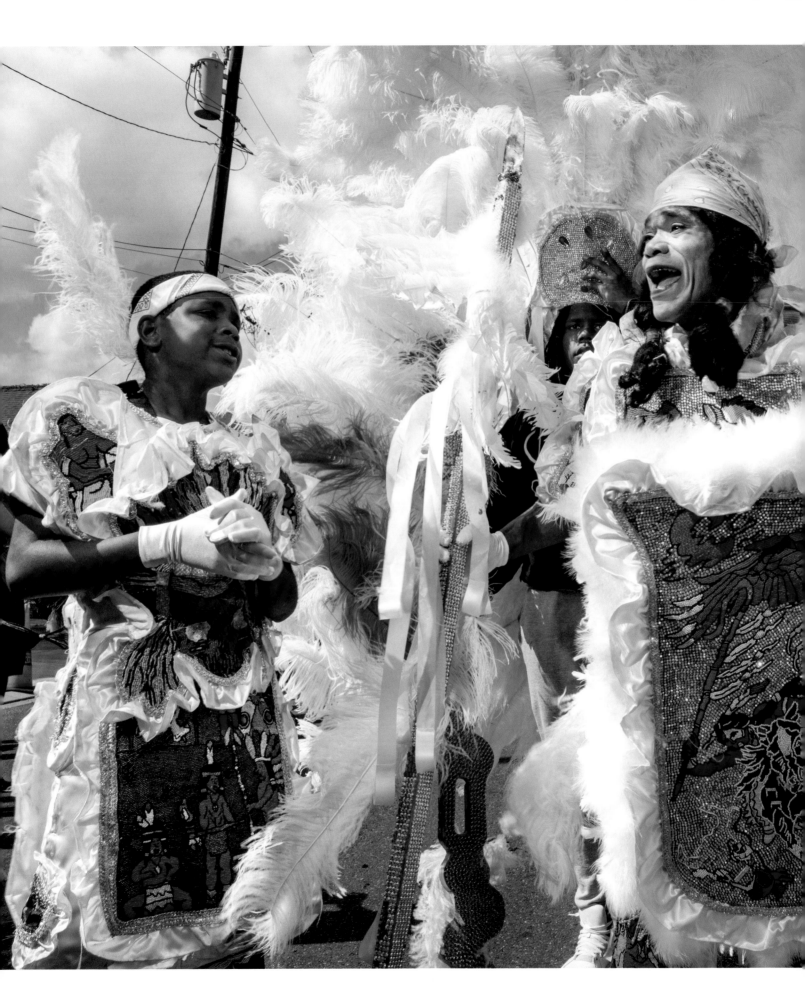

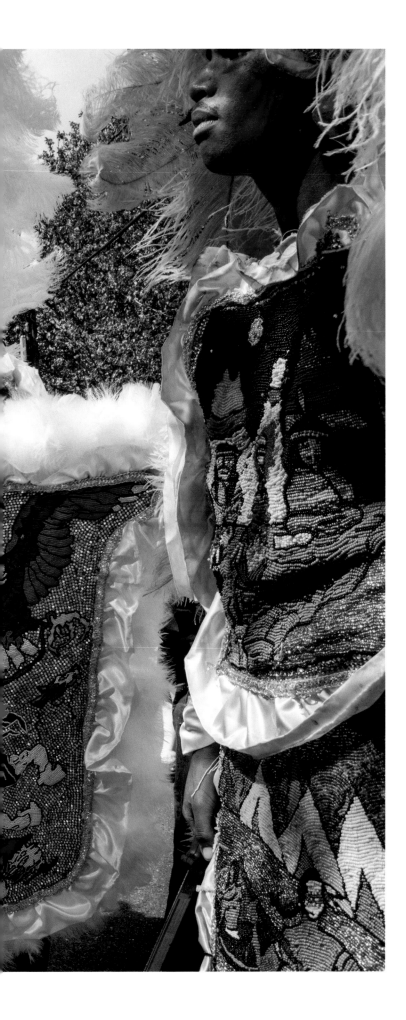

The Black Masking Indian practice is rooted in the legacy of resistance, of heroic warriors resisting domination. Yet the origin story remains contested. Black maskers were documented as early as 1823, with Black Masking Indians formally recognized in the 1880s—making them among the city's earliest maskers. Oral histories and scholarly research include a few interwoven themes for the focus on Indian imagery and themes:

• Extreme racist repression that organized the Black community to form methods of protection and demonstrations of strength.

• The 1884-85 Cotton Centennial's demonstrations of brilliant costumes, plumage and customs of the Plains Indians which were widely viewed and admired.

• The aid and unions between Native Americans and enslaved Africans who sought freedom from their mutual oppressors.

Black Masking Indians (often called Mardi Gras Indians) are an expression of self-love and self-pride, with an emphasis on African religious and cultural origins. Significant and thoughtful research documents various origin theories, but perhaps Cherice Harrison-Nelson, Big Queen of The Guardians Of The Flame Maroon Society, says it best…"masking has at its heart Black-on-Black love; the costume is a manifestation of that love."

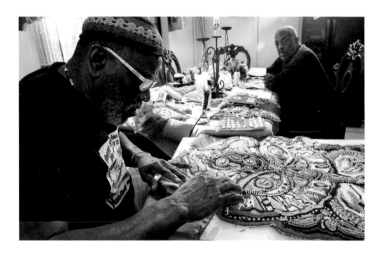

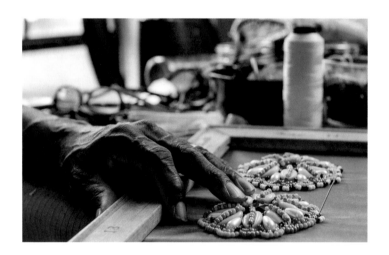

Black Masking Indian suits take a staggering investment of time and money: thousands of hours of hand-sewing, beading and feathering, with a different and distinctive color scheme each year. Designs take cues from Native American and African traditions, with maskers adding local flavor and expressing the individuality in their design. It takes a full year to create these works of art which are worn traditionally only on Mardi Gras Day, St. Joseph's night, and a few other occasions. Each tribe or gang has a color scheme for that year, but otherwise maskers are not bound by strict guidelines; individuality and creativity rule. Designs are generally categorized in two dominant styles: beaded patches that tell a story (sometimes identified as the uptown style); and West African themes that may include three-dimensional elements (sometimes identified as the downtown tradition).

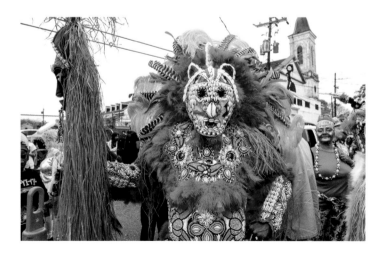

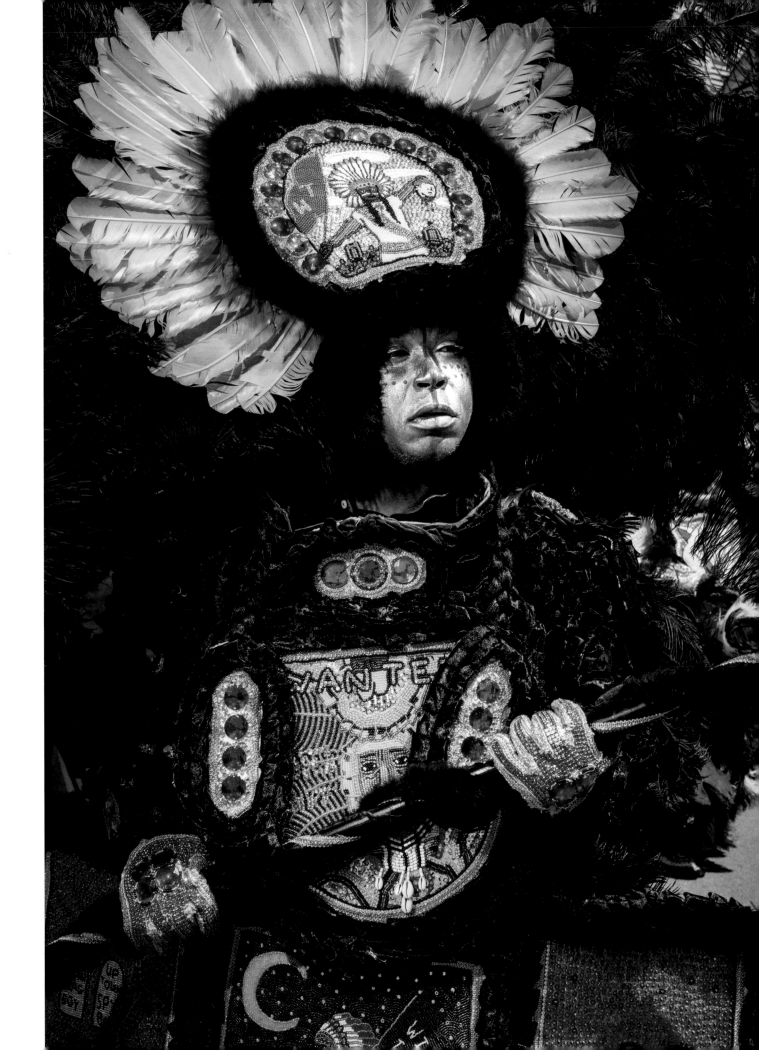

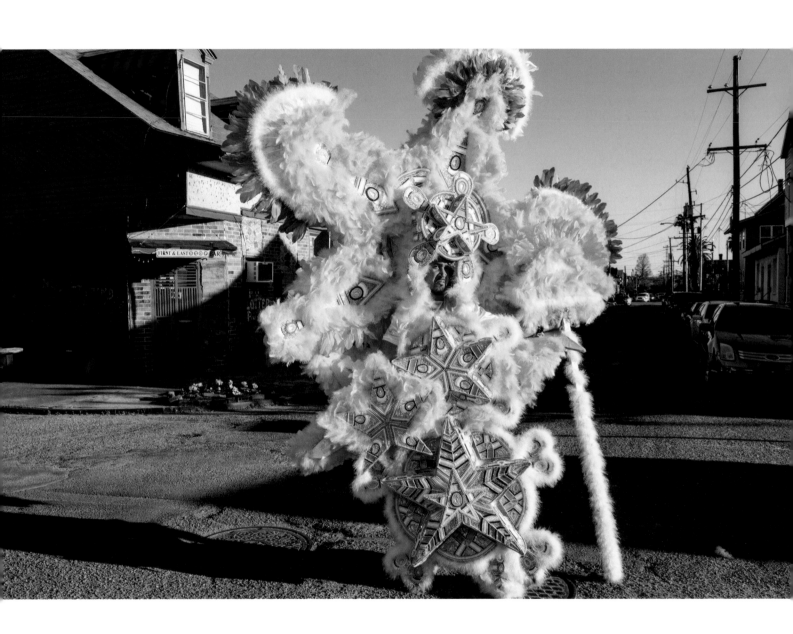

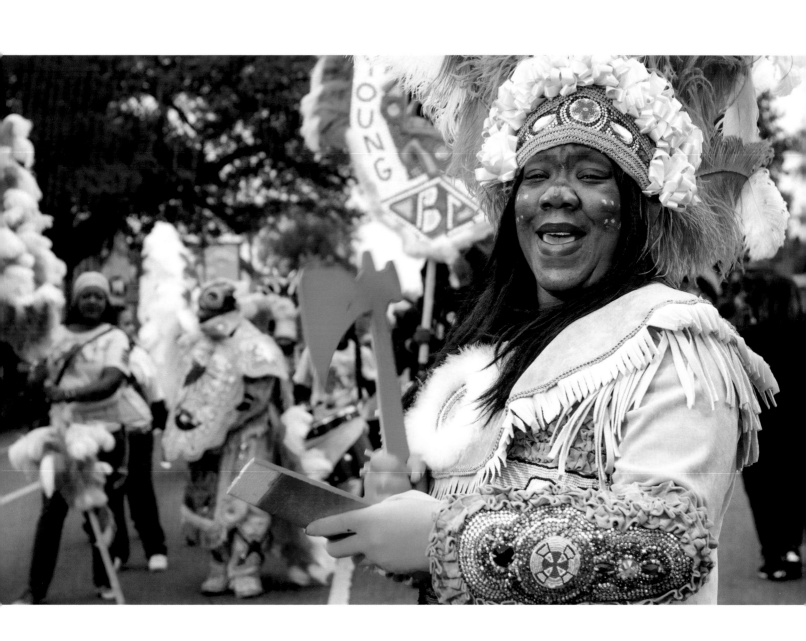

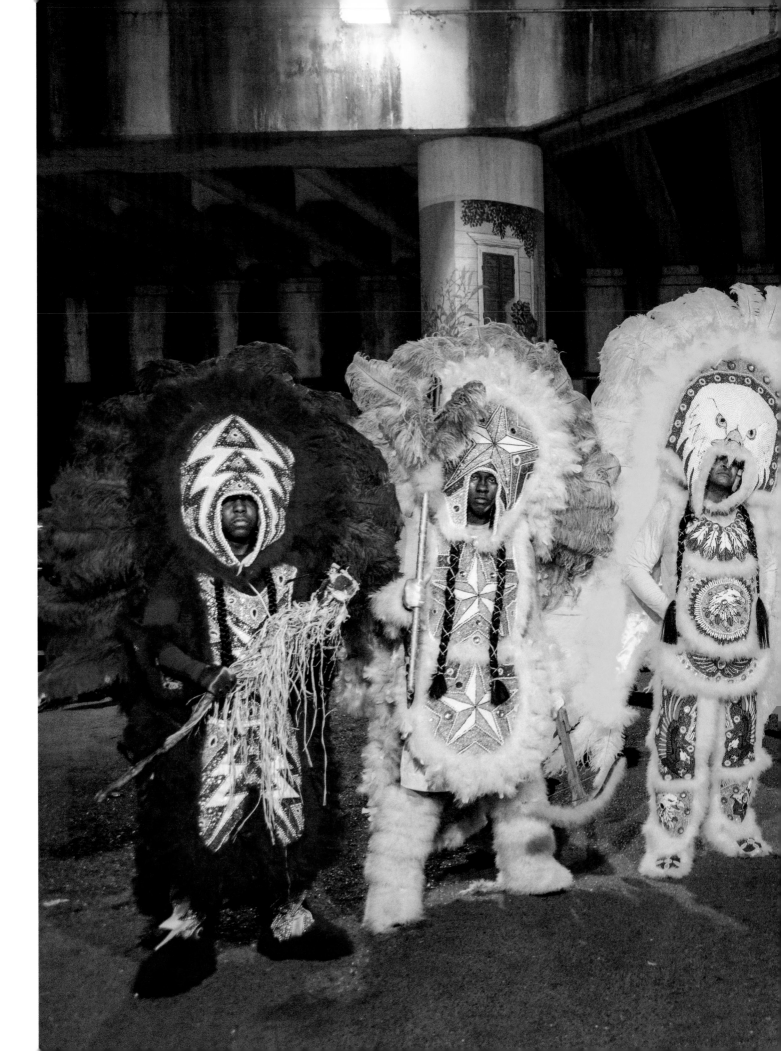

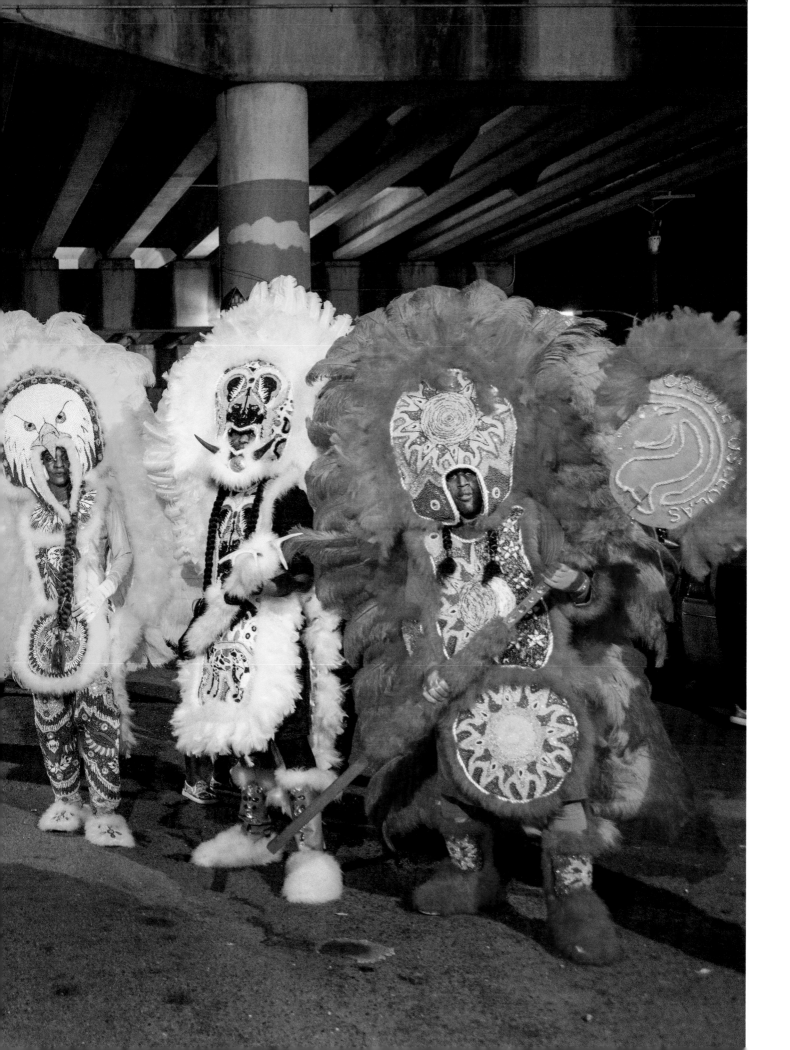

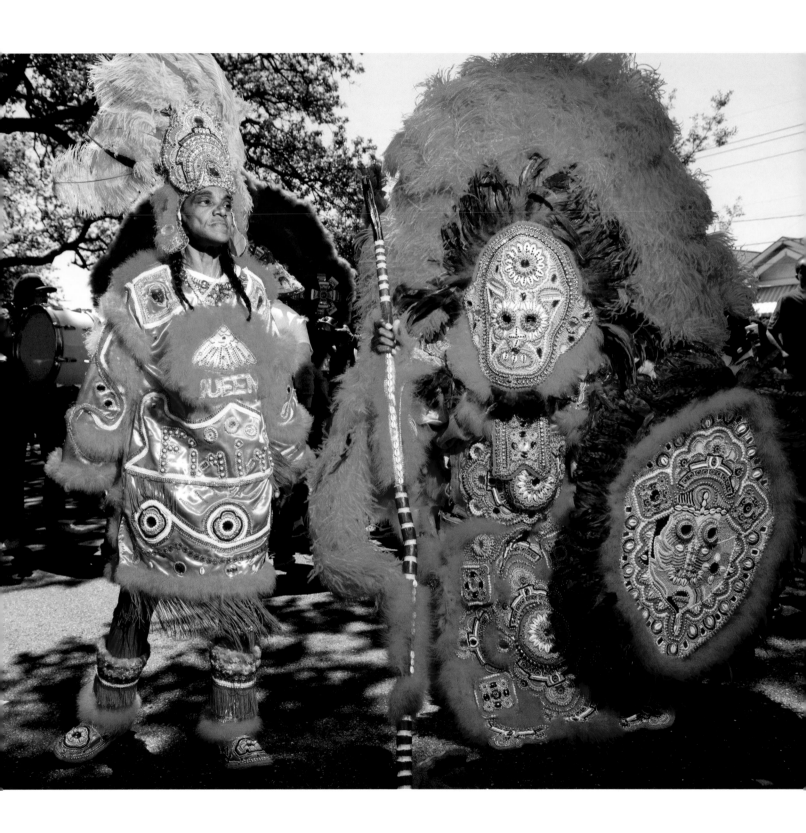

"**Without the togetherness of family, you just can't do it. I don't even feel right sewing by myself. This is a blessing, to have my wife and family, my support runs deep. This is a spiritual thing. When I look at the years, looking back from Katrina to now, the love from everywhere, it makes you work harder.**"
—Big Chief Demond Melancon,
 Young Seminole Hunters

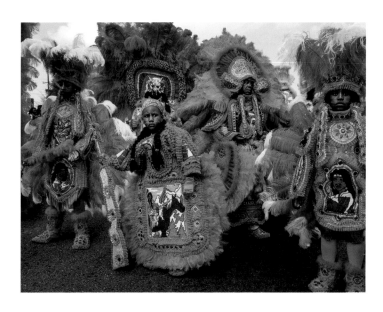

This sense of community is also evident in how customs are transferred to joining members: not only are elders respected and practices passed from one to another through oral traditions, but young children enter the tribes early and further the tradition. During weekly practices throughout the year, connections are made, traditions passed down, songs are sung. Writer Kalamu ya Salaam notes that the traditional art form has seen change over the years, but the basic elements have stayed the same over two hundred years: masking, procession and ritual.[5]

Music and dance are critical components, linking the practice to African origins and creating a multi-disciplinary fusion. The call and response chanting includes the lead singer backed by a chorus and percussion generally of drums, hand clapping and tambourines, cow bells, marching bass drum and bottles. Songs use inventive and adaptive lyrics—a secret patois that usually celebrate acts of bravery and defiance ("We won't bow down"), as well as the proud heritage of the Indian nations.[6]

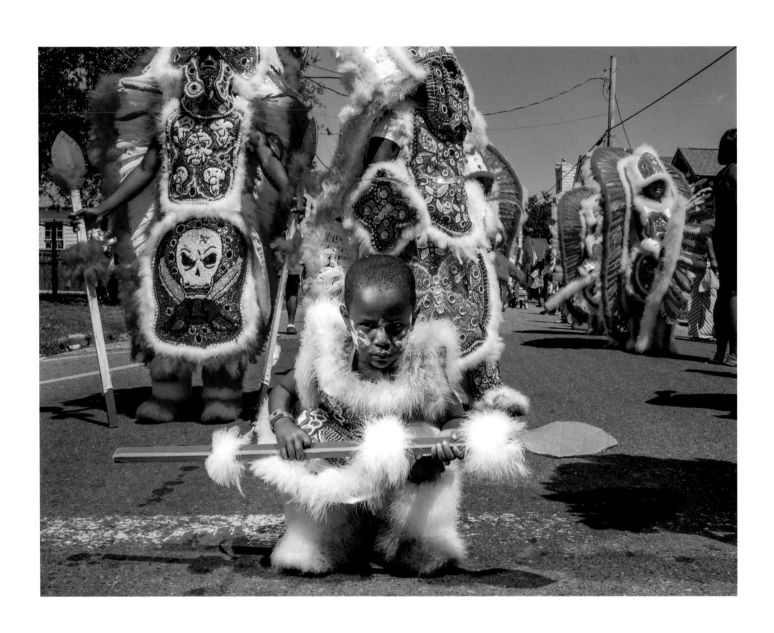

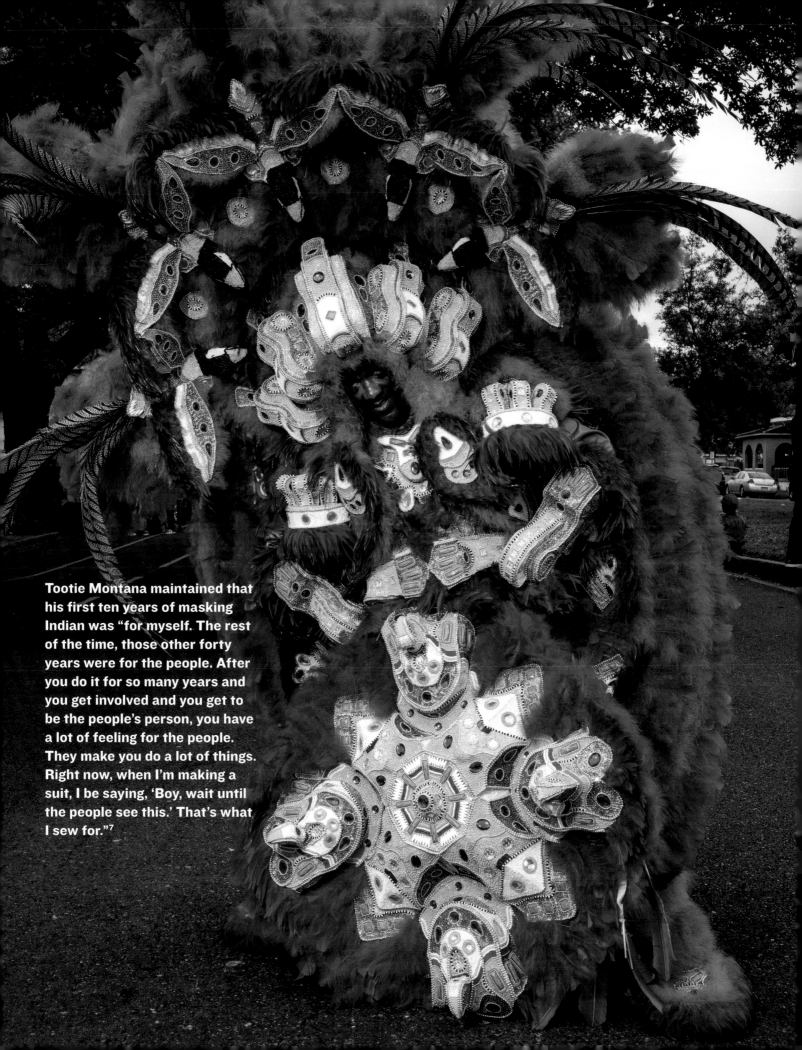

Tootie Montana maintained that his first ten years of masking Indian was "for myself. The rest of the time, those other forty years were for the people. After you do it for so many years and you get involved and you get to be the people's person, you have a lot of feeling for the people. They make you do a lot of things. Right now, when I'm making a suit, I be saying, 'Boy, wait until the people see this.' That's what I sew for."[7]

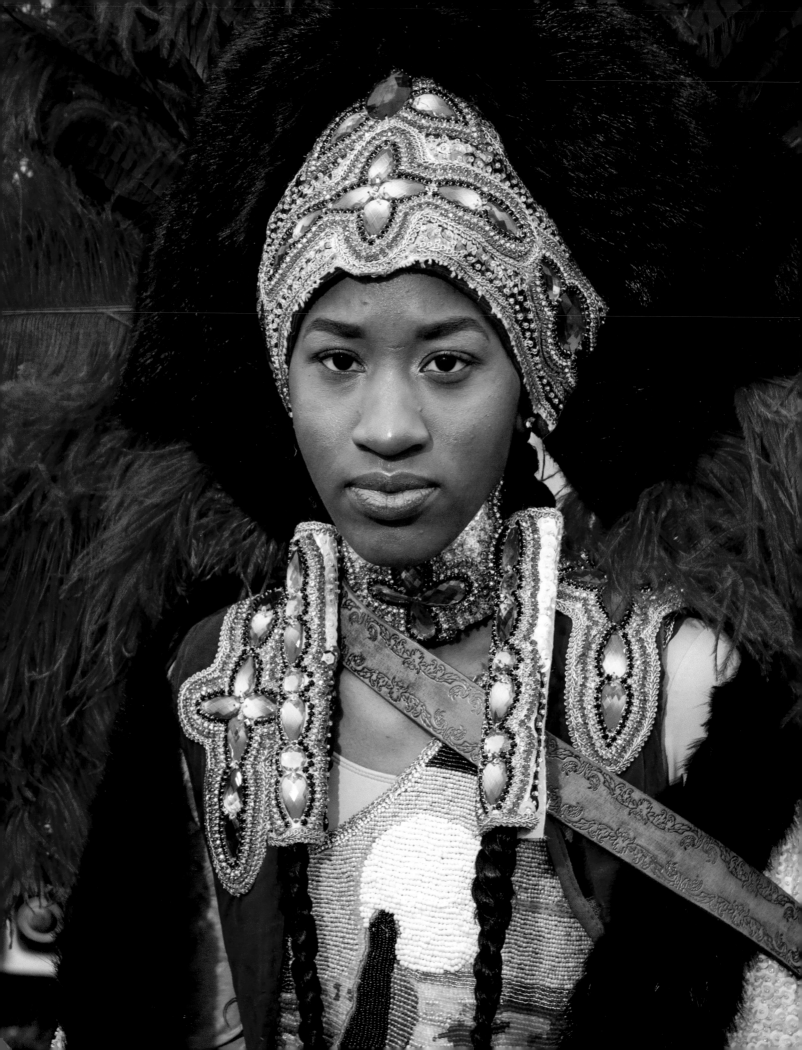

The number of Black Masking Indian tribes fluctuates, and some tribes do not want publicity. *I Wanna Do That!* estimates that there are close to seventy tribes in current practice and have included the most current list we could compile for 2020.

It is impossible to share the depth of Black Masking Indians' practice in our photo narrative; meanwhile, we respectfully honor these maskers and their place in the cultural pantheon of New Orleans. New Orleanians of all walks give tribute to the Indian's immense contributions and their importance as an essential and vibrant contemporary practice. Indeed, these artists serve as inspiration and a vast resource for many of the marching krewes. It's a captivating community that has been the subject of significant, deep, and scholarly research. We encourage you to visit our *Resource* section to find a trove of rich and deep sources where experts share information about Black Masking Indians. Dig in, we promise you will be fascinated.

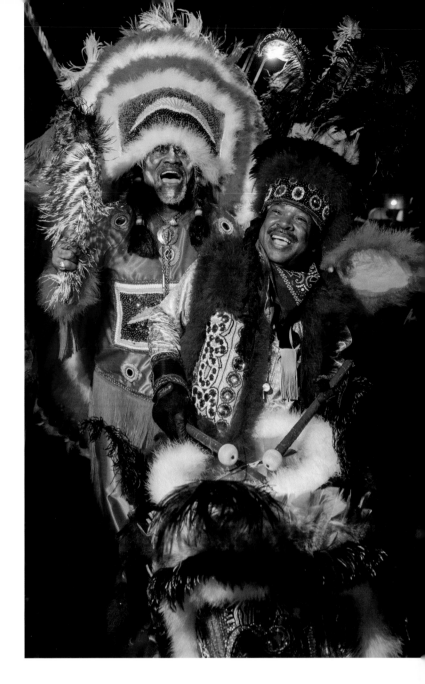

"For me to be a contemporary maroon means not bowing down...it means being self-actualized and, most important, comfortable with me in this stretched-out skin. I don't mask. I unmask."
–Cherice Harrison-Nelson, Maroon Queen, Guardians of the Flame Maroon Society

1 Kalamu ya Salaam, He's the Prettiest: A Tribute to Big Chief Allison "Tootie" Montana's 50 Years of Mardi Gras Indian Suiting, (New Orleans: New Orleans Museum of Art, 1997, unpublished interview).

2 Wild Tchoupitoulas, "Brother John," *Wild Tchoupitoulas* album

3 Wild Tchoupitoulas, "Here Dey Come," *Wild Tchoupitoulas* album

4 Wild Tchoupitoulas, "Meet the Boys on the Battlefront," *Wild Tchoupitoulas* album

5 Kalamu ya Salaam, He's the Prettiest: A Tribute to Big Chief Allison "Tootie" Montana's 50 Years of Mardi Gras Indian Suiting, (New Orleans: New Orleans Museum of Art, 1997, unpublished interview).

6 George Lipsitz, "Mardi Gras Indians: Carnival and Counter Narrative in Black New Orleans" *Cultural Critique, No. 10: Popular Narrative*, 99-121, University of Minnesota Press.

7 Kalamu ya Salaam, He's the Prettiest: A Tribute to Big Chief Allison "Tootie" Montana's 50 Years of Mardi Gras Indian Suiting, (New Orleans: New Orleans Museum of Art, 1997, unpublished interview).

BLACK MASKING INDIANS

Numbers in italics indicate photo pages.

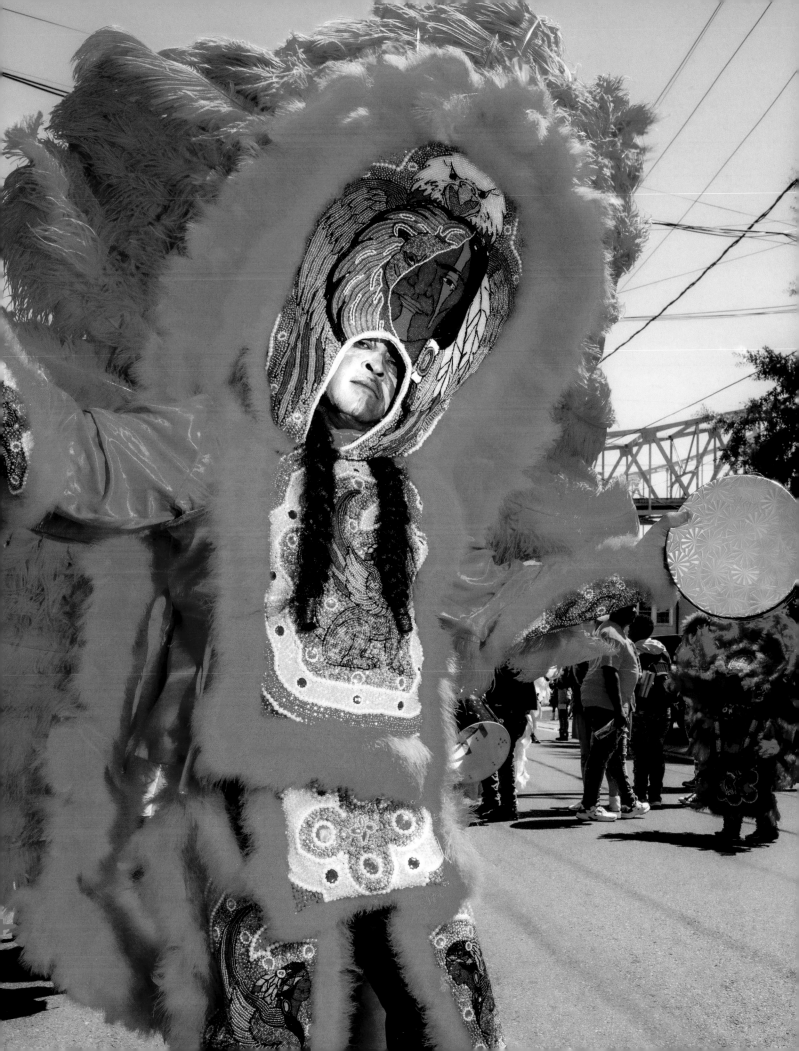

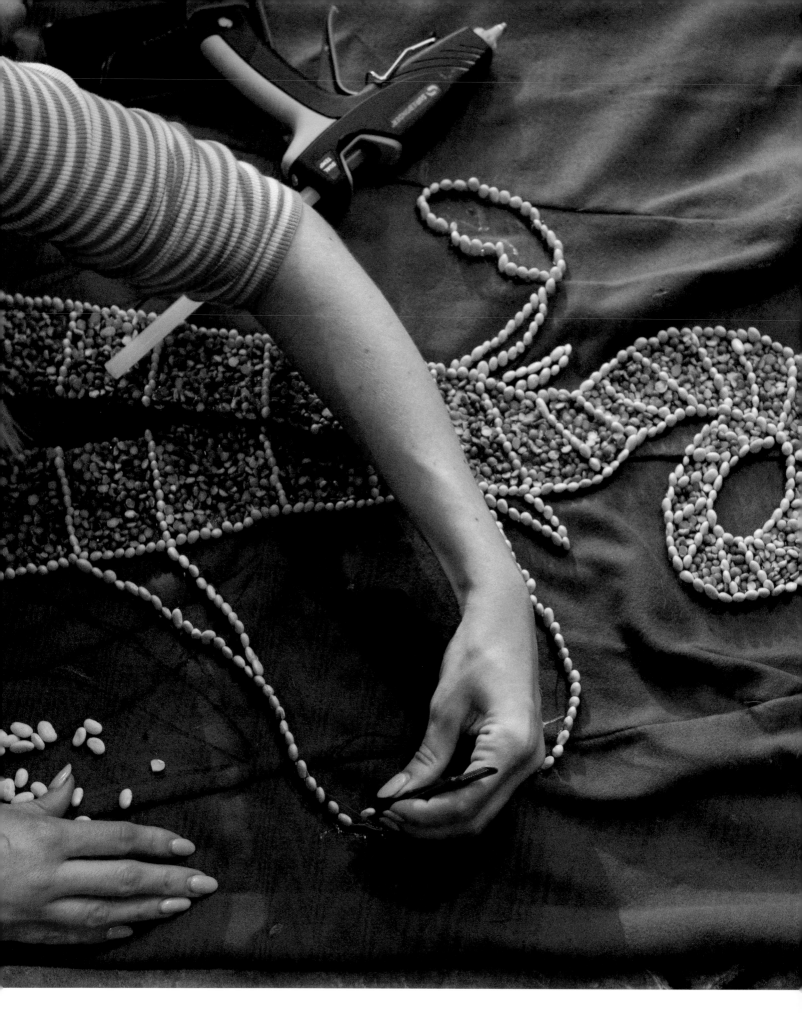

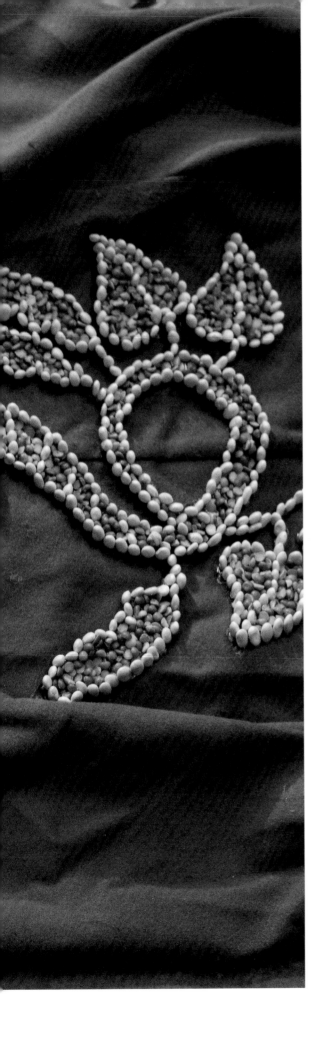

5
FAIT À LA MAIN

WORK YOUR FINGERS TO THE BONE
AND WHAT DO YOU GET? CONCEPT-
BENDING CARNIVAL CELEBRATION!
THE DEFINING CHARACTERISTIC OF
THESE KREWES IS THE EXTRAORDINARY
HAND-MADE ARTISTRY.

While many of the groups put a premium on the crafting of their parade appearance, the level and intentionality of the Fait à la Main krewes makes our hearts flutter. As with many other marching krewes, several of these groups draw directly from, and pay homage to Black Masking Indians traditions in their practice. For these krewes artistry is the driving force and the creation process is as fun as the actual parading. The details are hard to see when the parades move quickly down the street; linger here and look closer—the details are intriguing.

In addition to their costumes, or floats, krewe members hand craft "throws" or gifts they hand out to the covetous public. Theme related and krewe appropriate, these throws allow parade goers to bring a small part of the parade home with them.

It would be hard to put an estimate of the amount of time used to craft the work. Even before the end of the current year's parade, these artists are thinking ahead to the following year. Far in advance of the Carnival season their hands are making the next year's costumes, floats and throws. So much work for only one day's presentation! It is truly magical.

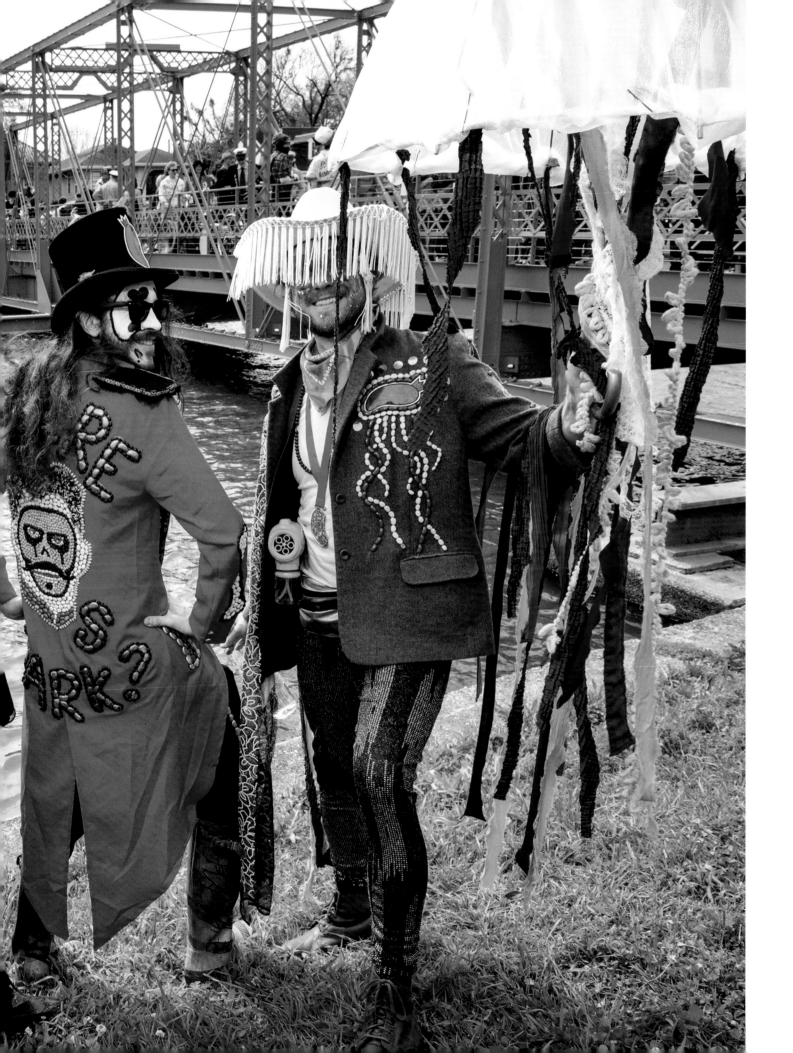

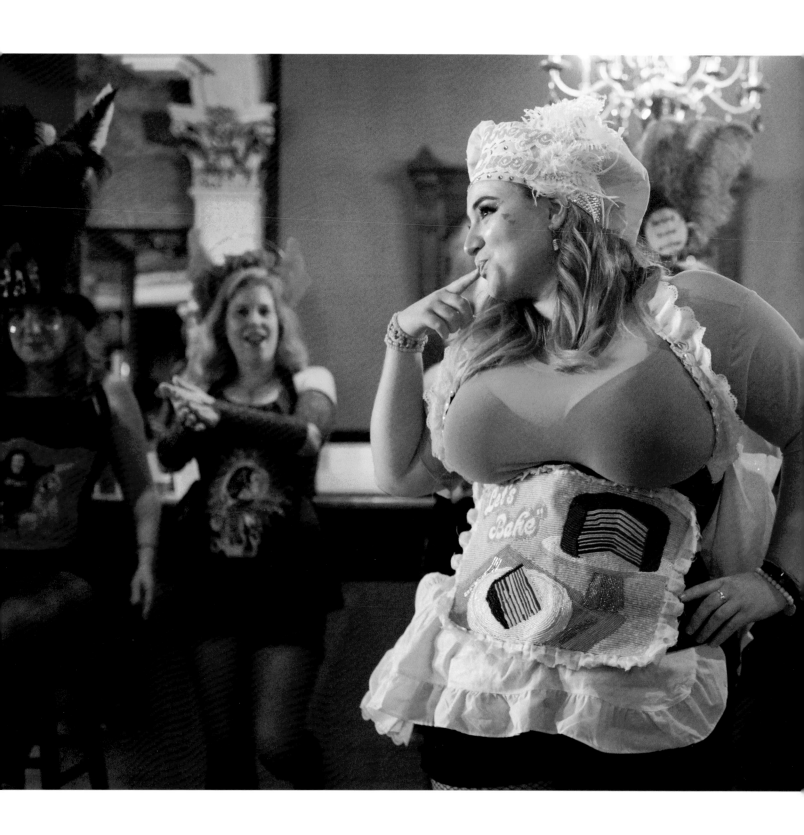

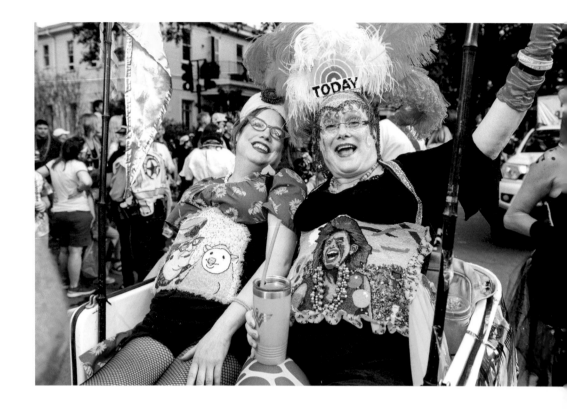

DAMES DE PERLAGE

The beading skills found both in Black Masking Indians costumes and the apparel in uptown Carnival royalty are the source of inspiration for the Dames de Perlage. These intrepid "ladies of beadwork" build bustiers and headdresses around a common theme and then parade with exuberance. Members create their costumes in monthly sacred perlage circles. Their work not only honors those artists whose work they emulate; it strengthens the pool of people capable of beading and supports the development of strong women throughout the city. As with Black Masking Indians, members barely rest their fingers before starting work on the next season.

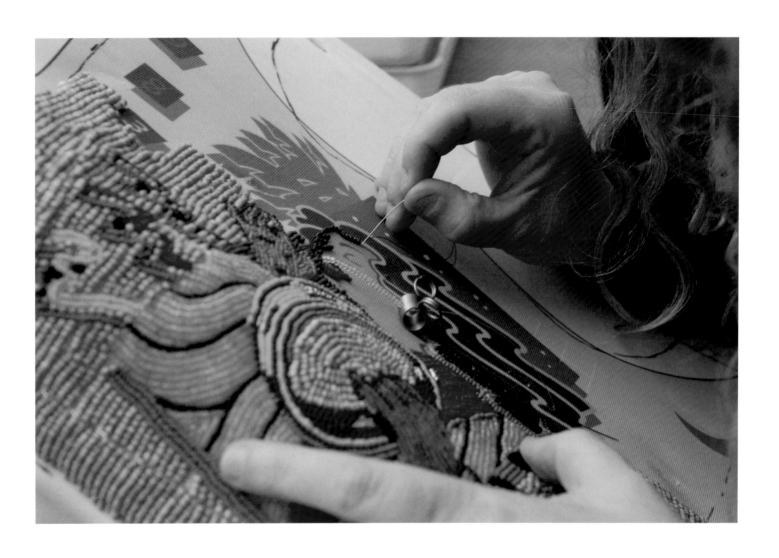

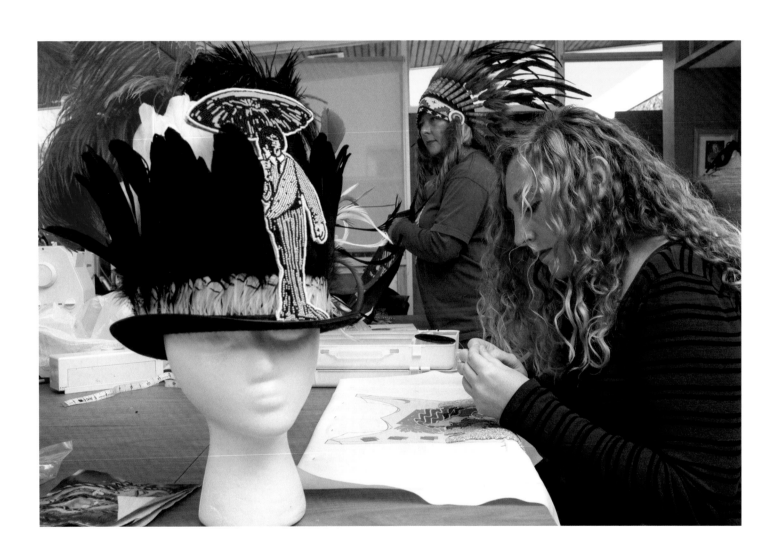

"With the right krewe, you gain a
sisterhood and an extended family
who celebrates and supports you
throughout life's ups and downs.
Once a Dame, always a Dame!"

–Seran Williams, Dames de Perlage

> "I feel reverential to be able to turn around on St. Charles Avenue and see our members light up. Some are professional artists, many are not, but all actively engage with the creative parts of their lives."
> —Laura Dean-Shapiro, Krewe des Fleurs

KREWE DES FLEURS

Founder Laura Dean-Shapiro sowed the seeds for the lovely Krewe des Fleurs in 2015 as a way to provide a space for creative engagement and active imaginations. Each season the Fleurs work with a professional artist to create a prototype of a specific genus—a wearable flower that each member individualizes in a wide array of colors and textures. There is a feminist identity at its core, and all female-identifying humans are encouraged to apply. Following theme, throws include "Seeds as Beads" to grow your own garden, and bespoke floral replicas. These flowers are a wild, wonderful moveable Carnival bouquet.

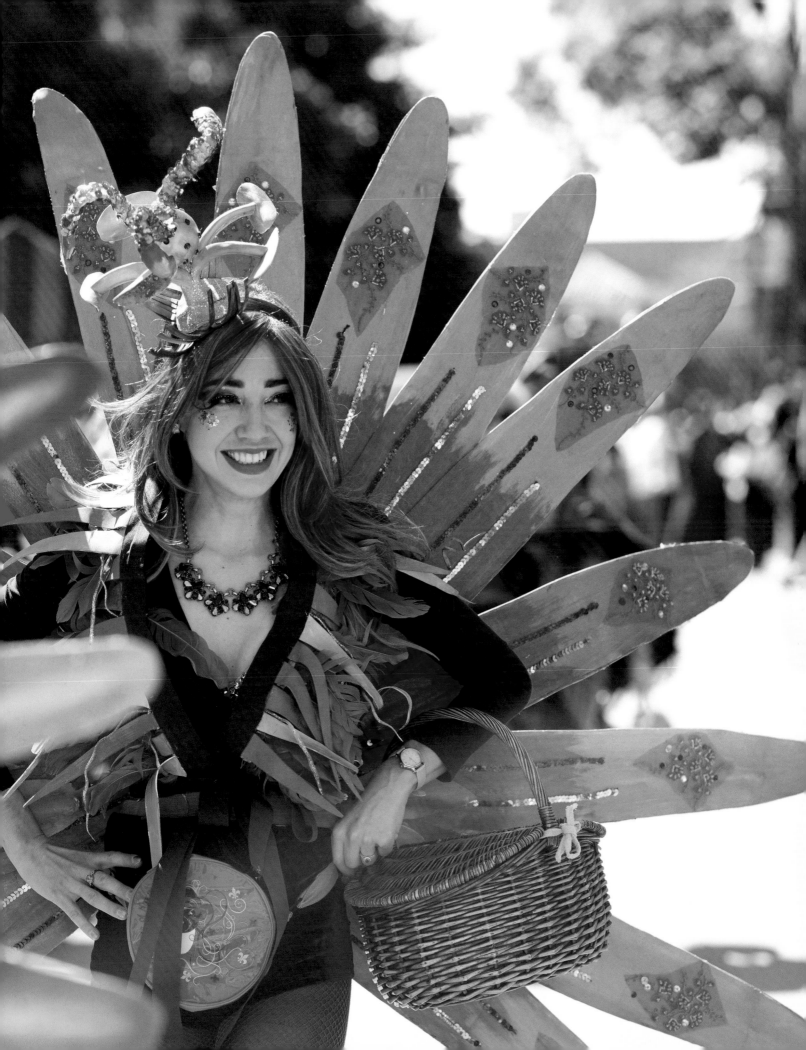

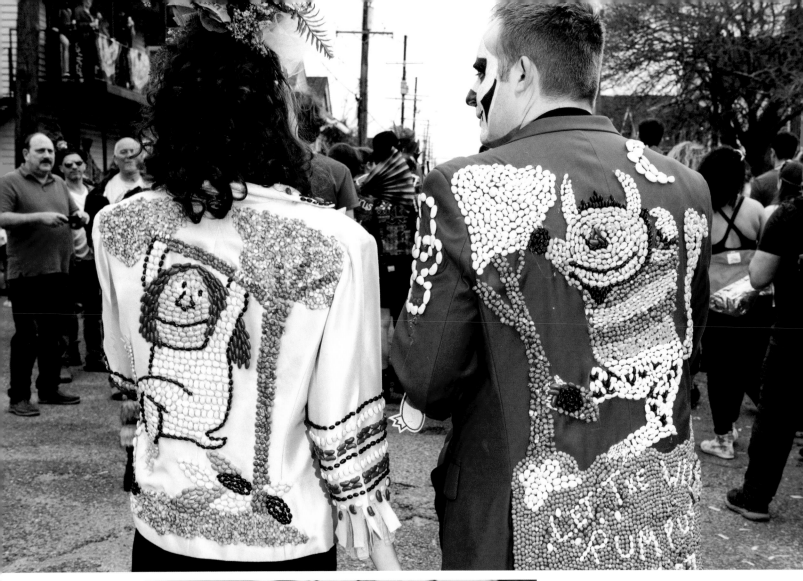

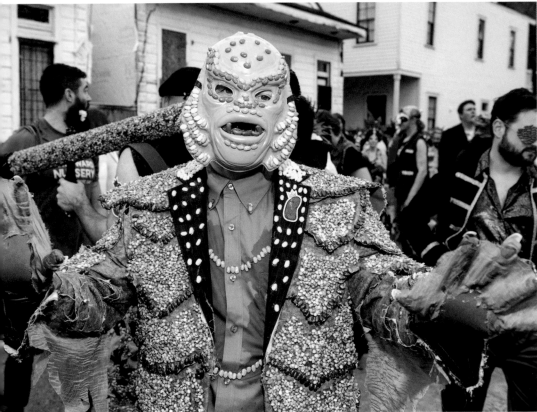

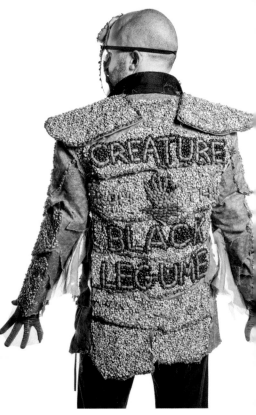

> "The joy of being THE parade means we are creating culture. We are bringing meaning to our lives through the expression of culture and enriching our community."
>
> –Devin DeWulf, Red Beans

KREWE OF RED BEANS

New Orleans transplant Devin DeWulf was in awe as he sat with and photographed Black Masking Indians sew their Carnival suits in various living rooms during his first Mardi Gras. That Halloween he created a jacket in homage using a glue gun and an adored, and readily available material, beans. This work grew into one of the most fascinating community-based works in the city—the Krewe of Red Beans. Since 2007 Krewe of Red Beans rolls on on Lundi Gras - Monday being the traditional day of the week for New Orleanians to eat their red beans and rice. They have been able to both grow in size and to maintain their commitment to small neighborhood parades that build community. Their growth has been in off-shoots: the Dead Beans with suits inspired by any mythological or folkloric tradition that deals with death, our mortality, or the afterlife; Feijao—the

"Big Beans" drawing on cultural similarities between New Orleans and Brazil; planned for future are Frejoles focusing on Mexican/ Louisiana similarities, and Green Beans with an environmental focus.

Beans have a simple formula: limit to one hundred fifty people, have two bands, and march three miles. They are community minded, holding fundraisers throughout the year (during the COVID-19 pandemic they launched a "Feed the Front Line" effort, which raised more than $1 million and served over one hundred thousand meals to frontline health workers in seven weeks). Members meet together to craft costumes starting in November. Kings and Queens are democratically elected at a celebration pre-parade to share their creations and vote on the "bean" with the best costume who becomes royalty for the year.

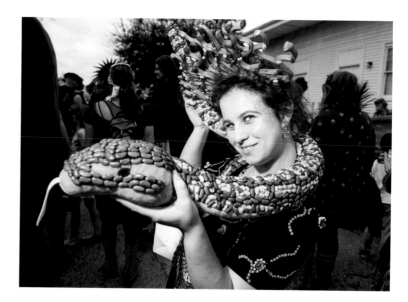

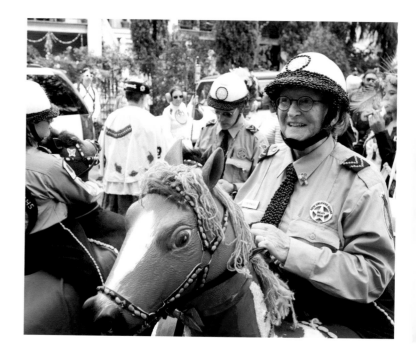

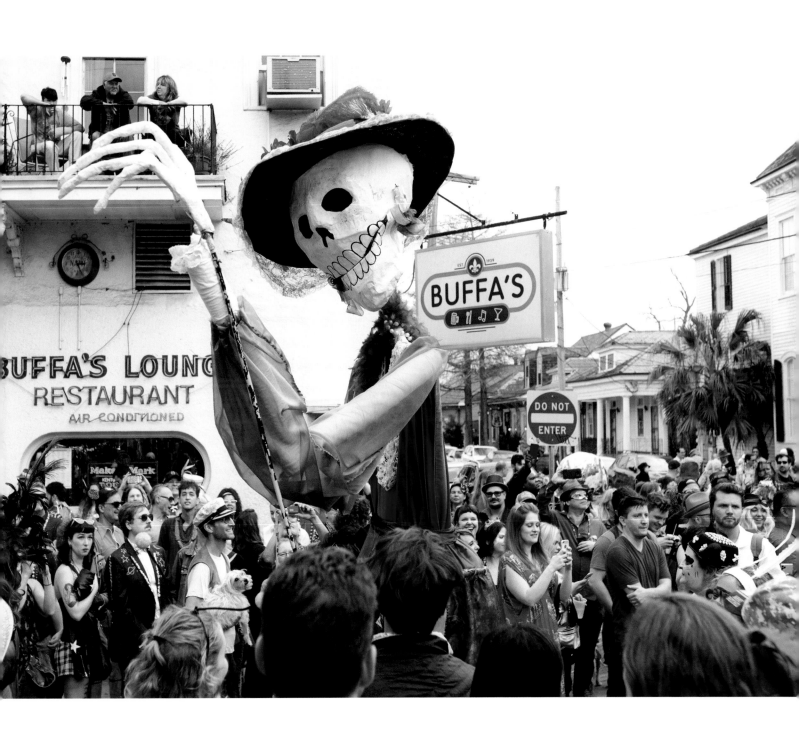

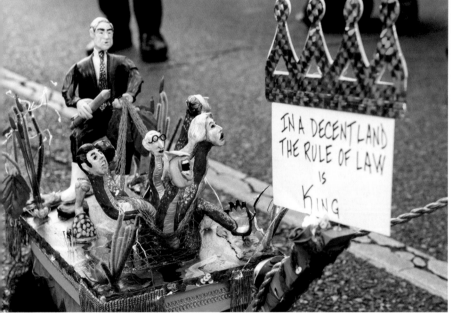

'tit Rǝx

There's little to compare with the joy that comes from watching shoebox-sized floats pulled by their "float masters" and "riders" who stroll in black formal wear with suave blue sashes. Lamenting the supersizing of parades, floats, krewes and throws, a group of artists and community members bucked the trend in 2008. Building upon New Orleans' grade school tradition of decorating shoe boxes, the group formed as the first Mardi Gras microkrewe: 'tit Rǝx. The name is drawn from a mix of the Cajun diminutive 'tit, an abbreviation of petite, and the "king of parades," Rex.

Floats are capped at thirty in number and built around a clever theme, and are generally subversive or at least wildly witty. The tiny "throws" are matched to the floats and desperately coveted. 'tit Rǝx is as charming as it is clever, as wily as it is beautiful.

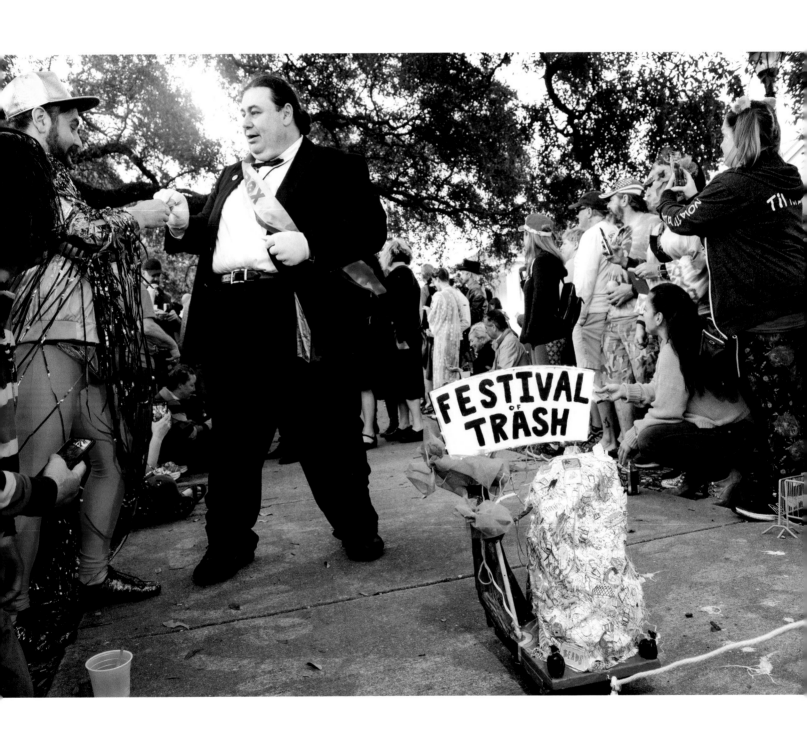

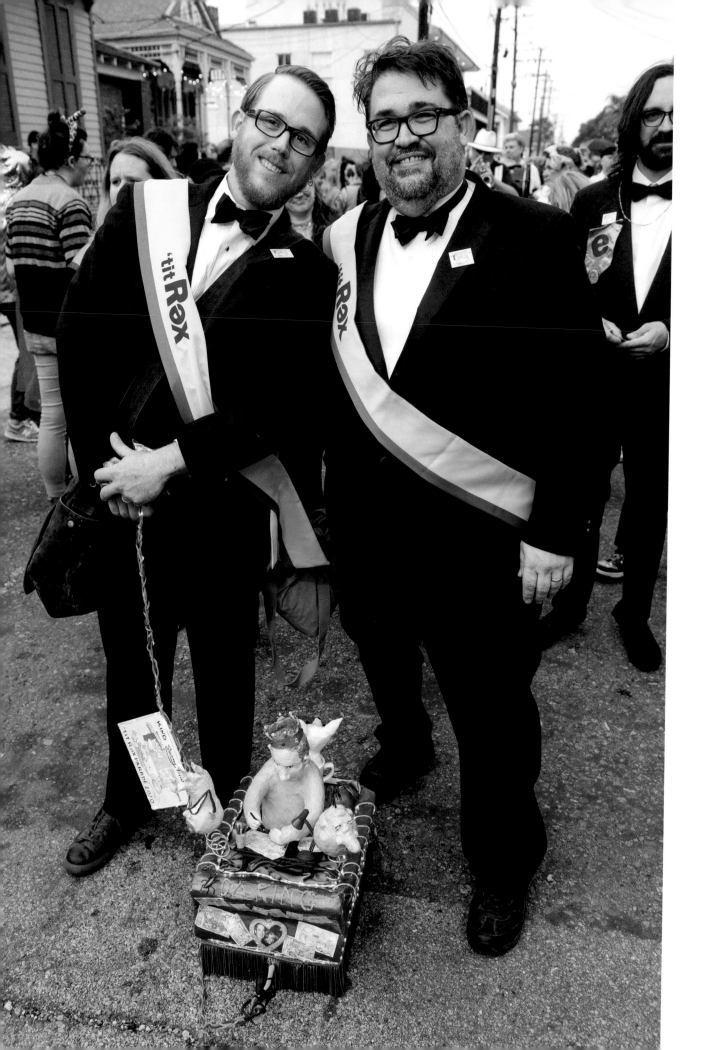

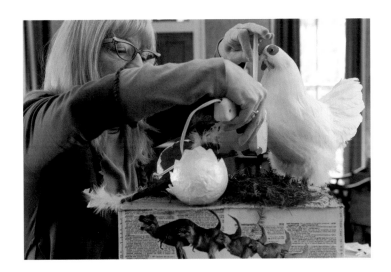

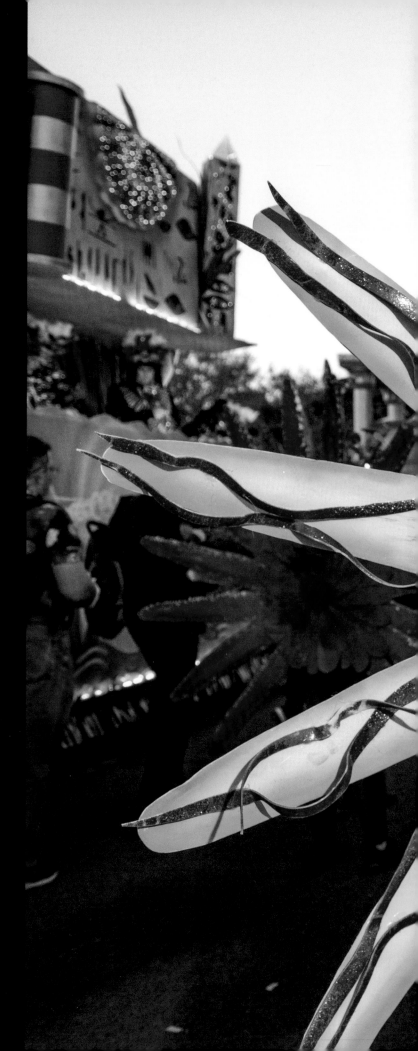

FAIT À LA MAIN

Krewe des Fleurs
Krewe of Red Beans
Krewe Feijao
Krewe of Dead Beans
'tit Rәx

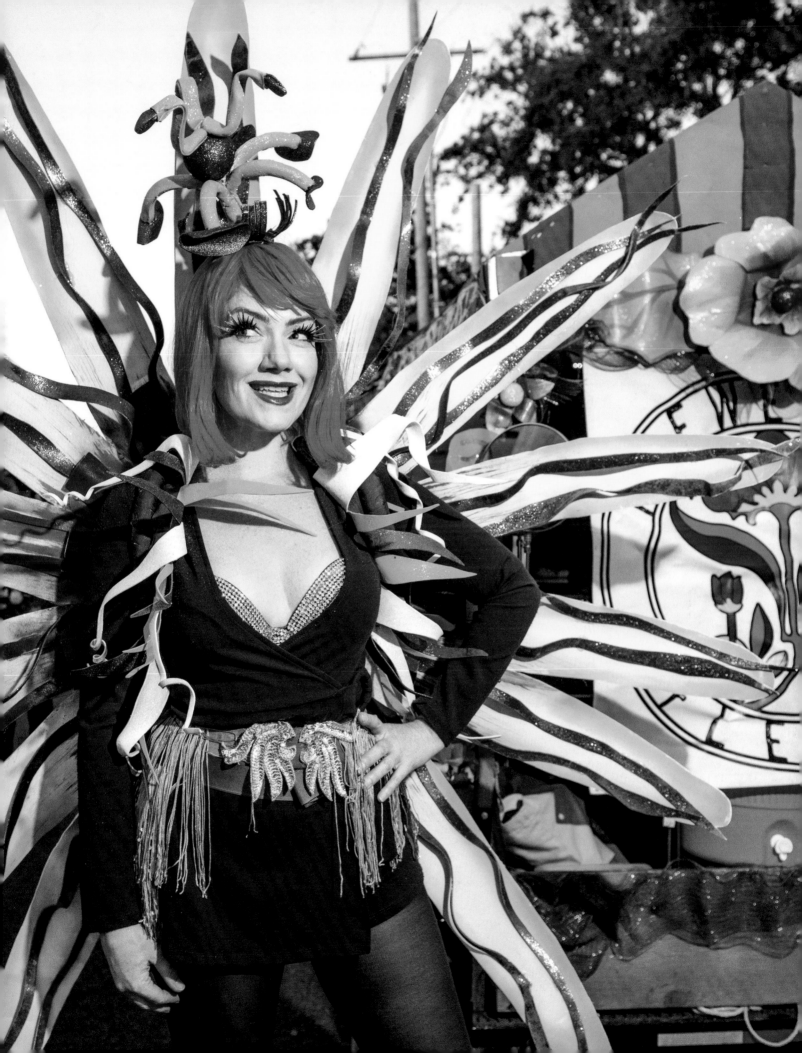

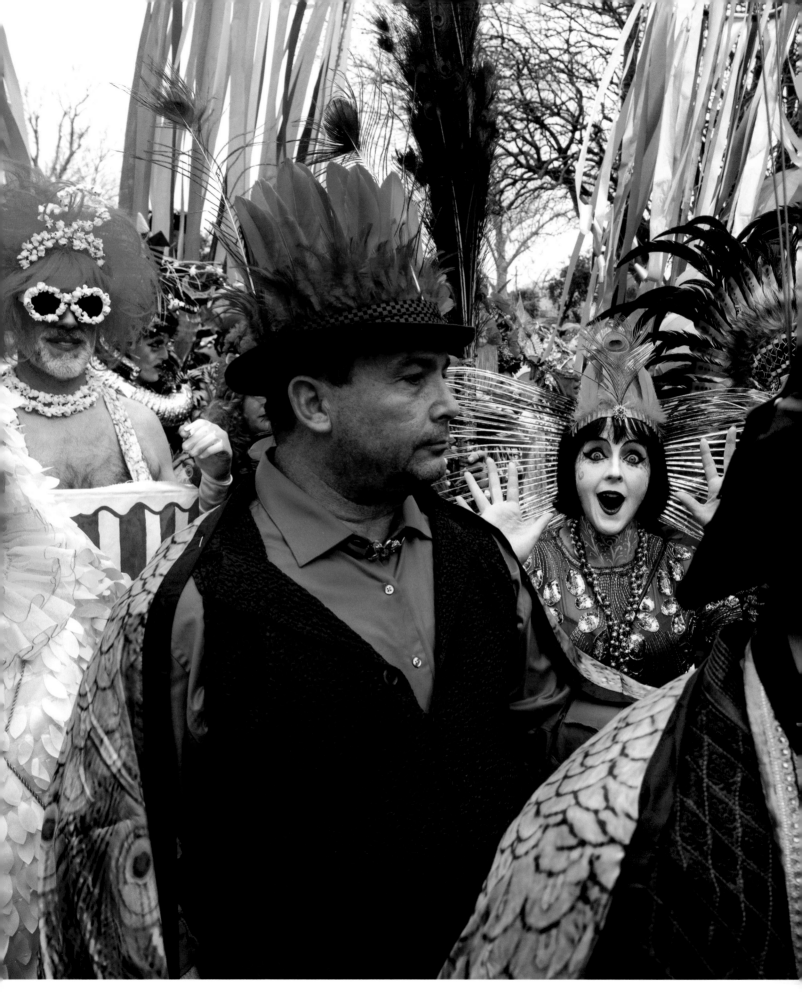

6
I LOVE A PARADE

IN THE KALEIDOSCOPE OF MARCHING
KREWES, THIS GROUP MAY HAVE THE
MOST SPARKLY PIECES AND THE GREATEST
VARIETY. THESE KREWES MARCH TO A
DIFFERENT DRUMMER—THEIR OWN!

Each krewe has their own parade, usually less structured, often marching in neighborhood streets. Twelfth night begins with the Phunny Phorty Phellows and Not-so-Secret Society of Elysian Fields streetcar rides, and the Krewe de Jeanne d'Arc burns through the evening celebrating the Maid of Orlean in whimsical fashion. Illuminating the New Orleans connection to the islands, Mondo Kayo celebrates the Caribbean and the newly launched Krewe de Kanaval revels in the connections with Haiti. Inspired by the early history of Mardi Gras and the marching parades, the Societies of Ste. Anne and Ste. Cecilia bring their ribbon streamed poles and stunning and elaborate costumes out to parade on Mardi Gras Day. Who doesn't love these parades?

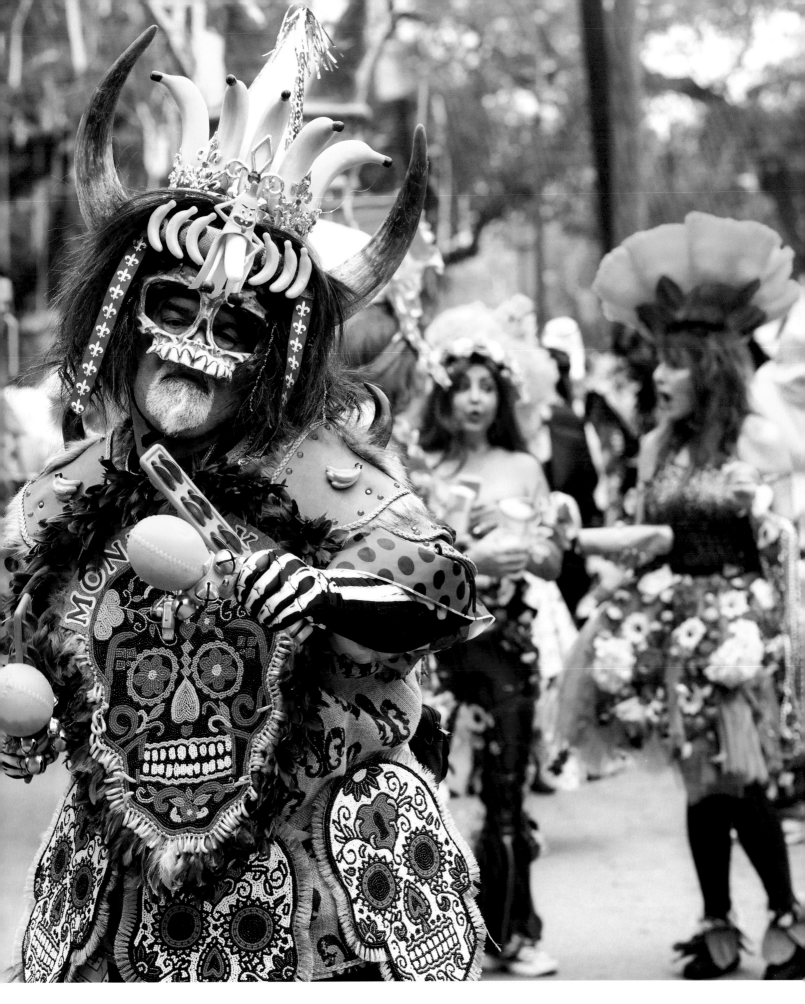

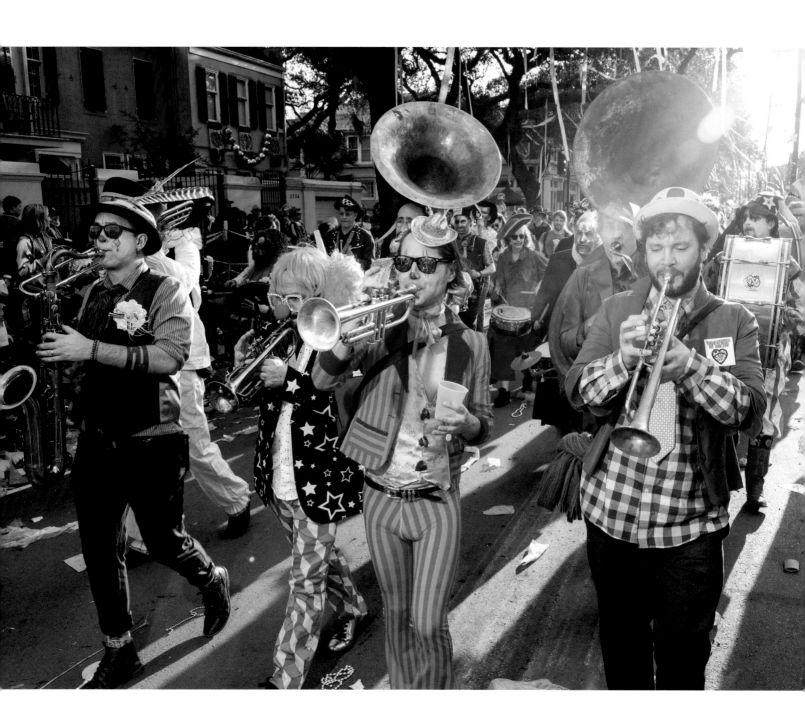

"WE PROVE THAT MARDI GRAS IS FOR EVERYONE AND YOU DON'T NEED A BIG BUDGET OR AN EXPENSIVE COSTUME TO BRING JOY TO THE TOWNSPEOPLE."

–Zoe Tristis, Krewe of Dreux

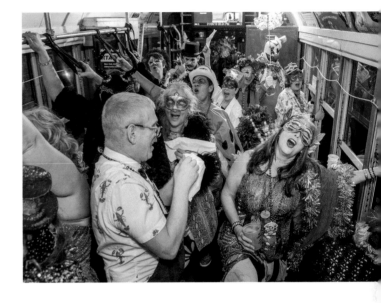

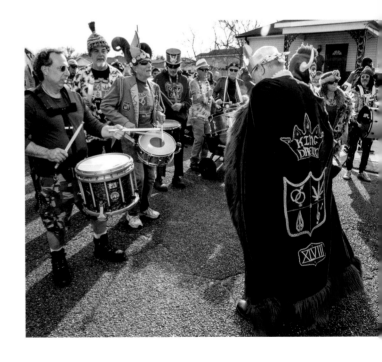

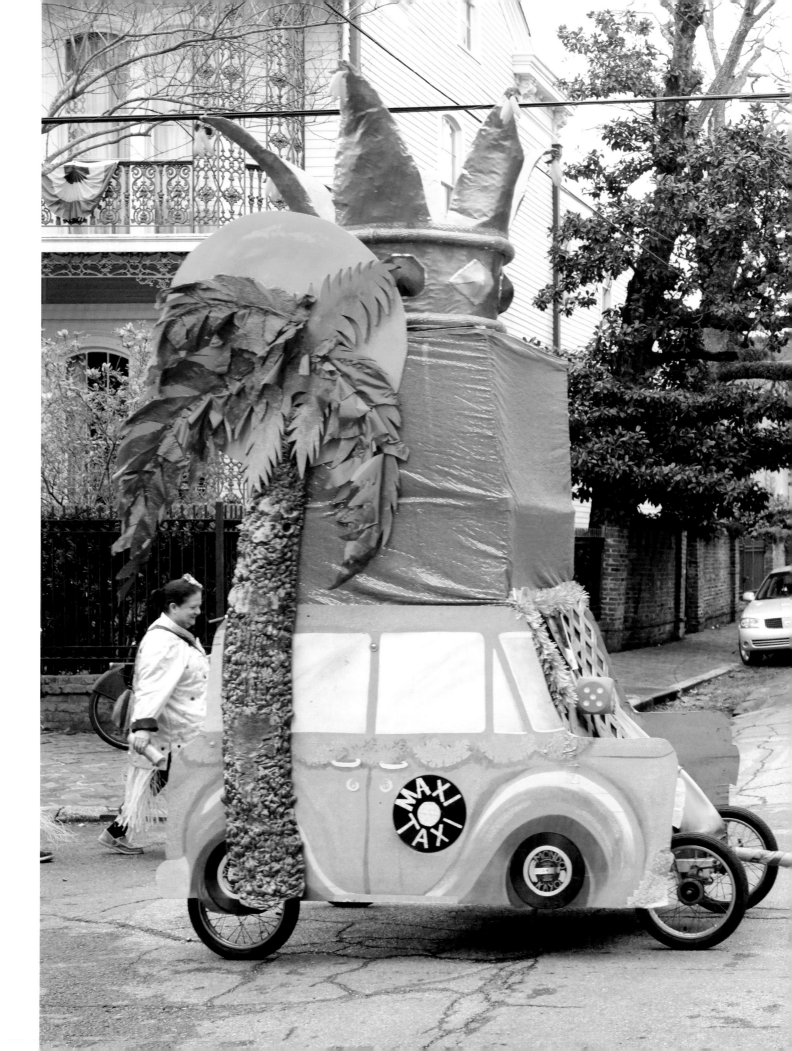

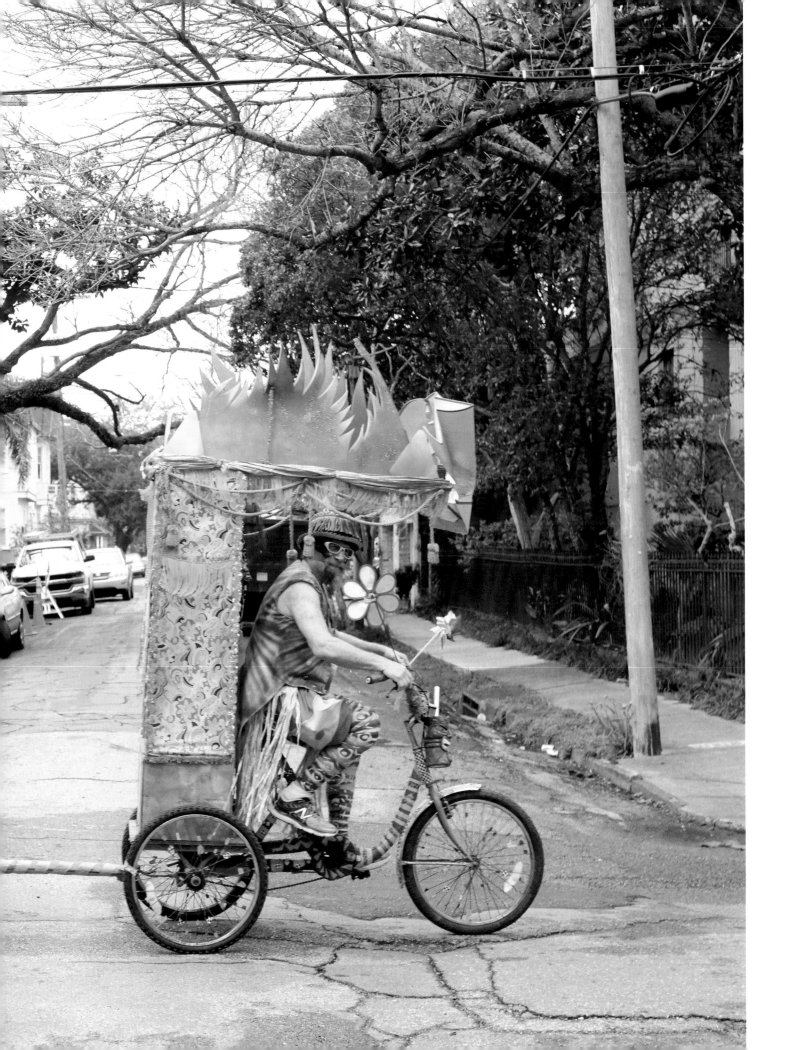

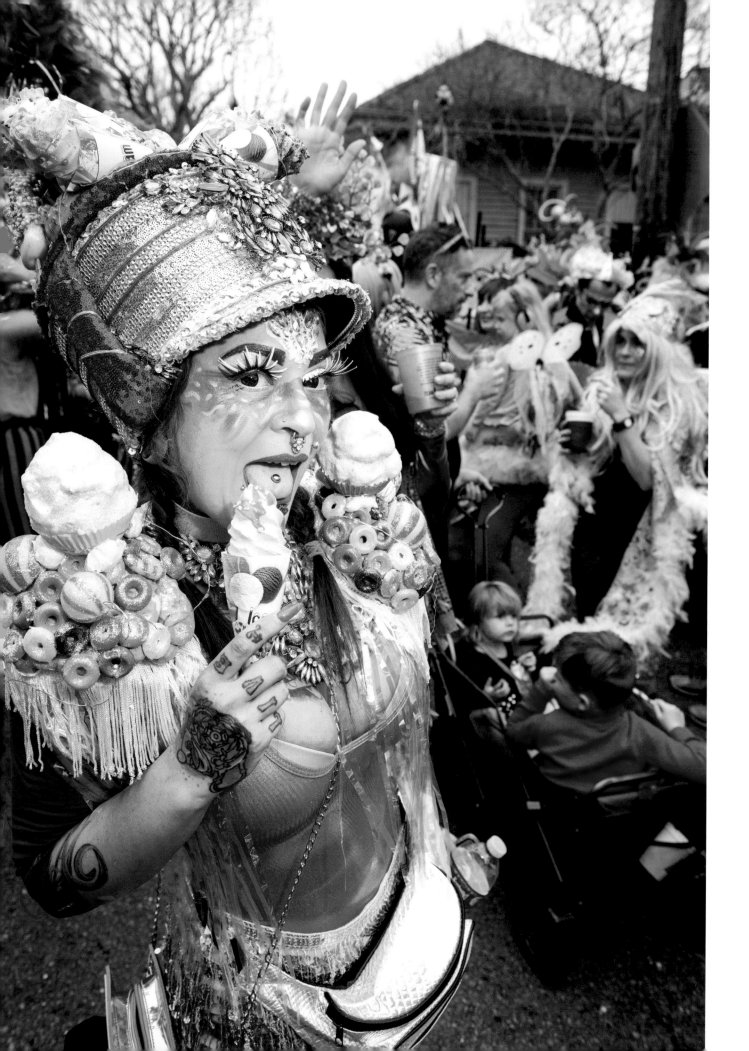

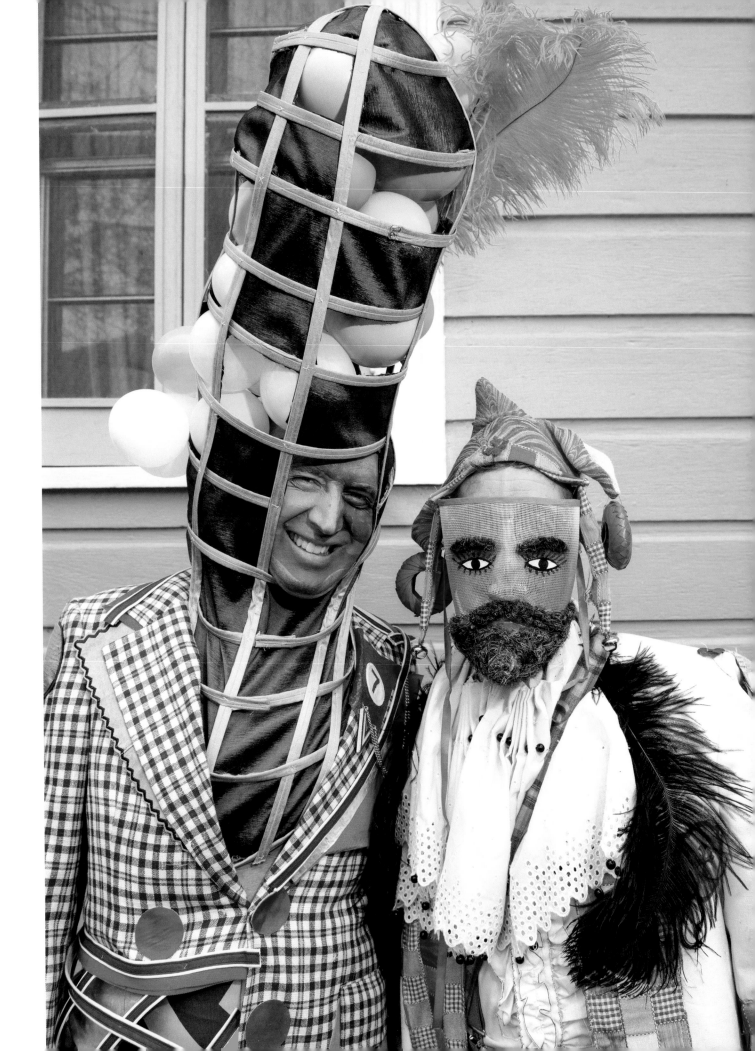

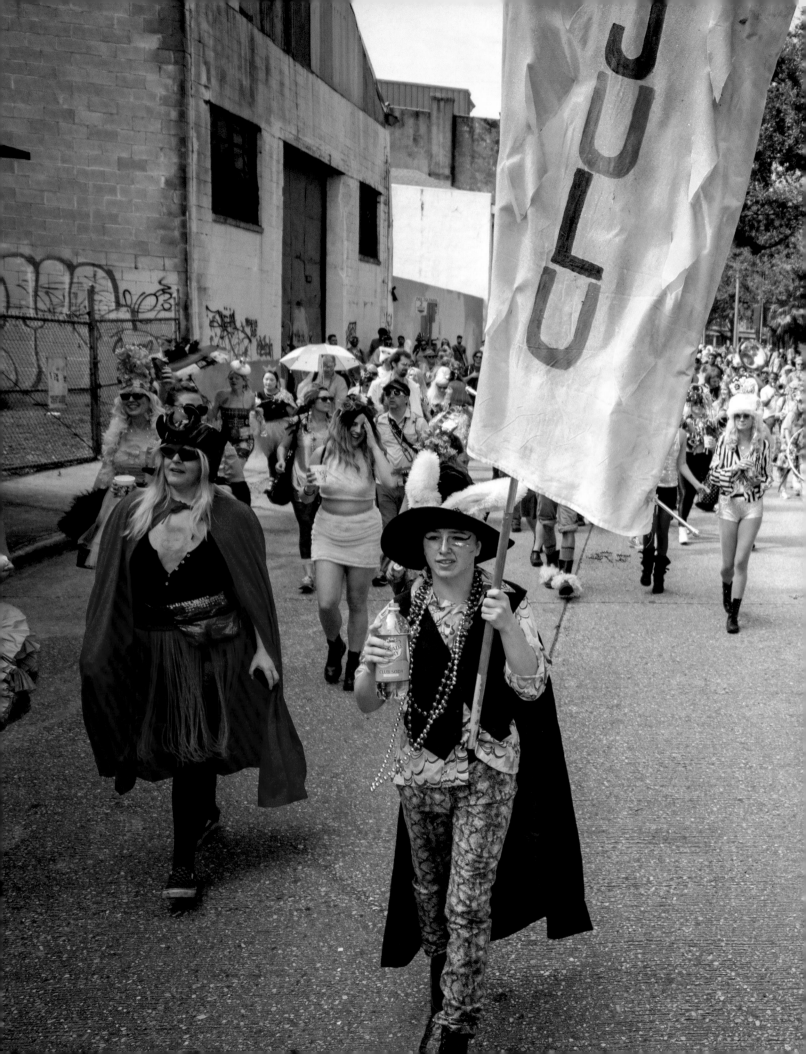

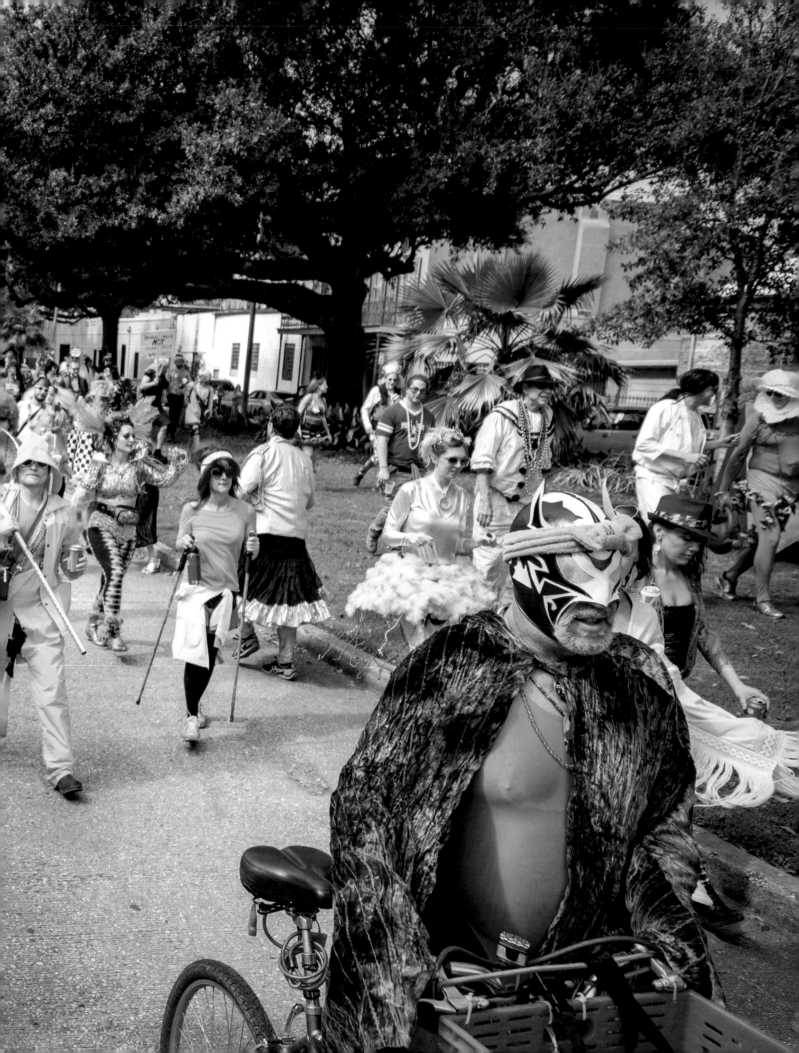

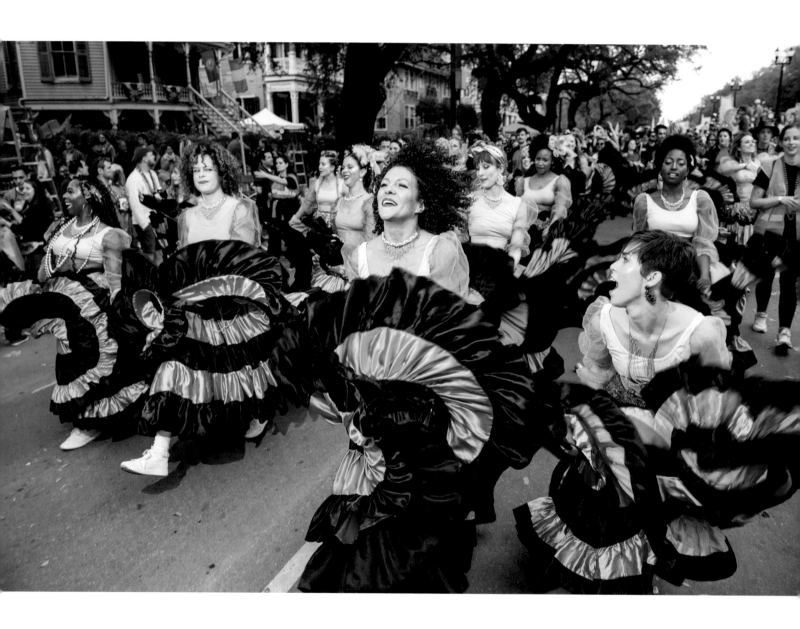

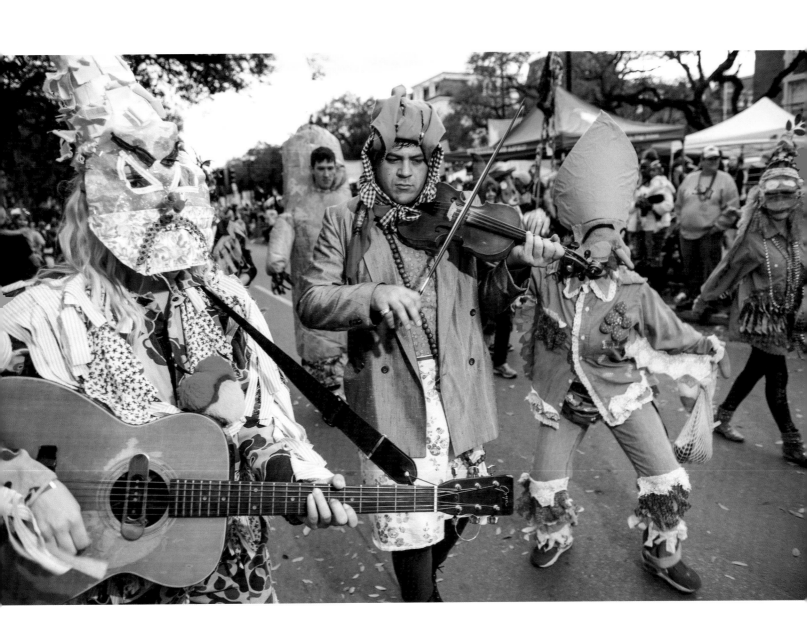

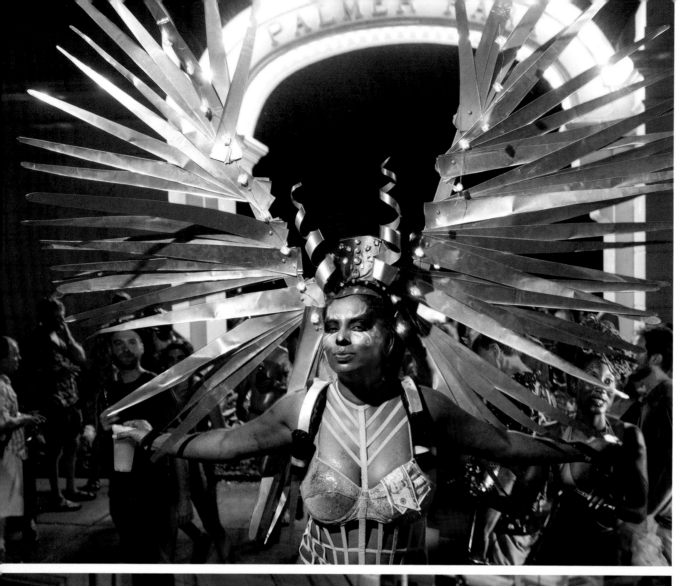
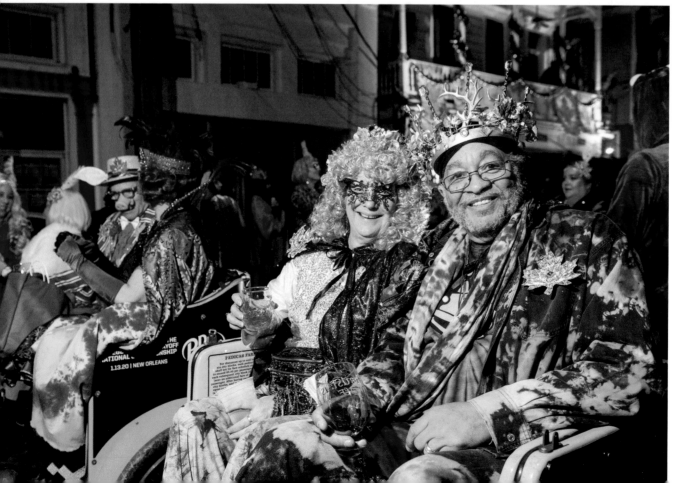

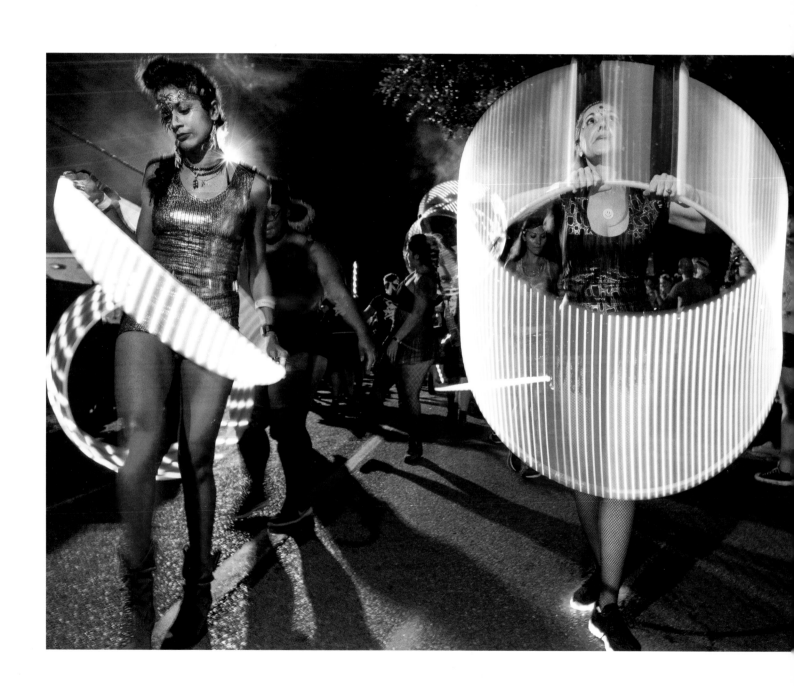

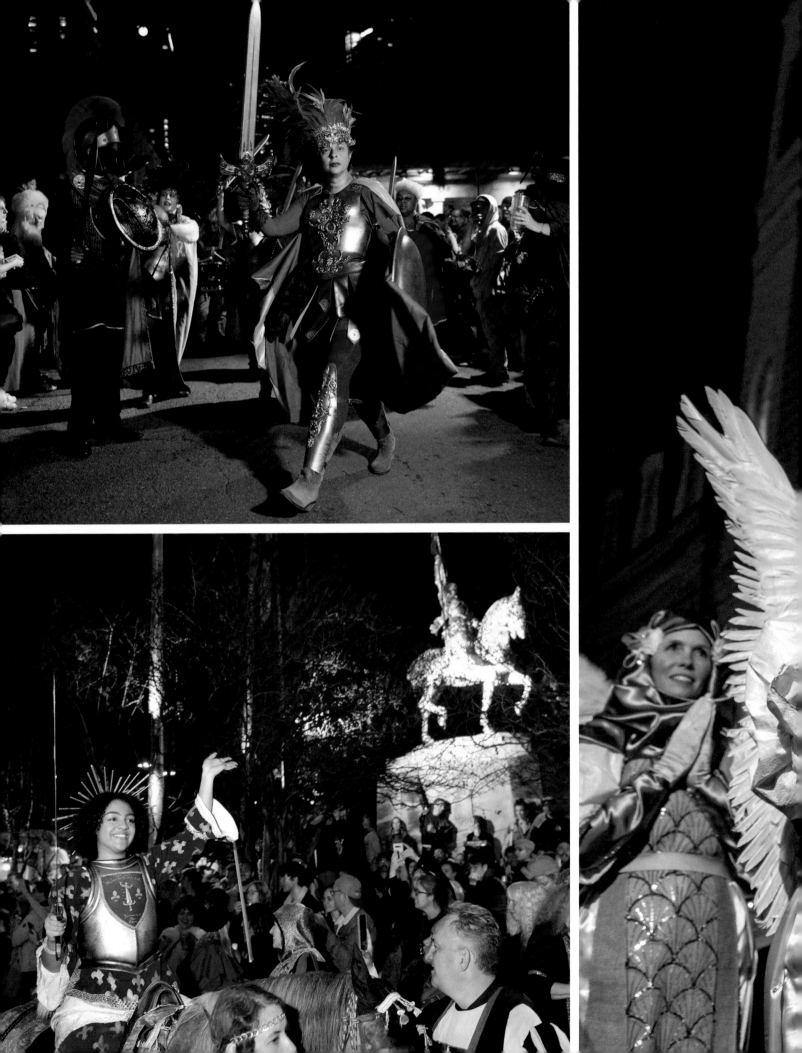

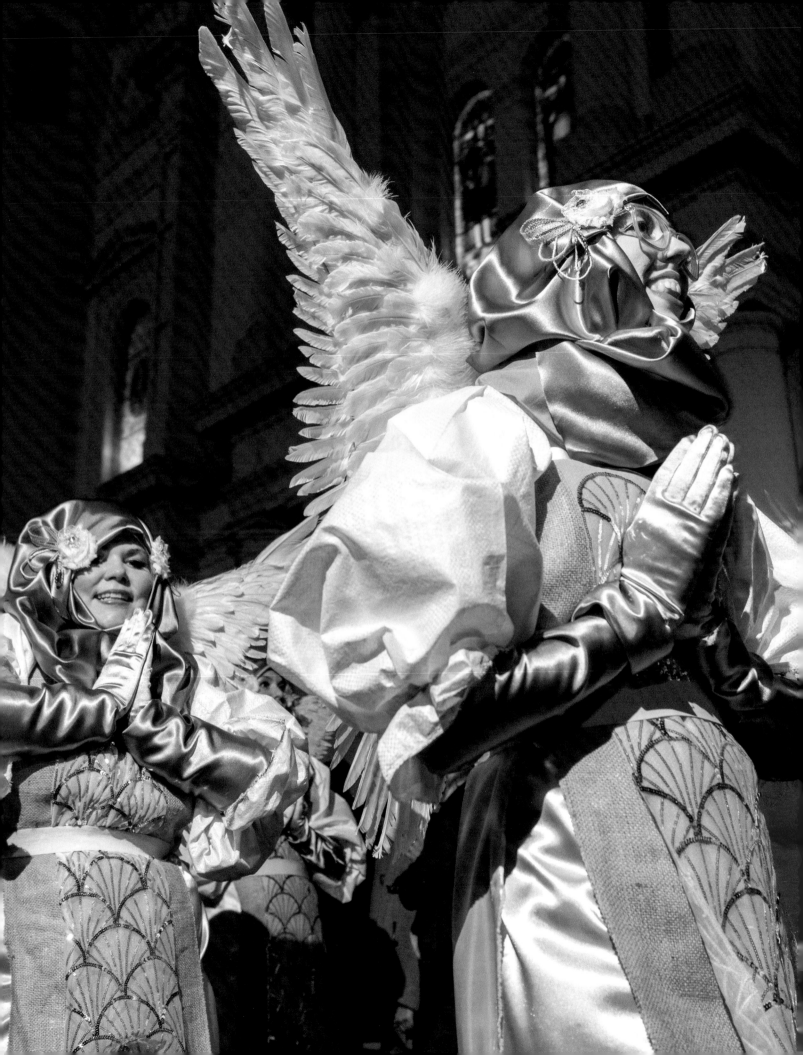

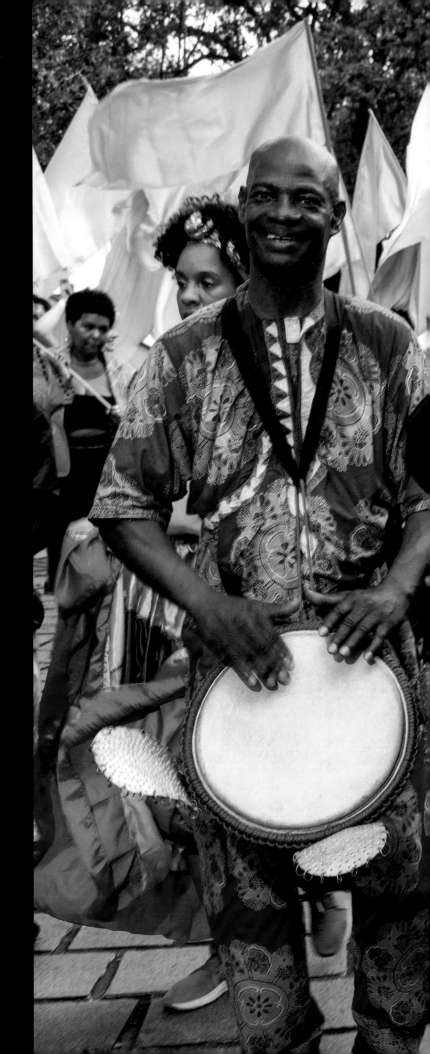

I LOVE A PARADE

Amazons Benevolent Society
Box of Wine
Julu
KOE Cyber Parade
Krewe de Jeanne d'Arc
Krewe de Kanaval
Krewe of 2.2
Krewe of Cork
Krewe of Dreux
Krewe of Fools
Krewe of Oak
Mondo Kayo
Societé de Champs Eluseé
Phunny Phorty Phellows
Societé de Ste. Anne
Society of Ste. Cecilia
Souper Krewe of Broth

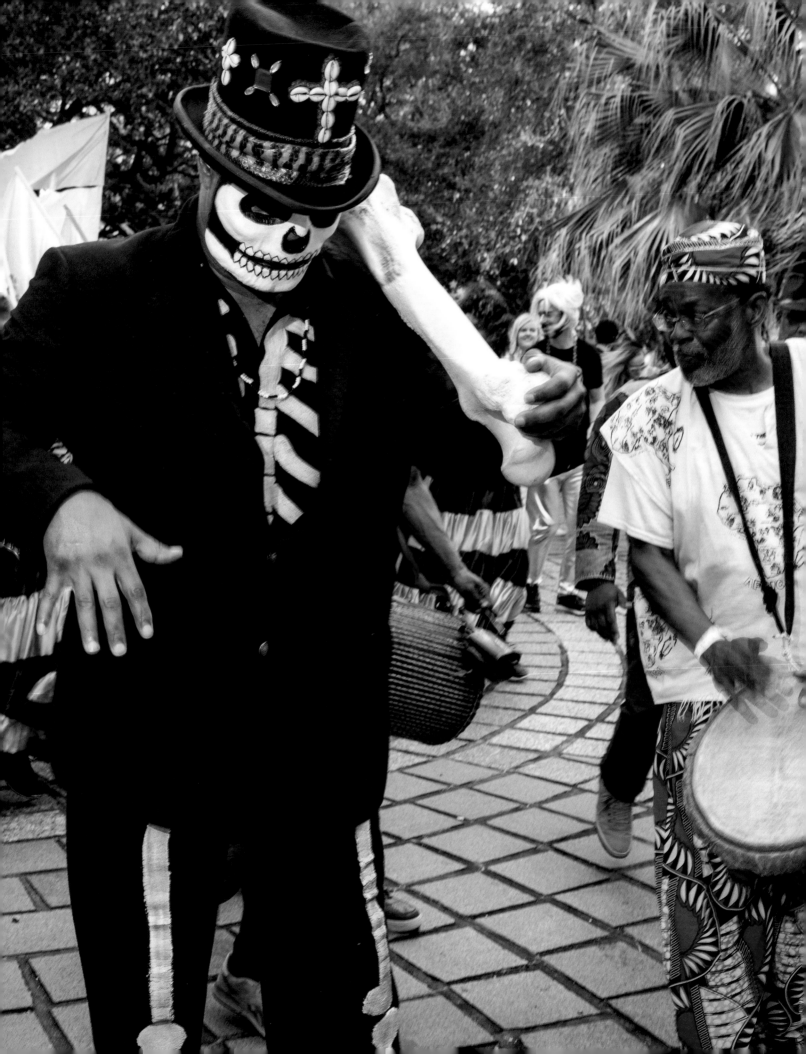

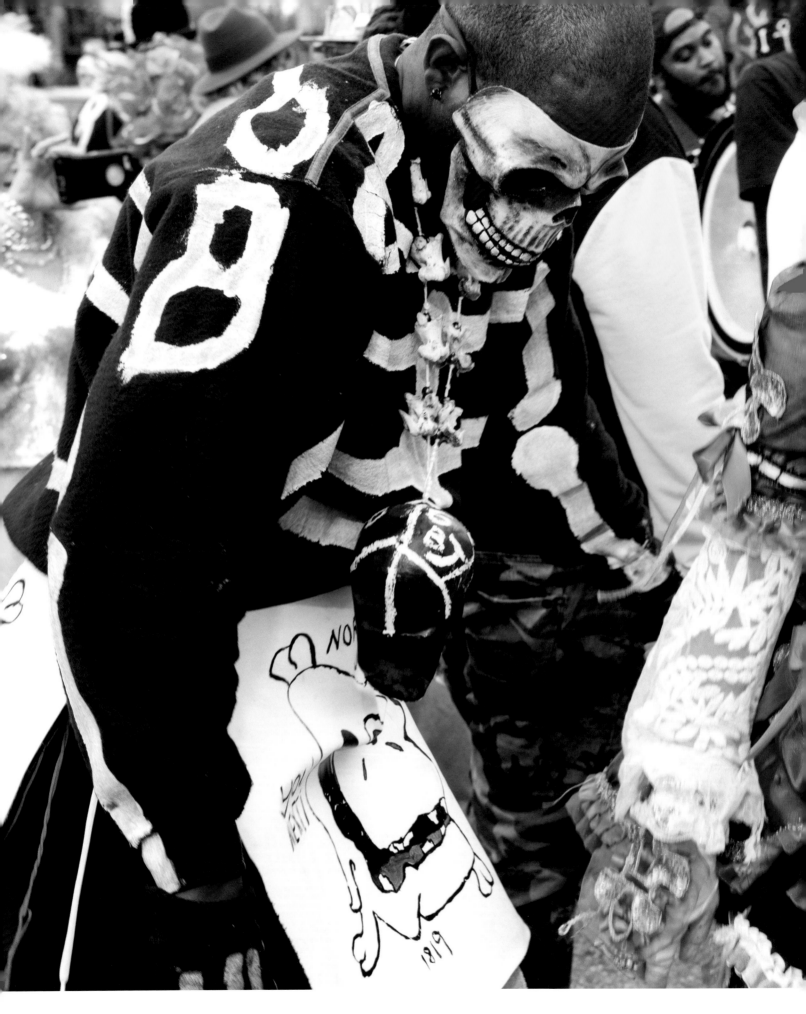

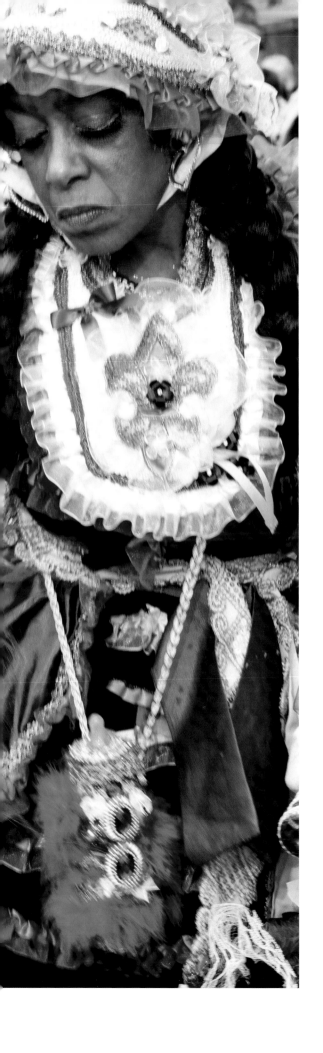

7

BABY DOLLS
& SKELETONS

BLACK MASKING TRADITIONS HAVE DEEP ROOTS IN NEW ORLEANS AND ARE AMONG THE FIRST CARNIVAL CUSTOMS IN THE CITY. HISTORICALLY RESTRICTED FROM PUBLIC CELEBRATIONS, NEW ORLEANS' BLACK COMMUNITY DEVELOPED THEIR OWN RICH CARNIVAL TRADITIONS, PRIMARY AMONG THEM BLACK MASKING INDIANS, BABY DOLLS AND SKELETON GANGS.

These practices have long, fascinating histories and are more spiritual in nature than many of the White Mardi Gras traditions. Black Masking traditions are rich, and their secrets create a special allure. Their long standing traditions reach back in history to inform today's masking practices. Baby Dolls lighten our spirits with their joyful, powerful Black femininity while the Skeletons keep us mindful of the fleeting nature of life.

"...so wherever the **Baby Dolls** were going, the ladies were going crazy: they were on top of the poles, on top the barricades, on top on the cars and the visitors were trying to figure out what was going on, the police were going **CRAZY**, they said *what was going on?* they said *that's those Baby Dolls dancing!* So they had to stop the music, which was kind of hard because it was, it was you got to realize what we do is spiritual; it's from the heart, it's from the soul."

–Cinnamon Black, Tremé Million Dollar Baby Dolls describing a time when Baby Dolls broke tradition and marched in Muses parade.[1]

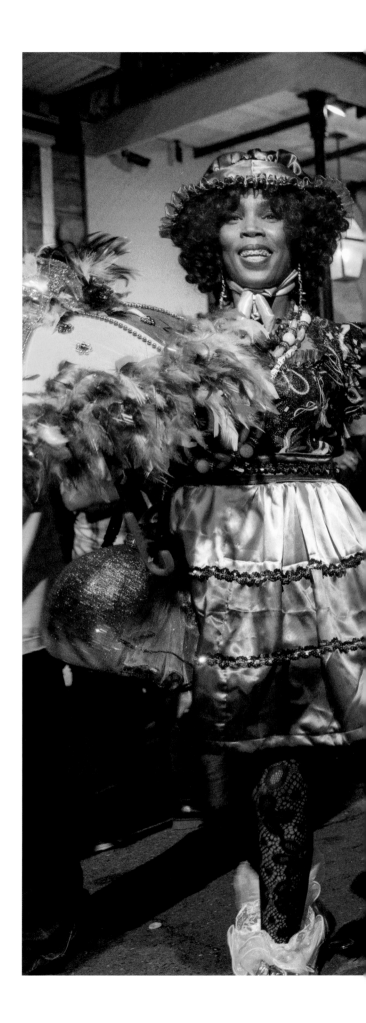

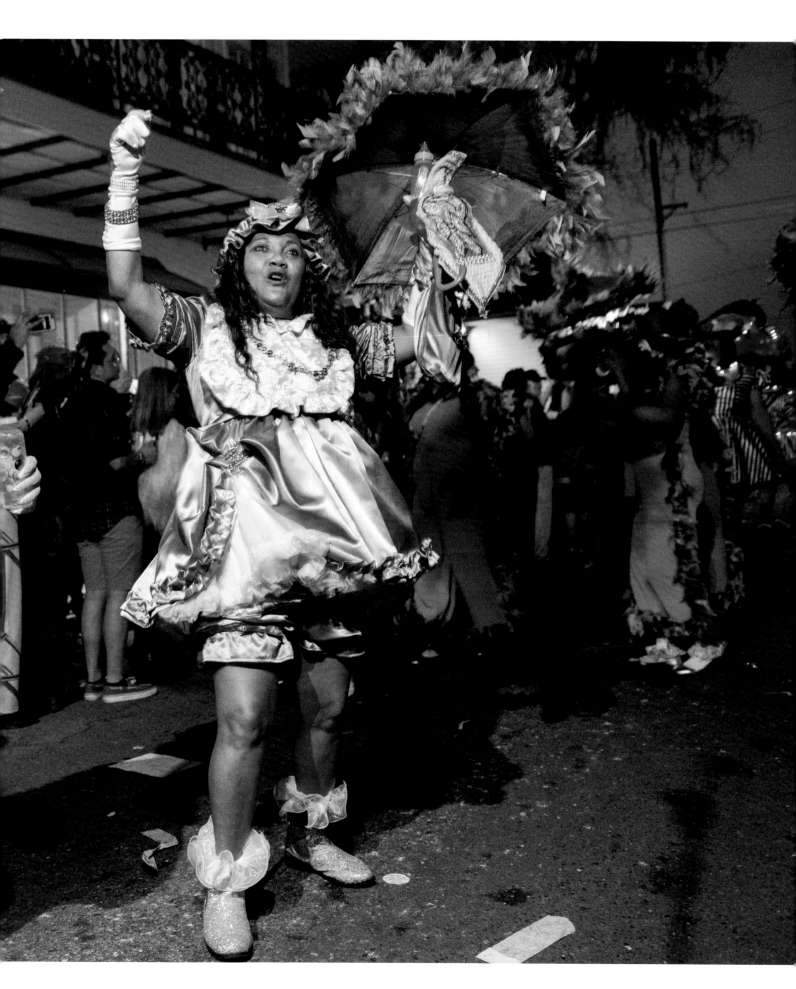

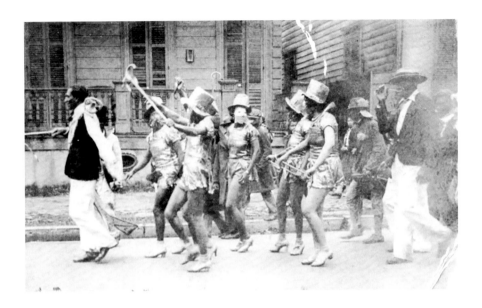

In the 1800s New Orleans, the neighborhoods of free people of color were rich in cultural influences brought by the enslaved populations. In addition to thriving businesses, music, dance, costuming and parading cultures were actively practiced. While surrounded by a city and country that devalued and challenged Black worth, these neighborhoods fostered a rich culture which in turn helped to define the communities.

Faubourg Tremé was developed adjacent to the French Quarter in the 1790s by a manumitted Black woman, Julie Moreau, and her French husband Claude Tremé. By 1841 people of African lineage owned 80 percent of the land in the Tremé, creating an empowered, free, and prosperous Black community—one of the first in the nation. The "town center" of Tremé, Congo Square, was the historic gathering place of the city's enslaved population. The neighborhood was the center of Black power at that time, also serving as the birthplace of civil

rights actions in the 1950s. Yet in the 1960s, White city leaders decimated the Tremé by replacing its prosperous, tree-lined stretch of Claiborne Avenue with the hulking concrete of the elevated Interstate 10 and raising blocks of homes to create Armstrong Park. This constituted a debilitating destruction of the community. Destruction continues today with the pervasive gentrification of the area. Still, the Tremé continues to be a life force of Black culture in the city and a place where many Black Maskers congregate on Mardi Gras Day.

Social aid and pleasure clubs, another fascinating and extraordinary practice of the Black community, are not a Mardi Gras practice. While they are not covered in *I Wanna Do That!*, we encourage you to discover their brilliance. There are rich histories and detailed studies of these Black cultural practices listed in our *Resource* chapter—explore and learn more about these cultural gems.

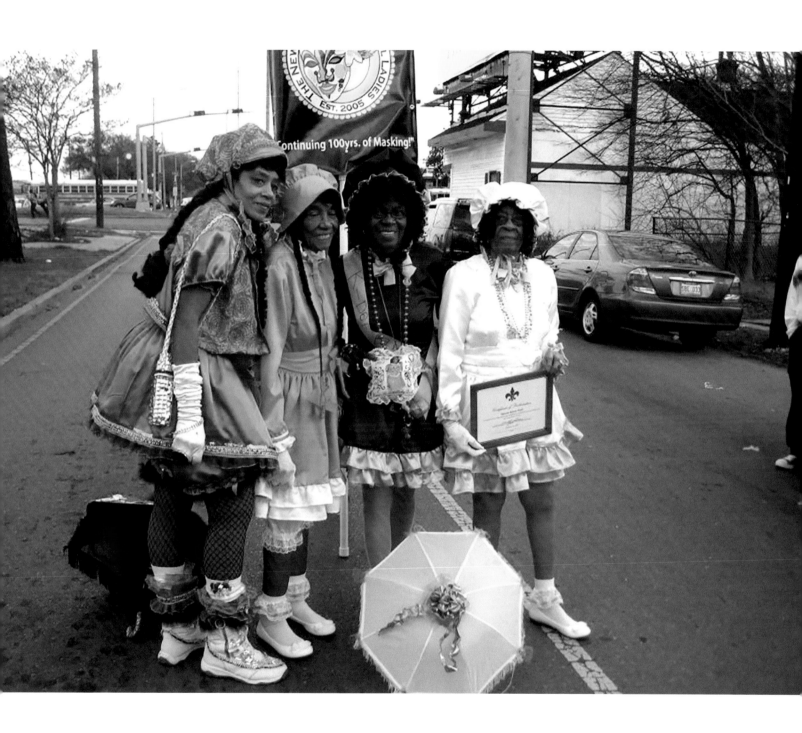

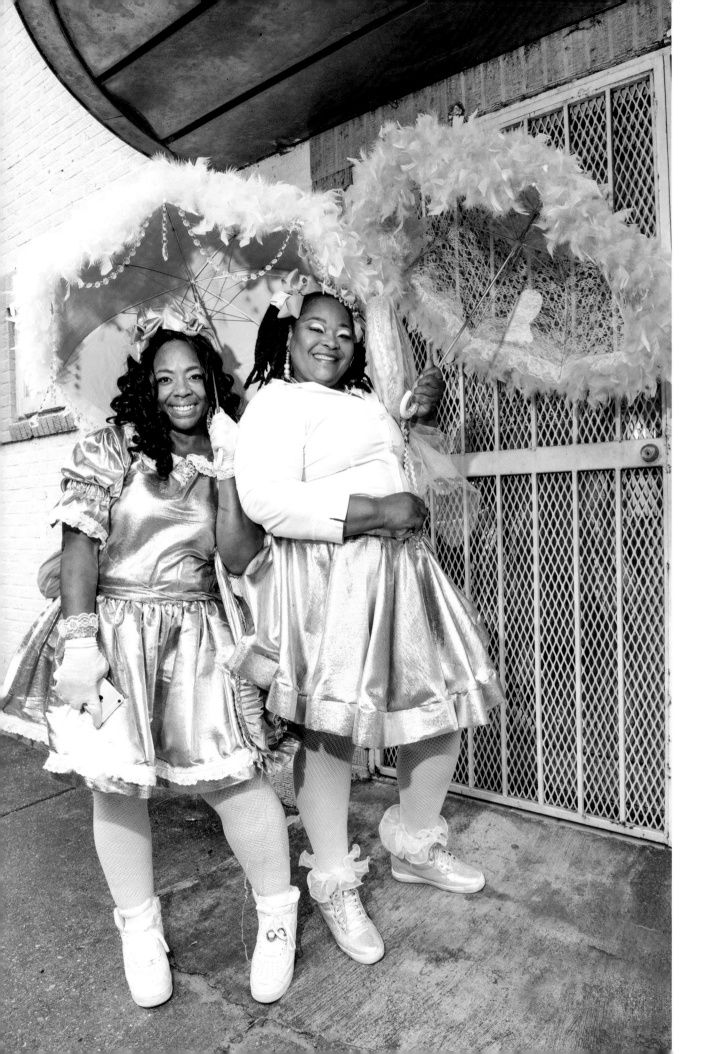

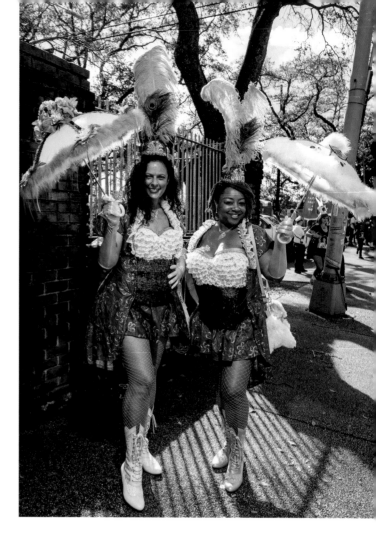

"These were women from some of the neighborhood clubs and they used to costume in satin—satin blouse and short satin skirts and satin caps—and they had music and they danced in the streets and occasionally following the Indians...on Mardi Gras Day."
–Emile J. LaBranche Jr.[2]

BABY DOLLS

There are a few origin stories for New Orleans' Baby Dolls. Many document prostitutes in "Black Storyville" who started masking as Baby Dolls around 1912, while others believe that one masker began the trend and was quickly imitated by others. Regardless of the exact origin, Baby Dolls were one of the first women's street masking groups. They marched with bravado, contrasting the feminine appearance of a doll with powerful masculine symbols such as cigars, money and sometimes weapons. They exuded a sense of independence and fun. With the birth of jazz in 1910s and the following advent of the Jazz Age in the 1920s, women cast off restrictions of the era and the empowerment and self-definition of the Baby Doll practice found a great fit. Their coquettish costumes with lots of ruffles, bloomers, lacy socks, lollipops, pacifiers, bottles, and fancy parasols belying their manly conduct and actions. Participation evolved to include some men, with hats and pants coordinating with the Baby Doll costumes.

"The Baby Dolls would come with the Indians. They were large women [i.e., not skinny] who looked very serious. They wore beautiful well-made costumes that had layers of ruffles on the skirts. They needed the ruffles to show off their dance of shaking on down."[3]

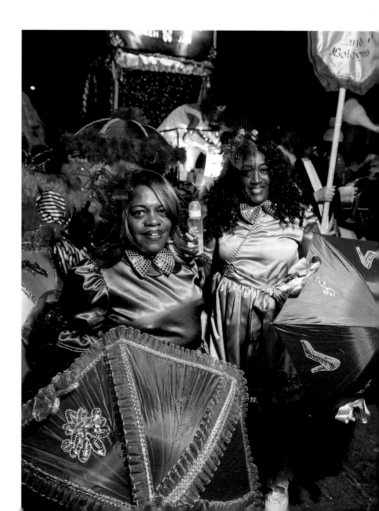

Distinctive factions emerged, often arising from specific neighborhoods or wards—generally music and dance moves differentiating the groups. Competition would be made for the best costuming and the best dancing and music, with groups being known by their special songs. By the 1920's members came from all walks of life, and by the 1930s the Baby Dolls had become an iconic part of Black Mardi Gras traditions.

For a period of time participation in the Baby Doll tradition declined, damaged by the Tremé neighborhood's disintegration, the aging of the existing Baby Dolls, the image of Baby Dolls being too risqué, and the sense that the practice was out of fashion and not timely during the Civil Rights Movement. In the 1970s the Batiste family lead by Miriam and Alma Batiste, re-energized their practice and in 2001 Antoinette K-Doe (wife of of well-known musician Ernie K-Doe) and Bruce "Sunpie" Barnes rekindled the practice of Baby Dolls and the Northside Skull and Bone Gang strolling up Claiborne Ave on Mardi Gras Day. Since that time the Baby Doll practice has blossomed with current members including a variety of styles: some groups moving away from more traditional costume and actions, and others staying true to tradition. Some groups do social and community work, some come for the dancing. Several groups have formed to accompany Black Masking Indians on their marches. Whatever the desire, this community has a beautiful and vivacious group of practitioners.

As "women dancing the jazz" (from jass/jazz to swing, to bebop, to rhythm and blues, to hip hop and bounce), they carry a message of hope and resilience to a community that has always relied on its culture to make it through life.
–Kim Marie Vaz

Kim Marie Vaz, *The "Baby Dolls": Breaking the Race and Gender Barriers of the New Orleans Mardi Gras Tradition.* Baton Rouge: Louisiana State University Press, 2013)

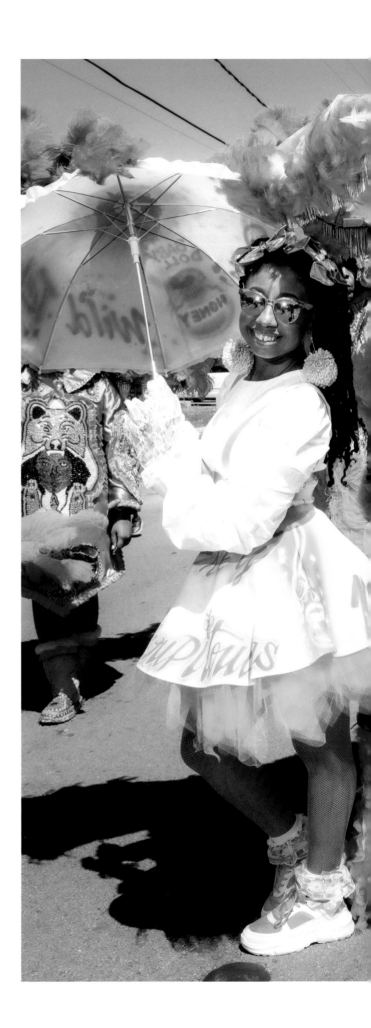

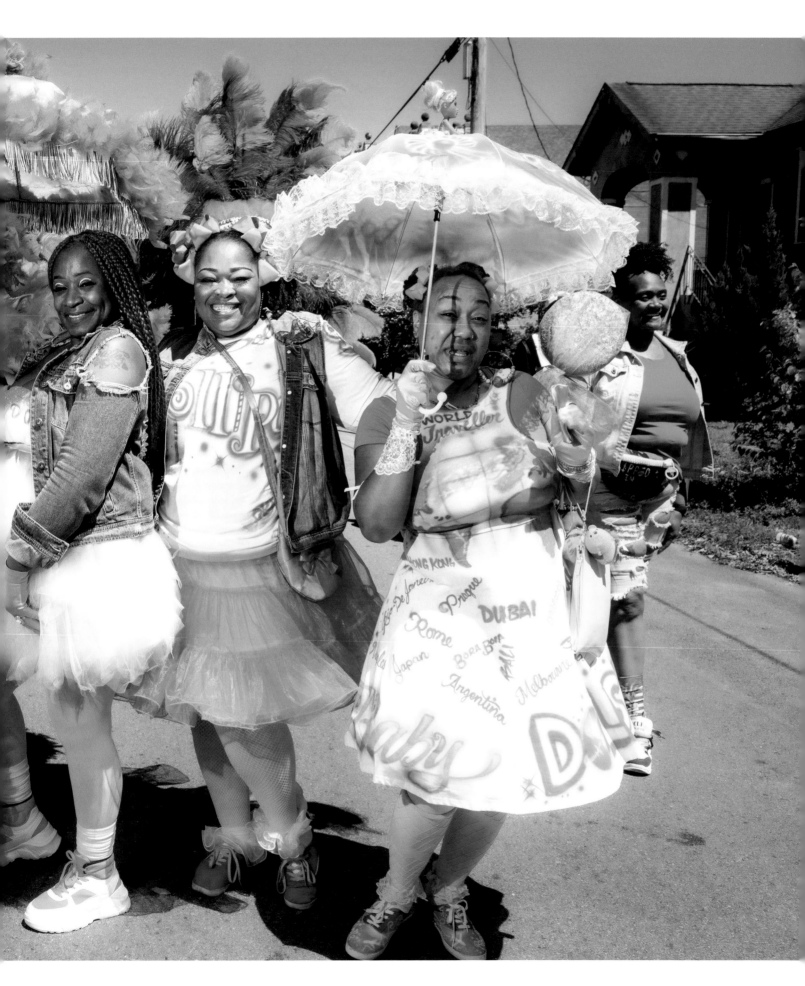

BABY DOLLS

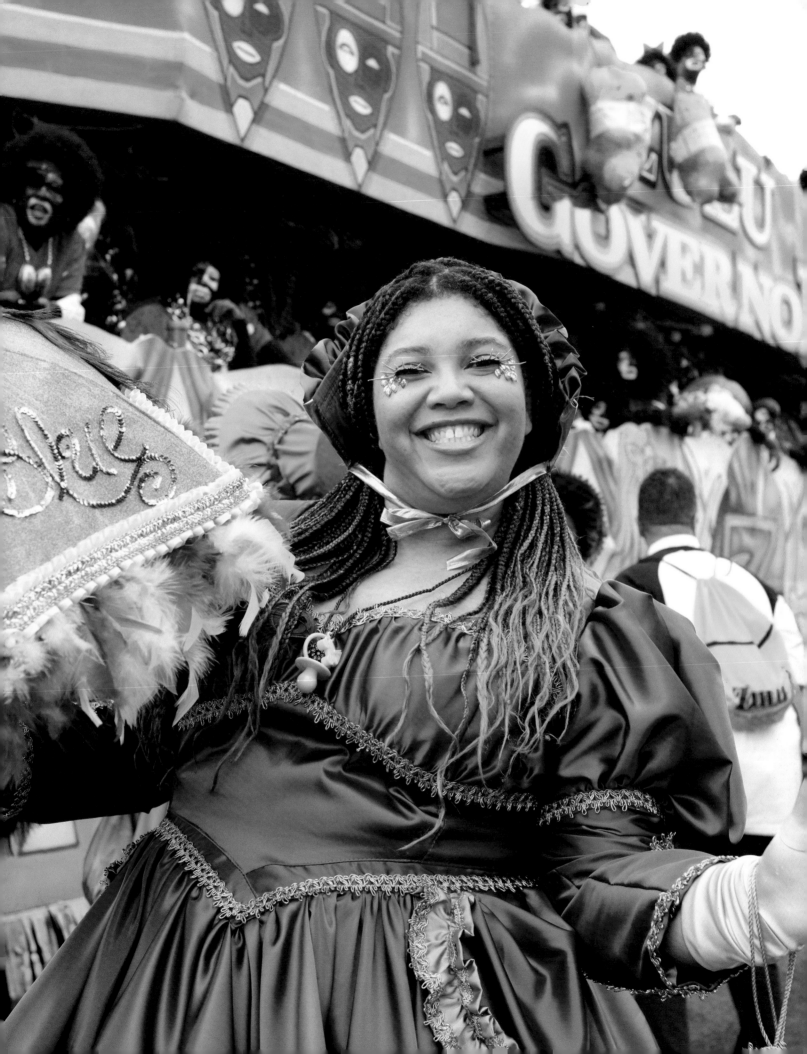

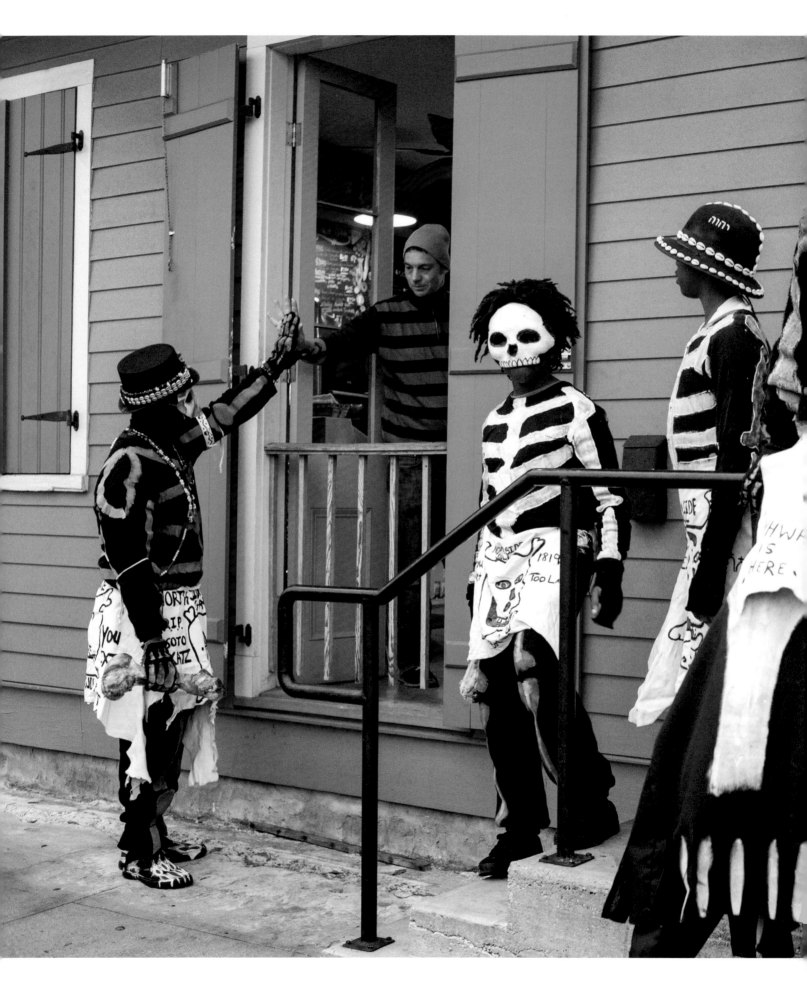

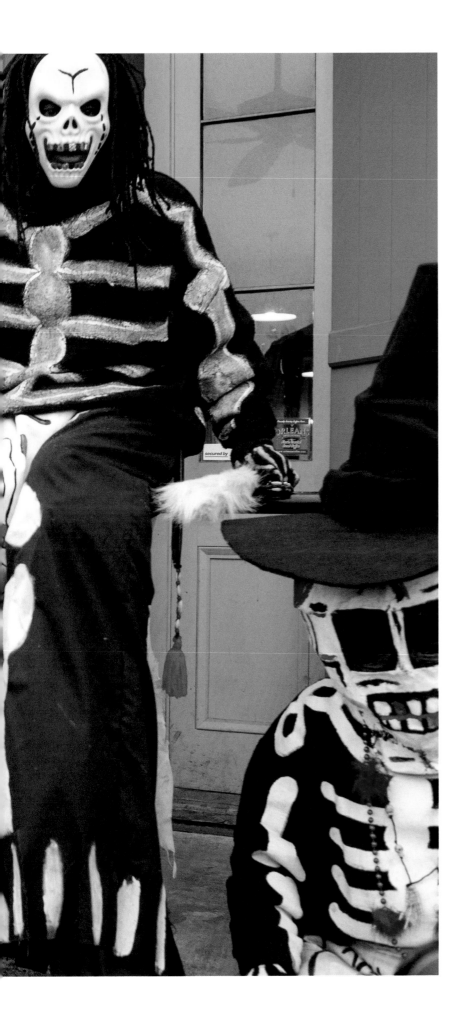

SKELETONS

Early on Mardi Gras morning the North Side Skull and Bone Gang roams the streets clacking bones, knocking on doors, beating drums with their ominous warnings "You Next!" or "The end is near!" As they usher in Carnival day, the skeletons warn that life is fleeting and precious, warn the youth about the dangers of the street and call on their ancestral family spirits to bless Carnival and ensure a safe celebration. It's a spiritual practice, harkening back to African roots and paying homage to those who came before them. "[Skeletons} were all in black and crossbones, ...and had papier-mâché heads, and many a kid, including myself, ran from the skeletons."[6]

"THE SKULL AND BONE GANG
ATTEMPTS TO MAKE PEOPLE
CONFRONT THEIR OWN MORTALITY
AND ANSWER TOUGH QUESTIONS
ABOUT THE WAY THEY'RE LIVING
THIS LIFE AND PREPARING
FOR THE NEXT ONE."

–Chief Bruce "Sunpie" Barnes[5]

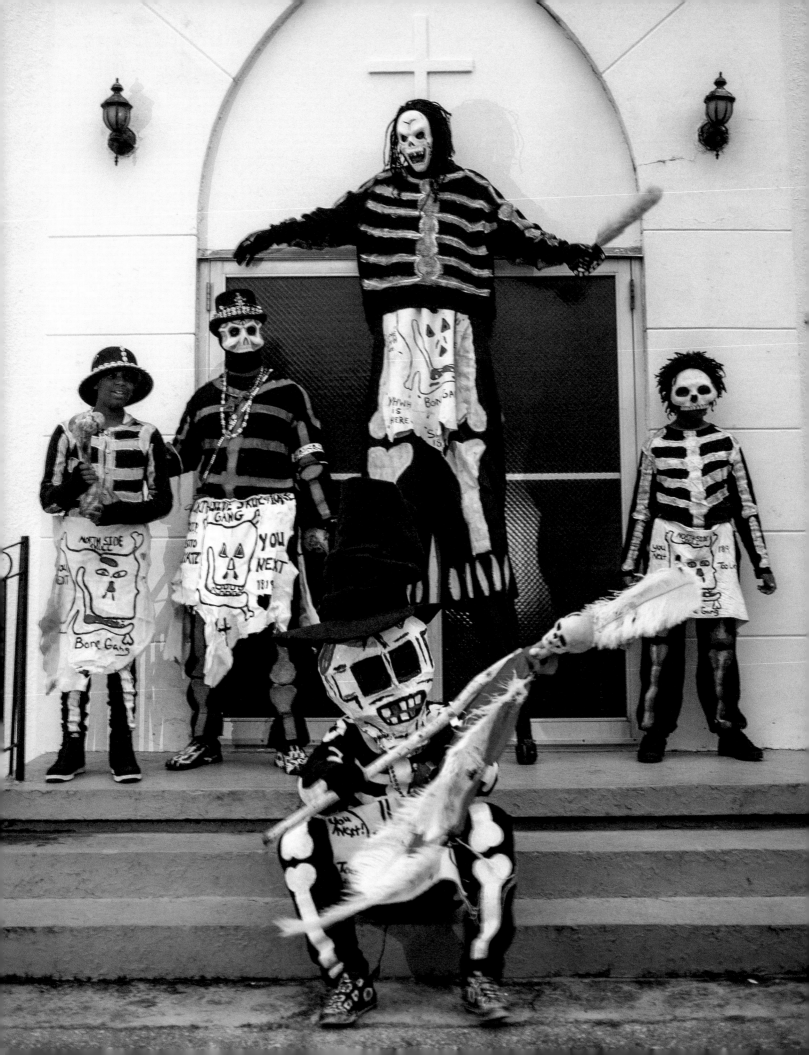

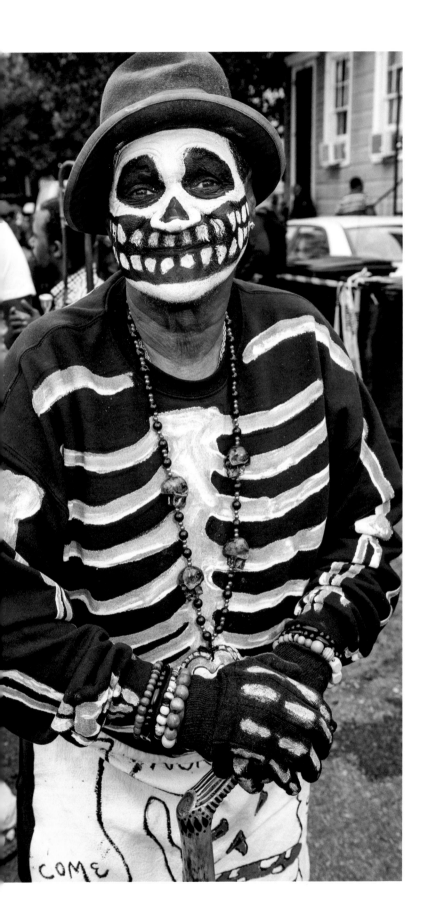

NORTHSIDE SKULL AND
BONE GANG SONG

–Composed by Big Chief Bruce "Sunpie" Barnes

Northside Bone Gang,
Northside Bone Gang,
If you keep drinking that wine,
you gotta come see us,
If you keep on taking them drugs,
you gotta come see us,
if you keep on doing those bad things out there,
you gotta come see us.
And then the song would come along:
We are the Northside,
we are the Bone Gang,
we come to remind you,
before you die.
You better get yo',
yo' life together,
next time you see us,
it's too late to cry.
Ashes to ashes,
and dust to dust,
you better straighten up,
before you come see us.
You better get yo',
yo' life together,
next time you see us,
it's too late to cry.

Additional references: Bruce Sunpie Barnes, Zohar Israel,
Fire In the Hole: The Spirit Work of Fi Yi Yi and the Mandingo Warriors
(Rachel S. Breunlin); *Inextremis Death and Life in the 21st-Century
Haitian Art* (Steve C. Wehmeyer)

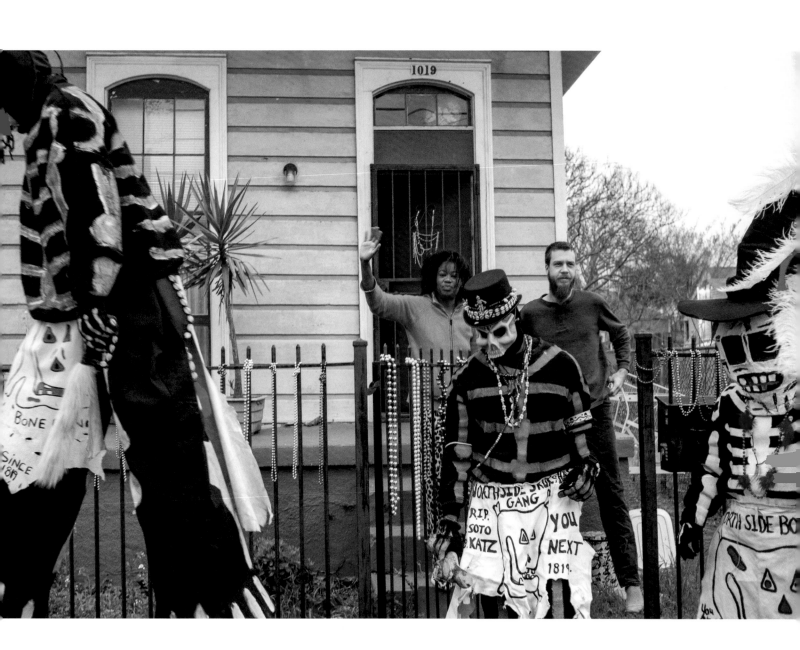

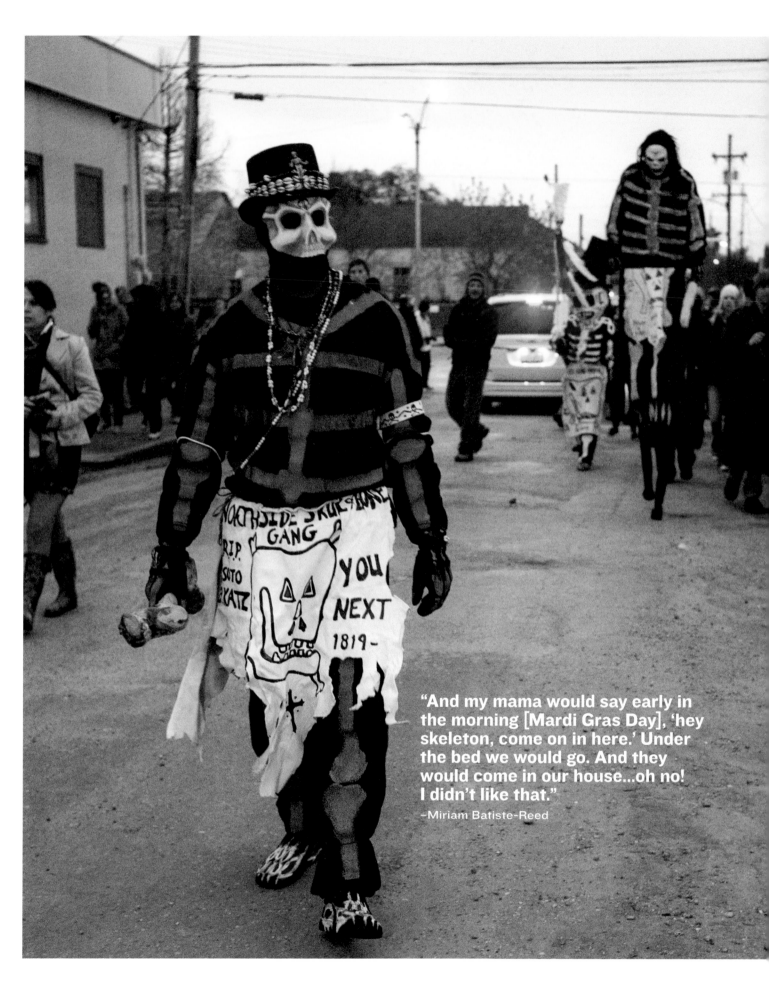

"And my mama would say early in the morning [Mardi Gras Day], 'hey skeleton, come on in here.' Under the bed we would go. And they would come in our house...oh no! I didn't like that."
–Miriam Batiste-Reed

For the past two hundred years, skeleton gangs have roamed without a set route through neighborhoods far from the large pageantry and crowds of Canal Street. Their intriguing costumes include black and white clothing with skeleton forms painted on them and oversized handcrafted skeleton skulls. They carry large animal bones, waists circled with aprons with simple drawings and handwritten text.

By the late 1990s, the skeleton tradition had wavered and nearly died out. The Northside Skull and Bones Gang, one of the remaining gangs, has experienced a strong resurgence and now is recruiting children to ensure the tradition continues.

[1] "Taking it to the Streets" interview with Action Jackson, WWOZ, 6/16/18

[2] Interview. Emile J. LaBranche Jr., Amistad Research Center. 6/2/1994 . Tremé Oral History Project Collection

[3] Millie Charles, Founding Dean of SUNO School of Social Work reminiscing about seeing Baby Dolls in her youth.

[4] Kathy Reckdahl, "New Generation of Northside Skull and Bone Gang keeps 200-year-old Mardi Gras tradition alive in Treme," The New Orleans Advocate, March 3, 2019, https://www.nola.com/entertainment_life/article_61560e35-3c9f-54d7-a012-a8424fdf69c4.html

[5] John Baily Cox, "Northside Skull and Bone Gang," ViaNolaVie, March 7, 2013, https://www.vianolavie.org/2013/03/07/northside-skull-and-bone-gang/

[6] Interview, Emile J. LaBranche Jr., part 2, Tremé Oral History Project Collection, Tulane University Digital Library, October 8, 1993 . https://digitallibrary.tulane.edu/islandora/object/tulane%3A86246

[7] Interview, Mardi Gras Indians, "Mardi Gras Morning (part VII): The Skull and Bone Gang," ViaNolaVie, February 28, 2019, https://www.vianolavie.org/2019/02/28/mardi-gras-morning-the-skull-part-7/

HISTORIC PHOTOS

pg 186
Baby Doll parade, *undated*

pg 187
NOBDL Centennial Celebration Baby Dolls (left to right), Resa "Cinnamon Black" Wilson-Bazile, Mercedes Stevenson, T Eva Perry, Mariam Batiste-Reed, *2012*

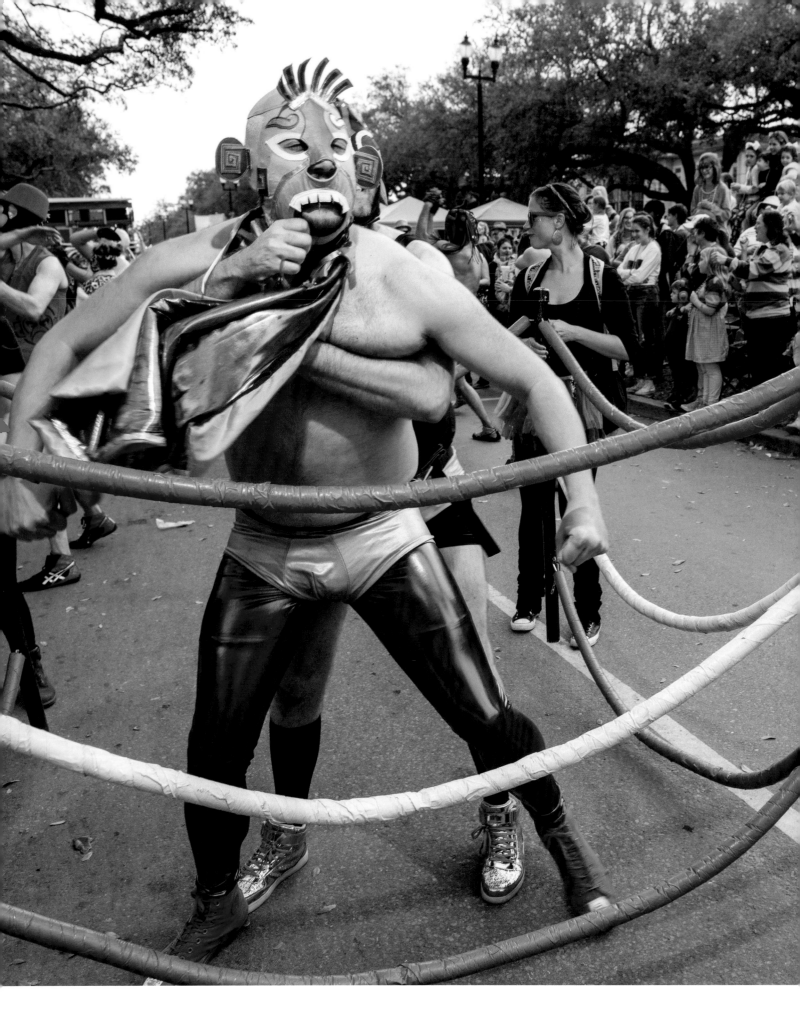

8

DO WHAT YOU WANNA

IT'S JUST NOT POSSIBLE TO CATEGORIZE
THESE KREWES—THERE IS NO BOUNDARY
TO CONTAIN THEM. ARE THEY MAN,
BEAST, IMAGINATIVE CREATURES, FAIRIES,
ROLLING CHAIRS...OR WHAT??

Krewe of Barkus has gone to the dogs. Several krewes adorn parades like colorful beads on necklaces: the Krewe of Kolossos with their gorgeous bikes, the dragons who roar through parades, pirates sailing their ships down the Avenue, and the Ladies Godiva, riding horses in all their natural glory. Or look for the suave Laissez Boys decked out in smoking jackets rolling in stylized motorized lazy boy chairs, or the Rolling Elvi who ride scooters dressed as Elvis followed by a float of Priscillas. And if you've never seen a Mexican wrestling match, stick around for the Lucha Krewe. Proving that anything is possible, these krewes have big fun and do what they wanna!

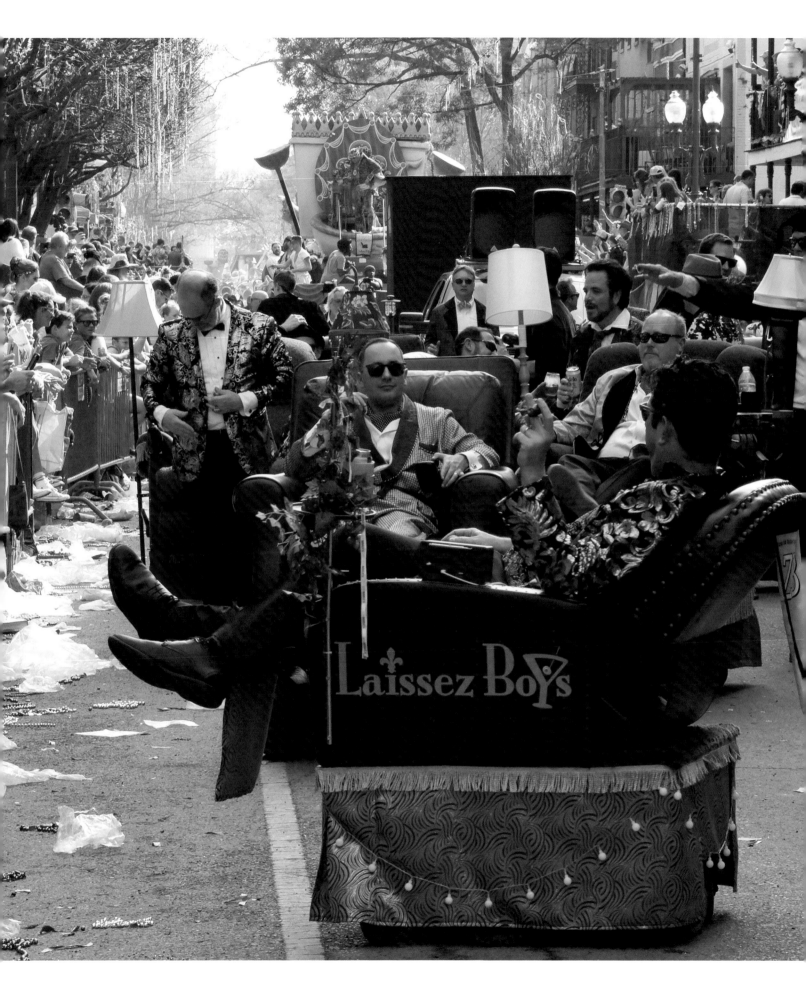

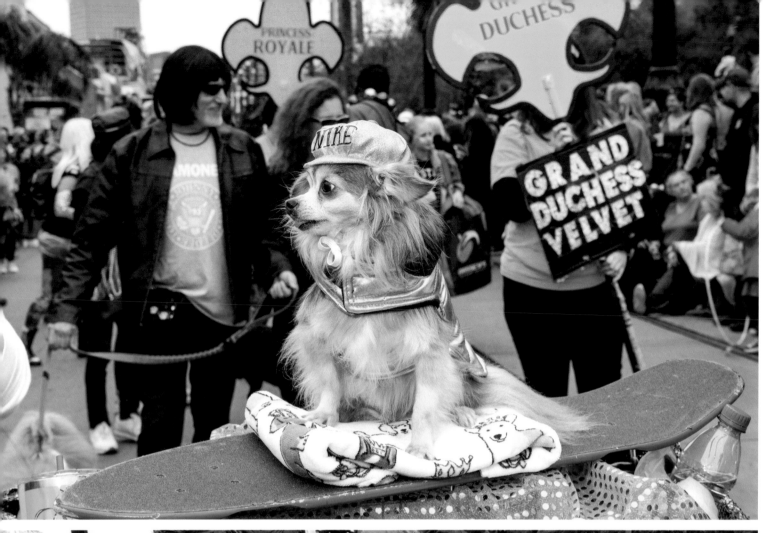

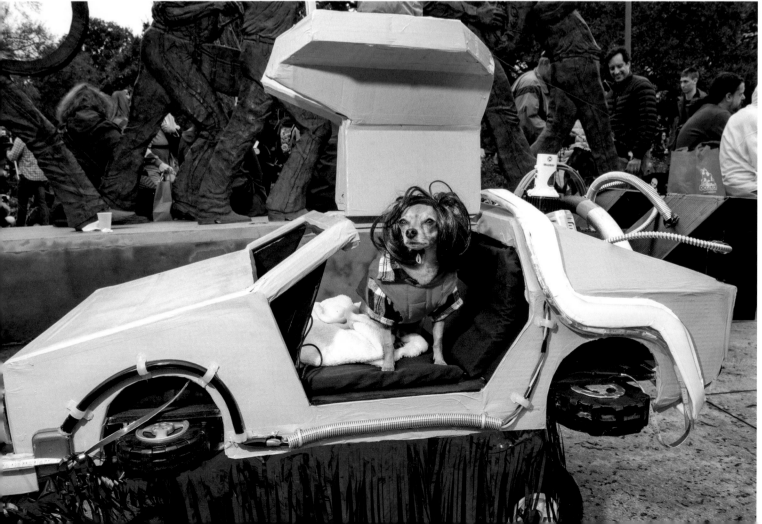

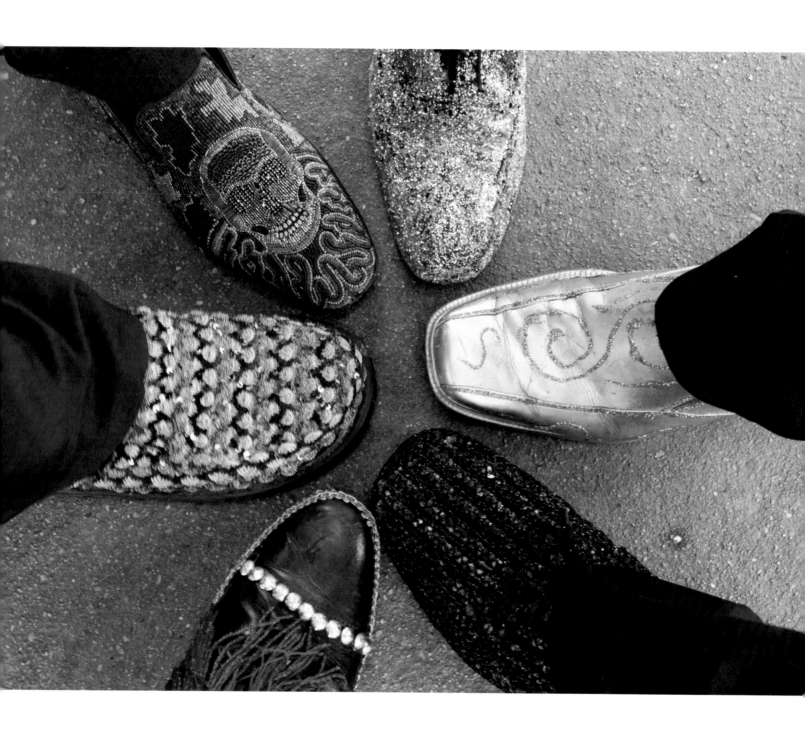

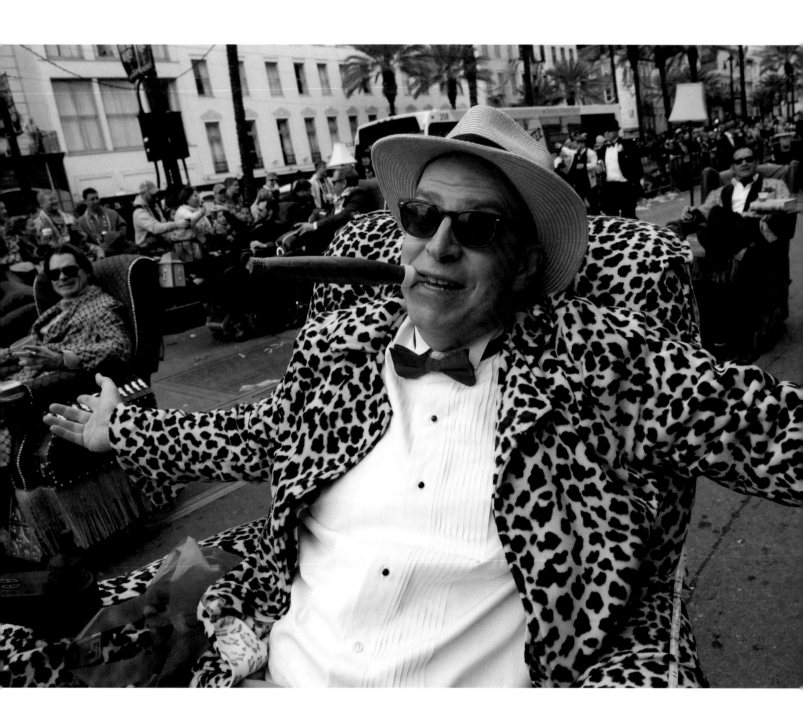

"Parading is a performance and most
people only have fifteen seconds to see
you. It's important that your performance
is the best it can be – so keep on smiling!"

–Michael Tisserand, Laissez Boys

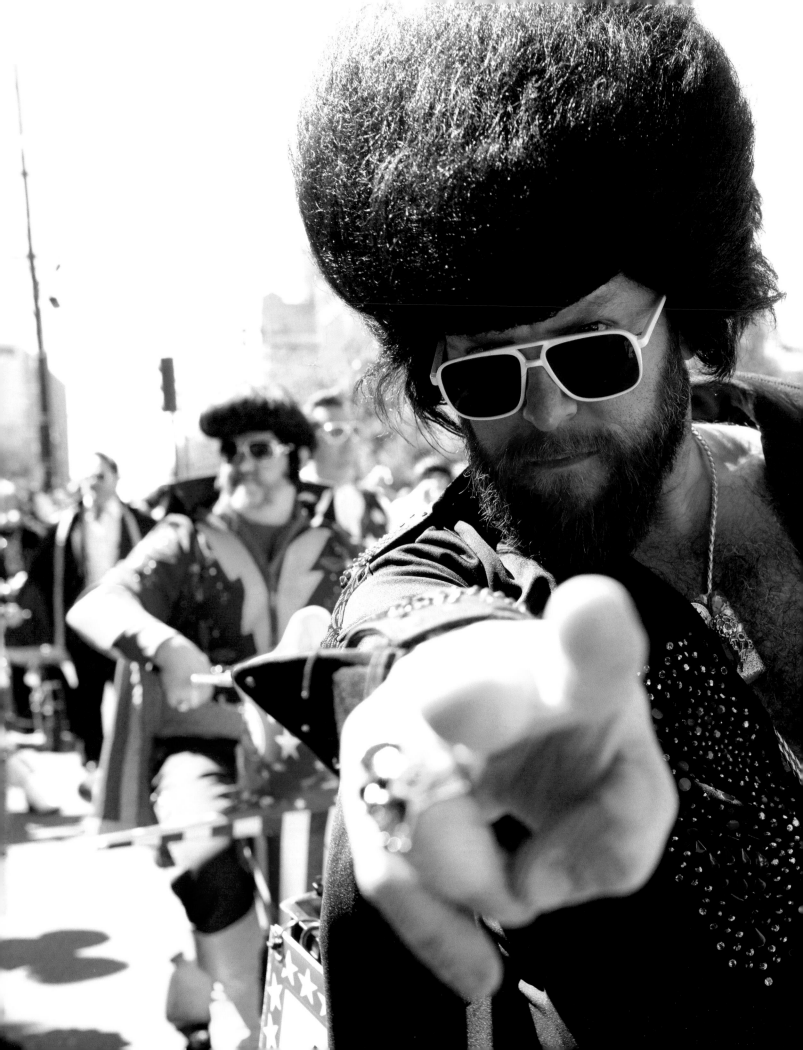

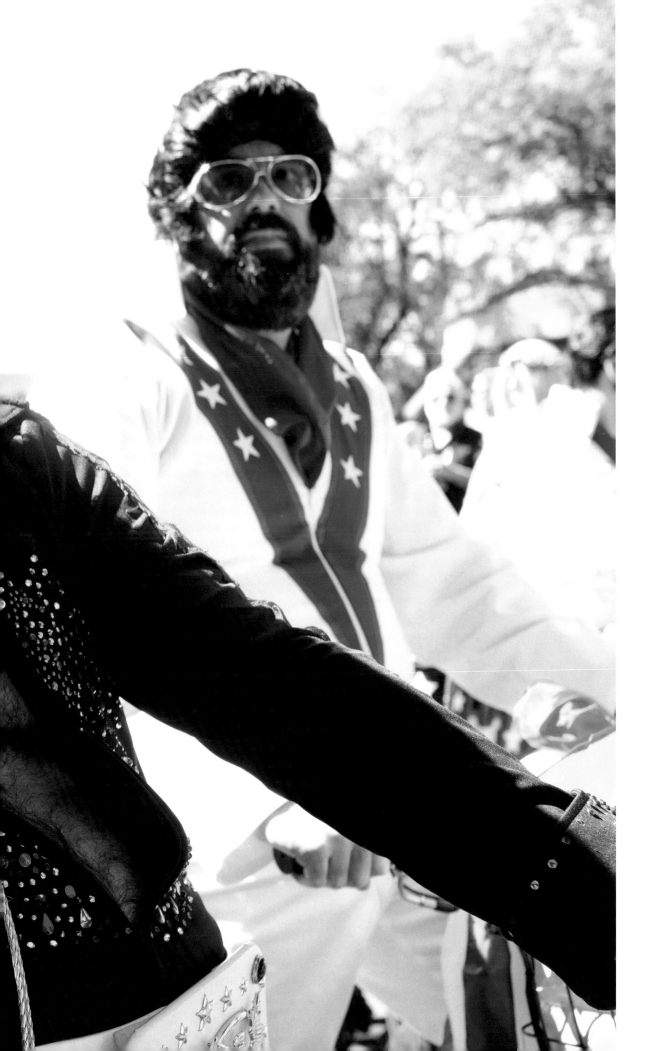

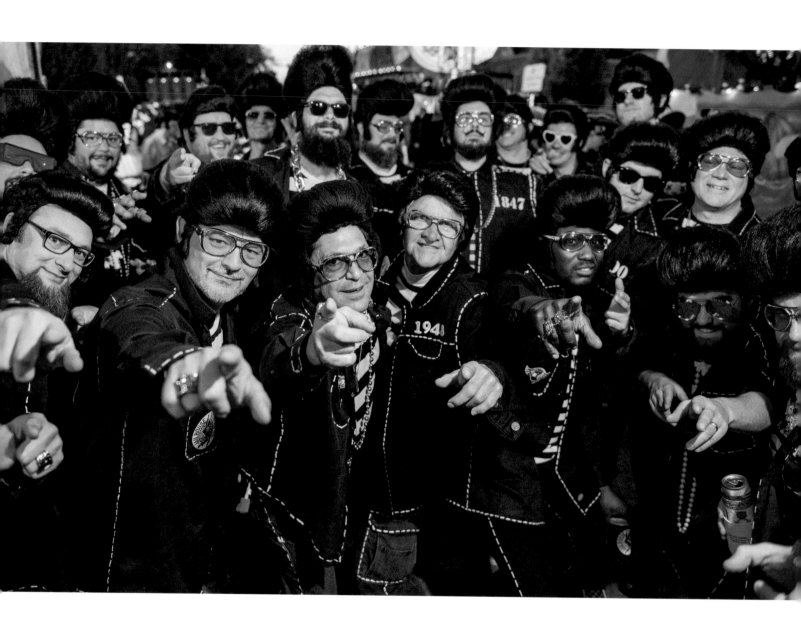

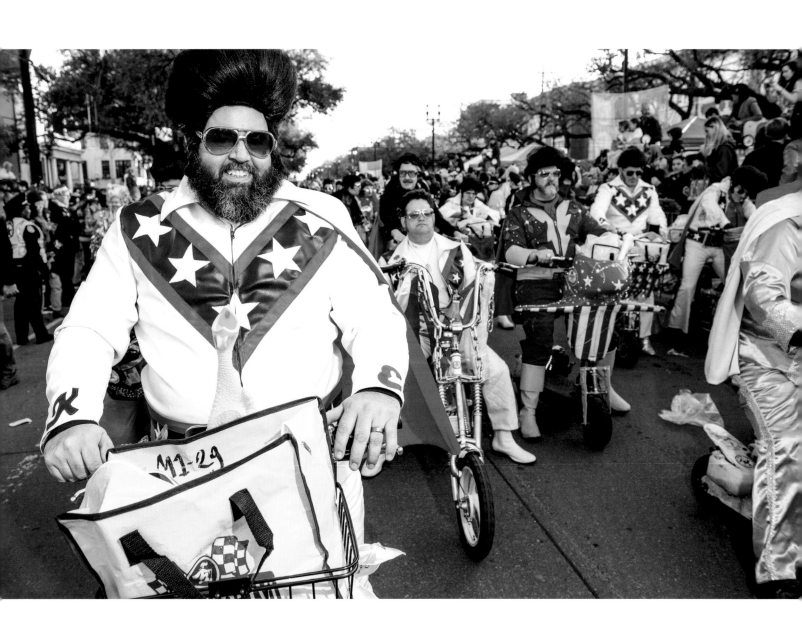

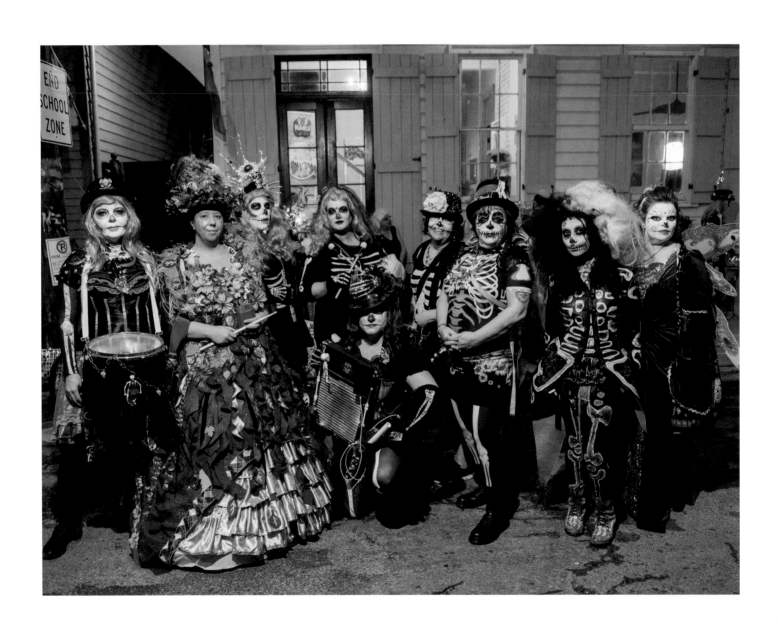

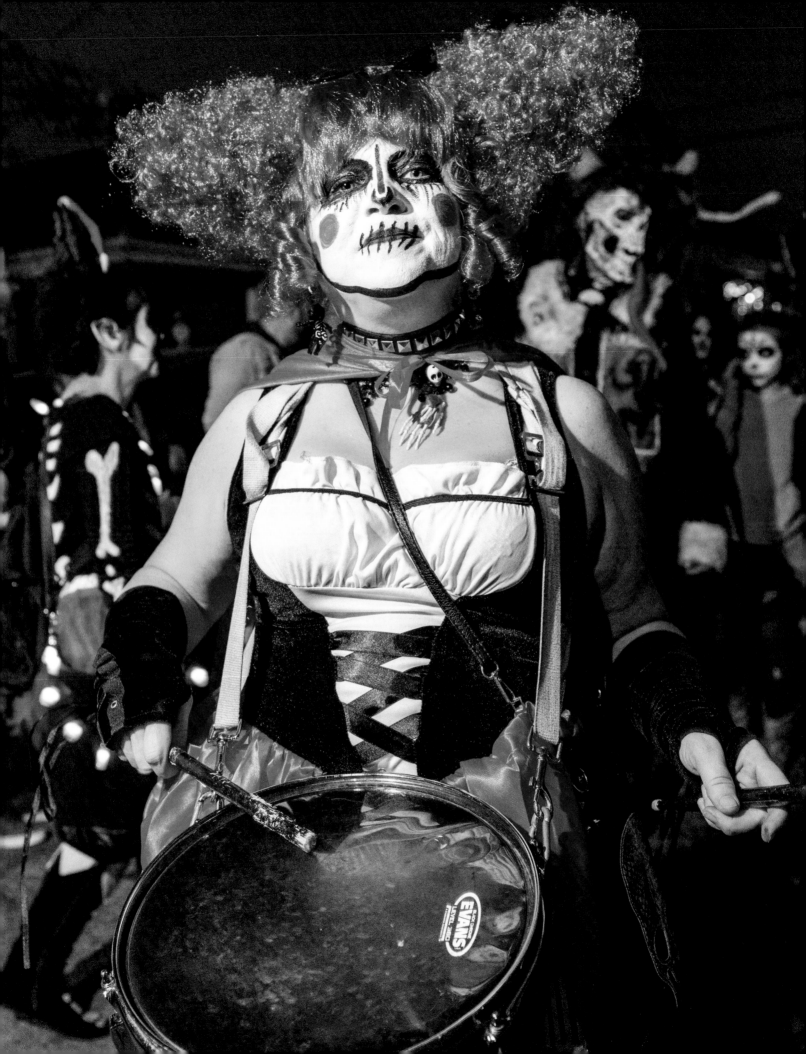

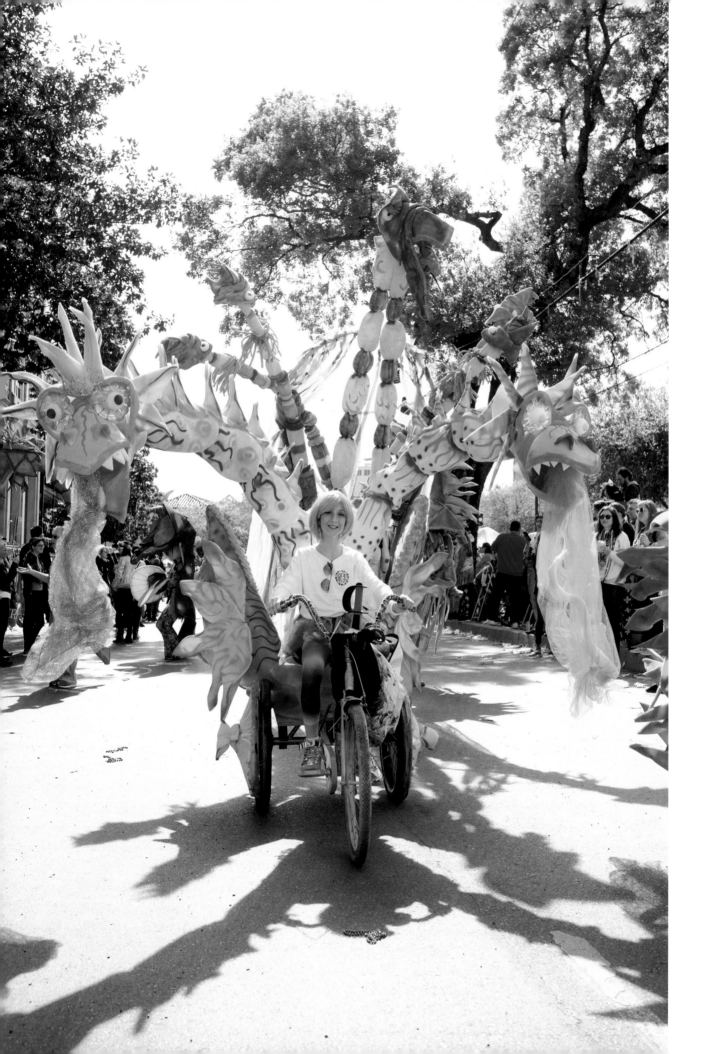

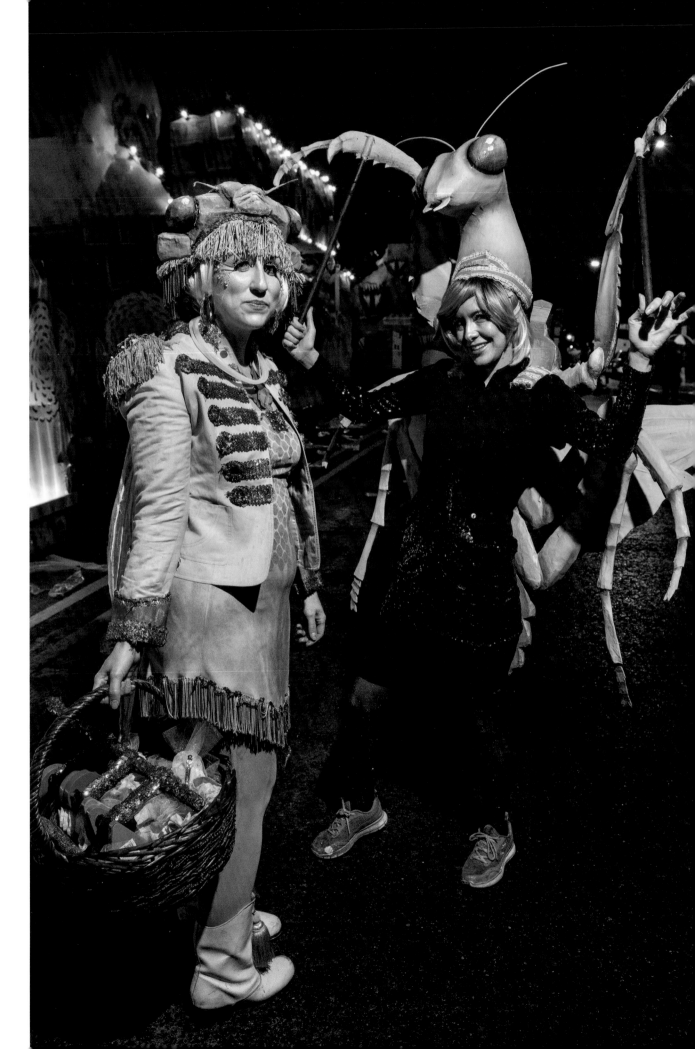

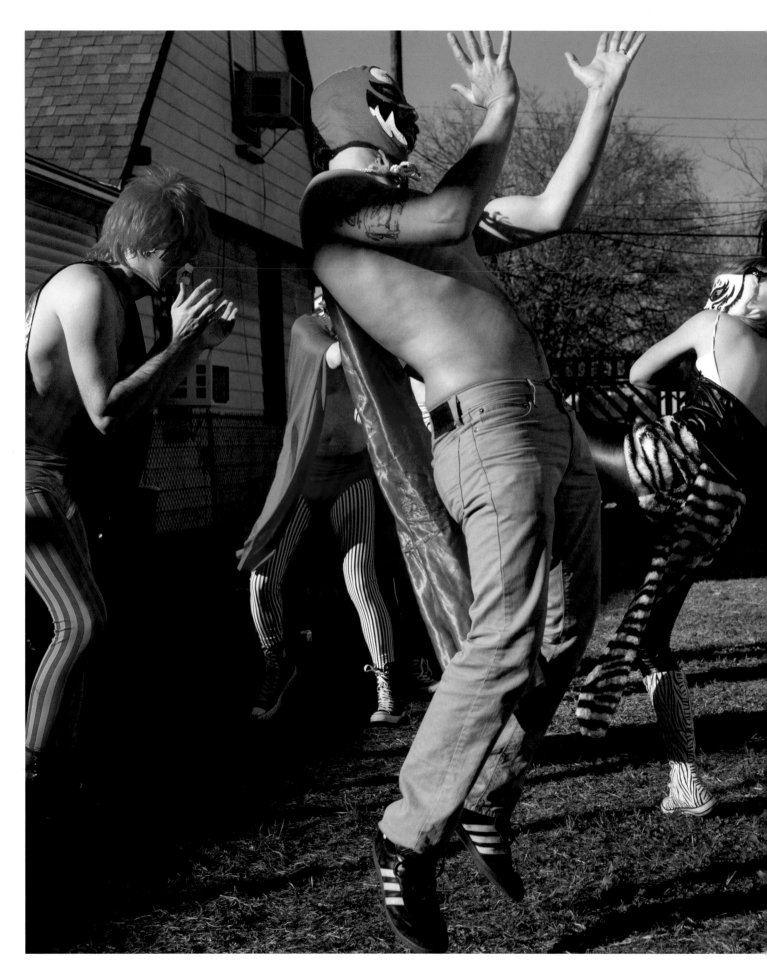

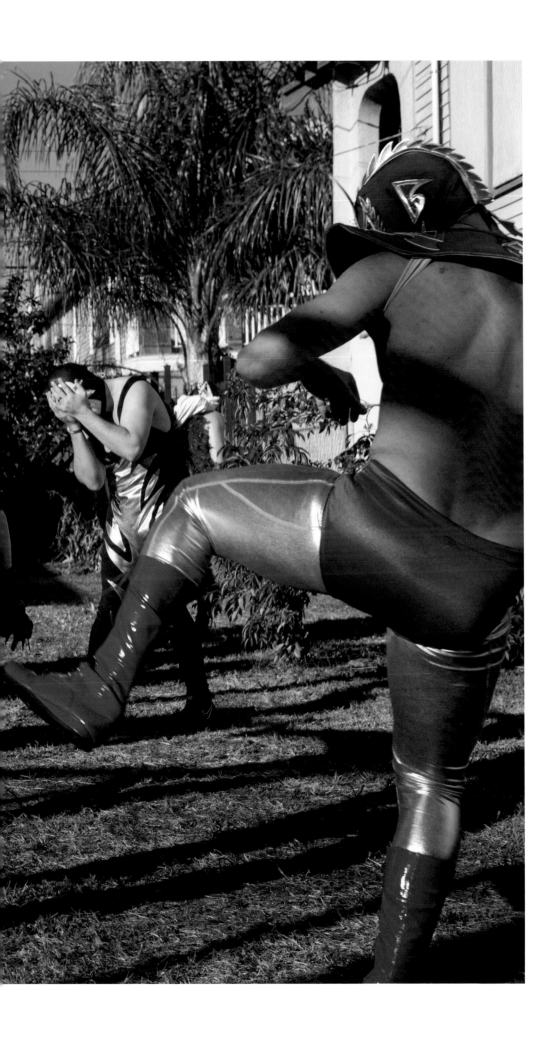

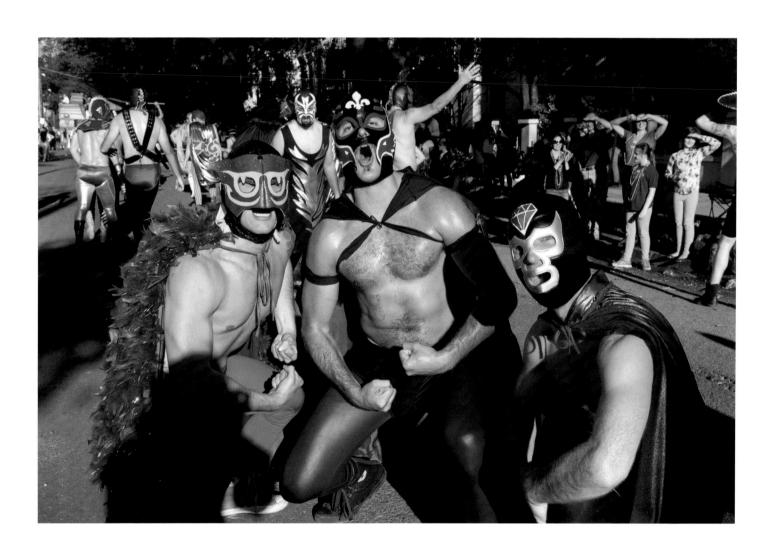

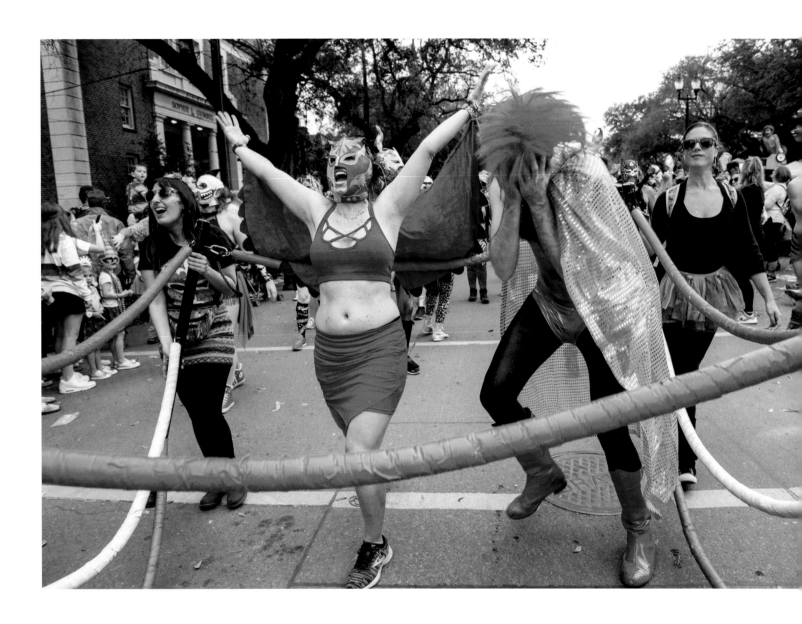

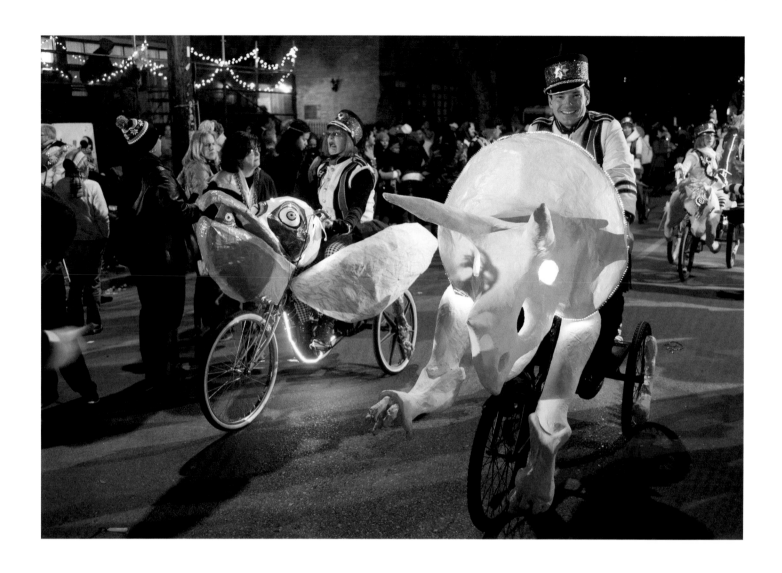

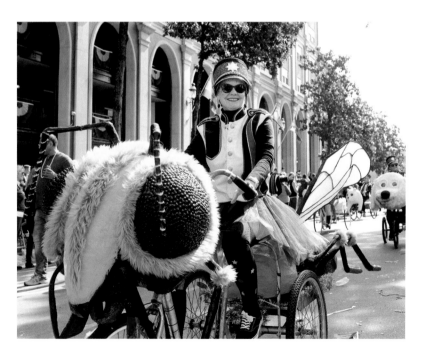

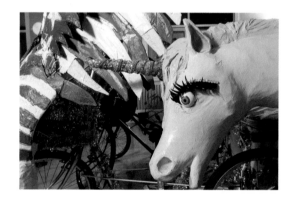

"FOR ME IT IS A CALLING –
WHAT MY LIFE WAS MEANT TO BE.
A LIFE'S WORK. PARADING IS
WHAT I WAS MEANT TO DO.
ORGANIZING A PARADE
IS BRINGING TOGETHER DOZENS
OF KINDS OF ART,
AND SHOWCASING IT."

–Katrina Brees, Founder, Krewe of Kolossos and Bearded Oysters

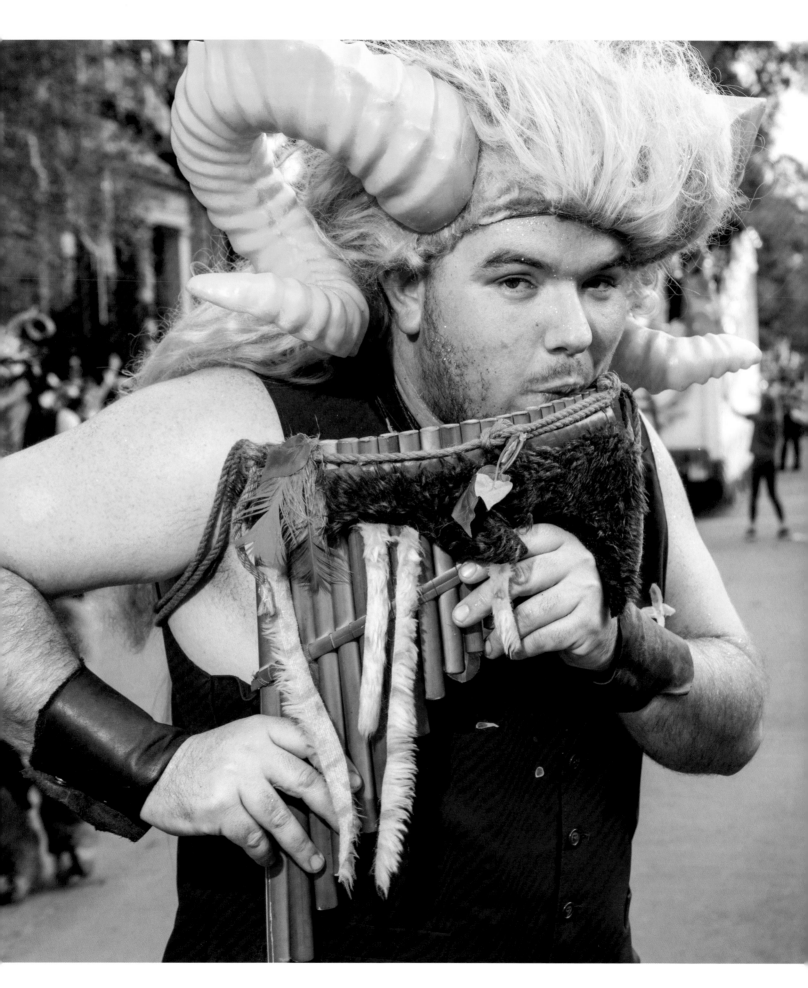

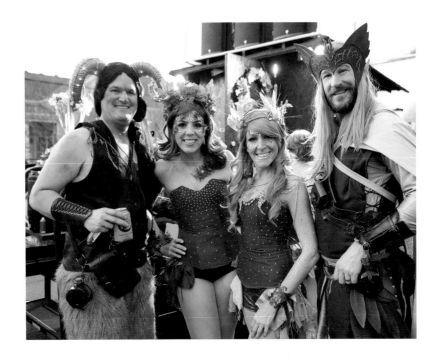

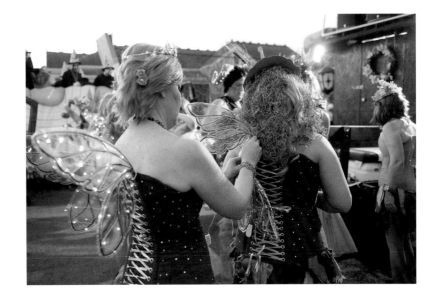

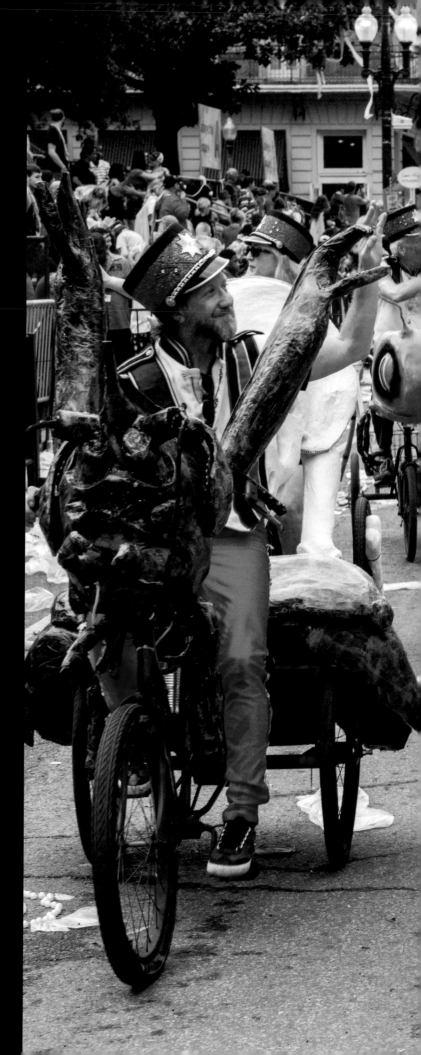

DO WHAT
YOU WANNA

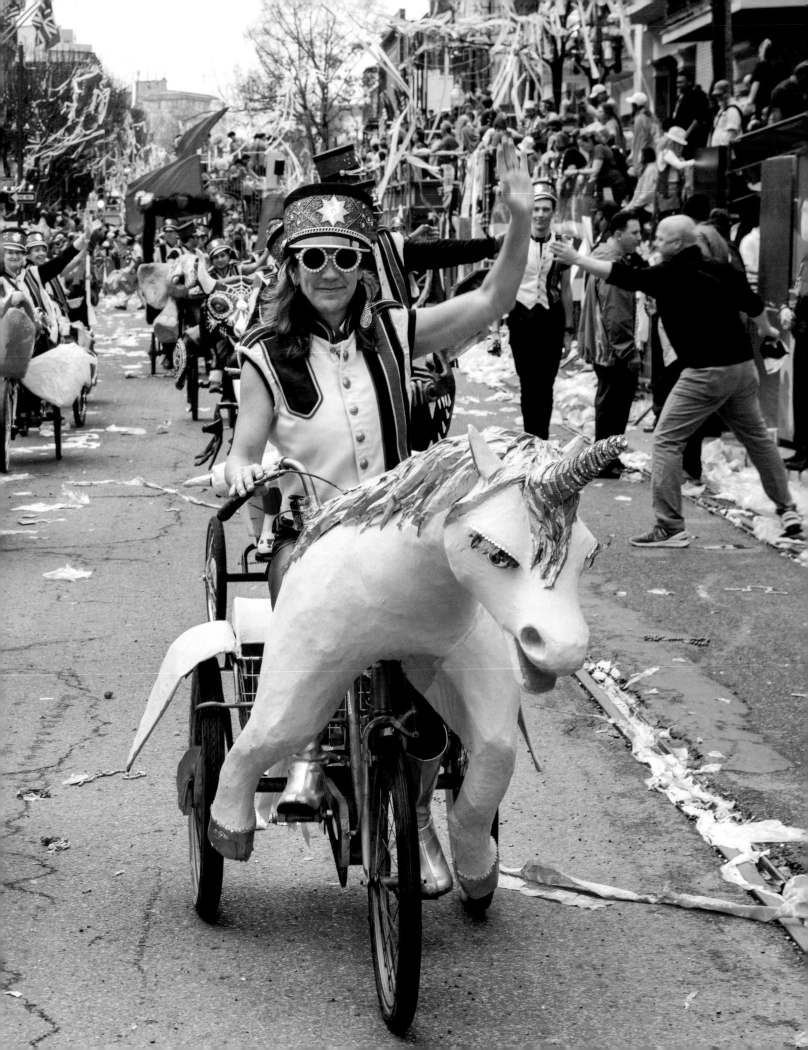

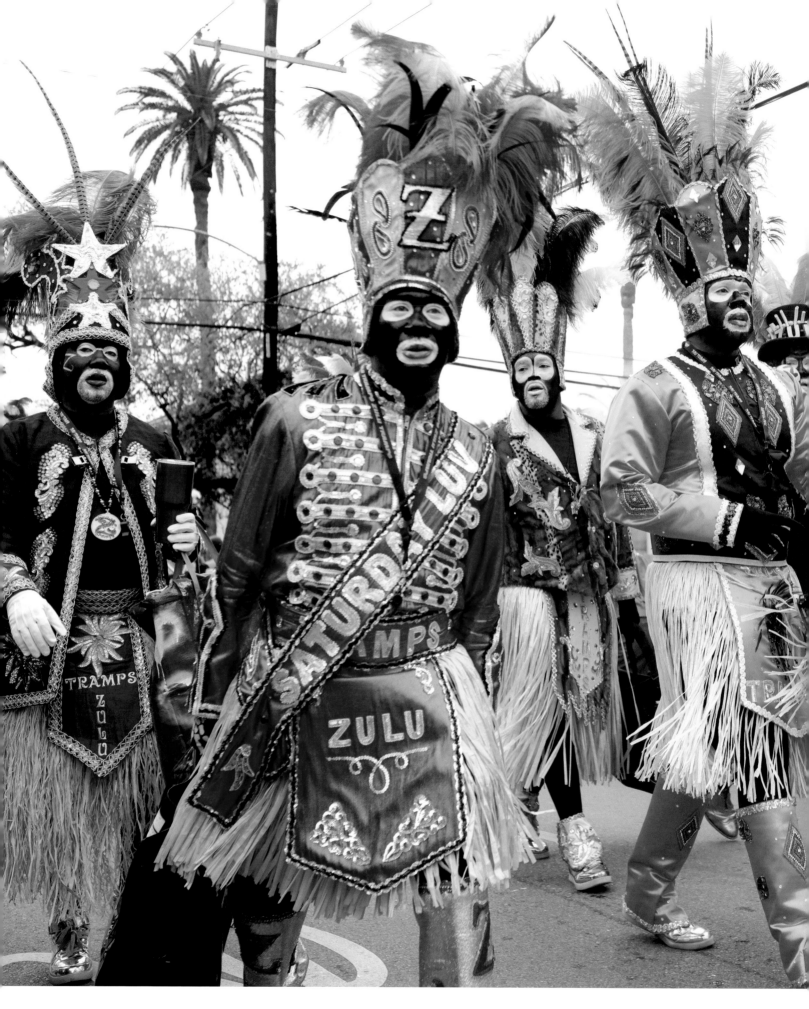

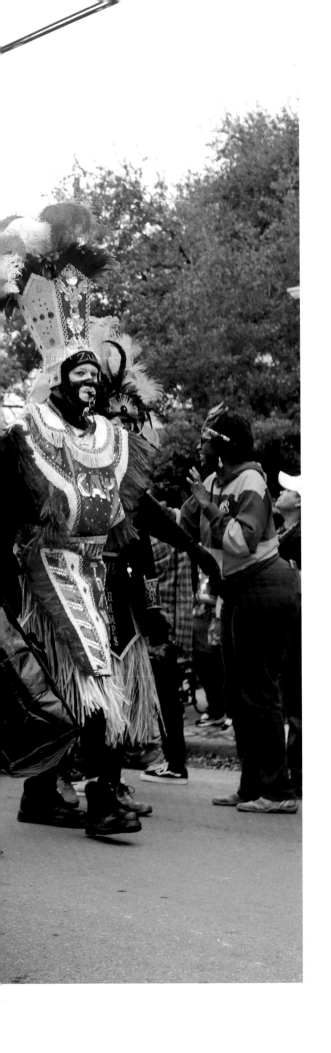

9

WALKING TO NEW ORLEANS

ALL OF OUR KREWES HAVE WORN DOWN THE LEATHER ON THEIR SHOES. THIS MIXED GROUP HAS A DIFFERENT TAKE ON PARADING INCLUDING SOME OF THE CITY'S LONGEST CONTINUALLY OPERATING KREWES. THEY'RE A QUIRKY GROUP OF CELEBRANTS; SOME CALL THEMSELVES CLUBS RATHER THAN KREWES, AND HAVE ALL MALE MEMBERSHIP. WE SALUTE THESE CHARMING FELLOWS, PEOPLE WHO EACH YEAR THINK—"FEET DON'T FAIL ME NOW!"

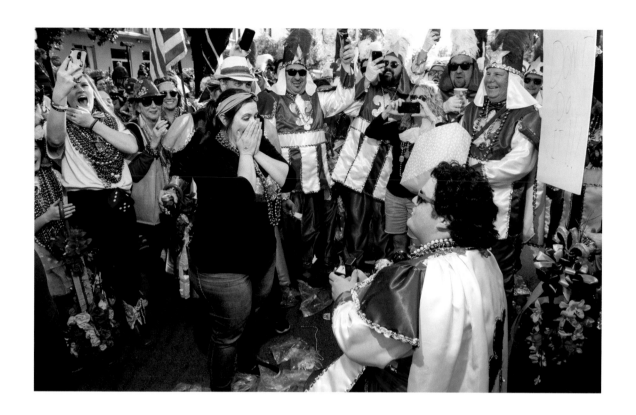

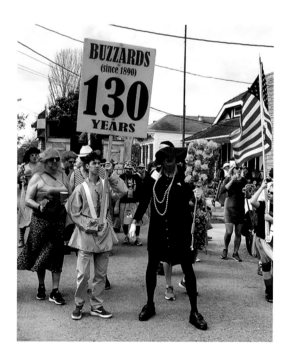

Three of these krewes meander through uptown streets following a band and sometimes parading together Mardi Gras morning and on St. Patrick's Day. Members often carry a cane festooned with paper flowers which they hand out to women along the route—often in exchange for a sweet kiss. These krewes carry on a proud tradition and while they may not be the flashiest, they make up for it with their passion and infectious spirit!

The Jefferson City Buzzards celebrated their 130th year of marching in 2020. They march on Mardi Gras and later in the year they walk in drag. Joining the marching club community in 1918, the Irish Channel Corner Club has strutted the streets of the Irish Channel neighborhood and the Lyons Club has brought joy to Carnival goers since 1947.

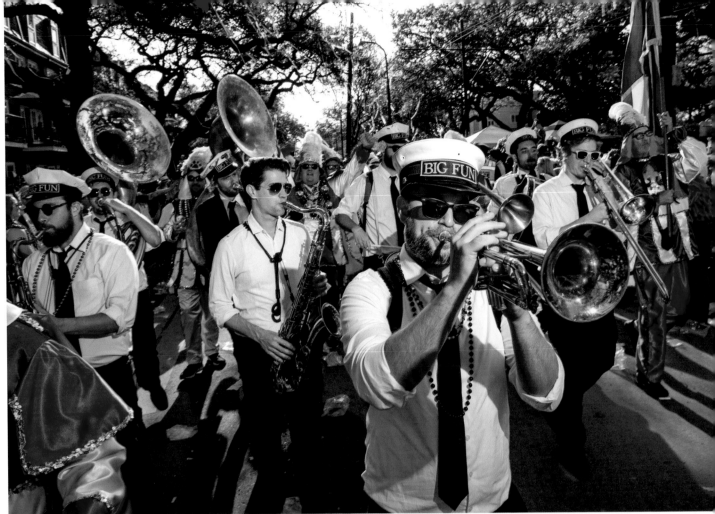

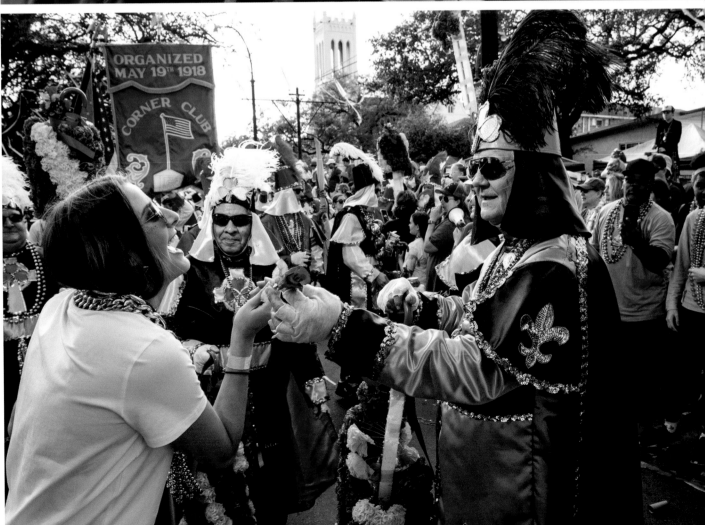

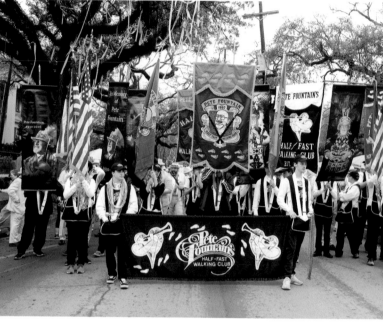

Local musical legend Pete Fountain started the
Half-Fast Walking Club out of his deep love for
Mardi Gras. More than two hundred walkers
participate in this krewe whose original name
was "The Half-Assed Walking Club." Led by
Pete Fountain until his death in 2016, this
sixty-year-old krewe has a "liquid" walk from
Commander's Palace and down through the
parade route each year.

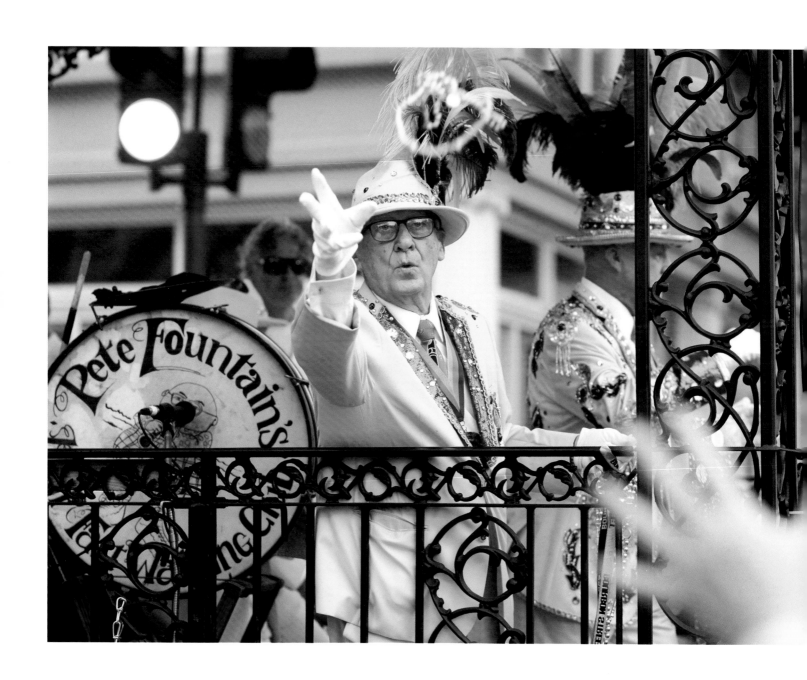

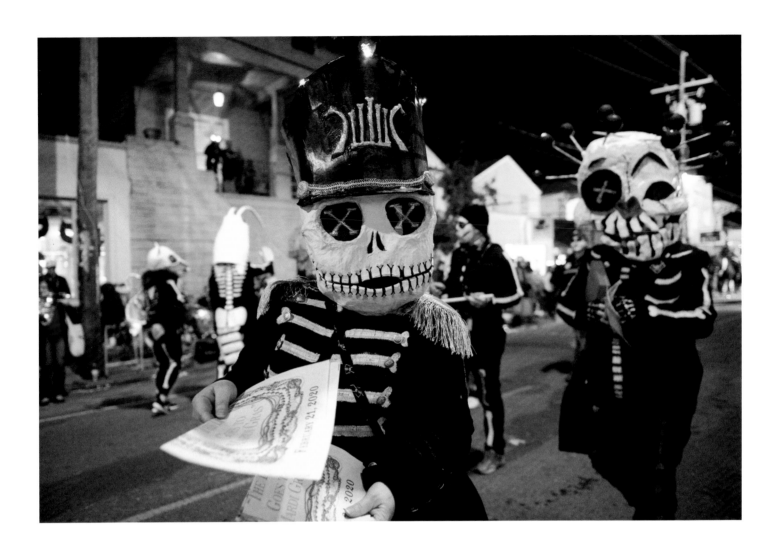

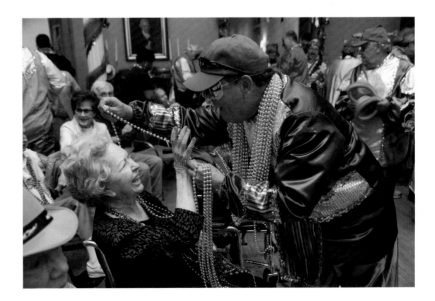

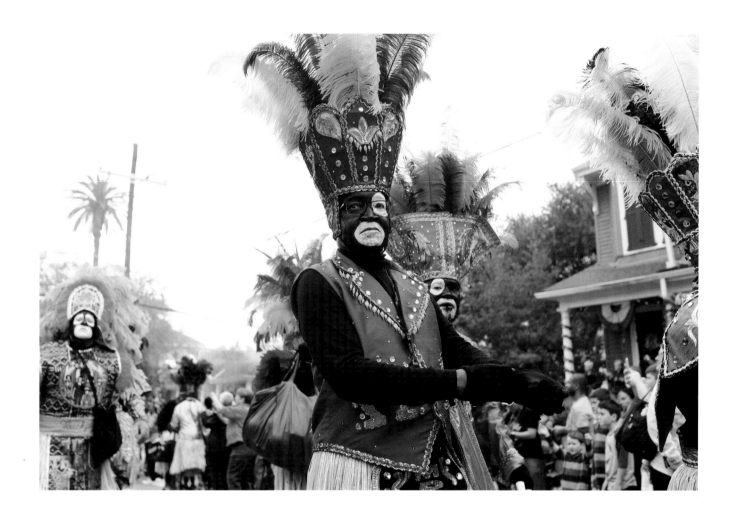

The Krewe of Toth parade was formed to serve people unable
to attend regular parades, the original route passing in front of
institutions that cared for people with disabilities and illnesses.
The group continues this support with the Toth Walkers who visit
extended healthcare facilities to bring them Carnival joy.

In 1909 the Zulu Social Aid and Pleasure Club formed, building
on eight years of less-formal marching by the Tramps. The Zulu
marchers are part of the parade, the Krewe of Zulu. These fierce
marchers clear the streets to shepherd in one of the city's most
beloved parades. Excitement builds when you see them coming
as the regal Zulu parade is following with floats full of coconuts
and fun.

WALKING TO NEW ORLEANS

Irish Channel Corner Club

Jefferson City Buzzards

Krewe D'Etat Skeletons

Lyons Club

**Pete Fountain's
Half-Fast Walking Club**

Thoth Walk

Zulu Walkers

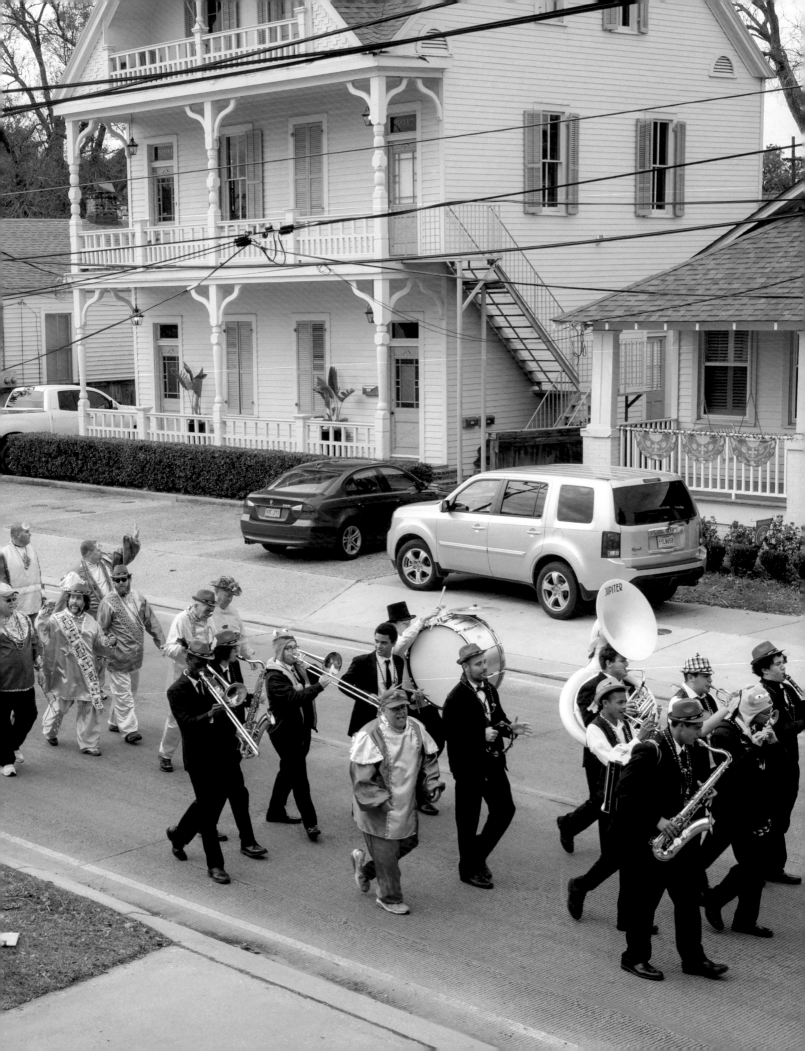

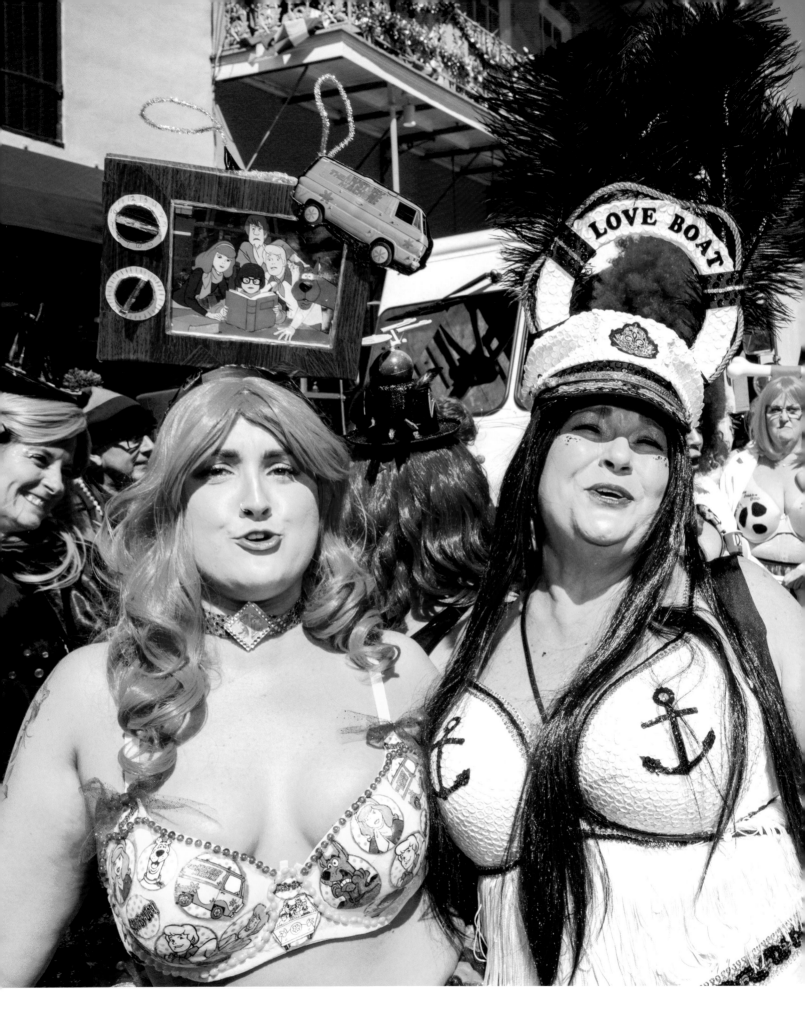

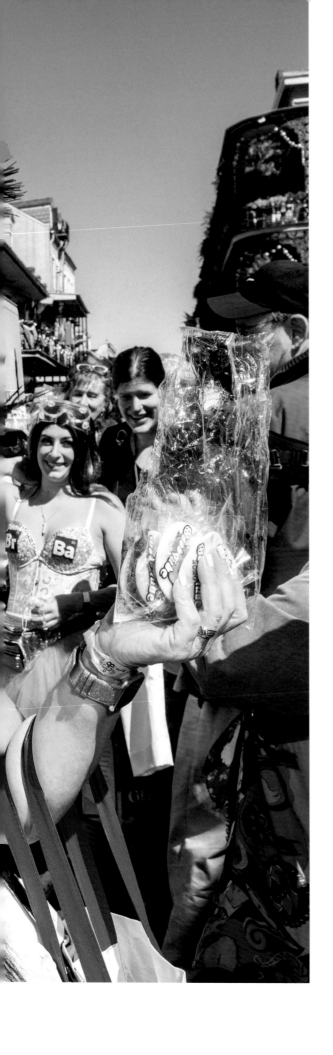

10
LOCAL'S DAY IN THE QUARTER

TOURISM IS NEW ORLEANS' NUMBER ONE INDUSTRY AND, AS SUCH, THE CITY IS OFTEN FULL OF VISITORS. PARKING, CROWDS, AND THE INCREASING COMMERCIALIZATION OF THE FRENCH QUARTER KEEP MANY LOCALS FROM REGULAR VISITS. THAT CHANGES ON THE FRIDAY BEFORE MARDI GRAS WHEN LOCALS THRONG TO THE QUARTER.

These celebrants, some of them formal krewes and some not so formal, have lunches at fancy restaurants, hang on balconies, and stroll the streets—sometimes with bands and usually in costume celebrating life in the city. They celebrate survival or simply want to be sassy and dazzling. Keep your eyes open and you can find Goddesses, Madams, Dragonflies, Prissy Hens, Dames and Divas. While many of these groups foster the empowerment of female identity, they all present the joy locals feel for a Mardi Gras celebration. Get your reservations early and join in the fun.

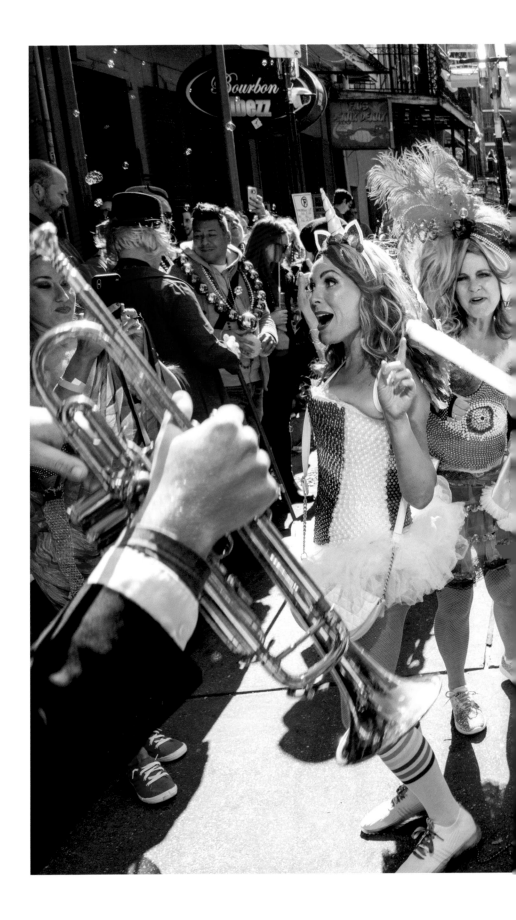

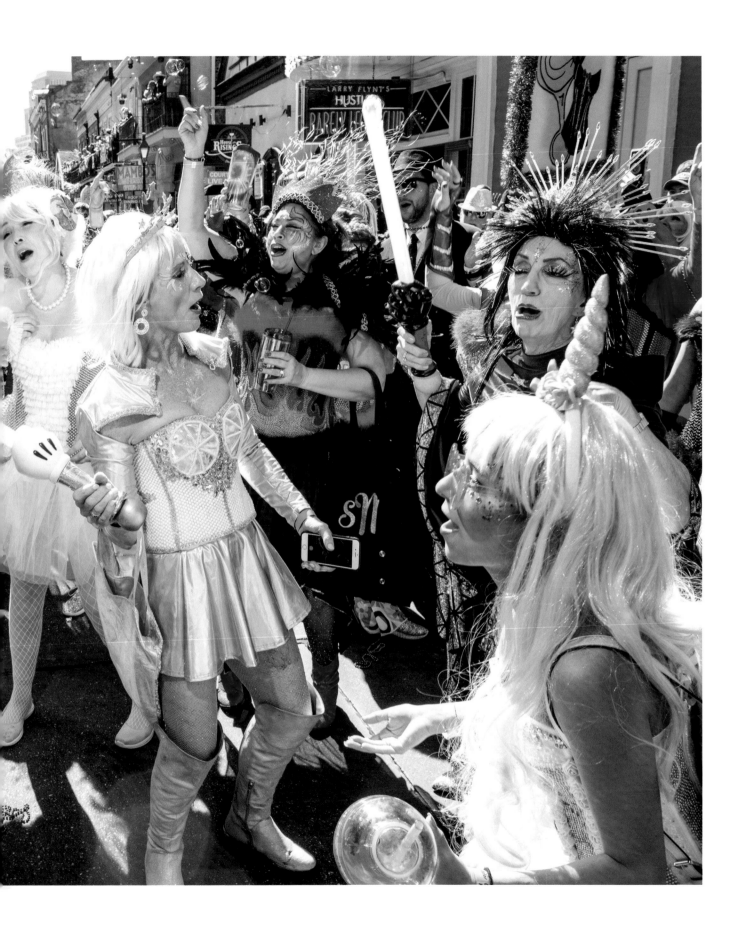

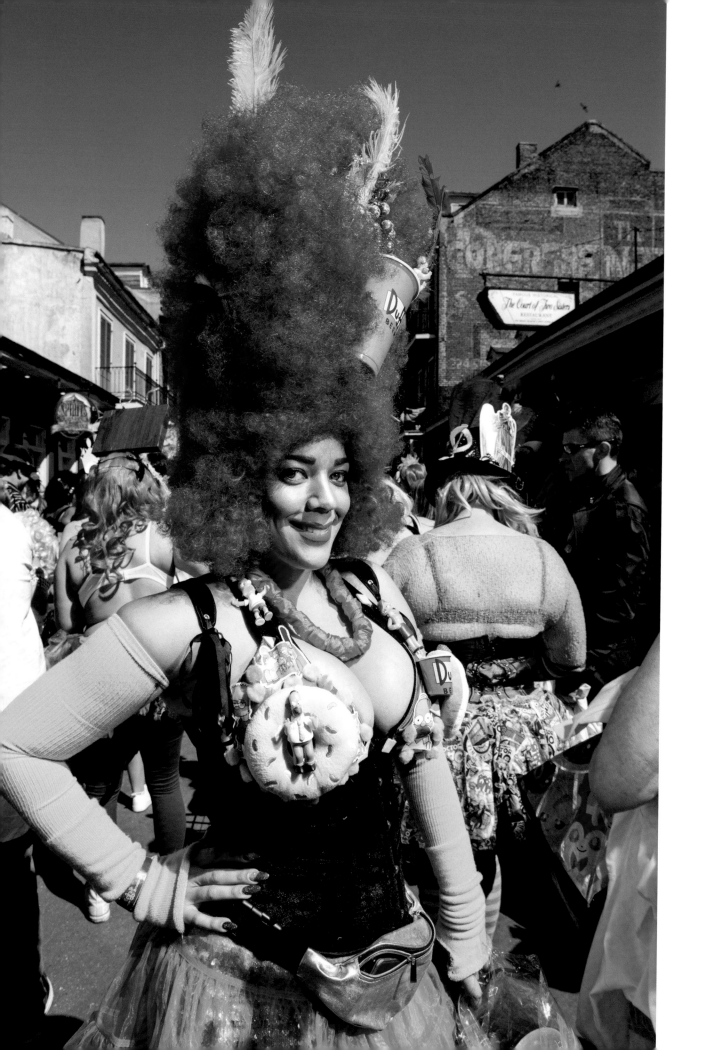

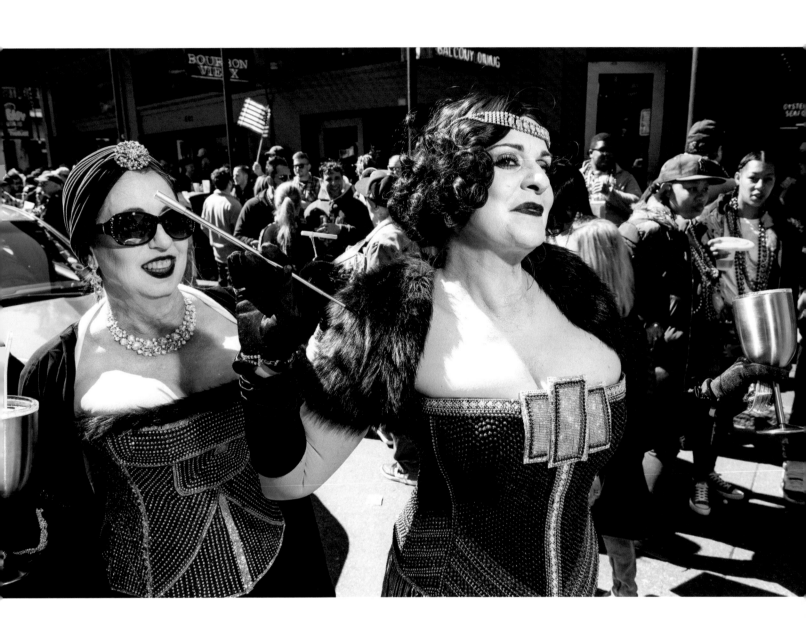

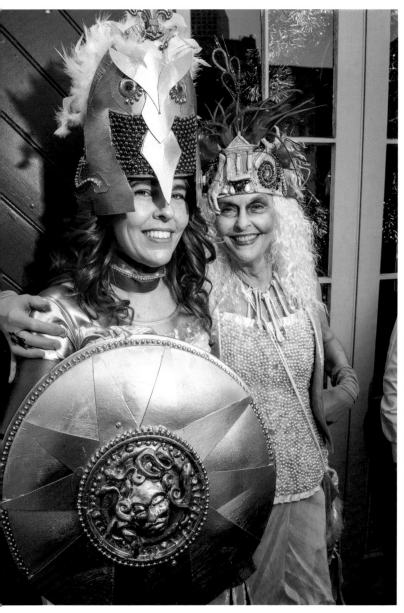
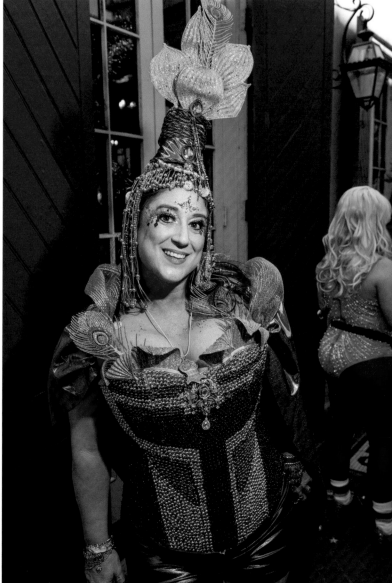

THESE GROUPS PRESENT THE JOY LOCALS FEEL FOR A MARDI GRAS CELEBRATION.

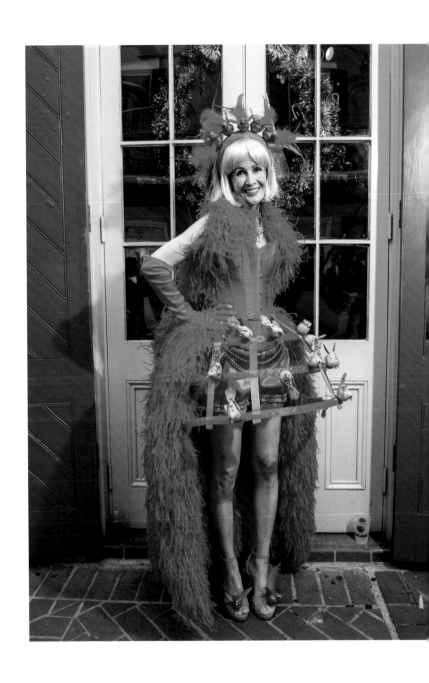

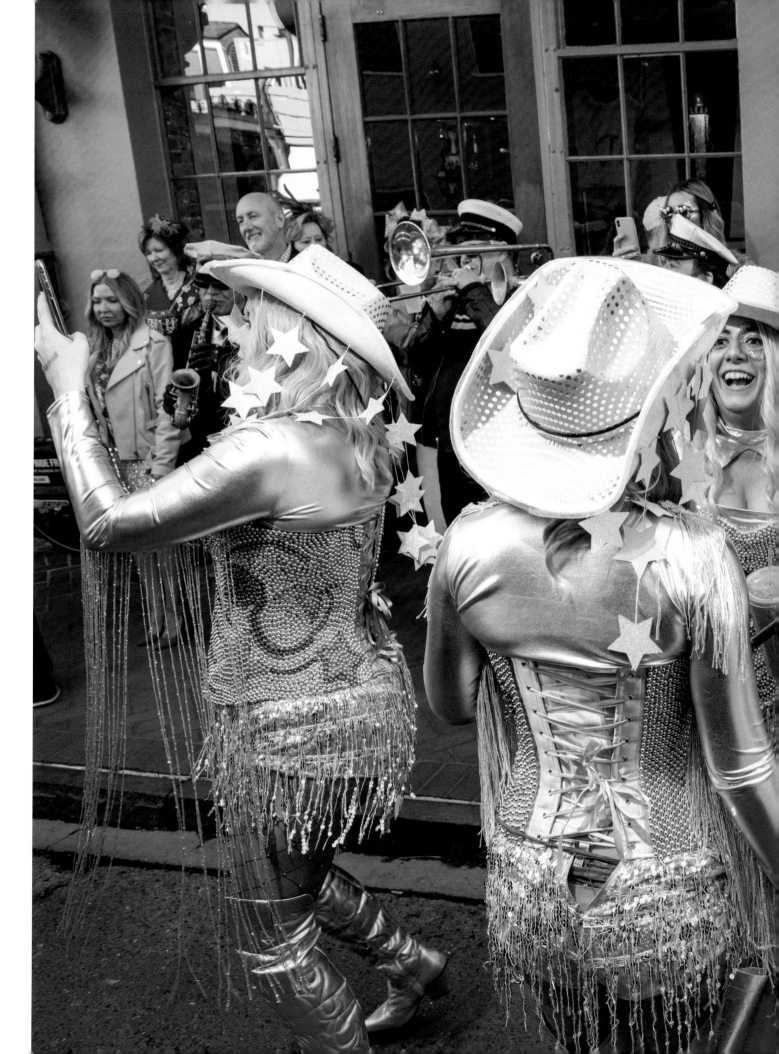

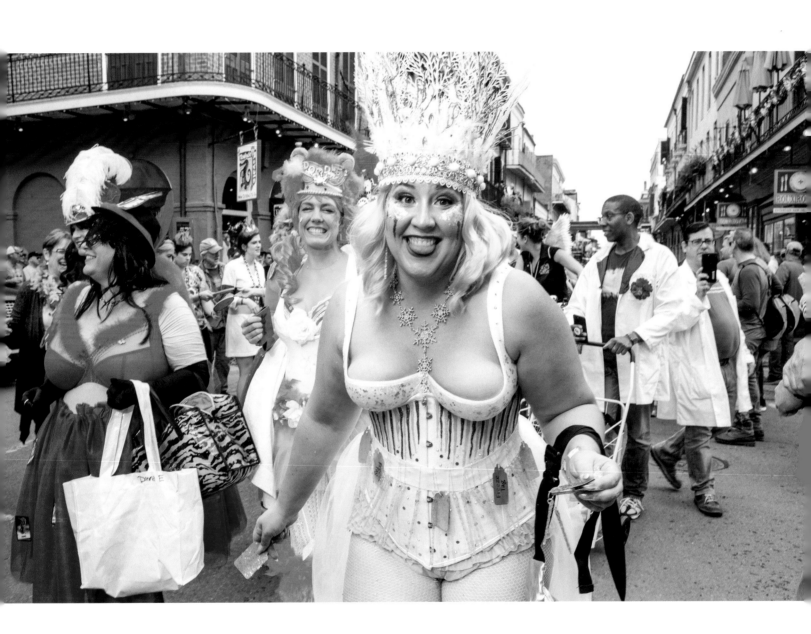

LOCAL'S DAY
IN THE QUARTER

Bosom Buddies and Breast Friends

DIVAS

French Quarter Madams

Krewe of Goddesses

Krewe of Crescent City Dames

Persphone's Dragonflies

Prima Donnas

Prissy Hens and Strutting Cocks

...and so many others

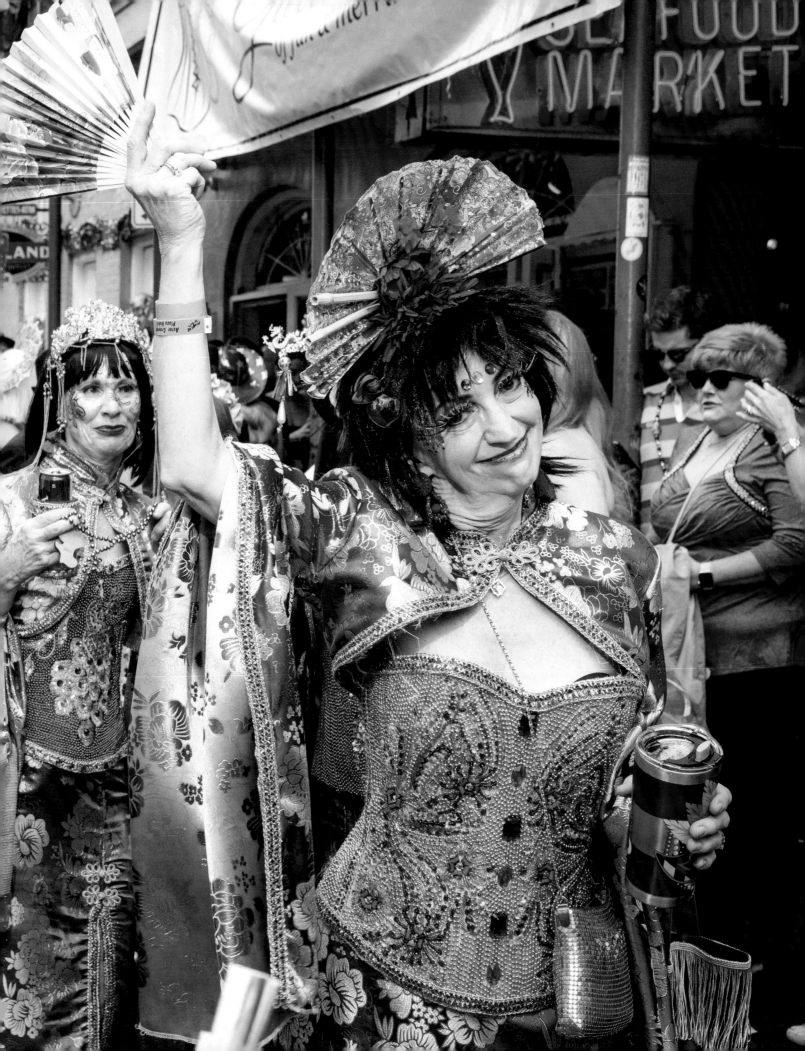

ON STARTING A KREWE

"My brain says don't do it, but my soul says to go forward. It's fulfilling in ways you don't believe."
–Brett "Slab" Patron, 610 Stompers

Tell your idea to a few close friends. If their eyes light up, go for it. It if makes you feel good, start promoting on social network and go with it.
–Beth Etheridge, Chewbacchus

Start small—decide your group size and understand that things change. If you don't want the krewe to change you have to stay in charge. Build into culture intentionality. Farm out more responsibilities. Remember—this is extra-curricular!
–Camille Baldassar, Original Founder, Pussyfooters

Know what you're getting into and know why you're getting involved. Understand what you want to bring and how you're going to deliver it. Who is the intended audience? You'll find that you're drawn to certain people, and they pull something from you that wasn't there. We made a difference and want to inspire people to do the same. Use your powers for good. We're really good at fun, and fun can raise a lot of money for good purposes!
–Shelita Domino, Pussyfooters

If you're starting a krewe, you need a right hand you can really trust. Go and be in another krewe before you start one. If creating a krewe, include people who have had leadership experience and try to balance out the personality traits.
–Laura Shapiro, Krewe des Fleurs

Lovingly handle conflict and have very loving communication.
–Ex-marcher of several krewes

Running a group is nothing like being in one. You need real leadership skills. It helps that I'm not a drinker! As you start your work, think about what you are starting and stay true to that experience.
–Katrina Brees, Krewe of Kolossos

Be prepared for lots of work. If you don't love it, it won't last. Having cohesion with your image is really important to creating and maintaining an identity.
–Devin DeWulf, Red Beans

It takes commitment and lots of energy. You have to invest time in creating your costume, practicing the dances or rhythms, and if you are organizing the group, it is like a second job with lots of emails, logistics and planning.
–Sarah Dearie, Bloco Seriea

If you are thinking of joining or creating a marching krewe, don't feel intimidated...small krewes like us bring lots of joy to the route. You can be a group of three or four starting out. You can be new to town and looking to make friends. Just don't let fear of the unknown stop you. Just do it!
–Teresa Aielo, Bayou Babes

To start your own krewe you must have a very thick skin because it can be competitive...everyone has their own opinions and philosophy. You may even think you are starring in an episode of *Mean Girls*, but I guarantee you will never want to be uninvolved, you will not regret it but will live for it.
–Anita Oubre, Mahogany Blue Baby Dolls

Define who you want to be and who you don't want to be and each year assess how close you are to that goal and adjust.
–Michael Tisserand, Laissez Boys

DOS AND DON'TS OF ADMINISTRATION

"Keeping the krewe together is much like sweeping feathers."
–Carol Miles, DIVAS

Krewes are not a democracy: they are hierarchical, more dictatorial than parliamentary—you must manage chaos. How you lead defines the work. Having three people in leadership is good. You can always make a majority, not a stalemate.
–Kirah Haubrich, Overlord DiLithiumCrystal and GrandMamalier of Chewbacchus

If you're committed to a consensual process, you must remain true to that commitment, and hold unapologetically to the theme and focus, even if it presents more challenges.
–Various krewe members

Nobody is paid in our krewe—and the reality is that the first year it was a forty to forty-five hours a week job.
–Laura Shapiro, Krewe des Fleurs

You have to have serious time management to ensure that everyone is in a place where they feel supported. You're drawn to certain people, and they pull something from you that wasn't there.
–Shelita Domino, Pussyfooters

Have sliding scale for performances - free for good causes, paid for corporate events-kind of a moral scale.
–"Slab", 610 Stomper

Have created "Gilda Lily" who handles all communications, makes public announcements and communicates with the krewe, serving as the good cop/bad cop. More than one person makes the hard decisions so it's not one person who is seen as bad.
–Gilda Lily, Krewe des Fleurs

Plan for a storage unit and work that into your budget.
–Devon Dewulf, Krewe of Red Beans

ON BEING A MEMBER

"Focus on self-sufficiency, self-advocacy."
–Gilda Lily, Fleurs

If you want to have input on any decisions, you must work on those aspects in which you are interested. Put up or shut up.
–Casey Love, Cameltoe Lady Steppers

What you get out of participating is creative fulfillment, creating team and real relationships and fulfillment in helping others.
–Millisia White, NOBDL

Parading takes me to a special place deep within myself that I didn't know existed. It is a transformation of self that comes from deep within the soul. Dancing the streets gives me self-confidence, an utter joy and gratitude to be alive.
–Anita Oubre, Mahogany Blue Baby Dolls

Know what you're getting into and know why you're getting involved. A smile can go a long way. Understand what you want to bring and how you're going to deliver it. Recognize who is the intended audience.
–Shelita Domino, Pussyfooter

Don't be afraid to let your freak flag fly. For me, it's a creative outlet that is supported in this town. If you are a professional, you don't often have the opportunity to tap into your creative side. This provides it.
–Francesca Brennan, Krewe Bohéme

It's not about people seeing you, it's about being together and having a collaborative experience.
–Nancy Fournier, Flora and Fauna

ON MARCHING

"If you've been thinking about it, DO IT. You get to make Mardi Gras happen."
–Seran Williams, Dames de Perlage

Create an "oh shit kit", an emergency kit. with supplies–battery charger, tape, costume repair, make-up, etc."
–Beth Etheridge, Chewbacchus

You become a real-time, active piece of the history and culture of New Orleans. You see the real side of carnival that few get to experience.
–Seran Williams, Dames de Perlage

It's humbling to get home after twenty thousand steps and realize you have to make dinner and help the kids with homework.
–Shelita Domino, Pussyfooters.

Stay true to yourself–nothing wrong with being different. It's a passion you believe in. You'll accomplish some great things. You can do it!
–Millisia White, New Orleans Baby Doll Ladies

PARTING THOUGHTS (IDENTITY HAS BEEN REMOVED TO PROTECT THE INNOCENT)

Danger with parading is that people fall too in love with themselves.

No matter what the boundary is, there's always one or two people who push it.

Don't take yourself too seriously—at this point we are forty to fifty-year-old women in majorette costumes.

Have three rules: don't be an asshole, show up, do your part.

There's always someone who is a problem and you get rid of them another will pop up.

You can't have an affair with another Fleur's mate.

For all those groups coming together to shine their souls in the streets during Carnival this is my advice:

1 Be generous

2 Be patient with each other

3 Stay curious- let creativity flow

4 Smile

5 Invite a stranger

6 Drink less to feel more

7 Take in the magic of Mardi Gras with your eyes (give your screen a break)

8 Put Band-Aids, safety pins, extra ribbon, a $20 bill and more glitter in your backpack

9 Don't put your driver's license and car keys in your boot

10 Trust the unknown

–Camille Baldassar, Founder, Pussyfooters

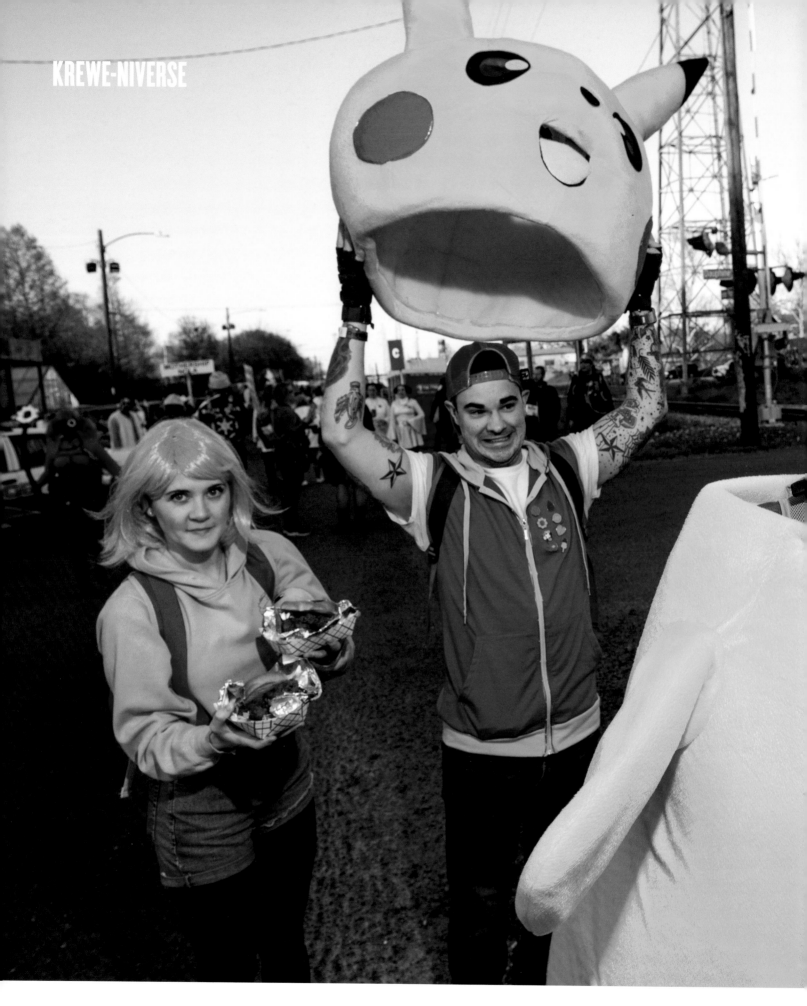

T he Krewe-niverse represents our best
understanding of the multi-faceted, ever
changing world of Mardi Gras marching
krewes. I Wanna Do That! has done our best to
present a snapshot of this universe in 2020. The
sacred and discrete universe of Black Masking
Indians is reviewed in Chapter 4 (pps 116–138) and
may be found listed following the Krewe-niverse,
but we have not attempted to capture them in a
two sentence, jocular description. Apologies in
advance for any mis-spellings, mis-representations,
omissions or inaccurate inclusions. We tried but
perhaps we were hampered by glitter...

...and Boleyns | Based on a pun about the increasing
number of krewes and an homage to Tudor
Queen Anne Boleyn, they are joined by Henry VIII,
executioners and many queens.

504 Eloquent Baby Dolls | Founded by Denise
Trepangier, these lovely ladies are a living legacy,
masking as Baby Dolls they dance as good as they look.

610 Stompers | The glory of dance is central to this
group of ordinary men with extraordinary moves.
They're philanthropist, they're dancers, their passion is
high energy.

610 Wampas | Powerful furred bipeds dance their way
on the Chewbacchus parade route - from planet Hoth
to 610 to the Bywater. What a journey.

6t'9 Social Aid & Pleasure Club | Begun as a
neighborhood parade marching from the 6th to the
9th wards, they now also march as a sub-krewe of the
krewedelusion parade.

Acronola Space Monkeys | This community of
creative monkeys are on a mission to share the love of
acrobatics and glitter in NOLA and beyond.

Aerial Space Squad | Combining the aerial arts and
cosplay for unique and exciting performances using
fandom-themed aerial hoop and pole performances.

AfroFuturist Krewe | The AfroFuturist Krewe desires
not only to have FUN, but to also spread awareness of
Black involvement in science-fiction and fantasy genres.

Alter Egos Steppers | Noted for sisterhood and public
service, you can find these hard-working, age-diverse
group of mothers, wives, sisters and daughters dancing
down the street in purple wigs.

Amazons Benevolent Society | In warrior tunics and breast armor, the Amazons cut a path through adversity on the parade route and at home, their swords representing a "ferocity of spirit and soul."

Amelia EarHawts and Cabin Krewe | Scarlet colored stewardess costumes announce this 85-member dance group inspired by female aviation pioneer Amelia Earhart. Can you handle the turbulence?

Amigos de los Amigos | This Mexican history-themed performance group began in 2008 first near Cinco de Mayo and parading in the Mardi Gras season.

Apollo 42 | An astronaut-themed krewe, Apollo 42's space cadets support Chewbacchus' mission of saving the galaxy with the magical revelry of Mardi Gras.

At DA Beach At DA Beach | This newly forming Mardi Gras krewe is a throwback to Pontchartrain Beach—take the ride!

Austin Aliens | Disciples of the Sacred Wookie, this group is part of the Chewbacchus subkrewe rodeo.

Avatar-licious | Disciples of the Sacred Wookie, this group is part of the Chewbacchus subkrewe rodeo.

Back to the Fuschia | Pink is only a color, Fuschia is the futu-cha!

Batdance | Disciples of the Sacred Wookie, this group is part of the Chewbacchus subkrewe rodeo.

Bayou Babes | Catch one of their glittery mini pirogues (swamp boats) from this group that centers their revelry on wetlands preservation and Zydeco music.

Bearded Oysters | Wearing beards and merkins, this group of all genders and body types marches throughout the year to bring community joy and personal growth.

Beyjorettes | A dancing Beyoncé tribute troupe, this group welcomes Queen Bey-loving women of all body shapes and backgrounds to join the Bey-Hive in the city's "fiercest" parade.

Big Easy Rollergirls | Skating through hell and high water, these tough ladies leave the roller rink to "jump, dance, spin, shoot-the-duck, skate backwards, and shed glitter" in New Orleans parades.

Black Storyville Baby Dolls | Founded in 2012, they are a modern homage to the women who famously costumed in the African-American part of New Orleans' red light district starting in 1912.

Bloco Sereia | Creativity and self-expression weave through the rhythms, dances, design, and puppets that Sierra brings showcasing traditional and contemporary fusions of Afro Brazilian rhythms and dances.

Books To Kids | Disciples of the Sacred Wookie, this group is part of the Chewbacchus subkrewe rodeo.

Bosom Buddies and Breast Friends | Aiming to be classy and sassy, never trashy, they walk in bras and hats, with tutus and wigs to finish their costumes. Founded in 2013.

Box of Wine | Traveling in front of the Bacchus parade, they both satirize and revere those ancient spiritual rites and rituals of the God of Wine.

Brainiacs | Disciples of the Sacred Wookie, this group is part of the Chewbacchus subkrewe rodeo.

Browncoat Brass | This science fiction brass band is the official music of the Intergalactic Krewe of Chewbacchus and is accompanied by the Championette dance troupe.

Camel Toe Lady Steppers | Inspired by the traditions of cabaret, camp, Fosse, and burlesque, this parading group is now a 50-member ensemble that showcase both staged and parade-driven performances.

Candy Girls | Oh so sweet, dressed in purple they bring some sugary shake.

Chewbaccha Rockas | Disciples of the Sacred Wookie, this group is part of the Chewbacchus subkrewe rodeo.

Chew-Bake-Us | They're nerdy, they're kitschy, they're bakey. They love food, fake food, crafting, puns, and pin ups.

ChewBorgUs | The Borg are coming to assimilate the Empire and the Rebellion! Resistance is futile!

Cirque du Force | Cirque du Force revels in the Star Wars theme throughout the Chewbacchus galaxy. They roll in glory with their magnificent Starship, the Force-42 Cargo Hauler.

Companionettes, The | Founded in 2015, The Companionettes dance troupe is based upon the science fiction character Inara and performs to the Star Wars-oriented music of Browncoat Brass.

Cosmic Cart Coterie | Disciples of the Sacred Wookie, this group is part of the Chewbacchus subkrewe rodeo.

Crescent City Dames | A corseted walking club that sashays down Bourbon Street every Friday before Fat Tuesday

Crescent City Fae | Started in 2016, the Fae's Sprites, Pixies, Pans and Elves are connected to all things glittery, nature loving and mystical-embracing that which is sometimes unseen but felt and heard.

Dames de Perlage | Preserving the art and history of hand-beading, these Dames work in perlage circles to complete an eye-popping bead-covered bustier and headdress in an annual theme.

Dance Connection, The | Established in 1979, this traditional dance team was the first troupe to use a mobile sound system. Their motto is "Unity...though dance and friendship."

Dancing in Uranus | Disciples of the Sacred Wookie, this group is part of the Chewbacchus subkrewe rodeo.

Dead Rockstars | Each year the all-male Dead Rock Stars celebrate the essence of a dearly departed rock star. With 20,000 watts of sound and 120 strong rockers, they put the pop in pop star.

Death Star Steppers | A group of stormtroopers, funking it up in New Orleans, the Death Star Steppers are the group for letting the Good Time Imperial Marches Roll.

Denim N'Dem | Denim aficionados and Canadian tuxedo devotees make up Denim N'Dem. Wear your denim best and come get down with them!

Dictator's Dancin' Darlings | The satirical male Darlings can be found in Krewe d'Etat each year. Little is known about this bunch that costumes as a new entity each year—and they seem to like it that way.

Disco Amigos | Disco Amigos want to host the world's largest disco party. Founded in 2012, you can catch this ninety-five-member krewe and get down to disco-era tunes with their disco ball!

DIVAS | These Divine Protectors of Endangered Pleasures march in beaded bustiers on the Friday preceding Fat Tuesday and are known for their specially designed bustier bead throws.

Expendable Extras | Disciples of the Sacred Wookie, this group is part of the Chewbacchus subkrewe rodeo.

Fhloston Paradise | Disciples of the Sacred Wookie, this group is part of the Chewbacchus subkrewe rodeo.

Flora and Fauna | Rising from the ashes of Krakatoa, Flora and Fauna will bring you a resplendent biome, honoring the beasts and the beauty of nature through carnival magic.

French Quarter Madams | Inspired by the entrepreneurial women of Storyville, these ladies use found, saved, and reusable objects on their stunning costumes while strutting with their Gentlemen Callers.

G.O.G.G.L.E.S. | An inclusive and ambitious group of builders, crafters, and revelers committed to bringing steampunk love to the masses. An annually changing theme is bolstered by neo-Victorian attire.

Game Krewb | Disciples of the Sacred Wookie, this group is part of the Chewbacchus subkrewe rodeo.

Generation Warriors Baby Dolls | These lovely ladies are a living legacy; masking as Baby Dolls they dance as good as they look.

GIGERGEIST | Their krewe is an ode to artist H.R. Giger's airbrush images of humans and machines connected in cold biomechanical relationships and is a dedication to the Alien movie series.

Golddigger Baby Dolls | Merline Kimble and Lois Nelson started the group in the 80s as a way to honor Ms. Kimble's grandparents' social aid and pleasure club, The Gold Diggers.

Gris Gris Strut | Devoted to forward-moving, full-on dance moves, this 95 member krewe has brought their energy to delighted parade goers since 2009.

Guise of Fawkes Krewe | A revolution-themed krewe that parades with krewedelusion and at other times of the year, Guise of Fawkes honors arrested anons, whistle-blowers, and political prisoners.

Honey, I Blew Up the Kingcake Babies | Disciples of the Sacred Wookie, this group is part of the Chewbacchus subkrewe rodeo.

Illuminaughties | Disciples of the Sacred Wookie, this group is part of the Chewbacchus subkrewe rodeo.

Intergalactic Krewe of Chewbacchus | THE krewe for reveling Star Wars freaks, Trekkies, Whovians, mega-geeks, gamers, cosplayers, circuit benders, cryptozoologists, UFO conspiracy theorists, mad scientists, and super nerds.

Interrobang‽ | Interrobang is a wide-eyed question, answered with surprise and delight. Crazy big creatures, pushed by hand (mostly) and built with love (entirely)!

InVaders | The Dark Side of the Force guides them. Mostly Sith Lords, they also welcome stormtroopers, AT-ATs, and others who are willing to side with Darth Sidious' Galactic Empire.

Irish Channel Corner Club | Organized in 1918 by a group of seven men on the corner of Third and Rousseau streets, this men's walking club disbanded for WW2 and reconvened in 1947, walking ever since.

Jailhouse Rockers | Founded in 2017, the Jailhouse Rockers are a dancing offshoot of the Rolling Elvi, proving that Elvis is still in the house.

Jayne Austen Book & Gun Club: Pride and Extreme Prejudice | Celebrating a mashup of the Hero of Canton, Jayne Cobb, with the works of revered author Jane Austen.

Jedi Nights | Disciples of the Sacred Wookie, this group is part of the Chewbacchus subkrewe rodeo.

Jefferson City Buzzards | Founded in 1890, the Jefferson City Buzzards Marching Club parades each Mardi Gras Day, walking through uptown neighborhoods.

Knights of Mondu | A sub-krewe of Krewe du Vieux's existential culmination of vision and spirituality, this group is not easily described—really!

KOE Cyber Parade | Self-proclaimed first "cyber krewe," KOE commenced in 1998 when a couple of netheads brought together people from twenty-eight states through online communication.

Krewe D'Ensite | A sub-krewe of the Krewe Bohème parade.

Krewe D'UndeROOs | Inspired by two young children and their playful family who wanted to ride ANT-THONY (a flying ant from Ant Man) IN the parade.

KREWE DAT 504 | Their Soul Purpose is to connect the world to New Orleans and all the good that New Orleans has to offer.

Krewe de C.R.A.P.S. | Known for their truly awesome parodies, this sub-krewe of Krewe du Vieux since 1994 continues its tradition of satire, fun and craziness.

Krewe de Fu | "Para-militant, Ultra-decadent" a melding of the martial and Mardi Gras arts and an excuse to build, party, and train in ways that otherwise don't fit into normal adult life.

Krewe de Jean D'Arc | Lighting the way to the Carnival season, Krewe de Jean D'Arc parades on the birthday of Jean—12th night and throughout the year to promote St. Joan and the city's French heritage.

Krewe de la Renaissance | The krewe celebrates personages from the 14th–19th centuries: Saxons, Vikings, Pagans, Danes, Scotts….oh my!

Krewe De LUX | Krewe De LUX is an auspicious celebratory organization dedicated to serving New Orleans in the form of luxury and light.

Krewe De Seuss | They aim to be whimsically ridiculous and frivolously preposterous! Of course. Marching is inspired by whimsical and impossible musical instruments imagined by Theodore Geisel.

Krewe de Vieux | Based on the historical concept of a parade as a venue for individual creative expression and satirical comment, KdV features mule-drawn floats and costumed revelers with jazzy musicians.

Krewe des Fleurs | These glorious larger-than-life costumes celebrate the beauty of a different flower each year with imagination and inspiration. They're hydrated and tended by "gardeners" on the route.

Krewe du Chu | A Pokemon themed Krewe! "Gotta throw 'em all."

Krewe du Glitz | Disciples of the Sacred Wookie, this group is part of the Chewbacchus subkrewe rodeo.

Krewe du Jieux | A free spirited krewe dedicated to deflating stereotypes that historically have been aimed at Jewish People through laughter and satire.

Krewe du Mando | Disciples of the Sacred Wookie, this group is part of the Chewbacchus subkrewe rodeo.

Krewe du Mishigas | Yiddish for "craziness," Krewe of Mishigas is a Jewish sub-krewe of Krewe du Vieux, having all kinds of crazy.

Krewe du Moon | Channeling Sailor Moon characters, these schoolgirls and friends bring their superhero powers to Chewbacchus.

Krewe du Resistance | Sparkly and fierce, this group of NB/Female Identifying Star Wars fighter pilots bring resistance to NO. They are the spark that starts the fire of resistance.

Krewe du Rouxge | New Orleans' all-redhead parading group, they are ginger and proud!

Krewe du Sue | Embracing satirical forms and traditions, this is a subkrewe of krewedelusion.

KREWE DU WHO | Krewe Du Who's community of enthusiastic and POSITIVE Whovians is open to all who share in their ongoing celebration of Doctor Who.

Krewe Dza Dza | Disciples of the Sacred Wookie, this group is part of the Chewbacchus subkrewe rodeo.

Krewe Feijao | The 3rd Red Beans krewe/parade, Feijao or "Big Bean" began in 2020 to draw on the similarities between La. and Brazil with their bean-heavy diets and carnival expressions.

Krewe of 2.2 | With the idea of taking it to the streets come hell or high water, the Krewe of 2.2 marches the Monday before Lundi Gras: everyone accepted but posers, hipsters, and douchebags.

Krewe of Bananas | They're a Mardi Gras walking krewe named after a dog who was named after a fruit.

Krewe of Barkus | The only Mardi Gras krewe in New Orleans for the canine population. They wag, they sniff, they pose in their costumes. And they allow their humans to join them.

Krewe of Boheme | Reflecting the creative and eclectic membership of bohemians and beauties, the fantastical Krewe Bohème presents a visual and auditory feast of mystery, artistry, and family fun.

Krewe of C.R.U.D.E. | The "Council to Revive Urban Decadence and Entertainment" (C.R.U.D.E) is a sub-krewe of Krewe du Vieux.

Krewe of Cork | Two Fridays before Mardi Gras (in costume), and select Fridays each month (T.G.I.C.D-Thank Goodness It's Cork Day) this group celebrates Wine! Food! Fun!

Krewe of Cosmic Cuties | Disciples of the Sacred Wookie, this group is part of the Chewbacchus subkrewe rodeo.

Krewe of Crescent City Dames | These "fantastically fabulous" natives celebrate friendship, sisterhood, and the great city of New Orleans while showing off their sensational hand-beaded corsets!

Krewe of Dead Beans | A sub-krewe of the Krewe of Red Beans, the Dead Beans wear suits inspired by any mythological or folkloric tradition that deals with death, mortality, or the afterlife from around the world.

Krewe of Dreux | Krewe of Dreux has paraded on the Saturday before Mardi Gras, bringing joy to the townspeople of the Gentilly neighborhood since 1972.

Krewe of Drips and Discharges | A sub-krewe of the Krewe du Vieux parade whose common commitment is to turn the most profane themes into a communal ritual of critique, lament, and ribaldry.

Krewe of Dude | New Orleans' calmest (calmer than you are) krewe, they like White Russians, Sioux City Sarsaparillas, and/or the occasional acid flashback. Do you abide? Rolling on Shabbos since 2017.

Krewe of Dystopian Paradise | "We hereby pledge to celebrate our city and each other, until we fall into the swamp, sink into the sea, succumb to the zombie apocalypse, or die of extremely boring natural causes."

Krewe of Fools | "Pro Bono Ridiculum"— this krewe's mission is to celebrate, preserve, protect, and promote the art of street performance in New Orleans.

Krewe of Full Bush | A Krewe of fuzzy humans who are absolutely pro-hair. No doubt merkins are prohibited.

Krewe of Goddesses | The Goddesses reclaim their divine sexuality working towards the empowerment of the female identity, body positivity, and sex positivity through outreach, activism—and parading.

Krewe of Heavenly Bodies | Krewe of Heavenly Bodies is the hottest thing this side of the Galaxy, welcoming all cosmic revelers from constellations to sputniks, from black holes to Uranus.

Krewe of Hellarious Wingnuts | The Krewe of Hellarious Wingnuts celebrates all the wingnuts out there! From your baby cousin to the girl down the block, from yo' mama to your ownself.

Krewe of J.A.W.S. | Disciples of the Sacred Wookie, this group is part of the Chewbacchus subkrewe rodeo.

Krewe of JULU | Begun in 1993 by a surprising lust for Eastern European folk music, this parade has grown into an indescribable annual tradition each Tuesday before Lent. Get ready to celebrate!

Krewe of K.A.O.S. | A sub-krewe of the Krewe du Vieux parade whose common commitment is to turn the most profane themes into a communal ritual of critique, lament, and ribaldry.

Krewe of Kokomo | A band of intergalactic party animals faring from their home island of Kokomo on an adventure to spread the good word of their deity, Jabba the Tiki Hutt.

Krewe of Kolossos | Kolossos is an inspiring mobile spectacle transforming trash into a whimsical world of Carnival. Featuring art bike floats, circus performers, dancers, colorful costumes, and interactive props.

Krewe of Krakatoa | Krewe du Krakatoa is the living embodiment of Tiki culture in New Orleans. They are resurrecting the grand Poly Pop tradition. Aloha!

Krewe of L.E.W.D. | A sub-krewe of the Krewe du Vieux parade whose common commitment is to turn the most profane themes into a communal ritual of critique, lament, and ribaldry.

Krewe of Lafcadio | Paying tribute to journalist and writer Lafcadio Hearn (1850-1904) who published extensively about New Orleans culture.

Krewe of Life | Disciples of the Sacred Wookie, this group is part of the Chewbacchus subkrewe rodeo.

Krewe of Mama Roux | Their name is an homage to Dr. John, their themes are irreverent and play mischievously with words. Since 1988, this group has members of all stripes most of whom are long-standing.

Krewe of Mardi Gore | Disciples of the Sacred Wookie, this group is part of the Chewbacchus subkrewe rodeo.

Krewe of Oak | Friday before Mardi Gras (half a year later in Mid-Summer), Krewe of Oak makes a "predictably risqué" neighborhood circuit with many of our favorite marching krewes throwing down.

Krewe of Red Beans | Krewe of Red Beans takes inspiration from and supports local culture through homage and philanthropy, creating fascinating costumes and terrific culture...of course on Red Beans Monday.

Krewe of Remix | Science fiction and costuming blended with debauchery = Costuming Across Universes.

Krewe of RUM | These "Really Unsophisticated Men" connect through the spirit rum, and when not marching, host rum tastings. Their motto is "Saving the World's problems, one rum cocktail at a time."

Krewe of Sharknadeaux | Disciples of the Sacred Wookie, this group is part of the Chewbacchus subkrewe rodeo.

Krewe of SLUTS | These ladies enjoy the NOLA life: they're "SEXY LADIES UP TO SOMETHING."

Krewe of Smegheads | Vindaloo and lager are life!

Krewe of Space Age Love | Known for its fearless attitude that all who exist are fair game for their political and social satire, Space Age Love rolls with Krewe du Vieux.

Krewe of SpaceCats | They're cats. From Space.

Krewe of SPANK | They foster unity, equality, and good times while creating lower echelon, satirical Mardi Graserie under the influence of a shit-ton of beer, chemicals, and glitter.

Krewe of Spatacus | Disciples of the Sacred Wookie, this group is part of the Chewbacchus subkrewe rodeo.

Krewe of Stranger Things | They fight against The Upside Down and believe that a great group of friends can fight and win against all odds.

Krewe of Sustainable Uplift | Embracing satirical forms and traditions, this is a subkrewe of krewedelusion.

Krewe of the Living Dead (KOLD) | Calling New Orleans Area Zombie and Horror Nerds to unite, the Krewe of the Living Dead provides the most unique Zombie walk experience in the world, NOLA Style.

Krewe of the Mystic Inane | Rolling as a sub-krewe of Krewe du Vieux, the Mystic Inane share their drunken revelry with you every Mardi Gras, satirically!

Krewe of 'Tit Rex | The antithesis to colossal parades, this micro-krewe is not only witty and wily with miniature throws matching satirical shoebox floats, they're all guided by suave float-masters and riders.

Krewe of Underwear | Krewe of Underwear's common commitment is to turn the most profane themes into a communal ritual of critique, lament, and ribaldry. And they've got moves too.

Krewe of Uranus | Disciples of the Sacred Wookie, this group is part of the Chewbacchus subkrewe rodeo.

Krewe of Zissou | Disciples of the Sacred Wookie, this group is part of the Chewbacchus subkrewe rodeo.

Krewe Rue Bourbon | A sub-krewe of the Krewe du Vieux parade whose common commitment is to turn the most profane themes into a communal ritual of critique, lament, and ribaldry.

Krewe What Thou Wilt | These New Orleanians consider themselves guardians of the spirit of Carnival: they co-mingle their madness with that burning joy found at every gate and by-way of the city.

krewedelusion | Embracing the forms and traditions of our satirical parades, krewedelusion' mission is to save the Universe, beginning at its center—New Orleans. They're a parade with a purpose.

Krewepernatural | They're Supernatural fans first, craft nerds second with all their parade throws and cosplay costumes made by hand each year—as is their contraption, the Impala.

KREWE-THULHU | Perhaps they're inspired by Lovecraft's Cthulhu—a blend of octopus, dragon, and human? Regardless, they "Roll for Sanity!" with Chewbacchus.

Ladies Godiva | Necks swivel as they pass in the Muses Parade, these Ladies Godiva ride horses in their nude costumes covered only by their hair.

Laissez Boys | These men of industry practice and teach the art of earned relaxation, the majesty of intemperance and the value of chairitable servitude. These gentlemen glide in style.

Le Krewe de Chaos Intergalactique | Formerly the Intergalactic Krewe of Chaos, they are part of the Chewbacchus sub-krewe rodeo, and their krewe is supersecret.

lee hans solo fook | Disciples of the Sacred Wookie, this group is part of the Chewbacchus subkrewe rodeo.

Leijorettes | Numbering more than 100 dancing members, Leijorettes honor Princess Senator General Leia Organa of Alderaan. No need to travel to a galaxy far, far away to see them kickin' it live.

Les ReBelles | Connecting women regardless of age, shape, and background through dance, Les ReBelles celebrate "La Liberation de la Femme" with a relevant theme each year.

Lucha Krewe | In their colorful masks, these luchadores practice high flying maneuvers and freestyle wrestling in a mobile wrestling ring on the parade route. Off-route this co-ed krewe is community focused.

Lyons Club | Founded in 1947 the Lyons Club parades uptown starting on Lyons Street with brass band music on Mardi Gras and St. Patrick's Day.

Mahogany Blue Dolls | They're thrilled and honored to share the unique masking tradition of the Baby Dolls; the Mahogany Blue Dolls bring the celebration with them.

Mahogany Reggae Baby Dolls | These lovely ladies are a living legacy; masking as Baby Dolls they dance as good as they look.

Mande Milkshakers | The Mande Milkshakers have crossed the lake to shake things up in New Orleans parades since 2017. They're the Northshore's first marching group and women's organization.

Mardi Gras Dream Weavers | A group of people who bring dreams to reality, creating costumes for those with mobility issues from wheelchairs and walkers.

Mario Kart Krewe | A group of friendly fanatics who blend nerdy parades with Nintendo charades.

Men in Black | Always the final krewe of Chewbacchus—they will neutralize you and you will have no memory of the parade. Click.

Ménage a Trike | A sub-krewe of the Krewe Bohème parade.

Mischief Managed | "We solemnly swear we are up to no good." A sub-krewe for fans of the Boy Who Lived (or He Who Must Not Be Named).

Mistick Krewe of the High Ground | Disciples of the Sacred Wookie, this group is part of the Chewbacchus subkrewe rodeo.

Mondo Kayo | Celebrating the "Northernmost Banana Republic" this footloose and rambunctious parade uses tropical abundance, gonzo mentality, and do-it-yourself vim to please the Tiki gods.

Montana Dancing Baby Dolls | These lovely ladies are a living legacy; masking as Baby Dolls they dance as good as they look.

Moon Marauders | Disciples of the Sacred Wookie, this group is part of the Chewbacchus subkrewe rodeo.

Mothership NOLA | Disciples of the Sacred Wookie, this group is part of the Chewbacchus subkrewe rodeo.

MSY | Dressed in royal blue, this krewe of airline stewardesses (named for Louis Armstrong international Airport whose call letters are MSY) strut their stuff.

Muff-A-Lottas | Saddle shoes, short skirts and 50s diner waitress outfits adorn the feisty Muff-A-Lottas dance troupe. Founded in 2009, they love to strut their "muff-stuff."

Muppets from Space | Part of the Chewbacchus sub-krewe rodeo, this children-based krewe celebrates furry Muppets from space.

Mystic Krewe of London, France & Underpants | They're on a mission to drop panties all over your quarter!

Mystic Krewe of P.U.E.W.C. | People for the inclusion of "Unicorns, Elves & Whinebots in Chewbacchus" parades year-round and welcomes all creatures, genders, and folks who want to spread love and glitter!

Mystic Krewe of Spermes | A sub-krewe of the Krewe du Vieux parade whose common commitment is to turn the most profane themes into a communal ritual of critique, lament, and ribaldry.

Mystic Order of Mystery Science | Disciples of the Sacred Wookie, this group is part of the Chewbacchus subkrewe rodeo.

Mystic Vixens | They get around! The Mystic Vixens are bringing their ladies dance/marching group to communities throughout the region.

Mystick Krewe of Comatose | Their motto, for those whose Latin is a bit rusty, says, "Thus I desire, thus I enjoy life to the fullest."

N'Awlins Nymphs | A satirical female group within the Krewe d'Etat parade. Changing themes annually, they have made mischief since 2012.

New Orleans Baby Doll Ladies | Rooted in longstanding tradition, the New Orleans Baby Doll Ladies update the essence of Creole masking, song and dance...because they "have something to dance about."

New Orleans Creole Belle Baby Dolls | A Creole Belle Baby Doll is a Louisiana-rooted beautiful Black woman who stands out amongst a crowd while in sisterhood, carrying on the one hundred-year-old masking tradition.

New Orleans Jedi/ Order of the Jedi | The JEDI Seek Wisdom and Knowledge in the Universal light. Now Let's get the Party Started!

Noisician Coalition | Their music is in the key of mayhem, their instruments are chaos, they are the Noisician Coalition...dare to dance with them!

NOLA Bombshells | Founded in 2016, the kiss-blowing charity organization combines choreography with community activism. See them in parades throughout town.

NOLA Cherry Bombs | These are "the foxes you've been waiting for." With hardcore dance moves, the NOLA Cherry Bombs' white tank tops, red tutus, and black boots are coming to a parade near you.

NOLA Chorus Girls | The spirit and aesthetics of early twentieth century chorus lines inspire this group that venerates jazz music and culture and vintage fashion. They also appear as shimmery angels on 12th Night.

Nola Jewels | A 1920s inspired dance group, the NOLA Jewels dress like flappers shaking their fringe as they celebrate Mardi Gras in a "fun, flirty, but classy" way.

Nola Night Lights | Who knew hula hoops and LED lights go together? Founded in 2017, these flow artists and acrobats bring magic and delight to the night marching in a variety of parades.

NOLA Ninjas | Disciples of the Sacred Wookie, this group is part of the Chewbacchus subkrewe rodeo.

NOLA Nyxettes | Strutting in their tuxes, tails, and top hats, this dancing krewe made its classy Carnival debut in 2014.

Nola Ram | Cosplay, imbibery, and an overall pursuit of fortune and glory guide Nola Ram as they celebrate the exploits of Dr. Henry "Indiana" Jones Jr.

NoLa Showgirls | Ostrich feathers swirl with these Las Vegas-style glamour-gals, the glitz belying the core intent of female empowerment by a group of moms, wives, business owners, and professionals.

NOPL Children of the READ-Volution | "We have facts. We have fiction. We know the difference!" Teach your children well.

NorthSide Skull and Bones | Clacking bones, knocking on doors, beating drums with their ominous warning "You Next!," the North Side Skull and Bone Gang has ushered in Mardi Gras Day for over 200 years.

Societé de Champs Elysee | Dedicated to the betterment of the neighborhoods along the cross formed by the Elysian Fields and Saint Claude/ Henriette DeLlille, this group ushers in 12th Night with song and cheer.

Organ Grinders | Like their namesakes, the Organ Grinders are street performers. They are scrappy opportunists who don't need anything much to get out there and shake tail (monkey tail, that is).

Oui Dats | Oui Dats dancing group sashays throughout the brightest city in the world with Mardi Gras parades and charity events across the North and South shores. They're sassy!

Papa Spat's Olives | Disciples of the Sacred Wookie, this group is part of the Chewbacchus subkrewe rodeo.

Persphone's Dragonflies | They celebrate beauty, creativity, and the unique bond between women by parading through the French Quarter on Local's Friday in gloriously beaded bustiers, handmade by each member.

Pete Fountain's Half Fast Walking Club | Founded by local legend jazz clarinetist Pete Fountain, this group of 220 members wear brilliant-colored tuxedos as they meander on the St. Charles Avenue route on Mardi Gras morning.

Phunny Phorty Phellows | First marching from 1878–1898, the Phunny Phorty Phellows were revived in 1981 leading the way by streetcar into Carnival season with costumes reflecting topical themes.

Pink wookie Posse | Disciples of the Sacred Wookie, this group is part of the Chewbacchus subkrewe rodeo.

Prima Donnas | The all-female Prima Donnas are the "Guardians of Haute Couture." Find them using the streets of the French Quarter as their runway the Friday before Mardi Gras Day.

Prissy Hens and Strutting Cocks | Feathers, feathers... everywhere! This poultry themed co-ed krewe is known for giving their signature Prissy hand-decorated eggs to a lucky few parade goers.

Pussyfooters | The iconic Pussyfooters led the recent boom in dancing groups. With members thirty years and older, they continue to impress with their trademark pink plumage, corsets, and philanthropy.

Queer Eye for the Scifi | Skewed towards sci-fi, comics, manga, and anime, this Chewbacchus sub-krewe is for LGBTQ+ cosplayers and their allies.

Red Satin Baby Dolls | These lovely ladies are a living legacy; masking as Baby Dolls they dance as good as they look.

Renegade Rebel Baby Dolls | Empowerment, social and community outreach are the hallmarks of the Renegade Rebel Bay Dolls who focus on being able to live in your own personal truth. Live and Love!

Ritmeaux Krewe | The love of Latin dance and music pulse throughout the Ritmeaux Krewe. The first of its genre, they started in 2016, promoting Hispanic/Latino Heritage through Latin dance and music.

Rogues (in other circles Irish Rogues) | Disciples of the Sacred Wookie, this group is part of the Chewbacchus subkrewe rodeo.

Rolling Elliots | No need to phone home—E.T.'s fans venerate this beloved extraterrestrial by riding throughout Chewbacchus with many version of ET riding in his milk crate on the fronts of their bicycles.

Rolling Elvi | They ride on all manner of decorated scooters, bringing the spirit of the King of Rock & Roll to New Orleans Parade goers. Celebrating Elvis in all his stages, this krewe keeps the fun rolling.

Roux La La | This is one swamp-steppin', booty-shakin', booze-guzzlin', pot-stirrin', glitter in your face dance troupe! Hot roux mixed with some la la and sassy moves for fun on the parade route.

Royal Order of Metatron | Disciples of the Sacred Wookie, this group is part of the Chewbacchus subkrewe rodeo.

Saintly Squadron Disciples of the Sacred Wookie, this group is part of the Chewbacchus subkrewe rodeo.

Seeds of Decline | A sub-krewe of the Krewe du Vieux parade whose common commitment is to turn the most profane themes into a communal ritual of critique, lament, and ribaldry.

Sensuous Sister of Zeltros | The Sensuous Sisters of Zeltros are devotees to the Sacred Drunken Wookie cloistered out of Crescent Lotus Studio. They praise him with their sexy veil dances.

Sideshow of the Damned | Sideshow weirdos, Freakshow family, Circus performers, and Carnies—one and all!

Silhouette Dance Company | Disciples of the Sacred Wookie, this group is part of the Chewbacchus subkrewe rodeo.

Sirens of New Orleans | These mermaids shimmy and shake throughout Carnival. At other times, hear their enticing call to improve the wellness of women and children and increase knowledge about marine life.

Skeleton Krewe | They celebrate the art of papier-mâché costume crafting and the long tradition of masking as skeletons in New Orleans and around the world with inspiration from the early walking processions.

Skinz and Bonez | "Enjoy yourself. It's later than you think!" admonishes the city's only female bone gang parading on Mardi Gras and Halloween. With humor, new members are "Wishbones" and children "Shortribs."

Societe de St Anne | Hula hoops on poles draped with ribbons lead an explosion of spectacular costumes snaking through the French Quarter to salute Rex then for remembrance at the river.

Society of St. Cecilia | Winding through the Marigny, Bywater, Treme to the French Quarter, the Society of St. Cecilia dances Mardi Gras Day away.

Souper Krewe of Broth | "It's a silly krewe, but I want to make it a force for good in our city, as well," notes founder Emma Herr. These human incarnations of soup clank pots, dish out actual soup, and celebrate life.

Southern Belle Baby Dolls | Supporting the power of women now through historic Baby Doll traditions.

Space Vikings | Space Vikings are fearless, horn-chugging, weapons-bearing warriors who traveled to earth on a beam of cosmic light to conquer the biggest parties.

Spare Parts Express | Louisiana's premier spacecraft repair and freestyle noise unit, SPEx provides grounded and orbital service to all registered ships in the Terran Zone.

Stank Wizards of Pomeranian | They are the Stank Wizards of Pomeranian, the krewe that celebrates the beauty of Pomeranians and the stank of our lord Shrek.

Star Steppin' Cosmonaughties | Celestial bodies in motion! The Cosmonaughties march in the annual Chewbacchus parade.

STOMP Troopers | Disciples of the Sacred Wookie, this group is part of the Chewbacchus subkrewe rodeo.

Streetcar Strutters | Their decorated conductors caps top these dancing lovelies as they "struts" the historic St. Charles Streetcar Line during Carnival and spread intoxicating Crescent City Magic all year long.

T.O.K.I.N. | "Totally Orgasmic Krewe of Intergalactic Ne'er-do-Wells," alive and well marching in Krewe du Vieux.

Tap Dat | An open community of joyous tap dancers, Tap Dat empowers through the art of dance. They dance continuously during appearances, making shorter parades a necessity.

The 689 Swampers | Wearing neon socks, shrimp boots, and camo vests, the 689 Swampers, an all-male dance group, engages audiences on the parade route, showing off their Magic Feet from Lafitte!

The Alkreweists | The Alkreweists formed in 2010 of folks who came to New Orleans to help in some part of the recovery process and stayed, marching each year in krewedelusion.

The Avengers | Disciples of the Sacred Wookie, this group is part of the Chewbacchus subkrewe rodeo.

The Call Girls | Disciples of the Sacred Wookie, this group is part of the Chewbacchus subkrewe rodeo.

The Children of the Cone | Disciples of the Sacred Wookie, this group is part of the Chewbacchus subkrewe rodeo.

The droids you're looking for | They are a mostly human-based organization. They come in peace and only want to entertain.

The Empowered Strike Back | Disciples of the Sacred Wookie, this group is part of the Chewbacchus subkrewe rodeo.

The Krewe of Won!!! | A sub-krewe of the krewedelusion Parade.

The Merry Antoinettes | These scandalous party queens form a creative collaboration that embraces the extravagance of 18th century France at events year round—but especially during Carnival.

The Pony Girls | These pretty ponies are of Amazonian height, splendidly appointed, even their harnesses sparkle as pull their Queen in New Orleans parades.

There is no Krewe only Zul | These Louisiana Ghostbusters are part of the Chewbacchus sub-krewe rodeo, and their krewe is super-secret.

Thoth Walk | A spin off of the venerated Thoth parade; started started in 1958 and continuing today as they visit charitable institutions on the Wednesday before the Thoth parade and mingle.

Tidal Wave NOLA | The Tidal Wave Dance Team is a community-oriented, high-quality dance team located in New Orleans.

Trash Monsters | They began a few years ago to make a difference in the parade refuse. They believe "Trash sucks and we hate it."

TrashFormers | The "marching Krewe with a job to do" makes a statement by collecting recyclable waste from parade goers in an interactive and enthusiastic way instead of producing it.

Treme Million Dollar Babydolls | Steeped in Baby Doll tradition, the group was founded by Reza "Cinnamon Black" Wilson-Bazile.

We Are All Wonder Woman | W-W-W -Wow. One of the largest Chewbacchus krewes and open to all, they believe "All the world is waiting for you and the power you possess!" Check out the invisible plane!

We Are Three | Disciples of the Sacred Wookie, this group is part of the Chewbacchus subkrewe rodeo.

Wild Tchopitoulas Baby Dolls | These lovely ladies are a living legacy; masking as Baby Dolls they dance as good as they look.

Women of Wakanda | Women of Wakanda is an Afro-futuristic parade krewe, a collective of visionaries, creatives, professionals, business owners, and self-proclaimed blerds!

Zulu Walking Warriors | The marching faction of the famous Zulu Aid and Pleasure Club, the Zulu Walkers lead the Zulu parade on Mardi Gras day.

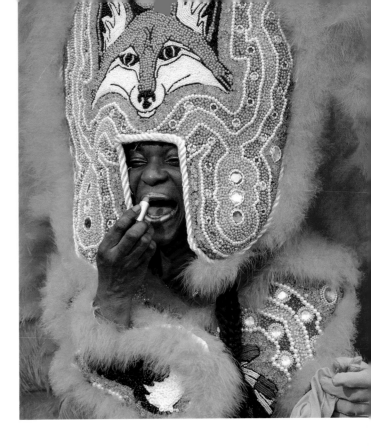

Black Masking Indians | The sacred and discrete universe of Black Masking Indians is reviewed in Chapter 4 (pps 116–138) and are included here. IWDT has not attempted to capture these important culture bearers in a two sentence, jocular description, but have listed them below.

7th Ward Creole Hunters
7th Ward Hard Headers
7th Ward Hunters
9th Ward Hunters
Algiers Warriors
Apache Hunters
Beautiful Creole Apache
Black Feather
Black Flame Hunters
Black Hatchet
Black Hawk Hunters
Black Mohawks
Black Seminoles
Blackfoot Hunters
Broken Arrow
Carrollton Hunters
Cheveyo
Cheyenne
Chippewa Hunters
Comanche Hunters
Congo Nation (Congo Square Afro New Orleans)
Creole Apache
Creole Osceolas
Creole Wild West
Cutthroat Hunters
Downtown Thunder
FiYiYi's Mandingo Warriors
Flaming Arrows

Geronimo Hunters
Golden Blades
Golden Comanche
Golden Eagles
Golden Feather Hunters
Golden Sioux
Guardians of the Flame Maroon Society
Hard Head Hunters
Lightning and Thunder
Loyal Breed Apache Warriors
Mohawk Hunters
Monogram Hunters
Red White and Blue
Seminole Hunters
Seminoles (Black Masking Indian Tribe)
Semolian Warriors
Shining Star Hunters
The Young Hunters
Tomahawk Hunters
Trouble Nation
Unified Nation
Uptown Warriors
Washitaw Nation
White Eagles
Wild Apache
Wild Magnolias
Wild Mohicans
Wild Red Flame
Wild Tchoupitoulas
Yellow Jackets
Yellow Pocahontas
Young Brave Hunters
Young Cherokee
Young Eagles
Young Generation Warriors
Young Hunters
Young Massai Hunters
Young Seminole Hunters

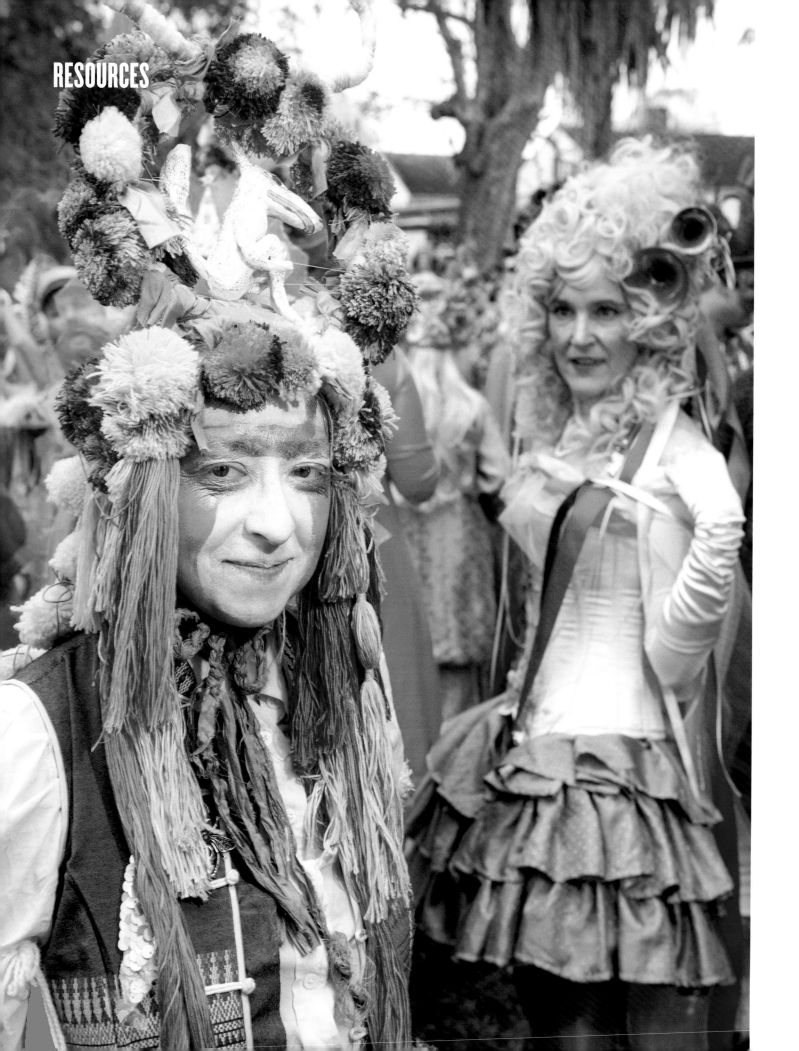

VARIOUS TRADITIONS

A Life in Jazz, Danny Barker, (Historic New Orleans Collection, 2016)

Celebrating Mardi Gras from the French Quarter to the Red River, Brian J. Costello, (LSU Press, 2017)

City of a Million Dreams: A History of New Orleans at Year 300, Jason Barry, (University of North Carolina Press, 2018)

Downtown Mardi Gras: New Carnival Practices in Post-Katrina New Orleans , Leslie A. Wade, Robin Roberts and Frank de Caro, (University Press of Mississippi, 2019)

Lords of Misrule: Mardi Gras and the Politics of Race, James Gill, (University Press of Mississippi, 1997)

Mardi Gras! A Celebration, Errol Laborde, Peggy Laborde and Mitchel Osborne, (Pelican Publishing, 2013)

Mardi Gras Chronicles of the New Orleans Carnival, Errol Laborde, Peggy Laborde and Mitchel Osborne, (Pelican Publishing, 2013)

Mardi Gras in the Country, Mary Alice Fontenot and Partick Soper, (Pelican Publishing, 1994)

New Orleans Carnival Krewes: *The History, Spirit & Secrets of Mardi Gras*, Rosary O'Neill, (The History Press, 2014)

Unfathomable City: A New Orleans Atlas, Rebecca Solnit and Rebecca Snedeker, (University of California Press, 2013)

Up From The Cradle of Jazz: New Orleans Music Since WWII, Jason Barry, Jonathan Foose and Tad Jones, (University of Louisiana at Lafayette Press, 2009)

BLACK MASKING INDIANS, BABY DOLLS, AND BLACK AND CREOLE TRADITIONS

All on a Mardi Gras Day: Episodes in the History of New Orleans Carnival, Reid Mitchell, (Harvard Press, 1995)

Big Chief Harrison and the Mardi Gras Indians, Al Kennedy and Herreast Harrison, (Pelican Publishing, 2010)

Chief of Chiefs: Robert Nathaniel Lee and the Mardi Gras Indians of New Orleans, 1915-2001, Al Kennedy, (Pelican Publishing, 2018)

Fire in the Hole: The Spirit Work of Fi Yi Yi & the Mandingo Warriors, Fi Yi Yi and Rachel Breunlin, et al (University of New Orleans Press, 2018)

From the Kingdom of Kongo to Congo Square: Kongo Dances and the Origin of the Mardi Gras Indians, Jeroen Dewulf, (University of Louisiana at Lafayette Press, 2017)

Krewe of New Orleans Baby Doll Ladies Homecoming, Millisia White, (Lulu.com, 2019)

Living the Black Storyville Baby Doll Life, Dianne Honoré, (self-published, 2017)

Mardi Gras, Gumbo, and Zydeco: Readings in Louisiana Culture, Marcia Gaudet and James C. MacDonald (University Press of Mississippi, 2013)

*Mardi Gras Indians ,*Michael Smith, and Alan Govenar, (Pelican Publishing, 1994)

Mardi Gras Indians: Carnival and Counter-Narrative in Black New Orleans, George Lipsitz, (University of Minnesota Press, 1990)

Rhythm, Ritual, & Resistance: Africa is Alive in the Black Indians of New Orleans, Robin Ligon-Williams, (Talking Eagle Press, 2019)

The Baby Dolls: Breaking the Race and Gender Barriers of the New Orleans Mardi Gras Tradition , Kim Marie Vaz, (LSU Press, 2013)

The House of Dance and Feathers: A Museum by Ronald W. Lewis, Ronald W. Lewis and Rachel Breunlin, (University of New Orleans Press/Neighborhood Story Project, 2009)

In Extremis: Death and Life in the 21st-Century Haitian Art, Steve C. Wehmeyer, (Fowler Museum at UCLA, 2017)

Gumbo YA-YA: Folk Tales of Louisiana, Lyle Saxon and Robert Tallant, (Baton Rouge: Louisiana Library Commission, 1945)

VINTAGE MARDI GRAS

Mardi Gras Treasures: Float Designs of the Golden Age, Henri Schindler, (Pelican Publishing, 2002)

Mardi Gras Treasures: Costume Designs of the Golden Age, Volume II, Henri Schindler, (Pelican Publishing, 2001)

Mardi Gras Treasures: Invitations of the Golden Age, Henri Schindler, (Pelican Publishing, 2000)

Mardi Gras Treasures: Jewelry of the Golden Age, Henri Schindler, (Pelican Publishing, 2006)

New Orleans Carnival Balls: The Secret Side of Mardi Gras, 1870-1920, Jennifer Atkins, (LSU Press, 2017)

Mardi Gras in New Orleans : An Illustrated History, Arthur Hardy, (Arthur Hardy Enterprises, 2009)

Annual Mardi Gras Guide, Arthur Hardy, (Arthur Hardy Enterprises, 1999)

Mardi Gras: Chronicles of the New Orleans Carnival, Errol Laborde, Peggy Laborde and Mitchel Osborne (Pelican Publishing, 2013)

Mardi Gras: A Pictorial History of Carnival in New Orleans , Leonard Huber, (Pelican Publishing, 1976)

ON-LINE

Mardigrasneworleans.com, a comprehensive guide to Mardi Gras intel and up-to-date information about all things Mardi Gras.

Musicrising.tulane.edu, dedicated to the study, preservation, and the promotion of musical cultures of the Gulf South region, including the states of Louisiana, Alabama, Florida, Georgia, Mississippi, and Texas, as well as the Caribbean, Latin America and the African Diaspora.

VIDEO

All on a Mardi Gras Day. Directed and written by Royce Osborn, documentary film that explores New Orleans' Black Carnival traditions.

Faubourg Tremé — The Untold Story of Black New Orleans. Directed by Dawn Logsdon and written by Lolis Eric Elie, documentary film that relates the history New Orleans' Tremé neighborhood.

Always for Pleasure. Directed by Les Blank, documentary about social traditions in New Orleans.

By Invitation Only. Directed by Rebecca Snedeker, documentary film that gives an unprecedented look at race inequities and inner workings of old-line Carnival societies and debutante balls.

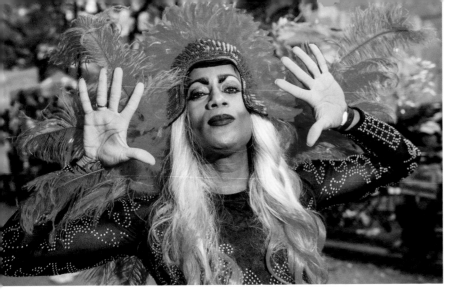

CHILDREN'S BOOKS

D.J. and the Zulu parade, Denise McConduit and Emile Henriquez, (Pelican Publishing, 1994)

Gaston goes to Mardi Gras, James Rice, (Pelican Publishing, 2000)

Dinosaur Mardi Gras, Dianne De Las Casas and Marita Gentry, (Pelican Publishing, 2011)

Jenny Giraffe's Mardi Gras Ride, Cecilia Dartez and Andy Green (Pelican Publishing, Reprint Edition, 2018)

Mimi's First Mardi Gras, Alice Couvillon, Elizabeth Morre and Marilyn C. Rougelot, (Pelican Publishing, 1991)

MUSIC

Professor Longhair, *Mardi Gras in New Orleans*, Nighthawk Records, 1981

Various artists, *New Orleans Gumbo: The Absolutely Essential 3 CD Collection*, Big 3, 2016

Various artists, *Nothing But A Party: Basin Street Records New Orleans Mardi Gras Collection*, Basin Street Records, 2012

Various artists, *Mardi Gras Dance Party*, Mardi Gras Records, 1998

The Wild Magnolias, *The Wild Magnolias*, Polygram Records, 1974

The Wild Magnolias, *They Call Us Wild*, Sunnyside Records, 2075

Bo Dollis & the Wild Magnolias, *I'm Back at Carnival Time*, Rounder Records, 1990

Bo Dollis & the Wild Magnolias, *1313 Hoodoo Street*, Aim Records, 1996

The Wild Tchoupitoulas, *The Wild Tchoupitoulas (and the Meters)*, Mango Records, 1976

VISIT

Back Street Cultural Museum: dedicated to preserving and showcasing Black masking traditions, this is an excellent place to please your eyes and expand your knowledge with this incredible collection. **www.backstreetmuseum.org**

Louisiana State Museums: The Cabildo and Presbytère are located on Jackson Square; sister museums they host exhibitions about the city including a permanent exhibition on Mardi Gras in New Orleans at the Presbytère. **www.louisianastatemuseum.org**

On Esplanade Avenue at the river, the **The Louisiana Jazz Museum at the Old U.S. Mint** has a permanent exhibition on jazz music and its interactions with the city - often an integral part of Mardi Gras. If you're lucky you can attend a performance at the venue on the third floor. **www.nolajazzmuseum.org**

INDEX

Numbers in *italics* indicate photographs. Photographers are listed in boldface.

BIOS

ECHO OLANDER

This Yankee child has found home and heart in the wide bayous, smoky bars and parade routes of New Orleans. Since the 1970s she has been exploring the intricate layers of New Orleans culture and striving to build creative capacity in the city. Following almost twenty years as the leader of a nationally recognized arts education organization, she is currently reinvigorating her own creative processes. Her current interest is the fertile place where self and community find vibrant connection.

YONI GOLDSTEIN

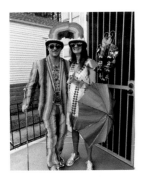

Raised in Washington DC in the 1980s, Yoni first made his way to New Orleans in the early 1990s where he discovered an enchanted realm that continues to thrive even to this day. His first Mardi Gras morning was a revelatory reminder that there is still magic in the world and that it is worth cultivating and expanding. Inquisitive by nature, Yoni has had several career incarnations, including travel agent, band manager, banquet chef, poker player, retail shop owner, website builder and project manager. He is an avid chess player, guitar player, reader, and patron of the arts. He is currently way behind schedule on creating his next Mardi Gras costume.

PATRICK NIDDRIE

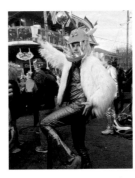

Patrick landed on the perfect medium for his bold, colorful artistic sensibilities when he discovered photography in 2007. A New Orleanian by birth (and choice!) he headed out into the world with nothing but his camera and his curiosity and let his lens guide him everywhere from the Swiss Alps to the Ganges Delta. Returning home periodically to establish his photography career, his business and artist client list has grown into the hundreds as art buyers have sought him out for his polished, yet spontaneous, style.

Patrick is a believer in the power of collaboration; that creative teams are greater than the sum of their parts. When shooting he likes to keep things loose and leave space for those wonderful off-the-cuff moments without sacrificing the clean, vibrant look he loves. See more at patrickniddrie.com.

RYAN HODGSON-RIGSBEE

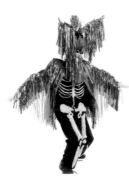

Ryan is a New Orleans based photographer. A native of Chicago, he studied photojournalism at Ohio University. Since 2005, he has worked as a staff photographer at the *Orange County Register* and as a freelancer for *ESPN Magazine, The New York Times, Conde Nast Traveler, New Orleans Advocate, Bitter Southerner, New Orleans Magazine, OffBeat Magazine, Gambit, Arthur Hardy's Mardi Gras Guide, Antigravity, Art+Design, Chicago Magazine, Le Parisien Magazine, Jazzism,* among many others.

Beyond his editorial work, Ryan collaborates with numerous New Orleans nonprofits, businesses, and artists to reach the public with photography that is both compelling and culturally responsible.

Ryan also has a number of long running personal projects exploring culture, music, and landscape in New Orleans and other unique communities across the nation. See more at rhrphoto.com.

ACKNOWLEDGMENTS

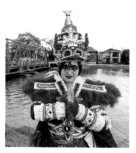

The work of creating a book is collaborative. We'd like to recognize the special people who have been there with us, providing mental support and helping with the myriad tasks required in a project of this magnitude. We are especially grateful to Jennifer Muth for her awesomeness and efficiency (especially with the Krewe-niverse), Sonny Schneidau for his keen eye, Sarah Woodward and Clé Torres for their support of the photo team.

Arthur Hardy was gracious with his time and support—including providing the compelling Foreword. We could not have asked for a better team than Susan Schadt and Lauren Esthus from Susan Schadt Press—they are the reason we have been able to make this information available to the world. The fantastic Tony Steck, DOXA/VANTAGE made the work pop and knows how to please the eye. Charlie Hughes dotted our i's and crossed our t's.

As with any project, this work has been a team effort. We are especially in awe and appreciation of the visual side of our creative team: our intrepid photographers. Ryan Hodgson-Rigsbee and Patrick Niddrie are passionate artists who have done an incredible job capturing the magic and exuberance on the streets. Because the task of covering the krewes was so large, we are grateful to some additional photographers who help to tell this important story.

Allen Boudreaux, @allenboudreauxphotography
Hunter Lee Daniel
Cyril Duplessis
Miatri Erwin, @miatri
Alexander Lanaux
Doug Mason, douglasmason.smugmug.com
Eli Mergel, shotbyeli.com
Marc Pagani, marcpagani.com
Katie Sikora, katiesikora.com
Jon Tenholder, instagram.com/thugcurse
Josh Vine, @joshvinemusic
Joshua Williams IV, joshuawilliamsiv.com

In telling the long history and current practices of Carnival in New Orleans, we are grateful for the invaluable conversations and support from knowledgeable sources including: Amistad Research Center—Lisa Moore; Bruce "Sunpie" Barnes; The Ella Project—Ashlye Keaton and Gene Meneray; The Historic New Orleans Collection—Jessica Dorman and Rebecca Smith; Krewe of Muses—Weezie Porter, Dionne Randolph, Staci Rosenberg, Virginia Saussy; Louisiana Division of the Arts—Maida Owens, Folklife; Louisiana State Museum—Jen Suran; New Orleans & Co.—Tara Letort; New Orleans Jazz and Heritage Foundation—Kia Robinson; Ben Sandmel, Folklorist, Tulane University Special Collections—Leon C. Miller and Lori Schexnayder.

Many people filled in the color and provided answers for our many questions. We thank the following for their time and support: Circe Olander Curley, Lake Douglas, Ali Duffey, Arthur Hardy, Scott Hutcheson, Don Marshall, Doug McCash, Sonya Robinson, Pam Stevens, Laura Tennyson, MK Wegmann and Jeanette Weiland.

We have huge gratitude for these folks who generally work without compensation, for their energy on the streets and for talking with us about why, and how they do it: Terese Aiello, Bayou Babes of NOLA; Camille Baldassar, Pussyfooter Founder; Julia Barecki and Bri Whetstone, Krewe Bohéme; Katrina Brees, Krewe of Kolossos; Francesca Brennan, Krewe Boheme and The Merry Antoinettes; Vivian Cahn, Krewe du Vieux and French Quarter Madams; Sarah Dearie, Bloco Seriea; Devin DeWulf, Krewe of Red Beans; Shelita Domino, Pussyfooters; Cyril Duplessis and Millisia White, New Orleans Baby Doll Ladies; Brooke Etheridge, Chewbacchus; Nancy Fournier, Flora and Fauna; Cherice Harrison-Nelson, Guardians of the Flame Maroon Society; Kirah Haubrich, Chewbacchus; David "Tenacious D" Hoover, 610 Stompers; Mindie Kairdolf (IWDT's Cover Girl), Krewe des Fleurs; Casey Love, Camel Toe Lady Steppers; Carol Miles, DIVAs; Anita Oubre, Mahogany Blue Baby Dolls; Brett "Slab" Patron, 610 Stompers; Laura Shapiro and Leslie Lewis, Krewe des Fleurs; Michael Tisserand, Laissez Boys; Zoe Tristus, Krewe of Dreux; Seran Williams, Dames des Perlage.

www.susanschadtpress.com

Published in 2020 by Susan Schadt Press
New Orleans

© 2020 by Echo Olander & Yoni Goldstein

Photographs © Ryan Hodgson-Rigsbee & Patrick Niddrie

Text and design © 2020 Susan Schadt Press
Designed by DOXA/VANTAGE

Library of Congress Control Number: 2020917301

ISBN 978-1-7336341-5-1

Printed by Friesens, Altona, Canada

We'd like to recognize the generous people without whose support we could not have brought this dream to life:

Portia Jackson

Bruce Blaylock
Shirley Olander
Daniel Sinclair

Heather Candell
Captain & Co. Real Estate, LLC
Jill Dupré and Josh Mayer
Carol Miles
Susan and Charles Schadt
Lauren and Patrick Templeman

Holly Ackerman
Edie Ambrose and Yakir Katz
Phoebe Autumn
Carolyn Babauta and Maia Holderby
Camille Baldassar
Joseph R. Blank
Kiki Bradley
Michael Brantmeier
Jeremy Bull
Vivian and Richard Cahn
Suzanne Charbonnet
Campion Carlson Family
David Colker
Circe and Denny Curley
Clete Diener
Leila and Andrew Eaton
Tom Ellis
Lauren and Nick Esthus
Finucane Family
Kirk Fogerty
Jason Fruzynski-Nalley
Scott Galante
Ragan and Dino Gankendorff
Claudia Garofalo
Michelle and Mary Gehrke
Jessica M. Giesel
Elise Gallinot Goldman and
 Matthew Goldman
Ilana and Stephen Goldstein
Uri Goldstein
The Green Family
Keadren Green
Holly and Vladimir Harris
Cici and Daniel Hawk
Michelle Russell Hollberg
Alice and Sandy Horowitz
R. Campbell Hutchinson

Ashley Kahn
Steve 'Quasi2018' Kaplan
Patricia and Michael Knapp
Xelaju Korda
Annie LaRock
Martha Lavin and Marc Solomon
JP LaGraize
Cebastian Martinez
Virginia McCollam and Andy Ryan
Susan and Paul McDowell
Edmund McIlhenny
Louise McIlhenny and
 Hugh Riddleberger
Bonnie and Chaffe McIlhenny
Charles Meeks
Lily and Spence Mehl
Christina L Moll
Alejandra "Sascha" Mora
Jennifer Muth
Julie Nalibov and Gerry Puchalski
Ellen and Peter Obstler
Leslie Parker
Diane Penfield
Callie Prechter
Sandra Rigsbee
Isabelle Schneidau
Maura Schonwald
Pablo Schor
Susan Seagren and Aaron Wilkinson
Zoe and Adam Shipley
Georgia and Larry Simpson
Dan Spayer
Rob Steinberg
Linda Usdin and Steven Bingler
Diane Wanek
Sarah Woodward
Mike Zolg